Convicting the Innocent

Convicting the Innocent

WHERE CRIMINAL PROSECUTIONS GO WRONG

Brandon L. Garrett

Harvard University Press

Cambridge, Massachusetts · London, England

2011

Copyright © 2011 by the President and Fellows of Harvard College
All rights reserved
Printed in the United States of America

Library of Congress Cataloging-in-Publication Data

Garrett, Brandon L., 1975–
Convicting the innocent : where criminal prosecutions go wrong / Brandon L. Garrett.
p. cm.
Includes bibliographical references and index.
ISBN 978-0-674-05870-5 (alk. paper)
1. Judicial error—United States. 2. Evidence, Criminal—United States.
3. Post-conviction remedies—United States. I. Title.
KF9756.G37 2011
345.73'064—dc22 2010037172

To the exonerees whose stories are told here

and to the innocent people who have not yet been exonerated

Contents

Introduction

IN OCTOBER 1993, Ronald Jones sat on death row in Illinois waiting to be executed. He had been sentenced to death for a gruesome rape and murder in Chicago. Jones clung to one last request—for a DNA test, which he claimed would prove his innocence. His lawyers offered to pay the $3,000 that it would cost to do the test. At the time, only a handful of people had ever proven their innocence using postconviction DNA testing. The prosecutors opposed testing, arguing that it would make no difference. Indeed, there appeared to be overwhelming evidence of Ronald Jones's guilt. Cook County circuit judge John Morrissey agreed and angrily denied the motion, exclaiming, "What issue could possibly be resolved by DNA testing?"[1]

Eight years before, in March 1985, the victim, a twenty-eight-year-old mother of three, was out dancing late with her sister on the South Side of Chicago. She was hungry and decided to get food a few blocks from her home at Harold's Chicken Shack. She ran into a friend on the street. As they talked, a panhandler approached; people in the neighborhood had nicknamed him "Bumpy," because of his severe acne. "Bumpy" asked the friend for fifty cents. She gave him fifty cents and all three parted ways.

Several hours later, the victim was found half-naked and dead in a nearby alley behind the abandoned Crest Hotel. She had been stabbed

many times and beaten. Ronald Jones, who was familiar to the police because he was a suspect in a sexual assault case that was never brought to a trial, was arrested. He had a severe acne problem and was known as Bumpy. He may have in fact been the man the friend saw that night. He was "a homeless, alcoholic panhandler" with an IQ of about 80.[2]

After Jones was arrested, he was placed in a small police interrogation room with walls bare save a sheet of paper listing the *Miranda* warnings. During an eight-hour-long interrogation, he confessed. Jones did not just say, "I did it." He made far more damning admissions, signing a written statement that included a series of details that only the killer could have known. The victim was assaulted in a room inside the vacant Crest Hotel, where police found a large pool of blood and some of her clothing. In his statement, Jones said that on the morning of the crime, he was walking "by the Crest," saw the victim, and assaulted her in a room inside. Police analysts detected semen in the victim's vagina. Jones said that they had sex. The pathologist testified that the victim had injuries from trying to fend off blows. Jones said they were "wrestling and tussling." The victim had been stabbed four times. Jones said he lost his temper and "cut her a few times" with a knife. Police had found a trail of blood leading out of a window that had no glass, into the alley where they found the victim's body. Jones knew there was "an alley" by the hotel and said he came and left through an open "side window."[3] It was unlikely that anyone could coincidentally guess so many details that matched the crime scene.

The lead detective testified at trial that he brought Jones to the crime scene, where Jones offered more details. Jones "showed us the room" and "showed us where the struggle took place and where she was actually stabbed." He accurately described the victim's appearance.[4] Jones supposedly offered all of these crime scene details without any prompting. Those details sealed his fate.

Ronald Jones's confession was not the only evidence against him. Forensic evidence also linked Jones to the crime. DNA testing was attempted on the semen evidence, but the results were said to be inconclusive. At the time of the trial, in 1989, DNA technology was brand-new and could only be conducted in cases with large quantities of biological material, so conventional A-B-O blood-typing was performed. At trial,

the forensic analyst explained that 52% of the population could have been the source of the semen and that Ronald Jones's blood type placed him in that group.

At the five-day trial, Jones took the witness stand and recanted his confession. In his closing argument, the prosecutor told the jury to consider that Jones was a "twice-convicted felon." He added, "Please don't be fooled by this man's quiet demeanor in this courtroom and on the witness stand. The only two eyes that witnessed the brutal rape and murder . . . are in this courtroom, looking at you right now."[5] The jury convicted Jones and sentenced him to death.

Jones appealed and lost. He argued that his confession was coerced and said procedural errors infected his trial. The Illinois Supreme Court denied his petition, as did the U.S. Supreme Court. Then the trial judge denied his request for DNA testing.

But at the eleventh hour, Ronald Jones's luck began to change. In 1997, the Illinois Supreme Court reversed the trial judge and granted his request for DNA testing. The DNA profile on the sperm did not match Jones. The DNA also did not match the victim's fiancé, with whom she had been living at the time of the murder. It belonged to another man, who remains at large.[6] Jones's conviction was vacated. But prosecutors waited until 1999 to drop the charges. Governor George H. Ryan pardoned Jones in 2000.[7] He had spent more than thirteen years behind bars.

DNA testing saved Ronald Jones's life. Jones later commented, "Had it not been for DNA, who knows about me?"[8] He likely would have been executed.

What went wrong in Ronald Jones's case? Why did he confess to a crime he did not commit? How did he confess in such detail? Why did the blood evidence appear to modestly support the State's case? The answers appear in the records from Jones's trial.

The transcripts of the criminal trial reveal a troubling story. Ronald Jones signed the written confession statement only after enduring hours of interrogation. On the witness stand at trial, Jones testified that a detective had handcuffed him to the wall and hit him in the head again and again with a long black object, because he refused to confess. Jones said that a second detective then entered the room and said, "No, don't hit him, because he might bruise." That detective instead pummeled him

with his fists in a flurry of blows to the midsection.[9] The defense had argued prior to trial that, based on this police misconduct, the confession should be suppressed. The detectives both denied Jones had been struck. The lead detective denied using any interrogation techniques at all. He testified, "I sit down, I interview people, I talk to people. That's all I do, sir." The judge ruled that the confession should be admitted at trial, explaining, "I do not feel that there was any coercion or any undue influence used upon the defendant."[10]

Even if the confession was physically coerced as Jones described at trial, it still raises a puzzle. Now that we know Jones was innocent, one wonders how he could have known so much detailed inside information about the crime. At trial, Jones explained that when police took him to the crime scene they had walked through how the crime happened. The detective "was telling me blood stains on the floor and different clothing that was found inside the abandoned building," and that the victim "was killed with a knife, and she was stabbed, three or four times."[11] It appears that Jones repeated the specific details about the crime in his confession statement not because he was there, but because the police told him exactly what to say.

The forensic evidence at Jones's trial was also flawed. Although the prosecutor told the jury in his closing statement that "physical evidence does not lie," in fact, the forensic analyst had grossly misstated the science.[12] Jones's blood type was the most common type. He was a Type O. However, he was also a nonsecretor, meaning that his body fluids did not reveal his blood type. Only 20% of the population are nonsecretors. The victim was a Type A secretor, as are about 32% of the population. The vaginal swabs collected from the victim's body matched her type and had Type A substances on them. The analyst testified that the percentage of males who could have been the source for the semen was the percentage of nonsecretors added to the percentage of Type A secretors, which would add up to about half the population.[13]

The analyst was wrong. A competent analyst would have explained that any man could have been the rapist. The analyst had found nothing inconsistent with the victim's Type A. This raised a problem that was common at the time, called the problem of "masking." Substances from the victim could "mask" any material present from the rapist. The evi-

dence from this crime scene was totally inconclusive. Nothing at all could be said about the blood type of the rapist.

The 250 Exonerees

In retrospect, Ronald Jones's case provides a stunning example of how our system can convict the innocent. If his case were the only case like this, we might call it a tragic accident, but nothing more. But his case is far from unique. Since DNA testing became available in the late 1980s, more than 250 innocent people have been exonerated by postconviction DNA testing.

Who were these innocent people? The first 250 DNA exonerees were convicted chiefly of rape, in 68% of the cases (171), with 9% convicted of murder (22), 21% convicted of both murder and rape (52), and 2% convicted of other crimes like robbery (5).[14] Seventeen were sentenced to death. Eighty were sentenced to life in prison. They served an average of thirteen years in prison. These people were typically in their twenties when they were convicted. Twenty-four were juveniles. All but four were male. At least eighteen were mentally disabled. Far more DNA exonerees were minorities (70%) than is typical among the already racially skewed populations of rape and murder convicts. Of the 250 exonerees, 155 were black, 20 Latino, 74 white, and 1 Asian.[15]

DNA testing did more—it also identified the guilty. In 45% of the 250 postconviction DNA exonerations (112 cases), the test results identified the culprit. This most often occurred through a "cold hit" or a match in growing law enforcement DNA data banks. The damage caused by these wrongful convictions extends far beyond the suffering of the innocent. Dozens of criminals continued to commit rapes and murders for years until DNA testing identified them.

Before the invention of DNA testing, the problem of convicting the innocent remained largely out of sight. Many doubted that a wrongful conviction could ever occur. Justice Sandra Day O'Connor touted how "our society has a high degree of confidence in its criminal trials, in no small part because the Constitution offers unparalleled protections against convicting the innocent."[16] Judge Learned Hand famously called "the ghost of the innocent man convicted" an "unreal dream." Prosecutors

have from time to time claimed infallibility, announcing, "Innocent men are never convicted."[17] Others acknowledged that human error is inevitable, but doubted that convicts could ever convincingly prove their innocence. Scholars spoke of "the dark figure of innocence," because so little was known about wrongful convictions.[18]

DNA exonerations have changed the face of criminal justice in the United States by revealing that wrongful convictions do occur and, in the process, altering how judges, lawyers, legislators, the public, and scholars perceive the system's accuracy. This sea change came about because of the hard work of visionary lawyers, journalists, and students who suspected that the criminal justice system was not as infallible as many believed. Barry Scheck and Peter Neufeld, two well-known defense lawyers, founded the pioneering Innocence Project at Cardozo Law School in the early 1990s, which helped to free many of the first 250 exonerees. I first met several of these exonerees when, as a rookie lawyer, I worked for Scheck and Neufeld representing innocent people who sued to get compensation for their years behind bars. Over the years, lawyers, journalists, and others established an "innocence network," including clinics at dozens of law schools, designed to locate innocence cases. Today, DNA exonerations have occurred throughout the United States, in thirty-three states and the District of Columbia.[19] Public distrust of the criminal justice system has increased, and popular television shows, books, movies, and plays have dramatized the stories of the wrongfully convicted.[20] We now know that the "ghost of the innocent man" spoken of by Judge Learned Hand is no "unreal dream," but a nightmarish reality.

What Went Wrong

What we have not been able to know, however, is whether there are systemic failures that cause wrongful convictions. Now that there have been so many DNA exonerations, we have a large body of errors to study. Did the first 250 DNA exonerations result from unfortunate but nevertheless unusual circumstances? Or were these errors the result of entrenched practices that criminal courts rely upon every day? Are there similarities among these exonerees' cases? What can we learn from them?

This book is the first to answer these questions by taking an in-depth look at what happened to these innocent people. Collecting the raw materials was a challenge. Although scholars have surveyed jurors and judges using detailed questionnaires, no one has studied a set of criminal trial transcripts to assess what evidence was presented, much less studied the criminal trials of the exonerated.[21] One reason is the difficulty and expense of locating trial records. These voluminous records must often be pulled from storage in court archives or requested from the court reporters. I was able to overcome these difficulties with the help of numerous librarians and research assistants. For each of the first 250 DNA exonerees, I contacted defense lawyers, court clerks, court reporters, prosecutors, and innocence projects around the country. I located documents ranging from confession statements to judicial opinions and, most important, transcripts of exonerees' original trials. I obtained 88% of their trial transcripts, or 207 of the 234 exonerees convicted at a trial.[22] I also obtained hearing transcripts and other records in thirteen of sixteen cases where exonerees had no trial but instead pleaded guilty. In the remaining cases, the records had been sealed, destroyed, or lost.

When I began to assemble this wealth of information, I had a single goal: to find out what went wrong. When I analyzed the trial records, I found that the exonerees' cases were not idiosyncratic. The same problems occurred again and again. Like Ronald Jones, almost all of the other exonerees who falsely confessed had contaminated confession statements. Most other forensic analysis at these trials offered invalid and flawed conclusions. As troubling as it was, Ronald Jones's case looked typical among these exonerees: his case fit a pattern of corrupted evidence, shoddy investigative practices, unsound science, and poor lawyering.

These trials call into question the "unparalleled protections against convicting the innocent" that the Constitution supposedly affords. The system places great trust in the jury as the fact finder. When the Supreme Court declined to recognize a right under the Constitution for convicts to claim their innocence, it reasoned, "the trial is the paramount event for determining the guilt or innocence of the defendant."[23] Yet at a trial, few criminal procedure rules try to ensure that the jury hears accurate evidence. To be sure, celebrated constitutional rights, such as the requirement that jurors find guilt beyond a reasonable doubt and that indigent

defendants receive lawyers, provide crucial bulwarks against miscarriages of justice. But those rights and a welter of others the Court has recognized, like the *Miranda* warnings, the exclusionary rule, and the right to confront witnesses, are procedural rules that the State must follow to prevent a conviction from being overturned. Few rules, however, regulate accuracy rather than procedures. Such matters are typically committed to the discretion of the trial judge.

Exonerations provide new insights into how criminal prosecutions can go wrong. We do not know, and cannot ever know, how many other innocent people have languished behind bars. Yet there is no reason to think that these 250 are the only ones who were wrongly convicted because of the same types of errors by police, prosecutors, defense lawyers, judges, jurors, and forensic scientists. The same unsound but routine methods may have contaminated countless other confessions, eyewitness identifications, forensic analysis, informant testimony, and defenses. Each chapter in this book poses a different question to analyze an aspect of what went wrong in these exonerees' cases.

Why did innocent people confess in such detail to crimes they did not commit? Chapter 2 begins with the case of Jeffrey Deskovic, who, like Ronald Jones, supposedly said much more than "I did it." Forty of these 250 exonerees (16%) confessed to crimes they did not commit. I expected to find some false confessions among these exonerees, since several such cases have become well known and because psychologists have studied how police pressure can coerce a false confession. I was surprised to discover, however, that all but two of those exonerees reportedly confessed to details about the crime that only the killer or rapist could have known. Those specific facts must have been improperly disclosed to exonerees, most likely by police. In Deskovic's case, it is not surprising that he succumbed to police pressure. He was sixteen years old and had to be committed to a mental hospital after a breakdown during his last interrogation session. More than half of the exonerees who falsely confessed were juveniles or mentally disabled. Criminal procedure played a role: the Supreme Court long ago abandoned reviewing the reliability of confessions, focusing instead on whether police coerced the admission of guilt.

Why did victims and other eyewitnesses testify that they were certain that they saw innocent people commit crimes? Chapter 3 begins with the case of

Habib Abdal, who, like 76% (190) of these 250 exonerees, was misidentified by an eyewitness. At trial, the victim pointed to Abdal and said she was absolutely certain that he was the rapist—but she was wrong. I expected eyewitnesses to have been confident by the time of the trial. I never expected to find that in most of these cases, eyewitnesses admitted at trial that earlier they were not so certain and that police had used unreliable and suggestive procedures. In Abdal's case, police showed the victim a single photograph of him and repeatedly pressured her to identify him. Initially the victim described a culprit that looked very different. When she first saw Abdal at the police station, she said he was not the rapist. Most other witnesses had similarly expressed uncertainty, or identified another person, or described an attacker who looked very different. Abdal was one of seventy-four black exonerees who were misidentified by white eyewitnesses—studies have long shown how cross-racial identifications are especially error prone. Once again, criminal procedure offered little guidance; the Supreme Court decades ago adopted a very flexible "reliability" standard that allows police to use highly suggestive procedures.

Why didn't forensic science show at trial that these people were innocent? Chapter 4 begins with the case of Gary Dotson. At Dotson's trial, an analyst gave the jury inaccurate statistics about blood types, just like in Ronald Jones's case. He also gave exaggerated testimony about hair evidence. Most exonerees had forensic evidence analysis in their cases. Although cutting-edge DNA technology later set them free, at trial the forensics were flawed. Reading these trials, I was confronted with a parade of invalid forensics by 61%, or 93, of 153 analysts called by the prosecution. Analysts concocted false probabilities. Analysts asserted, with no scientific support, that bite marks or hairs came from the defendant. Analysts used unreliable techniques. Nor is DNA testing infallible; DNA testing errors contributed to the wrongful convictions of three exonerees. All of this invalid and unreliable forensic testimony was one-sided. Only a handful of defense lawyers obtained experts to counter the flawed forensics. The Supreme Court now ostensibly requires that expert testimony be both reliable and valid, but judges to this day have largely disregarded those requirements in criminal cases.

Why did informants testify against innocent people? Chapter 5 begins with the case of David Gray, in which his jail cellmate became a star

witness for the prosecution. Informants played an unsavory supporting role in 21% of these trials. Most were jailhouse informants, and they did not just lie, as I expected. Instead, they did something more pernicious—they claimed to have overheard telling details about the crime. In Gray's case, the prosecutor admitted that the informant was a known liar but argued that the jury should still believe him. After all, the informant claimed that Gray told him detailed facts about the crime: he ripped the victim's phone off the wall; he wore flashy wine-colored shoes. Informants then denied they received any deals, although prosecutors in fact rewarded many with light sentences for telling such lies. Judges do not meaningfully limit or regulate the testimony of these untrustworthy informants.

Why didn't defense lawyers prevent convictions of their innocent clients? Chapter 6 begins with Earl Washington Jr.'s trial, which lasted just two days—even though it was a death penalty case. Imagining what I would do if I were innocent and on trial, I pictured these innocent people vigorously litigating their innocence. Washington, like more than half of these exonerees, took the stand to protest his innocence. Aside from their own words, though, all that most could do was present a weak alibi. Their alibis were usually family members who could be accused of bias. Washington's lawyer had no experience with death penalty cases. He called just two witnesses and presented only forty minutes of evidence. In his brief closing statement, he told the jury to do their job to decide if Washington did it. Afterward, the jury took only fifty minutes to convict an innocent man. Decades later, lawyers also uncovered how the police and prosecutors had concealed evidence of Washington's innocence from the defense. Although the Supreme Court has emphasized how the "crucible of meaningful adversarial testing" protects defendants, judges have long failed to ensure that defendants receive adequate representation or access to evidence of their innocence at trial.[24]

Why didn't appeals or habeas corpus review set innocent people free? Chapter 7 turns to the lengthy appeals and habeas proceedings that these innocent people pursued. One might expect that judges would look for serious mistakes like the ones in these exonerees' cases. However, judges only reluctantly review the evidence after a conviction. After all, most constitutional rights relate to procedure and not accuracy. Most exonerees did not try to challenge flawed trial evidence, and when they

did they almost always failed. Judges typically refused to grant a new trial, and some were so sure that these people were guilty that they called the evidence of guilt "overwhelming."

Why did it take so long for innocent people to be exonerated? Chapter 8 begins with the case of Frank Lee Smith, who died of cancer on death row after fighting for years to obtain DNA testing, which exonerated him only posthumously. Most of the exonerees fought for years to obtain access to DNA testing and an exoneration. The word *exoneration* refers to an official decision to reverse a conviction based on new evidence of innocence. An exoneration occurs if the judge, after hearing the new evidence of innocence, vacates the conviction and there is no retrial, or there is an acquittal at a new trial, or if a governor grants a pardon.[25] The 250 exonerees spent an average of thirteen years in prison. It took longer, an average of fifteen years, for them to be exonerated. Judges and prosecutors sometimes opposed requests for DNA testing. Judges sometimes initially refused to exonerate these people even after DNA tests provided powerful proof of their innocence.

Why didn't criminal justice systems respond to exonerations? Chapter 9 begins by telling how North Carolina responded to exonerations by creating an Innocence Commission to review potential innocence cases and by passing laws to reform interrogations and eyewitness identification procedures. But most jurisdictions have not responded at all, much less so comprehensively. In this last chapter, I revisit the questions raised in each of the prior chapters and suggest a set of solutions. State and local law enforcement are increasingly adopting reforms, such as recorded interrogations, sound eyewitness identification procedures, and audits of forensic work, each of which can help to prevent future wrongful convictions.

The Tip of an Iceberg

Do cases like Ronald Jones's tell us anything about the vast numbers of criminal cases processed in the United States each year? These 250 exonerations are just the tip of an iceberg. The submerged bulk of that iceberg lurks ominously out of view. The most crucial question about these exonerations cannot be answered. We do not know and we cannot know how

many other innocent people languish in our prisons. They remain invisible. One of the most haunting features of these exonerations is that so many were discovered by chance. Most convicts who seek postconviction DNA testing cannot get it. Some jurisdictions still deny convicts access to DNA testing that could prove innocence. In our fragmented criminal justice system, exonerations hinge on cooperation of local police, prosecutors, and judges. Most police in the 1980s did not routinely save evidence after a conviction. In Dallas, Texas, where biological evidence was preserved, we have a large set of nineteen DNA exonerations.[26] In nearby Houston, Texas, the county clerk destroyed evidence whenever its storerooms got full, so there have been just six DNA exonerations, despite a major scandal that led to the shutdown of the Houston crime lab.[27] Further, for most crimes, there is no useful evidence collected at a crime scene that can be tested using DNA. If DNA is a "truth machine," it tells us only about a sliver of very serious convictions, most for rape, chiefly from the 1980s.[28]

For all of those reasons, we will never know how large the iceberg is—but we have good reasons to worry that intolerable numbers of innocent people have been convicted. A federal inquiry conducted in the mid-1990s, when police first began to send their samples for DNA testing, found that 25% of "primary suspects" were cleared by DNA before any trial.[29]

The trial records in these cases give us every reason to believe that most of the police, prosecutors, forensic analysts, defense lawyers, judges, and jurors acted in good faith. Few likely realized they were targeting the innocent. They may have suffered from the everyday phenomenon of cognitive bias, meaning that they unconsciously discounted evidence of innocence because it was inconsistent with their prior view of the case, or they were motivated to think of themselves as people who pursued only the guilty. That makes these cases all the more troubling. If there is no reason to think that anyone acted differently in these cases as compared to others, then similar errors may have convicted countless other innocent people and led to the guilty going free.

Rather than blame individual people for their mistakes in these cases, my study of these wrongful convictions suggests that there are systemic problems calling for reforms. We should safeguard the accuracy of cru-

cial pieces of evidence like eyewitness identifications, confessions, forensics, and informant testimony. These 250 exonerations open a unique window on the underside of our criminal justice system. The chapters that follow will each take a hard look through that window to better understand why criminal prosecutions can go wrong—and how we can avoid convicting the innocent.

Contaminated Confessions

A FIFTEEN-YEAR-OLD GIRL'S body was found by a dirt path in a heavily wooded area of a park in downtown Peekskill, New York, near where she lived. She was attacked while walking in the park, listening to a New Kids on the Block cassette tape. She had been severely beaten with a blunt object. The medical examiner concluded she was raped.

Jeffrey Deskovic was seventeen years old and he was a classmate of the victim—both were sophomores at Peekskill High School. Deskovic attended her wake and funeral and appeared distraught. He told the police he was eager to help them solve the crime.[1] The first time they took him to police headquarters, a detective recalled asking him if he wanted to talk to his mother, and he said no. He was taken to an office and given the warnings required by the Supreme Court's decision in *Miranda v. Arizona*. Reading from a card, the detective read, "You have the right to remain silent and refuse to answer any questions. Anything you do say may be used against you in a court of law . . . You have a right to a lawyer before speaking to me and to remain silent." The detective asked, "Do you understand each of these rights I have explained to you?" Deskovic said he did and then signed the card to indicate his willingness to answer questions without an attorney.[2]

Deskovic spoke to the police many times over several weeks. He was interrogated for hours over multiple sessions. In one session, "police had a tape recorder, but turned it on and off, only recording 35 minutes." The tape recorder was on when Deskovic was read his *Miranda* rights, but the tape was not running when the detectives aggressively confronted him.[3]

Deskovic never said that he had raped or murdered the victim. But he reportedly offered other details. The detective explained that "he had begun telling me things that he could not possibly have known had he not, in fact, been the person responsible."[4] During another discussion, Deskovic "supposedly drew an accurate diagram of the crime scene," depicting details from "three discrete crime scenes" which were not ever made public. He had marked the map with notations such as "Struggle," "Raped there," and "Body found."[5] He had also told the detectives that he "sometimes hears voices."[6]

Particularly telling was the final interrogation, which began with a polygraph examination. The detective explained at trial that he did not conduct the polygraph examination to actually test Deskovic's truthfulness, but instead to "[g]et the confession."[7] After the polygraph exam, the detective told Deskovic that he had failed the test, in an effort to place more pressure on him. The interrogation ended with Deskovic curled up on the floor of the polygraph room in a fetal position and crying.

Before collapsing, he reportedly said that although "when he first began coming in he thought he was helping to get the guy responsible," he had gradually realized "that the guy was him."[8] He reportedly volunteered that the victim suffered a blow to the temple and that he tore her clothes. He said he struggled with her and held his hand over her mouth, maybe for "a little too long." He said that he ripped off her bra. The victim's torn bra had been found at the crime scene. He knew that the victim had taken photos on her way to the park and that she had dropped her keys. Finally, Deskovic reportedly said he had "hit her in the back of the head with a Gatorade bottle that was lying on the path." After hearing this, the police later claimed that they returned to the crime scene, where they found a Gatorade bottle cap.[9]

The day after his last interrogation and arrest, Deskovic was declared "suicidal." After he was hospitalized for months, the judge ordered him

examined and found him competent to stand trial.[10] Before trial, the judge also held a hearing to evaluate whether the confession statements were "voluntary" as required by U.S. Supreme Court and state court rulings. Police had used methods shifting from "passive" tactics eliciting information to "active" confrontations. The judge found these tactics lawful and the confession voluntary and therefore admissible, so the jury could hear about it at trial.[11]

Yet at trial the State had a problem. Although the State's theory was that Deskovic had raped and murdered the victim alone, the FBI laboratory had conducted DNA tests before trial. Deskovic was not the source of the semen found in swabs taken from the victim's body. At trial, the district attorney asked the jury to simply ignore that powerful scientific evidence. The district attorney speculated that perhaps the victim was "sexually active" and "romantically linked to somebody else" with whom she engaged in sexual relations shortly before her rape and murder. After all, "she grew up in the eighties."[12] There was no evidence she was sexually active and no investigation was conducted to test this conjecture, either by the prosecution or by the defense.

The trial transcripts highlight how central Deskovic's alleged admissions were to the State's case. The confession was the only evidence connecting Deskovic to the crime. The district attorney emphasized in closing argument that Deskovic had been given the *Miranda* warnings "numerous" times. He said there were "no deceptive tactics utilized," "no threats of violence. Handcuffs placed on him? Guns drawn? Beatings? None of this."[13] The district attorney then turned to the accuracy of Deskovic's statements, noting that after he told police about the Gatorade bottle "it was found there" (although just a cap was found) and that this was a heavy weapon, and "not a small little bottle."[14] The detectives "did not disclose any of their observations or any of the evidence they recovered from Jeffrey nor for that matter, to anyone else they interviewed." They kept their work nonpublic "for the simple reason . . . that [if a suspect] revealed certain intimate details that only the true killer would know, having said those, and be arrested could not then say, 'Hey, they were fed to me by the police, I heard them as rumors, I used my common sense, and it's simply theories.'"

The district attorney told the jury to reject the implication that Deskovic was fed facts, stating, "Ladies and gentlemen, it doesn't wash in

this case, it just doesn't wash." He reviewed each of the facts, asking the jury, "How would Jeffrey know this" unless he was the killer?[15] The facts that the detectives said Deskovic had volunteered trumped the hard science—the DNA evidence. The jury convicted Deskovic of rape and murder.

At sentencing, Deskovic told the judge, "I didn't do anything. I've already had a year of my life taken from me for something I didn't do." The judge seemed troubled: he agreed that "maybe [he was] innocent" but the "jury ha[d] spoken."[16] The judge imposed the minimum sentences of fifteen years to life. Deskovic then filed an appeal, which the appellate court denied, pointing to "overwhelming evidence of the defendant's guilt in the form of the defendant's own multiple inculpatory statements."[17] Deskovic ultimately served sixteen years in prison.

In 2006, new DNA testing again excluded Deskovic, but also did more: the tests matched the profile of Steven Cunningham, a murder convict who subsequently confessed and pleaded guilty. He had committed another murder while Deskovic was in prison. Cunningham later said that if he had known that another person had been wrongly convicted, he would have come forward, commenting, "Nobody should have to do time for something they didn't do."[18]

Now that we know Deskovic is innocent, how do we explain how he reportedly knew so many "intimate details" about the murder? Police could have made up the entire set of statements, but there is no evidence that occurred in Deskovic's case. Instead, police likely contaminated the confession by leaking facts or feeding them to him. The district attorney's postexoneration inquiry concluded:

> Given Deskovic's innocence, two scenarios are possible: either the police (deliberately or inadvertently) communicated this information directly to Deskovic or their questioning at the high school and elsewhere caused this supposedly secret information to be widely known throughout the community.

What are the chances that an innocent person, and a frightened youth at that, could have possibly guessed so many details? Given the level of specificity said to have been provided by Deskovic, it is most likely that officers told facts to him. Whether the officers did so intentionally or

inadvertently, in hindsight we know that they provided an inaccurate account of who said what during the interrogations.

Deskovic has since commented, "Believing in the criminal justice system and being fearful for myself, I told them what they wanted to hear."[19] Psychologists call such a confession a "coerced-compliant" confession. In a coerced-compliant confession, the pressure police apply during the interrogation may not be illegal, and it may come from tactics that judges have approved. The suspect complies with law enforcement pressure and confesses chiefly to obtain a gain, such as "being allowed to go home, bringing a lengthy interrogation to an end, or avoiding physical injury."[20] Deskovic is now suing for civil rights violations, which his complaint calls a "veritable perfect storm of misconduct." His lawsuit alleges that police disclosed facts to him.[21]

The Puzzle of False Confessions

False confessions present a puzzle: why do innocent people confess in such detail to crimes they did not commit? For decades, commentators doubted that a suspect would falsely confess. For example, Professor John Henry Wigmore wrote in his 1923 evidence treatise that false confessions were "scarcely conceivable" and "of the rarest occurrence."[22] This traditional understanding of confessions changed dramatically in recent years, as DNA testing exonerated people who had falsely confessed. We now know that false confessions may not be "of the rarest occurrence." While we do not know how often false confessions occur, there is a new awareness among scholars, legislators, judges, prosecutors, police departments, and the public that innocent people can falsely confess, often due to psychological pressure placed upon them during police interrogations.[23] Studies increasingly examine the psychological techniques that can cause people to falsely confess.[24]

I take a different approach, by focusing not on the psychology of false confessions but on their content. Forty of the first 250 DNA exoneration cases (16%) involved a false confession. I wondered what people who we now know are innocent reportedly said when they confessed. I used the trial transcripts to find out what was said during interrogations and how the confessions were described and litigated at trial. When I began this

process, I expected to see confessions without much information. An innocent person might be able to say "I did it," but obviously could not say what exactly he did, since he was not there at the crime scene. I knew it was possible that a confession could be contaminated if police prompted the suspect on how the crime happened, and I thought that I might find a handful of cases where this had happened. Scholars have noted that "on occasion, police are suspected of feeding details of a crime to a compliant suspect," and have described several well-known examples.[25] However, no one has previously studied a set of known false confessions to analyze what facts must have been disclosed to the innocent suspects.[26]

To my great surprise, when I analyzed these case materials I found that not just a few, but almost all, of these exonerees' confessions were contaminated. I sought out trial materials and court records for all forty exonerees who falsely confessed and I was able to obtain them for all forty.[27] I also located the text of written confession statements for most of these exonerees. All of those records provided a rich source of material.[28] All but two of the forty exonerees studied told police much more than just "I did it." Instead, police said that these innocent people gave rich, detailed, and accurate information about the crime, including what police described as "inside information" that only the true culprit could have known.[29]

Contaminated False Confessions

Confessions are incredibly powerful evidence at a trial. As the Supreme Court has put it, "A confession is like no other evidence. Indeed, 'the defendant's own confession is probably the most probative and damaging evidence that can be admitted against him . . . confessions have profound impact on the jury, so much so that we may justifiably doubt its ability to put them out of mind even if told to do so.' "[30] These confessions were particularly powerful because of their detail.

The Deskovic case shows how false confessions do not happen quickly or by happenstance. As law professor Samuel Gross puts it, "false confessions don't come cheap."[31] Confession statements are carefully constructed during an interrogation and then reconstructed during any criminal trial that follows. The Constitution requires that an admission

of guilt was "voluntary" under the circumstances. However, the power of a confession derives from the lengthy narrative describing what happened, and not from the bare statement that "I did it." During the "confession-making phase" of an interrogation, police ask about details regarding how the crime occurred.[32] Police are trained to carefully test the suspect's knowledge of the crime, by assessing whether the suspect can freely volunteer specific details that only the true culprit could know.

When police interrogated them, each exoneree supposedly gave self-incriminating statements and admissions of guilt to police, though some, like Deskovic, did not confess to all of the charged acts. In thirty-eight cases, the detectives testified that these defendants did far more than say "I did it." According to the detectives, the suspects had "guilty" or "inside" knowledge. For example, in exoneree Robert Miller's case, the prosecutor said, "He supplied detail after detail after detail after detail. And details that only but the killer could have known."[33] Only two exonerees relayed no specific information in their confessions. Travis Hayes could not say much of anything about the crime, but he was still convicted, even though the jury heard that DNA testing on the clothes the attacker wore had excluded him and his codefendant. The second, Freddie Peacock, was mentally ill, and he just told his interrogator, "I did it, I did it," but he was unable to provide any details at all about what he supposedly did, even after the detective told Peacock some of those details, including who the victim was.

In all of the other 95% of the false confessions studied (thirty-eight of forty cases), detectives claimed that the suspects volunteered key details about the crime, including facts that matched the crime scene evidence, or scientific evidence, or accounts by the victim. Police officers went farther and also claimed they assiduously avoided contaminating the confession by not asking leading questions, but rather allowing the suspect to volunteer each of the crucial facts.

Although defense lawyers tried to challenge almost all of these confessions, judges found the confessions to have been voluntarily made and appropriate for the jury to hear. The nonpublic facts contained in confession statements then became the centerpiece of the State's case. The facts were typically the focus of the State's closing arguments to the jury. Even after DNA testing excluded these people, judges sometimes ini-

tially denied relief, relying on the seeming reliability of these confessions. These false confessions were so persuasive, detailed, and believable that judges repeatedly upheld the convictions during appeals and habeas review. After years passed, these innocent people had no option but to seek the DNA testing that finally proved their confessions false.

These forty false confessions are unique and unusual. These forty examples cannot tell us how many suspects falsely confess. Nor are these cases representative of other confessions, much less other false confessions.[34] Many who confess do so in short interrogations.[35] In contrast, almost all of these interrogations were prolonged affairs, lasting many hours or even days. Fourteen of these exonerees were mentally retarded, three were mentally ill, and thirteen were juveniles. Just as in Deskovic's case, in 65% of the false confession cases (twenty-six of forty cases), DNA testing not only excluded the exoneree but also confirmed the guilt of others, some of whom themselves later confessed and pleaded guilty.[36] The forty false confessions were also concentrated in cases involving both a rape and a murder. Of the forty who falsely confessed, twenty-five cases were rape-murder cases, three were murder cases, while twelve were rape cases.[37] Seven exonerees who falsely confessed were sentenced to death. In contrast, most DNA exonerees, 68%, were not convicted of murder, but were convicted of rape (171 of 250 cases). As chapters that follow will describe, most of the rape cases involved a victim who identified the assailant. Cases with false confessions were typically murder cases where there was no eyewitness, police had few leads, and it was a higher priority for police to secure a confession.

All of those features make these cases highly atypical, but also especially interesting. They came to light not because of a challenge to the confession, but due to the independent development of DNA technology. These false confessions also allow one to study the problem of confession contamination, since one can be confident in retrospect that these innocent people could not have themselves known the specific details of crimes they did not commit.

Law Enforcement Practices

How are police trained to interrogate suspects, and what went wrong in these cases? Well-trained police receive instruction on the complex psychological tactics used to elicit confessions from suspects. Just as in the Deskovic case, a suspect who is identified as a potentially important source of information is asked to participate in an interview. The suspect is placed in a small interrogation room and given the *Miranda* warnings. In the initial stages of an interrogation, detectives try to make the suspect feel at ease. They ask open-ended questions. Many suspects readily confess at this point. Should that not occur, police may directly confront the suspect with their belief that he committed the crime. If that fails, police may use more elaborate and heavy-handed tactics.

The leading manual on police interrogations, originally written by Fred Inbau and John Reid and now in its fourth edition, provides a set of protocols branded the "Reid Technique." The Reid Technique instructs police to apply pressure but at the same time suggest that the suspect has something to gain by confessing. Those techniques are called "maximization" and "minimization." Police engage in storytelling and offer the suspect a series of alternative narratives. They try to get the suspect to initially agree to having committed legally excusable or less reprehensible acts. For example, using one common alternative narrative, police may try to get the suspect to admit having attacked the victim, but only in self-defense.[38] Police may also imply that they might grant leniency if the suspect confesses or impose consequences if the suspect does not. Such techniques were used in several of these exonerees' interrogations, ranging from "Mutt and Jeff" or "Good Cop, Bad Cop" techniques, to going so far as to threaten the death penalty.

Police can also sometimes use deceptions or fabrications by telling suspects, falsely, that forensic evidence proved their guilt or a collaborator has confessed and implicated them.[39] Police used a "false evidence ploy" in several exonerees' cases. David Vasquez confessed after he was told that his fingerprints were found at the scene.[40] Similarly, in the Central Park Jogger case, the detective told Yusef Salaam: "we have fingerprints on the jogger's pants or her jogging shorts, they're satin, they're a very smooth surface. We have been able to get fingerprints off of them."

Telling suspects that they failed a polygraph, perhaps falsely, may have played a role in eight of these false confessions, in which polygraph tests were used.[41] As in Jeffrey Deskovic's case, judges have found such psychological tactics permissible.[42]

Although they can use a range of psychologically coercive and deceptive tactics, police have long been trained to never contaminate a confession by feeding or leaking crucial facts. The Reid manual is emphatic on this point. During the confession-making stage of an interrogation, police may engage the suspect in a process of joint storytelling, but the narratives they employ to develop what happened have important limits. If the suspect is told how the crime happened, then the police cannot ever again properly test the suspect's actual knowledge of how the crime happened. Police have long known that suspects may admit to crimes that they did not commit, for a range of reasons, including mental illness, desire for attention, and to protect loved ones. For that reason, police are trained to ask open questions, like "What happened next?" Leading questions are not to be asked, at least not as to crucial corroborated details. The Reid manual advises that "[w]hat should be sought particularly are facts that would only be known by the guilty person." Further, police are trained not to leak such facts. Police black out key facts so that the press and the public do not learn those facts during an investigation. By avoiding contamination of the confession, the officer can at trial "confidently refute" any suggestion that those facts were fed to the suspect.[43]

Corroborated and Nonpublic Facts

If police are trained to avoid disclosing key facts, what happened in these exonerees' cases? In all but two of them, police claimed that the defendant had offered a litany of details, which we now know these innocent people could not have known. The police did "confidently refute" at trial that they disclosed those facts, making the confessions appear unassailable. Police told the jury that the defendant freely offered information that only the perpetrator could have known. If police had told the jury that the defendant had reluctantly nodded "yes" to a series of leading questions, then the confession would not be particularly credible; it would be obvious that it had been fed by the police.

Cases like the Deskovic case, involving unusual, specific, or numerous details, raise troubling questions. In such cases, it is highly unlikely that a person could have made such an elaborate and detailed "unlucky guess."[44] Similarly, in exoneree Dennis Brown's case, the sergeant who interrogated him testified as follows:

> Q. You're stating under oath you did not know what the victim had
> on that night, is that correct? You did not know the color of the
> couch?
> A. No, sir.
> Q. You did not know which arm she was grabbed by?
> A. No sir, I did not.
> Q. And that the defendant confessed to the rape of [the victim],
> correct?
> A. Yes.
> Q. And he gave you specifics as to that rape?
> A. Yes, sir.
> Q. And he told you about the house?
> A. Yes, sir.
> Q. And he told you what color the couch was?
> A. Yes, sir.
> Q. And he told you how he committed the rape?
> A. Yes, sir.[45]

The sergeant not only testified that Brown knew details regarding the crime, down to the color of the victim's couch, but that the sergeant *himself* did not know those crime scene details. The clear implication was not just that he did not feed those facts to Brown, but that it was *impossible* for him to have fed those facts to Brown. Now that we know with the benefit of postconviction DNA testing that Brown is innocent, it is quite likely that police did disclose those specific facts. It is unlikely that innocent suspects could reconstruct the crimes out of whole cloth from their own imagination. It is unlikely that police improperly leaked all of the crucial details of the crimes to the public, which the innocent suspects heard and then accurately recounted during their interrogations.

Douglas Warney's case provides still another example of a confession involving a litany of detailed nonpublic facts concerning the crime. Warney was said to have told police numerous facts, including that the victim was wearing a nightshirt, the victim was cooking chicken, the victim was missing money from his wallet, the murder weapon was a twelve-inch-long serrated knife that was kept in the kitchen, the victim was stabbed multiple times, the victim owned a pink ring and gold cross, a tissue used as a bandage was covered with blood, and there was a pornographic tape in the victim's television.[46] When asked under oath, "did you suggest any answers to him," the sergeant said that he did not. The prosecutor argued in closing that the reliability of Warney's confession was corroborated by each of these facts:

> The Defendant says he's cooking dinner, and he's particular about it, cooking chicken . . . Now, who could possibly know these things if you hadn't been inside that house, inside the kitchen? You heard the Defendant say that he took money . . . You know the wallet was found upstairs, empty, near the closet . . . You will see photographs of it . . . You heard the Defendant say that he stabbed [the victim] with a knife taken from the kitchen . . . that was the knife that they kept in the house. Where did they keep it? They kept it in a drawer under the crockpot where the chicken was cooking. Now, who would know the chicken was cooking? A person who got that knife and used it against [the victim], the killer. The Defendant described the knife as being twelve inches, with ridges . . . it was thirteen inches with the serrated blade.[47]

Notice how the prosecutor speaks of how the jury "heard the Defendant say" this and that fact. The jury never heard such a thing from Warney. They heard an officer read a typed confession statement that Warney had signed. They heard the sergeant describe the interrogation process. When the jury "heard" Warney testify at trial, he recanted his confession statement and proclaimed his innocence.

Years later, Warney was exonerated by DNA testing (the tests also inculpated another man who subsequently confessed). When interrogated he had "a history of delusions, an eighth-grade education and advanced

AIDS."[48] Warney has since maintained that the sergeant had told him all of those telling details described at trial.

Not only can individual confessions be contaminated, but false confessions can have a "multiplying" effect, in which additional innocent people are drawn into an investigation, and a group of confessions is contaminated. Seventeen exonerees not only falsely confessed to their own guilt, but they falsely implicated others who did not confess, eleven of whom were later also exonerated by postconviction DNA testing.[49] One example is the "Beatrice Six" case. A gruesome rape and murder of an elderly woman had remained unsolved in the small town of Beatrice, Nebraska. Eventually, four people confessed to participating in the murder. All four pleaded guilty, along with a fifth who pleaded guilty but did not confess.

A sixth person, Joseph White, was the only one in the group who refused to plead guilty; he requested an attorney during his interrogation and did not confess. In return for a lighter sentence, three of those who pleaded guilty testified against White at his trial: James Dean, Debra Shelden, and Ada JoAnn Taylor. Each openly admitted that police had suggested facts to them and that before speaking to police, they could not remember much of what had occurred the night of the crime. The contamination of the confessions was no secret. Taylor testified as follows at a deposition, which was read into the record at trial:

> Q. Can you actually separate today what you remember from the night this happened and what was suggested to you to help you remember what happened that night?
>
> A. No. It would almost be impossible to separate.
>
> Q. So whatever statements you have made recently, I take it, are not from your memory but from suggestions that have helped you remember?
>
> A. There has been parts from my memory as well as the suggestions.
>
> Q. Tell me what parts you actually remember that you don't have that you didn't have suggested to you.
>
> A. Oh, God.
>
> Q. Is there anything?
>
> A. Not that I can remember offhand . . . [50]

At trial, Taylor said that police "somewhat" suggested facts to her, and helped her to remember much, but not "all of the information." She explained: "Well, I have a tendency to believe all officers." Taylor admitted that police had showed her a video of the crime scene and had given her the statements of the other defendants to read.[51] She also testified that she was diagnosed with a "personality disorder" and had problems with her memory, though she also took credit for having some mental telepathy capabilities.[52]

Taylor admitted that police told her particular facts. For example, she said that police suggested a particularly idiosyncratic fact, an explanation for the presence of a ripped half of a five-dollar bill at the crime scene. She testified that Joseph White had "a trick that he does with a $5 bill" where he would rip it in half, and recalled asking him after the murder what he had ripped, and he had said a "five," meaning a five-dollar bill. When asked to explain the trick, she said, "I've never really understood it. I know he pulls a $5 bill out and he does something with it and he ends up with a ripped $5 bill. And he usually tosses part of it away." However, on cross-examination, she admitted that the deputy sheriff originally told her about the five-dollar bill; when he first asked about the money trick, she told him that White would make pictures with the money; and finally the deputy told her that White would tear the five-dollar bill.[53]

Although it was clear at trial that the confessions were contaminated, the jury chose to credit Taylor, Shelden, and Dean's statements. There was little other evidence in the case; the forensics were presented erroneously, but were not particularly probative. Joseph White was convicted and served nineteen years in prison until DNA tests led to his exoneration in 2008, followed by exonerations of the five others.[54]

Expert evidence also corroborated facts in false confessions. Ronald Jones, whose case was discussed in Chapter 1, reportedly confessed to stabbing the victim "a few times." This fact from his confession statement was corroborated by the medical examiner's opinion that the victim had been stabbed four times.[55] Ronald Williamson was said to have described wrapping a cord around the victim's neck to strangle her.[56] At trial, the medical examiner testified that the victim was in fact strangled.[57]

Denying Disclosing Facts

We now know that in many of these cases, police contaminated the confessions by disclosing facts to the suspects. But why didn't this come to light in the cases that went to trial? The answer is that at trial, the police denied ever having disclosed those key facts. The trial transcripts show that in twenty-seven of the thirty confession cases that went to a trial, the police officers testifying under oath at trial denied that they had disclosed facts to the suspect, or they described the suspect having volunteered the central facts during the interrogation. I do not know whether these police officers were aware that their testimony was false. Some of these officers may have been malicious. However, many of them may have believed they were interrogating a guilty person. Officers may contaminate a confession unintentionally (or intentionally), out of a belief that the suspect is guilty and is a danger to the public. Later they may not recall that they disclosed facts during a complex series of questions posed during a long interrogation. Washington, D.C., detective James Trainum has described how he unintentionally secured a false confession and did not initially realize what had happened. Later he determined he had actually disclosed key facts to the suspect, which he confirmed when he carefully reviewed the videotape of the entire interrogation.[58] Police did not record the entire interrogation for any of these exonerees, so we can never be certain precisely how these people came to falsely confess in such a convincing way.

In Nathaniel Hatchett's case, police unequivocally denied that they disclosed facts to him:

> *Q.* Did you ever supply the Defendant with details, specific details of the offense so that he would be able to recite them back to you when and if he decided to give you a statement about his knowledge and involvement with these crimes?
>
> *A.* I didn't.
>
> *Q.* You say you didn't, so I will ask the next question: Did you hear anyone else or see anyone else provide him with the kind of details that he eventually later gave you demonstrating his knowledge and involvement in this crime?

A. No. As a matter of fact, as lead investigator I was the only one
privy to such details at this point.[59]

Earl Washington Jr.'s case provides another example where the deni-
als of disclosing facts were crucial to the State's case. Washington falsely
confessed to a rape and murder in Culpeper, Virginia. He came within
nine days of execution and was in prison for eighteen years before finally
being exonerated by DNA testing. A long string of state and federal
courts denied his appeals and postconviction petitions, each citing the
reliability of his confession. Although he was borderline mentally re-
tarded, the Fourth Circuit, for example, emphasized that: "Washington
had supplied without prompting details of the crime that were corrobo-
rated by evidence taken from the scene and by the observations of those
investigating the [victim's] apartment."[60]

Two officers told prosecutors and then testified at trial that Washing-
ton was the one who, without prompting, identified a shirt as his own. It
was a distinctive shirt, its existence had not been made public, and it
was found in the rear bureau of the victim's bedroom many months after
the murder. The typed statement read as follows:

Officer 1: Did you leave any of your clothing in the apartment?
Washington: My shirt.
Officer 1: The shirt that has been shown you, it is the one you left in
apartment?
Washington: Yes sir.
Officer 1: How do you know it is yours?
Washington: That is the shirt I wore.
Officer 1: What makes it stand out?
Washington: A patch had been removed from the top of the pocket.
Officer 1: Why did you leave the shirt in the apartment.
Washington: It had blood on it and I didn't want to wear it back out.
Officer 2: Where did you put it when you left?
Washington: Laid it on top of dresser drawer in bedroom.[61]

This statement was powerful for several reasons. Most of this con-
fession statement consisted of officers asking leading questions with

Washington—recall he was mentally retarded—providing very brief answers. His most frequent response was "Yes sir." However, in that crucial passage, Washington gave uncharacteristically detailed answers. He reportedly offered that he left his shirt—yet the police had not made public that a shirt was found at the crime scene. Further, he told police about an identifying characteristic making the shirt unusual: the torn-off patch. He knew precisely where the shirt had been left, in a dresser drawer in the bedroom. And most remarkable, he said that he left it there because it had blood on it. Yet the shirt that the officers showed Washington no longer had blood on it; the stains had been cut out for forensic analysis.[62]

The prosecutor emphasized in closing arguments that the police were not "lying" and "didn't suggest to him" how the crime had been committed, but that Washington knew exactly how the crime had been committed. The prosecutor ended by discussing the shirt, and noting that Washington knew "the patch was missing over the left top pocket." The prosecutor continued, "Now, how does somebody make all that up, unless they were actually there and actually did it? I would submit to you that there can't be any question in your mind about it, the fact that this happened and the fact that Earl Washington Junior did it."

Now that we know Earl Washington Jr. did not commit the crime, but rather another man later identified through a DNA database who has now pleaded guilty, there are limited explanations for how Washington could have uttered those remarks about the shirt, together with other details about the crime. This was precisely the issue in a civil rights lawsuit brought by Washington after his exoneration. During that lawsuit, Washington's lawyers discovered that nearly ten years after the conviction and near the time that Virginia's governor was considering a clemency petition based on DNA testing, the second officer expressed real doubts about the interrogation. He admitted that facts were likely disclosed, telling the Virginia attorney general that either he or his colleague "must have mentioned the shirt to Washington" and that "his testimony in the record did not accurately reflect that the shirt had first been mentioned by the police."[63] In 2006, a federal jury found that the second officer fabricated the confession and violated Washington's constitutional rights by recklessly claiming that Washington volunteered

crucial nonpublic facts. The jury awarded Washington $2.25 million in damages.[64]

The high-profile "Central Park Jogger" case, in which five youths falsely confessed to brutally assaulting and raping a jogger in Central Park and were all exonerated by postconviction DNA testing years later, also involved a striking detail concerning a shirt. The prosecutor emphasized in closing arguments that one of the youths, Antron McCray, knew information that only the assailant could have known:

> You heard in that video Antron McCray was asked about what [the victim] was wearing and he describes she was wearing a white shirt . . . You saw the photograph of what that shirt looked like. There is no way that he knew that that shirt was white unless he saw it before it became soaked with blood and mud. I submit to you that Antron McCray describes details and describes them in a way that makes you know . . . beyond reasonable doubt that he was present, that he helped other people rape her, and that he helped other people beat her and that he left her there to die.[65]

In twenty-two cases, prosecutors emphasized in their closing arguments that the relevant facts were nonpublic or corroborated by crime scene evidence. For example, in Bruce Godschalk's case, the prosecution took the position that "Well, if he were guessing, he was guessing pretty darn good."[66] The prosecutor, in an incredulous tone, then told the jury that it was a "mathematically [*sic*] impossibility" that Godschalk could have guessed correctly on so many nonpublic facts regarding how the crime was committed. In Robert Miller's case, the prosecutor emphasized that "[h]e described the details . . . details that only the killer could have known."[67] In response to the defense's suggestion that he could have guessed such details, the prosecutor said, "Are you kidding? Are you kidding?" and added, "He supplied detail after detail after detail after detail." In the Rolando Cruz and Alejandro Hernandez trial, the prosecutor closed by telling the jury that Cruz told officers the victim "was anally assaulted. There's no way to know that information. He knows it because he was there."[68]

Recorded False Interrogations

What makes the contamination of these confessions initially appear surprising is that many of the interrogations were recorded; in twenty-three of the forty cases (58%) interrogations were partially recorded. Fourteen were audio recorded and nine had video. Additional interrogations were at some point partially transcribed by a stenographer. In all of these cases, however, only part of the interrogation, often a final confession statement, was recorded. There was no recording of what came before.

In some cases, police disclosed facts to the suspect even during the recorded part of the interrogation. For example, during David Allen Jones's recorded interrogation, when he did not recall the location of a crime, police reminded him that they had earlier showed him photos of the crime scene, asking, "You remember yesterday we showed you that picture" and that it was "by the water fountain" and "you remember that gate we showed you right there," finally eliciting only a response from Jones that was transcribed as "This right here (Untranslatable)."[69]

We do not know what transpired during the unrecorded portions of the interrogation. Law professor Steven Drizin notes that it is "not uncommon" for police to conduct an initial interview in which they "use a gamut of techniques" to secure admissions, but do not tape that interview. Rather, police tape a second interview only once the admissions have been secured.[70] Thus, in Nicholas Yarris's case, law enforcement emphasized that the two crucial facts he volunteered, that the victim was raped and that her car had a brown landau roof, were offered in "additional conversation that was not part of the normal statement," and therefore not on tape or transcribed.[71]

Chris Ochoa has since his exoneration described blatant abuse of recording, in which the Austin Police Department detective asked him leading questions about the crime. None of that questioning was on the tape. By Ochoa's recounting, the detective stopped the tape each time that he "came to a detail" and "it was wrong." The officers would "get mad," and show him photographs of the crime scene and the autopsy or tell him the answers, and then "start it, stop it, till they got the details. It took a long time."[72]

Other interrogations were not recorded, in some cases despite a department practice of doing so. In Dennis Brown's case, for example, police testified that interrogations were normally recorded, but police "chose not to turn it on" in his case because the defendant "just started talking."[73]

Some of the conversations that may have contaminated these confessions could have occurred at the crime scene itself. In thirteen cases, police brought the exonerees to the crime scene. Each reportedly identified in person features of the crime scenes that were nonpublic and corroborated by the investigation. Such visits were not recorded, so we do not know whether police in fact tested exonerees' knowledge of how the crime occurred at the scene, or whether they instead familiarized exonerees with the crime scene. Ronald Jones, whose case was discussed in Chapter 1, testified that the detective took him to the crime scene and told him a series of details about the crime.[74] Earl Washington Jr. led police to locations all around Culpeper, Virginia, having had no idea where the victim was murdered.[75] Even after being driven by the victim's building several times, he did not identify it; when asked to point to her building in the apartment complex he pointed to "the exact opposite end" of the complex. Only when the officer pointed to her apartment and asked if that was it did he say "yes."

Inconsistent Facts

We have heard about the detailed facts that these innocent people likely repeated during their interrogations. What do innocent suspects say when they are not prompted by police? In most of these exonerees' cases, when given a chance to volunteer information, they got the facts totally wrong, since they did not know anything about the crime aside from what they were told.[76] In at least 75% of these cases (thirty of forty cases), the exoneree supplied facts during the interrogation that were inconsistent with the known facts in the case.[77] These inconsistencies should have been a real warning sign that the confessions could be false.

Indeed, police may have been so frustrated that these innocent suspects were not giving them the answers they wanted that they resorted to feeding the facts rather than asking proper open-ended questions. Earl Washington Jr.'s case provides an example of this strategy. At his trial,

police testified about the separate stages of the interrogation. While in the second stage of his interrogation he supposedly gave accurate details about the crime, in the initial stage, whenever he was not asked a leading question, he got the answers wrong. When he was asked what race the victim was, for example, he told police that the victim was black. That was wrong; she was white.[78] He described stabbing the victim a few times—she had in fact been stabbed dozens of times. He described the victim as short when she was tall. He said he "didn't see" anyone else in the apartment, yet the victim's two children were there.[79] It was clear he knew nothing about the crime, but, ever compliant, he would eventually agree with whatever leading question was posed to him, politely saying, "Yes, sir." In fact, the police knew that if they were persistent, Washington would falsely confess. He had already falsely confessed to four other crimes. He confessed to every crime he was asked about, but in the other cases the victims told police he was not the assailant, or the confessions were deemed totally inconsistent with how the crimes occurred.[80]

Prosecutors had to explain inconsistencies to the jury by downplaying them and emphasizing instead the powerful nonpublic facts that each was said to have volunteered. Byron Halsey was also mentally disabled and highly compliant with police interrogators. Halsey made multiple incorrect guesses as to the manner in which a horrific rape and murder of two children occurred. When asked how he put nails into one victim's head, the officer recounted, "His initial response was crowbar. He grinned at us." "Then he came up and he said, 'Hammer.' He grinned again." "Then he mentioned chair. He grinned again." The perpetrator apparently actually used a brick. Following that interchange, the officer recalled that "he finally did tell us what he used to drive the nails into [the victim's] head." The prosecutor asked, "Any time was it suggested to the defendant what the answer should be?" and the officer answered, "No." In his closing statement, the prosecutor not only denied that any facts were disclosed but argued that the inconsistencies in Halsey's confession were part of a master plan to confuse the jury: "You know why, ladies and gentlemen, because he thinks he's just given a sworn statement that's going to let him off." The prosecutor added, "he's trying to mislead . . . he's trying to lie his way out of this in that confession."[81]

In a few cases, police may have inadvertently suggested mistaken facts due to their incomplete knowledge about the crime scene evidence, which turned out to be inaccurate. For example, in a recorded interrogation, Bruce Godschalk described entering the kitchen window of one victim's apartment. There was a problem. That apartment had no kitchen window. The detective claimed at trial that Godschalk had later changed his statement to say he had entered through a spare bedroom.[82]

Police often stopped investigating once they obtained a confession. They then failed to investigate major inconsistencies between the confession and the other evidence. In Earl Washington Jr.'s case, not only were the facts that he did volunteer inconsistent with the evidence, but police refused to test forensic evidence that might have shed light on his guilt or innocence. Recall that the shirt with the torn pocket was a key fact in his confession statement. Hairs were found in the pocket of that shirt, and early in the case, five other suspects' hairs were compared and they were excluded. After Washington confessed, police instructed the state crime laboratory *not* to compare his hairs to the ones found in the pocket of that shirt.[83]

In other cases forensic testing was not done because police did not want to call the confession into question. In Lafonso Rollins's case, the crime lab technician had found that blood-typing excluded Rollins and had asked his supervisors to send the evidence to the FBI for more sophisticated DNA testing. As the technician later testified, "his request was refused because police said Rollins confessed."[84]

In eight cases, the suspects had confessed, but DNA tests conducted at the time had already excluded them, providing powerful evidence of innocence. Yet police and prosecutors continued to insist that the defendants had committed the crimes. Judges and juries presumably believed the confessions and disregarded the DNA evidence. Those eight people were all exonerated only after additional DNA tests not only excluded them but also inculpated other persons.[85]

For example, in Deskovic's case, the police apparently stopped investigating the case after they secured the confession. Although the State's theory was that Deskovic raped and murdered the victim alone, recall that DNA results at the time of trial excluded him. The prosecutor had speculated that perhaps the victim had a boyfriend, and perhaps the

boyfriend's semen and not the murderer's accounted for the test results. There was no attempt to investigate the theory that the victim was sexually active, most likely because there was no such boyfriend. An inquiry conducted after Deskovic's exoneration concluded, "There is no evidence, for example, that much was done to locate the 'boyfriend' who was the supposed source of semen or even to document [the victim's] movements in the 24 hours before her death."[86]

Nathaniel Hatchett had a bench trial, before a judge and not a jury. The victim testified she had been raped by a single man, and DNA testing at the time of the trial excluded Hatchett. Yet the judge explained that "in light of the overwhelming evidence that the Court has . . . the Court does not find that the laboratory analysis is a fact which would lead to a verdict of acquittal." The judge emphasized that despite powerful DNA evidence, "in this case there is an abundance of corroboration for the statements made by Mr. Hatchett to the police after his arrest, about what happened during the assault." The judge had no theory to explain away the DNA test results that excluded Hatchett, but said instead that he found the confession "to be of overwhelming importance in determining the outcome of the trial."[87]

Judicial Review of False Confessions

Once these false confessions were obtained, why didn't judges and juries reject them? Almost all of these exonerees' defense attorneys did challenge the confessions before trial, and in each case the judge rejected the challenge. The only exonerees who we know did *not* challenge their confession at trial were those who pleaded guilty and had no trial, and one, Rolando Cruz, whose lawyers did not challenge his confession as involuntary but instead argued that police had completely made up his alleged statements regarding a dream or vision of the crime.[88] Of the twenty-nine exonerees who went to trial and whose available records indicate whether a challenge to the admission of the confession was made, twenty-eight (97%) made a challenge. All were unsuccessful.

The most obvious reason why defense lawyers' efforts to challenge the confessions failed is that the confessions seemed so accurate. After all, these defendants supposedly knew facts that "only the killer could

have known." Nor could they try to point out inconsistencies and ask the judge to scrutinize the reliability of these confessions. The U.S. Supreme Court has held that unreliability is irrelevant to the question whether a confession statement is sufficiently voluntary to be admitted at trial.[89] Judges are also very reluctant to rule that a confession cannot be heard at trial. The legal standard that judges use to review confessions focuses on the voluntariness of the bare admission of guilt, and judges will usually only exclude confessions in rare cases of flagrant police misconduct. Confession statements are regulated by the U.S. Constitution in two ways: the *Miranda* warnings and the requirement of voluntariness.

The Supreme Court developed the well-known *Miranda v. Arizona* protections to shield suspects from coercion and avoid difficult voluntariness questions by providing notice in the interrogation room that suspects have certain rights.[90] If the *Miranda* procedures had *not* been followed, these exonerees might have had straightforward challenges to their confessions. However, all of these exonerees waived their *Miranda* rights, just as the vast majority of suspects do.[91] Twenty-two of the exonerees signed waiver forms and eight waived their rights on video. We cannot know how many more exonerees who, like Joseph White, did ask for a lawyer and cut their interrogation short, might have also falsely confessed if their interrogations had continued.

Perhaps the most remarkable of the rulings concerning *Miranda* warnings was at the trial of Eddie Joe Lloyd. The most obvious evidence of his mental illness and suggestibility was that Lloyd had been interviewed while he was involuntarily committed in a mental hospital, with a preliminary diagnosis of bipolar affective disorder. The judge ruled that his statements were voluntary, noting, "[a]fter he is advised of his rights, it doesn't make a difference what form it takes."[92]

The Supreme Court's voluntariness standard regulates interrogations more broadly, by examining the "totality of the circumstances" to assess whether the confession was coerced, focusing on "the characteristics of the accused and the details of the interrogation."[93] The prosecution has the burden of showing that no undue coercion was applied.[94] Trial judges conduct hearings before trial to examine the question whether the confession was voluntary and should be admitted.

Judges ruled that these exonerees' confessions were voluntary, but often despite substantial evidence to the contrary. For example, one factor the Court has long taken into account when analyzing voluntariness is "the youth of the accused." Yet 33% of the exonerees who confessed were juveniles (thirteen of forty cases; five were in the Central Park Jogger case). A second factor is "low intelligence" of the accused. Studies have long shown that the mentally disabled tend to be submissive and eager to please authority figures, and vulnerable to stress and pressure.[95] Yet at least 43% of the exonerees who falsely confessed (seventeen of forty cases) were mentally disabled or ill, many obviously so. A third factor is "the lack of any advice to the accused of his constitutional rights." All of these exonerees waived *Miranda* rights prior to confessing.

A fourth factor is the "length of detention" together with "the repeated and prolonged nature of the questioning." Most of these exonerees endured quite lengthy interrogations. Typically, John Kogut was told "you're not going anywhere until we get the truth."[96] Only 10% of the exonerees for whom materials were obtained (four of forty cases) were interrogated for less than three hours. The other exonerees were interrogated for far longer, typically in multiple interrogations over a period of days, or interrogations lasting for more than a day with interruptions only for meals and sleep. Jerry Townsend was interrogated for thirty to forty hours over the course of a week.[97] Robert Miller was interrogated for thirteen to fifteen hours just during the portions of his interrogation that were recorded.[98] Yet again, judges found such confessions to be voluntary.

An additional factor includes "use of physical punishment such as the deprivation of food or sleep." While less common among these cases, some exonerees did allege, whether accurately or not we often do not know, that police used physical force on them during the interrogation. Marcellius Bradford later claimed that police beat him. Dennis Brown claimed that the officer first unbuckled his gun belt, then "put a knife on me."[99] Ronald Jones, whose case was discussed in the Introduction, described that a detective handcuffed him to the wall and hit him in the head several times with a long black object.[100] According to Jones, a second officer then entered the room and "was surprised" at "the treatment" "and told him, he said no, don't hit him, because he might bruise." That

officer proceeded with hitting him in the "midsection with his fist" when he would not confess. Paula Gray, who was seventeen and borderline mentally retarded, was kept at hotels with seven police officers for two days as a "protected custody witness" regarding a double murder investigation.[101] During her custody she made a statement inculpating herself and four other innocent people, in a case that became known as the "Ford Heights Four" case. Gray testified that she was asked, "Did they emphasize what would happen if you did not tell this story?" and answered, "That they would kill me." Police denied engaging in any such conduct.

Judges also consider the demeanor of the defendant during the interrogation to shed light on whether the confession was voluntary. The State admitted that David Vasquez gave a statement that "at times" was "virtually incomprehensible."[102] Byron Halsey, who had a "sixth-grade education and severe learning disabilities,"[103] by the detective's own admission gave a statement that was full of "gibberish" in which Halsey was "saying one syllable words, free flowing like a water fall" and at some times he fell into a "trance" state in which he "just stopped and looked out into blankness."[104]

Perhaps judges, when they ruled that those confessions were voluntary, relied on the fact that most exonerees signed written statements that contained boilerplate language on voluntariness. Thus, Lafonso Rollins signed a statement repeating that "he has been treated well" and "he has eaten pizza and a sandwich and has had coffee and cola to drink while he has been at the police station. Lafonso Rollins states that he has not been threatened in any way, nor has he been made any promises for this statement."[105] Similarly, Bruce Godschalk admitted at trial that he had been asked on tape by the detectives, "How have we treated you?" and he answered, "Very well."[106]

Why did judges look past all of the signs of coercion in so many exonerees' cases? Not only are judges reluctant to exclude a confession, which is central to the prosecution's case, but they may be especially reluctant to exclude a confession that appears so powerfully corroborated by detailed facts. For example, in Douglas Warney's case, though he alleged coercion, the judge relied heavily on how he initially approached police to talk about the crime: "This was information that he volunteered to submit himself to present, and he followed through on that."[107] Though the

Supreme Court has ruled out reliability as a reason to *exclude* a confession, judges focused on the apparent reliability of these confessions when they admitted these confessions and found them voluntary. In Bruce Godschalk's case, the judge emphasized that he "had given information to the detectives which was not released to the general public," though the judge did not say which specific facts he found convincing.[108] Similarly, in the trial of Paula Gray, who was seventeen years old and borderline mentally retarded, the judge noted, "Incidentally, the defendant testified with skill, with knowledge, explicitly, extremely clear, made her points well and all it means to me is whether she's in twelfth grade or whatever her educational level is she's a very intelligent person. That's my judgment and those are my findings and my decision."[109]

Use of Experts

Jurors may have a hard time imagining that a person would falsely confess. A defendant may try to use an expert to explain to the jury that false confessions can actually happen, and that the defendant was psychologically vulnerable to police suggestion or coercion. However, judges often deny indigent defendants the funds to hire such experts or they refuse to allow such expert testimony. Only 8% of the exonerees (three of forty cases) had testimony by defense experts such as psychologists or psychiatrists concerning their confessions. The three were David Allen Jones, Jerry Townsend, and David Vasquez. In Vasquez's case, the pretrial hearing transcripts are not in the court file; all that the file indicates is the judge's view that there was "conflicting evidence given by the psychiatrists."[110] Jones retained a psychologist who testified that he found Jones "mildly mentally retarded."[111]

At Jerry Townsend's suppression hearing, there was a lopsided battle of the experts; surprisingly, given a typical lack of defense resources, the contest was weighted in the defense's favor. Jerry Frank Townsend was mentally retarded and he confessed to every unsolved murder he was asked about, including about twenty murders, most in Florida. His lawyer later noted that he "was capable of confessing to just about anything," and the police "wanted to clean out the cold case files on him."[112] The defense called seven different clinical psychologists and psychia-

trists as experts. All of these doctors agreed Townsend could not readily understand the *Miranda* warnings, lacked capacity to be tried, and did not confess voluntarily. For example, one expert described how Townsend was retarded with an IQ of 59 to 61 and the mental development of a six- to nine-year-old.[113] Other experts testified that he was "easily led" and "highly suggestible." Townsend not only lacked capacity and had a mental age of a seven- to nine-year-old, but he "confabulate[d] all the time," engaging in "unconscious making up of material to fill in for what one doesn't know," like a person who is "senile." Townsend spoke like a "madman" and, in medical terms, was "intellectually limited and functioning at a psychotic level."

The prosecution called only one expert witness, who only had a master's degree in psychology (he was not a doctor).[114] He measured Townsend's "social adaptive" ability as nineteen years, although Townsend's IQ was "significantly below" average. He testified that Townsend would understand his *Miranda* rights.[115] The State also called one of the detectives who had interrogated Townsend, who gave his nonexpert opinion that Townsend had a "very severe speech impediment," but had "street smarts" and "made it clear that he understood his rights." The prosecutor then elicited lengthy testimony concerning the "specific facts" that Townsend supposedly knew about how the crimes were committed "which we have been able to, of course, corroborate."

In the end, the judge found this battery of defense expert testimony to be "testimony of convenience" and found that "the credibility of it is rather low and the believability of it just as low." The judge ruled: "I find that Mr. Townsend was sufficiently societally, if I may use that word, and functionally intelligent to know—to know his Miranda rights and to significantly and sufficiently waive them . . ." He added that Townsend "had so much knowledge of street parlance." He found it a closer question whether Townsend confessed involuntarily, but denied relief, noting, "You know, it would be good if all confessions were perfect." The judge explained, "I have yet to see a perfect confession, but I've not been in the criminal area that long."[116]

Townsend called the same experts to testify at trial. The State argued that Townsend's actions indicated the work of a methodical serial killer, and he was convicted. Townsend served twenty-two years in prison

before a Fort Lauderdale police reinvestigation led to DNA testing that cleared him and inculpated serial killer Eddie Lee Mosley (the DNA testing also linked Mosley to a murder for which Frank Lee Smith was falsely convicted).[117]

Other exonerees, had they obtained experts, might have presented the jury with research on causes of false confessions, or evidence that they lacked capacity or otherwise were susceptible to coercion or suggestion. In the Deskovic case, for example, the district attorney's inquiry found that "the defense did not attempt to introduce psychiatric evidence that might have persuaded jurors that Deskovic was particularly vulnerable to the police tactics employed against him and that those tactics induced a false confession. In the absence of such evidence, the defense attack on the statements seemed scattershot and unfocused."[118]

Reforming Interrogations

Ronald Jones's conviction and the years he spent battling for his freedom, with judges denying relief at every turn, now begin to come into focus. In Chapter 1, I described how not only was his trial short and his defense tepid, but every step of the way, judges relied on the facts in his confession to argue that he could not possibly be innocent. Ronald Jones, Jeffrey Deskovic, Earl Washington Jr., and all of the others I have discussed in this chapter each gave detailed false confessions that vividly show how a false confession may involve not just coercion but the ability to convince an innocent suspect to develop a crime narrative. When that narrative was contaminated by the disclosure of key facts, absent DNA tests, the criminal system could not untangle what transpired. Social scientists and legal scholars have long recommended that judges evaluate the reliability of entire interrogations rather than simply focus on *Miranda* warnings or voluntariness.[119] However, even robust reliability review faces another problem. As these cases show, to the extent that facts were disclosed to the suspect, confessions appear uncannily reliable.

As we will see throughout this book, evidence can be contaminated in many ways. Police can leave physical evidence exposed to the elements so that it degrades. They can tell an eyewitness that one of the people in

the lineup has a prior conviction, which would tend to encourage the identification. Contamination can be very hard to detect or undo. Once police tell a suspect details about the crime, one can never know for sure whether the suspect truly knew those details or if he learned them from the police.

Contamination of confessions can be discouraged. The easiest way to avoid it is to require that police record interrogations from start to finish. As Chapter 9 will discuss, this reform has been adopted in eighteen states, the District of Columbia, and hundreds of police departments. A lengthy and complex interrogation, the centerpiece of a criminal investigation, should not be undocumented and then recounted based on biased or fallible human memory. Indeed, police have embraced recording interrogations so they can show a judge that the confession was reliable and voluntary.

Recording entire interrogations is an important step but is not enough. If the recording shows that the confession was contaminated, and prosecutors nevertheless pursue the case, the judge should step in to assess whether the confession should be excluded as unreliable. David Vasquez's case provides a cautionary tale. Vasquez was borderline mentally retarded, and he was interrogated by the police after becoming a suspect. The police had determined "that the bindings used to secure [the victim's] hands had been cut from the venetian blinds in the sunroom. The noose employed for her execution had been cut from a length of rope wrapped around a carpet in her basement."[120] Part of the interrogation was recorded. It was obvious from the recording that Vasquez had no idea what was used to bind and murder the victim:

> *Det. 1:* Did she tell you to tie her hands behind her back?
> *Vasquez:* Ah, if she did, I did.
> *Det. 2:* Whatcha use?
> *Vasquez:* The ropes?
> *Det. 2:* No, not the ropes. Whatcha use?
> *Vasquez:* Only my belt.
> *Det. 2:* No, not your belt . . . Remember being out in the sunroom, the room that sits out to the back of the house? . . . and what did you cut down? To use?

Vasquez: That, uh, clothesline?

Det. 2: No, it wasn't a clothesline, it was something like a clothesline. What was it? By the window? Think about the Venetian blinds, David. Remember cutting the Venetian blind cords?

Vasquez: Ah, it's the same as rope?

Det. 2: Yeah.

Det. 1: Okay, now tell us how it went, David—tell us how you did it.

Vasquez: She told me to grab the knife, and, and, stab her, that's all.

Det. 2: (voice raised) David, no, David.

Vasquez: If it did happen, and I did it, and my fingerprints were on it . . .

Det. 2: (slamming his hand on the table and yelling) You hung her!

Vasquez: What?

Det. 2: You hung her!

Vasquez: Okay, so I hung her.

The feeding of facts to David Vasquez was blatant—and it was caught on tape. Nevertheless, the judge denied the motion to suppress the confession. Facing the death penalty, Vasquez then chose to plead guilty rather than risk a trial. He was exonerated by postconviction DNA testing five years later.[121]

These contaminated false confessions vividly illustrate why what goes on in the interrogation room should not remain undocumented, unregulated, unreviewed, and as a result, shrouded in darkness. Recording can bring interrogation practices into the sunlight. Although contamination is an insidious problem that may be hard to eradicate, recordings can validate professional interrogations and make review by judges far more effective. Reforming criminal procedure to safeguard the reliability of interrogations can help us better separate true from false confessions.

Eyewitness Misidentifications

A WOMAN WAS BIRD-WATCHING with her husband in a park in Buffalo, New York, in May 1982. As the sun set, she was getting cold and decided to return to the car alone. But as she walked down a jogging path, a man approached. He suddenly ran up and jumped out from behind, and said, "Scared you, didn't I?" She caught only a glimpse of him before he grabbed her, choking her neck and blindfolding her with a bandana. He dragged her into a thicket, raped her, and left.[1] She reported the rape to the Buffalo Police Department that evening and gave them a description of the attacker. Although blindfolded, she "could feel a close cropped beard and moustache and fairly thick lips." She saw only "dark skin but rather reddish undertones," and that he had "a space between his upper front teeth." The man was between 5'8" and 5'10".

More than four and a half months passed, and she heard nothing from the police. Finally, in September, the police called her to the police station and asked whether she could "make an identification," from "a black and white photo, a line-up photo." She told the officer that she was not sure if she "would be able to identify him again."[2]

She was shown a standard photo array with six photographs, one of which was a photo of a man named Habib Abdal. She was not able to identify her assailant. She told the officer that there were three men in the

array who looked somewhat similar to her attacker. At trial, she testified that she tentatively chose Abdal. She said: "I then chose one man that looked closest to my description that I had in my head that I knew of the assailant." This should have immediately indicated a serious problem. She could not identify Abdal, but said his photo looked the "closest." She had in fact told police that he looked different from the culprit. Social science research has shown that witnesses should be told that the culprit might not be in the lineup, because otherwise the witness may comparison shop and pick whoever looks most like the attacker.[3]

Police next asked if it would help if she saw a live lineup. The police did not conduct a lineup with other men who resembled Habib Abdal. Instead, they took her to a room to look through one-way glass at just two men—Abdal and a white man. In effect, they used a showup, a procedure where a lone suspect is presented to the witness. Even that was not enough to convince her. For about fifteen minutes, the police made suggestions to her that she identify Abdal. They told her that he was in custody because he was involved in another crime, or in another rape. The police then put overt pressure on her to make an identification. The victim recalled all of this pressure and testified about it at trial: "And the more pressure they put on," she said, "the less I would listen to them and the longer I took in making an identification, because this was a man's life, I didn't want to just make an identification to make it easy for everyone."[4] She testified that the police had a "specific mind set" and that "they wanted" her to identify Abdal. She told the jury, though, that she made a conscious effort to resist. She told police that "there were two differences still" and she could not identify Abdal. They decided to then take her to look at Abdal up close—"I was able to look eye to eye" with him. Even then, she was not able to identify him. She heard him speak, and that did not help change her mind; "he used different voices."

Finally, an officer said, "Wait a minute, I have an older photo," and brought her a black-and-white mug shot of Abdal. She "immediately identified the man in the photo." That photo had been taken in 1978, five years before the assault. Yet the victim said when she saw that photo, she "had no hesitation whatsoever" and was "positively sure."[5]

Her certainty increased at trial and other aspects of her account also changed. At trial, she testified that her attacker spoke to her and she

looked at him directly for about thirty seconds before he assaulted her. In her original statement she said he spoke from behind her and she barely saw him before he blindfolded her. Her original statement described only being able to feel facial hair; she could not describe it.

Where the victim had seen differences between Habib Abdal and her attacker, at trial she found similarities. She testified, "It's the same protruding eyes, but, slightly bulging. It's the same yellowing whites. The same slightly hooded eyelid. The same oval face that comes to the same slight narrowing pointing of the chin. It's the same width of the shoulders I felt. It's the same coloration . . ." However, in her descriptions to police she had never described those "hooded eyelids." She testified that the defendant had the same dark gums or spaces between his teeth. However, her original description was very specific about a single space between the upper front teeth. She told police the man could be between twenty-five and forty. However, Abdal had a gray beard and was forty-three years old. She described an attacker who was between 5'8" and 5'10", just a few inches taller than she. However, Abdal was much taller than that. He was 6'4".[6]

Finally, the victim testified at trial that she was completely certain Habib Abdal was her attacker. She claimed, "I have the same picture in my mind today as I had then."[7] That statement was false. But it was very powerful. There was no other evidence linking Abdal to the rape. The forensic evidence from the rape kit was inconclusive. The hairs found on the victim did not match Abdal. The jury convicted Abdal based on the account of this eyewitness whose memory was deeply tainted, the product of sustained police efforts to induce her to make an identification. There was a picture in her mind after the rape—and at first, her memory may have been accurate. Her initial descriptions did not resemble Abdal, but rather another man. After the police used suggestive techniques, though, the picture in her mind changed and her certainty about her identification of Abdal increased. In the last chapter, we saw how police can contaminate a confession by suggestion or outright feeding of facts during an interrogation. Here, we see contamination of a different kind of evidence: the memory of an eyewitness. In Abdal's case, to this day, the true culprit has not been found. Abdal spent sixteen years in prison before being exonerated by postconviction DNA testing in 1999. We will

hear more about Abdal's postconviction ordeal in Chapter 8, which describes the struggles of these exonerees to obtain DNA testing and an exoneration.

Suggestive and Unreliable Identifications

As in many trials, the key moment in Habib Abdal's trial occurred when the eyewitness pointed to him in the courtroom and said she was completely certain that he was the man who attacked her. As Justice William Brennan wrote, "[T]here is almost nothing more convincing than a live human being who takes the stand, points a finger at the defendant, and says 'That's the one!'"[8] Almost all of the eyewitnesses at these innocent persons' trials testified that they were certain they had identified the right person.

Judges expressed disbelief that these eyewitnesses—or any eyewitnesses—could be mistaken. In Jerry Miller's trial, the judge said, "I have never heard that in my life, that a rape victim with a person who is unmasked says they can't identify him. I never heard that in my life."[9] Jurors were moved by this eyewitness testimony. In Marcus Lyons's case, a juror later described how powerfully it affected them that the victim was "shaking like a leaf" when she identified Lyons at trial.[10]

The role of mistaken eyewitness identifications in these wrongful convictions is now well known. Eyewitnesses misidentified 76% of the exonerees (190 of 250 cases).[11] Nevertheless, when I began studying these cases, I was worried that I would not be able to say very much about eyewitness misidentifications. After all, we do not often have records of what transpired during the identification procedures, because police usually do not document them. The trial records are often all that we have to go on. To my surprise, I found that the trial records alone told a troubling story. In the vast majority of these cases, the seemingly powerful eyewitness testimony was flawed. I obtained trial materials for 161 or 85% of the 190 exonerees (out of 250) who were misidentified by eyewitnesses. Two related problems recurred: suggestive identification procedures and unreliable identifications.[12] In this chapter, I will focus on each problem in turn.

First, eyewitness memory is not just fallible; more important, it is malleable. I did not expect these trials to describe police using suggestive

procedures. Yet in 78% of these trials (125 of 161 cases), there was evidence that police contaminated the eyewitness identifications. Many of these eyewitnesses were asked to pick out the suspect using suggestive methods long known to increase the chances of an error. Police either made remarks that indicated to the eyewitness who should be selected during a lineup, used showups where the eyewitness was asked whether a single person was the attacker, or used lineups in ways that made it obvious whom the eyewitness was supposed to choose because the defendant stood out.

Suggestion is related to the second problem, false certainty. Although these witnesses were confident at trial, their false confidence may have been created by what came before. Not only were eyewitnesses in fact wrong, having identified an innocent person, but at trial the flaws in their memory were often quite glaring. I expected to read that these eyewitnesses were certain at trial that they had identified the right person. They were. I did not expect, however, to read testimony by witnesses at trial admitting that they earlier had trouble identifying the defendants. Even if there had been problems, eyewitnesses might not recall their hesitance at the time they first identified the defendant. Yet in 57% of these trial transcripts (92 of 161 cases), the witnesses reported they had *not* been certain at the time of the earlier identifications. Witnesses said that they had been unsure when they first identified the defendant, or they had identified other people, or they had trouble making an identification because they had not seen the culprit's face. While not my focus here, almost all cases also involved defendants who looked very much *unlike* the person the victim initially described, with glaring differences in their height, weight, or hair, or in other telling physical features like tattoos or gold teeth or scars. Witnesses also admitted they could not get a good look at an attacker because it was dark or the attacker hid or ordered them not to look. As the months passed after the crime, their memory had also faded.

This is not to say that police necessarily engaged in purposeful misconduct. Police likely believed they had a guilty suspect. They may have had good reasons to place the exoneree in a lineup. Some of the procedures they used might seem like a good idea, if one were not trained about the nature of eyewitness memory. For example, police may have

conducted repeat lineups because they wanted to be sure they had the right person, and not to cement an error. They may have tried to comfort the victim by mentioning that they had already arrested a suspect, not realizing that doing so affects the reliability of the identification that follows. Moreover, as we will see, lenient criminal procedure rules do not require police to do anything different than what they did in many of these cases. With judges taking a hands-off approach, most police departments have few procedures and little formal training on eyewitness identifications, despite the importance of eyewitness identifications in so many criminal cases.

Yet for decades social scientists have warned of the fragility and malleability of eyewitness memory and the ways that commonly used police practices create unnecessary risks of tragic errors. As Professor Gary Wells, a psychologist who helped pioneer the study of eyewitness memory, puts it, "eyewitness testimony is among the least reliable forms of evidence and yet persuasive to juries."[13] Eyewitness misidentifications are common. Data suggest that in actual police lineups, witnesses choose known innocent "fillers" an average of 30% of the time.[14] Upward of 75,000 suspects are identified each year by eyewitnesses in the United States.[15] These exonerations raise disturbing questions about how accurate those eyewitnesses may be.

Eyewitnesses and Victims

Who were the eyewitnesses who misidentified innocent people? I was surprised to discover that 36% (68 of 190 exonerees) were identified by multiple eyewitnesses, some by as many as three or four or five.[16] At least 290 eyewitnesses misidentified the 190 exonerees who had eyewitness evidence in their cases. Of those, 73% (213 of 290) were victims, typically victims of a rape. In cases involving multiple eyewitnesses, prosecutors emphasized that the evidence was particularly strong. For example, in Cody Davis's case, the prosecutor told the jury that "in this case you have two witnesses, again, that made the identification of Cody Davis, the defendant, on their own, in separate locations, at separate times they did that."[17] One wonders how separate individuals could have all made the same mistake. In some cases, the exoneree may have become a sus-

pect because his appearance resembled the perpetrator; eyewitnesses could have made the same, but understandable, mistake.[18] However, poor police procedures could also have tainted all of the witnesses. Studies suggest that one eyewitness can be influenced by the identification of another.[19] For example, in Richard Alexander's case, as in several others, the eyewitnesses all viewed photo arrays together in the same room.

Of the exonerees convicted based on an eyewitness identification, the vast majority, 84%, were convicted of rape (159 of 190 cases).[20] In 93% of the cases of an exoneree convicted of rape (159 of 171 cases), a victim testified as an eyewitness at trial. In contrast, in the fewer murder cases that had eyewitnesses, the eyewitnesses were typically not victims, but rather people who said they saw the culprit near the crime scene.[21] Rape cases might not have gone forward had the victim not been able to identify the defendant; the victim identifications were often crucial to closing the case.

Much of this chapter focuses on testimony by victims of rape. Only fifteen of the exoneree rape cases had identifications by acquaintances (in contrast, most reported rapes involve acquaintances).[22] These victims were called on to identify total strangers. Moreover, victims saw these strangers during rapes in which they often feared for their lives. High levels of stress strongly affect the ability to accurately identify a person. While most of these victims were women, women do not have more trouble identifying people as eyewitnesses; the evidence is quite to the contrary.[23] In addition, most of these identifications were cross-racial, with a white victim and a black defendant, unlike most rape prosecutions, which are same-race. As I will discuss later in this chapter, that may be part of the reason why so many witnesses misidentified the culprits.

To protect the privacy of victims, their names are not used, except in a few instances in which the victims themselves have spoken extensively about their cases. Criminal investigations and trials can be extremely difficult for the victims and their families, who must revisit violent events. Wrongful convictions severely impact victims and their families in new ways. They learn that the true culprit was not convicted, but remained or still remains at large. Sometimes victims played a role in the

error, often very much inadvertently, but as I will explain, police could have prevented some errors by more carefully preserving the victim's memory.

Police Procedures

How do police determine whether an eyewitness can identify a culprit? Police use a range of techniques to test an eyewitness's memory. If a suspect is found shortly after the crime, police may present that suspect to the eyewitness directly. Such a one-on-one procedure, called a "showup," is inherently suggestive. Police may use such a procedure only in the hours immediately following an incident, in order to quickly identify the perpetrator or rule out the suspect and continue their investigation.[24] If police do not quickly locate a suspect, they may show a witness books or computerized collections of mug shots. If that also fails, police may ask the witness to work with a police sketch artist or with a computer program to generate a composite image. That composite may be used in wanted postings to try to apprehend a suspect.

In at least forty-six exonerees' cases, eyewitnesses initially worked with a sketch artist or a police officer using an "Identikit" or computer program to make a composite image of the attacker. Studies suggest composites are highly problematic. People have far more difficulty giving an accurate verbal description of individual facial features than recognizing an entire face.[25] In Allen Coco's trial, the victim said that only "after the composite" did she begin "looking and putting pieces together myself of what I remembered of that person's face."[26] The process of creating the composite may have distorted her memory.

If police eventually locate a suspect, they conduct an identification procedure to test the eyewitness's memory. In a live lineup, a suspect stands in a row of "filler" individuals and the witness looks at the group from behind one-way glass. In the past few decades, police have mostly stopped using live lineups because it is so time-consuming to find people who look similar to a suspect. Instead, they use photo arrays, typically using a set of six photos (a "six-pack"). Among the 161 exonerees studied, 118 were identified in a photo array, 61 in a lineup, 53 in a showup, and 46 from composite images prepared by witnesses. Most witnesses viewed

more than one type of procedure, and viewing multiple procedures may have reinforced false identifications.[27]

Although most of these crimes and police investigations occurred in the 1980s, some were more recent. In any case, police practices have not significantly changed in most departments. Police departments have detailed procedures, manuals, and training on a host of subjects, ranging from traffic stops to use of force. Yet many still do not have any written procedures or formal training on how to conduct lineups or photo arrays. For example, in James Ochoa's case, an officer saw nothing wrong with conducting a showup six hours after an incident, rather than using a photo array. At a preliminary hearing, he admitted that he had never been trained on how to create a photo array. Ochoa's lawyer sarcastically asked, "Do you think that at any time between now and the jury trial you will have a chance to refresh yourself on proper lineup procedure?"[28]

The Supreme Court's Due Process Test

If techniques like showups are so prone to error, why are police still allowed to use them? In *Manson v. Brathwaite* (a case involving a prison custodian named Manson, not the famous serial killer), the U.S. Supreme Court noted the dangers of suggestive identification procedures.[29] The Court had long recognized "[t]he vagaries of eyewitness identification," where "the annals of criminal law are rife with instances of mistaken identification."[30] Accordingly, in *Manson* the Court affirmed that the Due Process Clause of the Constitution embraces a right to be free from unduly suggestive eyewitness identification procedures, such as showing the eyewitness a single photograph of the suspect, or telling the eyewitness whom to identify in a lineup.

However, the Court in *Manson* added a caveat that undercut the power of that holding. Even if the police engage in suggestive procedures so potentially suggestive that they violate due process, the identification may still be admitted at trial if it is otherwise "reliable." The Court's flexible multifactor test for what counts as "reliable" provides almost no guidance to police or judges. Even the aggressive use of suggestion by the police in Habib Abdal's case could be excused if the judge found the identification

"reliable" because the witnesses seemed certain by the time of the trial. In practice, the test leaves it to the defense lawyers to bring out the weakness of the identification during cross-examination, and to the jury to decide if the eyewitness is reliable. In the exonerees' cases, defense lawyers typically did cross-examine eyewitnesses, often aggressively. Yet the apparent confidence of these eyewitnesses may have trumped evidence of suggestion and unreliability. Jurors place great weight on the apparent confidence of an eyewitness, although, as I will discuss, confidence at the time of trial is very misleading.[31]

Suggestive Procedures

We know, then, that police have expansive authority to encourage eyewitnesses to identify the person the police already suspect committed a crime, and that police are in a position to suggest, sometimes unintentionally and sometimes overtly, which person the eyewitness should choose. Is that what happened in these exonerees' cases?

We do not know what happened and what was said at these identifications, apart from what witnesses later recounted at the trial. Police typically do not document identification procedures, aside from keeping a copy of the photo array, or perhaps a form the witness signed. In only four cases was the entire procedure recorded. Experts have long recommended that police record eyewitness statements and identifications to create an accurate record of what eyewitnesses say and how confident they are.[32] Defense attorneys were present in only sixteen of these identification procedures. Defendants have a right to have a lawyer present at postindictment lineups, but most of these cases involved photo arrays, not live lineups, and most involved identifications conducted well before an indictment. The defense lawyers could only try to find out what actually happened at an identification by questioning the eyewitness and the police who conducted the procedures at trial.

Given how poorly documented eyewitness identifications usually are, I was particularly surprised that even based on what the eyewitnesses and police said at trial, it was clear these lineups were riddled with irregularities and procedural flaws—though perhaps no more than is typical. These exonerees' trials typically involved procedures long known to

create risks of suggestion, ranging from showups in 33% of the trials with eyewitness testimony (53 of 161 trials), to biased lineups in 34% (55), to suggestive remarks in 27% (44), to hypnosis in 3% (5). While some cases had more than one type, 78% (125) involved one of those types of suggestion. The sections that follow will discuss each of those suggestive procedures in turn.

Showups

One of the most obviously suggestive procedures simply shows an eyewitness a single photograph or single suspect—a "showup." Showups outright tell the eyewitness who the suspect is and for that reason have been "widely condemned."[33] Some 33% of the trials obtained with eyewitness misidentifications (53 of 161 trials) involved a showup, either live or by showing a single photo.[34]

Showups are clearly allowed and justified only shortly after a crime occurs, when a suspect is found near the scene. Under such special circumstances, police have an important public safety reason to detain a potentially dangerous person immediately; otherwise they would have to let him go while they tried to prepare a lineup procedure. Further, police can ideally rule out innocent persons quickly without an arrest. Only eleven exonerees were identified in crime scene showups. For example, Gene Bibbins was identified in a showup five to fifteen minutes after the assault. Similarly, Anthony Robinson was identified a half hour after the assault.

Such cases are noteworthy. Those victims misidentified the defendant right after the crime when their memory was still fresh, perhaps in part because showups are inherently suggestive. Unlike lineups, which include fillers who can help to protect an innocent suspect from a misidentification, showups provide no alternatives for the victim to choose.[35] Not only is a showup by its nature suggestive, but it can also be conducted even more suggestively. In exoneree Gene Bibbins's case, for example, a showup was made more suggestive where police placed him in a squad car for the victim to view, after they had just showed her his apartment, where she identified a radio as the one stolen from her during the assault.[36]

In addition, forty-two exonerees were identified in showups that were *not* conducted in the crime scene area right after the crime. Those show-ups were suggestive and had no justification, because they occurred long after the crime, when police could and should have easily prepared a lineup. Six exonerees were identified for the first time in court at a hearing or at trial. Police made no effort to use a lineup or photo array to test the eyewitness's memory in the months after the incident. Perhaps they suspected the eyewitness could not identify the attacker if given a choice.

Many of these showups were blatantly suggestive and unnecessary, yet they were readily admitted at trial. Willie Davidson was identified in a showup in which police staged a sort of performance. The victim had only seen her assailant in the dark with his face covered by a stocking. Police repeatedly pulled a stocking over Davidson's head and off his head, with the victim present. Each time they asked the victim to identify him, asking, "is this it, is that it." Although the victim had not seen her assailant's face, after that display, she identified Davidson as the culprit.[37]

Similarly, in Alan Crotzger's case, a showup was used precisely because an eyewitness could not otherwise identify him. The eyewitness had failed to identify him in the photo array. The police then took his photo out of the array and presented it alone in a showup. The eyewitness then identified the photo and at trial said "there was no doubt" that it was of the attacker. When the defense brought a challenge at trial, the judge ruled, "I don't believe [the identification] in any way was tainted."[38]

A showup that directly subverted judicial review was conducted in Neil Miller's case. His defense attorney was concerned that earlier photo arrays had been conducted in a suggestive manner. The victim had selected two photos from an array, but was not sure if she could pick either. The first of the two was a six-year-old photo of Neil Miller taken when he was only sixteen. The second was of another man. The detective showing her the photos manipulated the situation by instructing her, "if she had a first impression, that the best thing to do was go with her first impression." Having picked Neil Miller's photograph first, the victim then identified Neil Miller's photo.[39]

The defense lawyer scheduled a hearing to argue that a new photo array should be conducted. In the courthouse, just before the hearing was

to take place, the prosecutor walked the victim past Neil Miller in the hallway outside. Yet even after being told that her attacker might be in that hallway, she still was not sure, and just thought he *might* be her attacker. She was not positive until she followed Miller into the courtroom (where it was obvious who he was), looked at him again, and said, "This is him." Now the hearing to request a new lineup was a pointless exercise. Even if the judge ordered that a new photo array be conducted, due to both of the prior suggestive procedures the victim would likely again pick out Neil Miller, and then testify with confidence before the jury that he was the person who assaulted her.

Additional eyewitness misidentifications, other than from showups, occurred after witnesses were exposed to single images of the exoneree. Some witnesses also saw wanted posters or media coverage displaying a composite drawing of the suspect. In Michael Blair's case, for example, all three eyewitnesses had already seen photos of him in the local newspaper or on television before picking his photo from a lineup.[40]

Stacked Lineups

Although showups may be highly suggestive, a lineup may also be suggestive if it is not set up fairly. At least 34% of the trials obtained with eyewitness testimony (55 of the 161 trials) were biased, or stacked to make the suspect stand out. If some of the fillers in the lineup do not look anything like the description of the culprit, or the suspect, then the lineup is not a sound test of the eyewitnesses' memory.[41] I say at least 34%, because problems with the photo array or lineup may not have been brought out at trial. Once again, it was surprising how often problems with the identifications were raised at trial.

The case of Marvin Anderson, who was convicted in 1982 of a brutal rape, involved a clear example. The victim, a white woman, had told police at the hospital after her attack that she could never forget the face of her attacker as long as she lived. Her attacker was a light-complexioned black man with short hair, medium height, and a thin mustache. He had told the victim that he dated "a white girl." The investigating officer knew of only one black man in town who lived with a white woman, and that was Marvin Anderson. The officer did not have a photo of Anderson

on file, because he had no prior record. So, the officer obtained a photo ID from his employer. The victim was given a group of photographs to review. At trial she said she "didn't notice any difference in them." However, unlike all of the black-and-white mug shots shown to the victim, Anderson's work identification was a color photograph, and also unlike the others it had his employee number on it. She picked Anderson's photo.[42]

Just an hour after being shown those photos, the victim was then shown a live lineup and asked "if she could pick out the suspect." Anderson was the only person in the lineup repeated from the photo array. The people in that lineup were chosen because they looked similar to Anderson. The victim looked at the lineup twice and picked Anderson both times.[43]

Anderson's trial attorney moved to exclude the pretrial identification, arguing that it was unduly suggestive. He pointed out that Anderson "is a dark-skinned person," and not light complexioned (by the time of trial the victim now remembered describing her attacker as medium complexioned). He argued that Anderson was the only person shown in both the photo array and lineup. He did not point out the obvious—that Anderson's was the only color photo in the array. The judge ruled that "there's been no showing here that the photographs were irregular or were arranged in any irregular way or, uh, were presented in any way to, uh, identify a particular person."[44]

Another man whose photo was included in the photo array, but who was not in the lineup, was named John Otis Lincoln.[45] He turned out to be the actual culprit. The victim had failed to identify her actual attacker in the photo array. After Anderson had served fifteen years in prison, DNA testing in 2001 not only exonerated Anderson but inculpated Lincoln, who was then convicted. This came as no surprise to Anderson, who had heard from many in the community that Lincoln committed the crime. Lincoln had stolen the bicycle used by the assailant a half hour before the rape. Lincoln even confessed in 1988 at a hearing, but the trial judge called Lincoln a liar and denied the motion for a new trial.[46]

The most common type of flaw in these lineups was to construct them so that the exoneree stood out. In Ronnie Bullock's case, the only man in the six-person lineup with distinctive bumps on his face like the victim

had described was Bullock.[47] In Lonnie Erby's case, he was the only person in the array who had facial hair.[48] The list goes on and on. Other lineups included markings identifying the suspect. Thomas Doswell's photo had an "R" written on it, signifying he had previously been charged with rape.[49]

In at least fourteen cases, the exoneree was the only person repeated in multiple viewings. Studies have shown that such repetition can cement a false identification by making a wrong person look more familiar.[50] For example, in Larry Fuller's case, the victim was shown two arrays, and his was the only photo repeated. After the first array, the victim said Fuller looked "a lot like the guy" but could not identify him. The second time, although the attacker had no facial hair, while Fuller had a full beard, the victim explained, "I knew that was the face," and she "looked at the picture again and I put my finger over the part, the hair, and then I could identify him." She did say she was "very slow in identifying him because [she] did not want to identify an innocent man."[51] Had police repeated photos other than Fuller's, maybe she would not have done just that.

A voice lineup, nicknamed an "earwitness identification," may be even less reliable than eyewitness identifications. Forty-four eyewitnesses identified the defendant not just by sight, but by voice, in a "voice lineup" where the police had persons speak a phrase that the attacker had uttered. What research exists on such voice lineups suggests that they may be similarly susceptible to the influence of suggestion.[52] Other witnesses identified voices in the voice equivalent of a showup, as in Habib Abdal's case, where the witnesses were asked if they recognized a single suspect's voice.

Suggestive Remarks

Whatever the type of procedure used, police may contaminate the identification by telling the eyewitness whom to pick out of a lineup or saying something to reinforce an identification. In another 27% of the trials involving eyewitness testimony (44 of 161 trials), it came out at trial that police made suggestive remarks. We do not know how many more cases involved suggestive remarks not brought out at trial; what is surprising

was how often the eyewitnesses and officers openly described use of suggestion at trial.

Suggestion can occur before the lineup begins. The American Psychology-Law Society recommends that police instruct a witness that the suspect might or might not be present in the lineup or array. Otherwise the witness may assume that the culprit is present and pick the person who looks most like the culprit. The failure to give those admonitions substantially increases the risk of a misidentification.[53] Although some states and police departments have adopted lineup reforms in response to these exonerations, as I will discuss in Chapter 9, most police departments still have no written procedures and no set of standard instructions. At the time these exonerees were convicted, police might have casually shown the witness photos and just asked if the suspect was there. In only fourteen trials was there evidence that the witness was specifically told that the suspect might not be in the lineup.[54] The danger is that the witnesses may logically assume that the police brought them to the station for a reason—because the police arrested the culprit. Indeed, many of these witnesses said they assumed they had been asked to come to the police station to look at the culprit.

In some cases, police further biased the eyewitnesses by telling them beforehand that they had apprehended a suspect whom they had placed in the lineup.[55] For example, in Robert Clark's case, police told the victim that not only did they have a suspect but that he was caught driving her car. In Richard Johnson's case, the officer called the victim and said, "you need to come in for a line-up, we think we have him."[56] In Robert McClendon's case, the victim recalled at trial that "they just told me to pick out the person who done that to me."[57] In many trials the issue was not raised, and since almost none of these lineup procedures were documented, we do not know whether police gave biasing instructions to the witnesses in even more cases. Again, what is surprising is how often police or the victim did recall and describe biasing instructions at trial. Police may have made such remarks to victims to comfort them and to encourage them to come in to see a lineup that they might have been quite afraid to look at.

In some cases, police made remarks that were perhaps not so well intentioned. A few eyewitnesses even recalled police outright telling—or demanding—that a particular person be identified, and eyewitnesses, or

even the police, openly described this police misconduct at the trial in their testimony. Habib Abdal's case is an example of aggressive police suggestion; recall how the victim said that police kept pressuring her to identify the suspect. There were others. In Alejandro Dominguez's case, police told the victim, "watch the one sitting there. Tell me if that is the one."[58]

In Richard Johnson's case, the victim looked at his photo in an array for about five minutes but was not certain; "I said I wanted to see him, I thought that from a picture it was hard to tell." The victim testified at trial: "After a while passed and I hadn't said anything, they said, you know, you have been staring at that photograph a long time and I said I think it's him."[59] In Gilbert Alejandro's case, before the lineup the victim was told that the suspect was named Gilbert Alejandro, whose family she knew, so she knew what he looked like. The lineup was also apparently designed so Alejandro would stand out; she testified that the others in the lineup were "fatter than him."[60]

In Larry Mayes's case, the police officer testified that the victim looked at the live lineup and "She said, 'No. 5.'" This was a problem: No. 5 was a filler. The officer recalled, "So I grabbed her and I said, 'Come on in the room, and shut the door and look at everyone and see if he is in here.'" The victim then "studied all five subjects and made the statement, 'No. 4. That's him. It looks like him. Yes, that is him.' I asked her, 'Are you positive? . . .' And she said, 'Definitely, yes.'"[61] Larry Mayes was No. 4. Not only was the victim pressured to disregard her initial nonidentification, but years later the victim revealed that police had hypnotized her in an effort to enhance her memory.

In five exonerees' cases, eyewitnesses had been hypnotized prior to identifying the defendant.[62] Lesly Jean had his conviction reversed because the fact that hypnosis was done was concealed from the defense, just as in the Mayes case; indeed, the victim may have first identified him while under hypnosis.[63] Hypnosis was initially developed as a therapeutic technique, but by the 1970s law enforcement began to use hypnosis to "recover" or "refresh" memories of forgotten traumatic events. However, studies show that hypnotism does not increase the accuracy of eyewitness testimony and in fact can make a witness far more susceptible to suggestion.[64]

Police also made statements after an identification that would tend to enhance the victims' confidence. After the victim had identified Larry Fuller, police told her that Fuller had previously been in prison for armed robbery.[65] In Anthony Green's case, the attacker had told the victim that his name was Tony, and after she identified Green's photo, police said, "this guy's name is Anthony, Tony."[66] In Ronald Cotton's case, the victim later recounted that "When I picked him out in the physical lineup and I walked out of the room, they looked at me and said, 'That's the same guy,' I mean, 'That's the one you picked out in the photo.' For me that was a huge amount of relief."[67]

Several cases highlight how untrained police can unintentionally reinforce a mistaken identification. In Thomas McGowan's case, the victim identified his photo from an array. The victim explained that she slowly reviewed each of the photos, looking at them for "quite a long time." Reviewing one photo for the second time, she told the officer, "I think this is him." She recalled that he "said I have to be sure, and when I picked it up the second time, I said, 'I know this is him.' "[68] While the officer may have been trying to be cautious, telling the victim that she had to "be sure" encouraged her to express more certainty. If the officer had instead just asked how certain she was, he could have obtained more objective information. Similarly, in Larry Johnson's case, the victim was asked after she identified him whether she was certain. She said, "Yes," and the officer told her that she "had to be a hundred percent sure."[69]

In none of these cases did anyone claim the police gave any nonverbal cues to the eyewitness. A lineup administrator who knows which person is the suspect can shake her head, nod, point, or slow down or speed up the procedure to indicate the suspect. Such cues can be unintentional and unconscious. We do not know from reading these trial transcripts if other types of suggestion occurred.

The Reliability Test

In many of these cases, then, police engaged in the kind of suggestion that the Supreme Court has said is impermissible, although nevertheless excusable if there is enough evidence that the identification is "reliable."

A close look at the trial materials also sheds some light on why judges may have decided that these identifications passed muster at the time of trial. Judges can rule that an eyewitness identification may not be presented to the jury, if they decide that it was both tainted by suggestion and unreliable. However, the test that they use to evaluate reliability is deeply flawed and has been much criticized by social scientists. The Supreme Court's test in *Manson* asks the judge to look at five factors to assess reliability, in no particular order of importance: (1) the eyewitness's certainty; (2) the opportunity to view the perpetrator; (3) the degree of attention; (4) the accuracy of the description the witness gave; (5) the time between the incident and identification. The test is so flexible as to be toothless, and, it also includes some factors that do not actually give judges good information about the reliability of eyewitness identifications. I start with eyewitness "certainty," because the role played by that factor was most problematic in these cases.[70]

False Confidence

The problem with focusing on eyewitness certainty is that the certainty of eyewitnesses by the time of trial may be completely different from their certainty at the time their memory is most reliable—when they first identified the defendant. These exonerees' cases illustrate that problem vividly. Almost all of the eyewitnesses in these trials expressed complete confidence at trial that they had identified the attacker. The eyewitness in Steven Avery's case testified, "There is absolutely no question in my mind."[71] In Thomas Doswell's case, the victim testified, "This is the man or it is his twin brother" and "That is one face I will never forget."[72] She rated, on a scale from one to ten, her certainty as ten. However, she described her attacker having a full beard, which Doswell did not have when picked up three hours after the attack. In Dean Cage's case, the victim was "a hundred percent sure."[73] One hundred percent was a modest figure. In Willie Otis "Pete" Williams's case, the victim said she was "one hundred and twenty" percent sure.[74] The victim in Donald Wayne Good's trial gave a chilling depiction of what it was like to see him in the lineup. She said: "Instantly, I knew it was him. Instantly. And my whole body reacted. I just fell, I collapsed. I grabbed my husband. If

he hadn't been there, I would have been on the floor." She said, "My God, it's him."[75]

When did these eyewitnesses become so confident? I assumed they would recall having always been sure of their identification. I did not expect to learn that many of these witnesses were actually not so sure when they first identified the defendant, long before the trial. Police often do not document eyewitness certainty at the time of an identification, yet their certainty at that time is most indicative of the accuracy of the identification.[76] In 57% of the trials with eyewitness testimony (91 of 161 trials), the witnesses had earlier not been certain at all, a glaring sign that the identification was not reliable. In 40% of the trials with eyewitness testimony (64), the trial transcripts revealed how an eyewitness did not initially identify the defendant, but rather a filler, another suspect, or no one at all. In 21% of the trials with eyewitness testimony (34), an eyewitness admitted initial uncertainty about the identification. In 9% of the trials with eyewitness testimony (15), an eyewitness reported not having seen the culprit's face at all. Some cases had more than one type of evidence of eyewitness uncertainty.

It is powerful to see a person point to the defendant in court, explaining that his memory is like a photograph, and that man is the one. But human memory is not like a photograph; it is dynamic and fragile. While jurors are particularly impressed with confident eyewitnesses, certainty is one of the most malleable features of human memory. Social science research has for decades shown how suggestion or poor procedures can generate false and inflated confidence.

Suggestion and certainty are related. Only 12% of the cases reviewed (20 of 161 cases) had no evidence of police suggestion or of clear unreliability involving prior uncertainty. The other 88% involved evidence at trial of suggestive procedures, evidence of clear unreliability, or both (141 of 161 cases). And still more cases may have involved suggestion or unreliability that the trial transcripts do not reveal.

These eyewitnesses' certainty may have increased with each identification procedure used, if police conducted not one but multiple identifications. In addition, not only identification procedures but routine preparation for trial increases an eyewitness's certainty. A prosecutor will rehearse each of the questions, walking the eyewitness through every-

thing that happened, everything she saw, and everything she told police. The eyewitness would then see the defendant again in court, perhaps at pretrial hearings, and then finally at trial, sitting at the bench with his lawyer. At trial, the prosecutors typically followed the same script, discussing chronologically everything that happened, and culminating with the courtroom drama of the eyewitness pointing to the defendant from the stand—and then at the very end of the questioning, asking the eyewitness if she is certain.

Every step in the criminal process that comes before that question, "how certain are you that the man you have pointed to is the man you saw," enhances the certainty of the eyewitness. The *Manson* test's focus is wrong. Instead, the way to prevent contamination of the early and most reliable impression in the eyewitness's mind is to take a clear statement from the eyewitness immediately after the identification procedure, to find out how confident he was then. That is what social scientists have long recommended, to preserve eyewitness memory just as police carefully preserve trace evidence from a crime scene to ensure its integrity.

Although the most crucial and accurate information is how certain the eyewitness was at the time of the first identification, at that time most of these eyewitnesses were not sure.[77] For example, Calvin Johnson was arrested in 1983 for two rapes in College Park, Georgia. Both victims where white, while Johnson was black. The first rape victim picked Johnson's photo out of a photo array, but when she observed a live lineup, she picked a filler. The second victim did not identify Johnson from the photo array, saying she "wasn't sure," but did identify him at the live lineup. The photo used in the array showed him as clean-shaven. However, at the time of the crime, Johnson had a full beard and mustache, as his boss and others testified. Yet both victims had described their attacker as clean-shaven, or at most as having had some stubble.[78] Those inconsistencies should have made the victims uncertain, and in fact at the time of the initial procedures, they were not certain.

Yet at trial both victims identified him. One explained that the reason she didn't identify Johnson when looking at the lineup was that "I just refused to let myself look at him anymore, and I just picked another person." She said, "I picked the wrong one, and I knew it," thus admitting

that she had falsely accused an innocent person.[79] At trial, however, she said she was certain: "I know I'm right. I know that's him."

The second victim, against Johnson's lawyer's objection, had been allowed to hear the first victim's testimony at the preliminary hearing, and the second victim admitted that after that hearing she remembered more details, including a ridged sweater the attacker wore. She now testified she was certain that Johnson was her attacker, saying, "It's the man with the beard sitting right there" and "you'll get your time." After leaving the stand, she lunged at him, yelling out: "You stupid bastard."[80]

In these exonerees' cases, we now know that the accurate response, when viewing these lineups, was "none of the above"—except in three remarkable cases. In John Jerome White's case, the victim picked White out from a photo array. She had been told by the detective that "he had caught somebody" and she should come see a live lineup, where she again identified White. The seventy-four-year-old victim said she was "almost positive" he was her attacker, even though there was very little light during the attack and she was not wearing her prescription eyeglasses. White's lawyer argued that she was initially uncertain, but became more certain as police showed her White's photo, explaining, "Once she saw that picture though, once that poison seed was planted it began to grow and she became more positive as to the statements from then on . . . by the time she got into the court, she was absolutely positive that was the man."[81]

DNA testing not only excluded White and exonerated him after twenty-two and a half years in prison, but it confirmed the guilt of another man. That man, James Edward Parham, was coincidentally standing in the lineup in 1979, when the victim picked White. He was not a suspect but just happened to be in the county jail at the same time and was placed in the lineup. He had raped another woman in Meriwether County six years later and eventually pleaded guilty to the crime for which White was convicted.[82] Parham looked very different from White. Parham was older, was much stockier, and had a round face, just as the victim had initially described. Yet having already identified White's photo and then been told by the detective that "he had caught somebody," she may have looked for White in the lineup and never carefully looked at the actual perpetrator who was standing right there before her.

We heard how the victim in Marvin Anderson's case had failed to identify the actual perpetrator, and there was also a third case like that. Jennifer Thompson has described how she misidentified Ronald Cotton; she said, "I was certain and I was wrong." She was sure Cotton was the attacker even when at a postconviction hearing she saw Bobby Poole, whose guilt was later confirmed through postconviction DNA testing. When she was asked if she had ever seen Poole before, she said, "I have never seen him in my life. I have no idea who he is."[83]

Unless the witness happens to mention doing so at trial, we may not know if the witness had previously picked out the wrong person or had been uncertain, since police do not typically document how certain eyewitnesses are when they first make an identification. In 21% of the cases (34 of 161 cases), the eyewitness's initial uncertainty did emerge at trial. In Bruce Godschalk's case, one of the victims testified at trial that she was very certain: to the question "Are you positive in this identification?" she answered, "Absolutely." Yet at the lineup, she was unsure and had to look three separate times before making an identification. Police departments often do not keep records of such repeat viewings, but data suggest that eyewitnesses make more errors each time they need another viewing to make their identification.[84] In Anthony Capozzi's case, a victim had identified a filler in one lineup, but testified at trial that she was now sure that Capozzi was the attacker. She explained that she had felt "rushed" and therefore identified the filler.[85] In 40% of the trials with eyewitness testimony (64 of 161 trials), the eyewitness did not initially identify the defendant but instead selected a filler, another suspect, or no one at all.

Similarly, one of the eyewitnesses in Kirk Bloodsworth's case had initially told the police officer that she never got a good look at the person she saw with the murder victim. At trial, though, she repeated her identification, stating that she saw him for forty-five seconds, and that questioning her identification "really upset" her because "I'm trying to be so strong and hold onto this case as much as I can. You don't know how many doctors I have seen to try to forget this, you know."[86]

In Terry Chalmers's case police conducted several lineups, and since they documented each, we can see the victim's confidence changing over time. At the first photo array, the victim was shown a book of mug shots

as well as a photo array. She said that two of them "could be" the attacker. At a second photo array, she said that Chalmers was "very close" to the person who raped her. She asked if he was the same person that had been shown to her in the first photo array, and police told her that "it was the same person." This reinforcement then prompted her to ask to see him again in a live lineup. At a final lineup, which was transcribed with counsel present (and objecting to the fact that many in the lineup did not resemble Chalmers), the victim picked Chalmers within "twenty seconds of the viewing" and he was arrested.[87]

Although many of these eyewitnesses were uncertain initially, by the time of the trial, almost all were positive they had identified the right person. In only four cases were the eyewitnesses *not* sure at trial that they had identified the right person.[88] Jerry Miller had an eyewitness testify that she was not sure but was willing to say that it "looks like him."[89] In Jimmy Ray Bromgard's case, the victim testified that at the lineup, "when I first saw him I wasn't too sure." At trial, she testified that she was "not too sure."[90] Yet the officer who conducted the lineup offered the jury a different account: "My impression she was quite sure, very sure."[91]

Discrepancies in Descriptions

A second factor in the *Manson* "reliability" test, which does not in fact provide very useful information about reliability, is the degree to which the eyewitnesses' initial description of the culprit matches the defendant's appearance. This factor seems at first blush more objective than the others. However, an innocent person could be placed in a lineup because police felt that he matched the description. More important, people are far better at recognizing entire faces than accurately describing particular features.[92]

Since police often did not carefully record initial descriptions of the attacker, we cannot always tell if the descriptions shifted over time to resemble the defendant. I was surprised at how often it emerged at trial that exonerees did not resemble the initial descriptions of the culprit. In unusual cases like Willie Jackson's, a misidentification was understandable: the true culprit was his brother, who looked like him. However, in 62% (100 of 161 cases), the exonerees looked very different from the

initial description. Witnesses had described culprits with major differences from the exonerees in hair, facial hair, height, weight, scars, tattoos, piercings, teeth, and eyes.[93]

An extreme example of such discrepancies is Ricardo Rachell's case, in which the victim and another eyewitness both identified Rachell but had described an attacker who could speak clearly. Rachell had been seriously injured by a shotgun accident years before that disfigured his face and allowed him to speak only with great difficulty. At trial, Rachell took the stand in his own defense and demonstrated his significant speech impediment. Nevertheless, Rachell was convicted and sentenced to forty years in prison. Indeed, in thirteen cases, eyewitnesses failed to describe prominent scars. Dean Cage had distinctive scars on his face, which the victim never mentioned. Anthony Capozzi had a prominent scar on his forehead and a face pitted from acne, which three witnesses did not describe.

Eight exonerees had distinctive teeth. James Giles's lawyer argued: "Now, what is unusual to me is that he has got two gold teeth, two prominent gold teeth. No mention of that. Yes, I think it is mistaken identification."[94] Carlos Lavernia had a silver front tooth with a star in it, as well as numerous tattoos, none of which the victim described. Eyewitnesses in forty-seven cases inaccurately described obvious facial hair (or lack thereof). In Steven Avery's case, the victim said the attacker had brown eyes, but Avery had blue eyes. She admitted: "I originally said brown eyes . . . When I picked out his photo in my hospital room as I handed it to the Sheriff I commented, "He's got blue eyes, I was mistaken."[95] In sixty-seven cases, eyewitnesses did not accurately describe the exoneree's hair, getting the color or hairstyle completely wrong. In still more cases, they failed to describe height or weight with any accuracy. In eight cases, they did not accurately describe the complexion of the attacker.

If judges took the *Manson* test seriously, perhaps they would have excluded some of these identifications based on discrepancies. However, when defense lawyers tried to raise these discrepancies at trial, they had no success. Judges or jurors may have intuitively understood that this *Manson* factor is not a useful gauge of reliability. People can sometimes accurately recognize a face, even if it is hard to accurately describe the

details of the facial features. Social scientists have found no connection between ability to accurately describe a person and the accuracy of an identification. The discrepancies could instead be a symptom of the suggestive procedures used in so many of these cases. Exonerees did not look like initial descriptions of the culprit because they were the wrong men. Yet despite those differences in appearance, they were picked anyway.

Opportunity to View

The remaining *Manson* factors each focus on how good a look the eyewitness had. Unlike the previous factors discussed, these do provide judges with useful information about reliability. Yet in many of these cases, eyewitnesses had a poor view of the culprit, but judges still admitted the identifications.[96] The next *Manson* factor asks what opportunity to view the eyewitness had. While police often do not document how good a look the eyewitness had, and by the time of the trial, eyewitness accounts may be affected by suggestion, I was surprised at how many cases involved poor opportunities to view the culprit.

In most of these cases, the assailant ordered the victims not to look at them or covered their eyes, even threatening to kill the victims if they looked at their faces. The culprits often kept their faces hidden from view or wore masks. In general, most rapes occur at night and in a home.[97] In only twenty-one of these exonerees' cases, an eyewitness described excellent lighting conditions, while in most the lighting was poor. Only slightly more than half of the cases involved a witness who reported seeing the offender's entire body.

The victim in Dennis Brown's case testified that she "was memorizing his face, his eyes, his arms." But when asked, "Could you see his face?" she admitted she only "saw his complete face twice when his mask dropped for like a—long enough—as soon as it dropped, he pulled it back up."[98] In Gilbert Alejandro's case, the victim could only see his eyes and nose. In Fredric Saecker's case the victim saw only the attacker's build or outline.[99] The victim in Clark McMillan's case identified him at trial, but admitted that it was so dark in the woods where she was assaulted that she could not even see blood on a cut on her own finger.

Victims often saw attackers in the dark or in poor lighting, and under terrifying circumstances in which they feared they would be killed.

Obviously, better police procedures cannot change the fact that violent crimes commonly occur under conditions where the eyewitnesses do not see the attacker for long, cannot see well, are focused on a weapon, and experience great stress. All of those features can reduce accuracy of identifications.[100] Social scientists call such factors "estimator variables," as opposed to "system variables" that improved police procedures can change.[101]

Degree of Attention

The *Manson* factor regarding degree of attention is closely related to opportunity to view. At trial, the victims most often said that they only had a chance to look at the attacker for a matter of seconds. Many of these assailants disguised their own face, covered the victim's face, remained in the dark, or ordered the victim not to look at them. Fewer of the cases involved long viewings of the attacker for many minutes.[102] The actual degree of attention of these eyewitnesses was likely far less than the short viewings they recalled. Reports at a trial occurring many months later are to be distrusted. Studies suggest that eyewitnesses overestimate the amount of time they see an event, particularly a stressful event, and they also overestimate how much of a person's face they could observe.[103] As the victim testified in Willie Jackson's case, "It could have been a couple of minutes, and it could have been a couple of hours because to me it seemed forever. And I don't want to exaggerate . . ."[104]

Suggestion affects memory of duration, as with everything else that eyewitnesses recall. For example, witnesses are especially likely to say that they had an adequate or excellent view of a culprit if police make remarks that confirm their identification, like "Good, you identified the suspect."[105] Recall how the victim in Habib Abdal's case initially told police she was not looking at her attacker at all when he spoke to her, but later, after police pressured her to identify Abdal, she said she saw his face for thirty to forty-five seconds.

Most of these eyewitnesses were victims under conditions of extraordinary stress, during brutal sexual assaults, often with the attacker holding

a weapon. Understandably, victims will first focus on a weapon, and not the attacker's face; as the victim in one exonerees' case recalled, "I was focused on the gun until he was physically on top of me."[106] Studies have found that while moderate stress may improve concentration, "a witness in a high stress situation is more likely to be an unreliable witness."[107] However, prosecutors argued and jurors may have believed the opposite, that stress makes one concentrate better on the face of an attacker.

The Passage of Time

Finally, the *Manson* test includes as a factor the passage of time between the incident and the first identification procedure. This is a useful factor, because accuracy greatly decreases over time. Studies suggest this process begins to occur within hours after an event.[108] Many of these identifications were made long after the crime. Recall that the victim misidentified Habib Abdal four and a half months after the assault. Only a handful of cases, including the ten crime scene showups, included identifications the same day as the attack. Most of these eyewitness identifications occurred weeks or months after the crime.[109] Trials occurred even later, typically more than a year after the crime. If judges took this factor seriously, as well as the opportunity to view and degree of attention factors, they might have excluded many of these identifications. The problem with the *Manson* test is that it is so flexible, and worse, it includes unsound factors. Judges may have put those other factors to the side and focused on eyewitness certainty at the time of trial, a factor that is misleading and does not predict accuracy.

Cross-Racial Identifications

There are other factors that are not included among the five factors that judges use, but that should be very important to judges when they evaluate eyewitness identifications. Social scientists have long found an "other-race effect," in which the likelihood of misidentification is higher when an identification is cross-racial.[110] Judges should more carefully examine cross-racial identifications, but in the past they did not, although this is slowly changing, as I will discuss in Chapter 9. One expla-

nation for why so many DNA exonerees were minorities, out of proportion even to their overrepresentation among rape and murder convicts, is that so many of these cases involved cross-racial identifications. At least 49% of the exonerees identified by eyewitnesses had a cross-racial identification (93 of 190 cases). In 71 of those cases, white women misidentified black men.[111]

Racial disparity is glaring in these exonerees' cases. Many more DNA exonerees were minorities (70%) than is typical even among average and already racially skewed populations of rape and murder convicts. Most striking, 75% of the exonerees who were convicted of rape were black or Latino, while studies indicate that only approximately 30% to 40% of all rape convicts are minorities.[112] Why were so many of these exonerees minorities? Is being black a risk factor for being wrongly convicted?

Those are not easy questions to answer, since several factors may explain the racial disparity. One explanation may have to do with the race of the victims, and not just the race of the defendants. The vast majority of the victims in the 250 exonerees' cases were white 72% (180), while 24% of the victims were minorities (43 black, 15 Latino, and 1 Asian), with no information available in the remaining cases (11). In particular, the cases of 49% of the exonerees convicted of rape (84 of 171 cases) involved black or Latino offenders and white victims. In contrast, most sexual offenses, almost 90%, are committed by offenders of the same race as the victim.[113] There is a long history of discrimination surrounding charges of rape involving white women and black men. There is also some evidence that prosecutors may pursue more serious charges in cases involving white victims and black men. There is evidence that white jurors may be less sympathetic to black defendants, and may be more likely to convict black defendants in crimes involving white victims. And more generally, these exonerees' cases may reflect racial disparity in the criminal justice system. Black males are incarcerated at many times the rate of white males, and minorities make up the majority of prison inmates at any given time.[114] Finally, a related explanation is that, as social scientists have shown, eyewitnesses are more likely to make mistakes in cross-racial identifications. Once an identification is made, it is more likely that the defendant will be convicted, even if the

eyewitness was initially unsure. Therefore, one might expect to find many cross-racial identification cases in a group of innocent convicts.[115]

One victim described her difficulty making a cross-racial identification in Thomas McGowan's case; she said that when she was looking at the lineup, "I didn't pick anyone out, but I showed the police officer a person who looked similar to the defendant, because I didn't know how to describe a black person to the police."[116] The defense lawyer did not follow up on that statement. In contrast, a victim at Patrick Waller's trial explained that when she viewed the lineup, "I did not want just some African-American male to be punished. I wanted the individual who has done this to be punished, and I was going to be sure that I had that individual before I did anything."[117]

Larry Johnson's lawyer argued that the cross-racial identification may have contributed to a mistake, and the prosecutor responded by telling the jury, "Black men as you can see among yourselves are all very different."[118] One exoneree sought to introduce an expert to testify about the risk of a cross-racial misidentification. In Perry Mitchell's case, an expert began to testify about his work on cross-racial identifications, but before he could say what the research showed, the judge sustained a State objection and held the testimony was not admissible under South Carolina law.[119] Anthony Hicks also raised the issue, and the judge held, "We have a black man, and there's a record, at least some record in this country of mistakes about black men who have been imprisoned after conviction, misidentifications, and we have had at least one in this community. I hear you." The judge found, though, that there was not "anything in this record that suggests that because Mr. Hicks is a black man he is here."[120]

The only exoneree to have success arguing that cross-racial identifications pose additional risks of error was McKinley Cromedy. As I will describe in Chapter 9, the New Jersey Supreme Court later struck down Cromedy's conviction and required judges to instruct jurors that cross-racial identifications may be more prone to error.[121]

Child Witnesses

A second factor that the *Manson* test does not explicitly take account of is the age of an eyewitness. In 12% of the cases with eyewitnesses (22 of 190 cases), the eyewitnesses were juveniles or children. All states have rules regarding the competency of child witnesses, although many courts assess competency quite deferentially. Social science research has found that children often accurately answer open-ended questions, but when children are asked leading questions, they can easily incorporate false information and are highly vulnerable to suggestion.[122]

In Leonard McSherry's case, the victim was six years old, and seven at the time of trial. She had been abducted from her home for ten hours and raped. The only other eyewitness was her five-year-old brother, who saw her walk away with a stranger and get into his car. Minutes later, he told their mother that his sister got into a green truck with a stranger. At trial, a police officer testified and described how they used suggestive techniques that should be avoided, especially with child witnesses. For example, the officer indicated they asked the victim leading questions: "We were trying—the child was under a lot of strain and stress, so we were not asking her direct questions like you are asking. They were more kind of trying to help her go along with what we were trying to empha-size." Similarly, at trial and on the stand, where the victim was asked an open-ended question, she was unresponsive, but when the question was changed to a leading question, she could answer yes or no.[123]

The victim was interviewed two days after the incident. At trial, the officer admitted that her testimony at the time seemed very unreliable. "We knew she was confused and did not put too much credibility to anything she was saying." A month later, the victim was asked to draw a picture of the house, but what she drew was confusing and not useful.[124] The defendant was arrested and the police claimed that the next day, the victim gave a very detailed description of a house and also picked the house from a photo array. The officer testified that she described a tall dresser with a TV on it, a photograph of the perpetrator, a bed with a blue sheet cover, three doors in the bedroom, and a large round mirror—and the officer testified that she told them all of this before the police had entered the house.

The judge gave great weight to that testimony. When denying a motion for a new trial, he noted, "I remember that little girl's testimony, and that bedspread stands out in my mind. I don't think this was an I.D. case. Her testimony weighed very heavily in how I felt of the rightness of the jury's verdict."[125] Yet there were inconsistencies. At the lineup, she picked a filler, though supposedly after leaving she told police that although she wrote down number six, she had meant to write down number three, which was McSherry. The defense lawyer argued: "Ladies and gentlemen, the bottom line is, if you pick two people out of a lineup, that is a misidentification." The lawyer added, "She saw some other guy. She saw the green truck guy."[126]

As it turns out, the defense lawyer was right. The police officer and the victim's mother both testified that she initially described a green truck but later insisted that the car was a station wagon. At trial, the police claimed that the victim picked the defendant's car, a yellow station wagon, from an array of photos. However, when asked at trial what color the car was, she answered, "Green." Similarly, her brother said he saw a green truck. Before the alleged descriptions of the house and only two days after the abduction, the victim took police to an apartment complex and led them upstairs to a door. She said the attacker had taken her to a place with the numbers zero and one on the door. The police discounted her initial descriptions when they focused on McSherry.

It is possible the officers had fed the victim those detailed facts about the inside of McSherry's house—which we now know she never saw. Or perhaps the police officers unintentionally led the victim to make these descriptions through the use of leading questions. The officer admitted they reinterviewed her, after conducting a search of the house, to try to find out more details.[127] In a civil rights case McSherry later filed, it emerged that police also interrogated McSherry regarding the details of the house he lived in after they arrested him. Only later did they interview the victim. In 2002, she stated in a deposition that the police gave a false account at trial. She was impatient when police interviewed her, she did not actually identify a yellow car or McSherry's house, and she never described the inside of McSherry's house to the police.[128]

Who was the "green truck guy"? When McSherry was exonerated, the DNA matched that of George Valdespino, who was serving a life

sentence in California state prison at the time of McSherry's release. Valdespino had been arrested in Costa Mesa one week after the abduction, and was charged at that time with kidnapping and molesting a four-year-old girl. In December 2001, Valdespino admitted in a taped confession that in 1988 he had kidnapped a girl in the Long Beach area while driving a green Ford Ranchero and had taken her to a motel room (with numbers on the door).

Judging Eyewitness Identifications

In view of the evidence of police suggestion and unreliability in these misidentifications, the question arises: why did judges admit them at trial? Judges are highly reluctant to suppress eyewitness identifications; after all, in many of these cases, the eyewitness was the rape victim, and without her testimony, there might be no case at all. In fifty-eight cases, we have some information about how the trial judge applied the *Manson* factors, because the trial records include rulings on a motion to suppress the eyewitness identification. As discussed, the *Manson* test is so deferential that all of these tainted and unreliable identifications were admitted. The judges that discussed the identification in any detail typically emphasized the witnesses' certainty at trial, the factor that is the most misleading. Still worse, in some cases, judges discounted evidence that should have been of far greater concern than certainty at the time of trial—the eyewitnesses' earlier uncertainty. In Ulysses Charles's case, one victim did not identify anyone in the lineup, telling the prosecutor, "I think or I know that it was No. 4, but I was afraid to say so because it had been so long"—the lineup was conducted three years after the offense. At trial, though, she identified Charles, saying that earlier she "was scared." The judge ruled, "To specify that a witness must . . . make a declaration within a short period of time of the lineup is not to take into account human traits, human frailties."[129]

Larry Holdren had an identical twin brother, which presented a special problem. In a pretrial hearing the defense discussed the photo array, and said that of the five people in the lineup, three had the wrong color hair (black instead of blonde), and the other two were of the defendant—and of his identical twin brother, whose photo was wrinkled and washed

out. Larry Holdren's photo was the only one in the lineup that resembled the victim's description. Worse, during the assault the victim was not wearing her glasses and there was not much light. The judge ruled, "This is not a very good photo array . . . there is a suggestive aspect of the photo array," but emphasized "without hesitation the victim selected one of two people, in any event, who had remarkable similarity in their appearance . . . and I think that that tends to take the edge off of the suggestiveness."[130]

Kirk Bloodsworth, the first person exonerated from death row, and convicted based on testimony by five eyewitnesses, tried to call an expert to testify regarding social science research on eyewitness identifications, but the judge denied the request, finding that "the evidence would tend to confuse or mislead the jury." The Maryland Supreme Court agreed, in a decision that is still the law in Maryland.[131] Ronald Cotton also had a motion for an eyewitness expert denied. We will see in the next chapter how judges routinely allowed prosecution experts to render unscientific forensic testimony. In contrast, judges refused defense lawyers' requests to present social science evidence on eyewitness error. Just three exonerees had eyewitness experts testify.[132]

The law regulating eyewitness identifications is even more lenient than I have described so far. Even a defense "victory," the suppression of an identification, is usually at best only partial and temporary. A pretrial identification could be suppressed, but an in-court identification before the jury may still be allowed. Neil Miller's case was an example of a rare case where the judge excluded an identification because it was conducted in an unconstitutionally suggestive manner and was unreliable. Recall how the police conducted an illegal showup on the morning of a hearing scheduled to examine the identification in the case. However, judges bend over backward to let the eyewitness still identify the defendant at trial, ruling that the courtroom identification has an "independent source," based on the witness's original view of the perpetrator.[133] Thus, the jury in Neil Miller's case still heard about her identifications of Miller *before* the illegal showup. They also saw her identify him in court and say she was positive he was the attacker. Similarly, in Carlos Lavernia's case, the victim admitted that none of the lineup fillers remotely matched her description, and the judge suppressed her prior

identification—but she identified Lavernia in court and said she was "absolutely positive" he was her attacker.[134] Given the flaws in the *Manson* approach and the casual way that judges apply that flexible test, it was no wonder that police so often used suggestive eyewitness identification procedures—judges let them do it.

Closing Arguments and Jury Instructions

Once judges found these eyewitness identifications admissible, they were typically the central evidence at trial. Both the prosecution and the defense typically focused their efforts on the identifications. As one would expect, the defense emphasized irregularities in the identification procedures and any evidence of unreliability. For example, in William Harris's case, the defense argued that only suggestion could explain why an initially unsure eyewitness could now be so certain, arguing: "there's too many inconsistencies, too many problems with the correct identification made early as compared, as it was molded later by all of these police officers and later on into the positive identification, 'the most convincing I.D. ever.'"[135]

In contrast, prosecutors emphasized eyewitness certainty. For example, in Carlos Lavernia's case, the prosecution argued in closing, "Do you think a woman under those circumstances gets any surer? Have you ever seen anyone surer, any more positive about who the person was?"[136] Prosecutors also downplayed inconsistencies in victim descriptions. The prosecutor at Anthony Hicks's trial mocked the defense:

> [The victim] gives you all of this that matches him, and because she doesn't initially see the cleft in his chin, [defense counsel] would have you believe, you know "He's the innocent victim of the Madison Police Department! We've got the wrong guy!"[137]

Since defense lawyers were rarely present at the identification procedures and the procedures were not documented, the defense could do little but point to such inconsistencies—but prosecutors could respond by pointing to the witnesses' certainty.

Or prosecutors could dwell on the seriousness of the crime. In Perry Mitchell's case, the prosecutor argued: "Some Supreme Court Justice said eyewitness identification is untrustworthy. Well, I bet that Supreme Court Justice never had a knife pulled up to him and drug him over in the woods. I think he would change his mind then."[138]

In some exonerees' trials, the judge's instructions to the jury were transcribed. Judges sometimes gave detailed instructions. For example, in Alan Newton's trial, the judge told the jury, "Identification testimony is an expression of belief or impression by the witness. Its value depends on the opportunity the witness had to observe the offender at the time of the offense and to make a reliable identification later."[139] The judge then explained factors to consider when weighing such testimony. The case was also unusual in that the jury sent back questions concerning the eyewitness testimony; they asked to reread the victim's testimony regarding how good a look she had at her attacker. In Nicholas Yarris's case, two witnesses were initially unsure about their identifications but were positive at trial. The judge instructed the jury that "an individual can make a mistake as to identification even when the individual is trying to tell the truth," and then asked the jury to evaluate the reliability of the identifications.[140] Beyond such instructions telling jurors to assess the credibility of eyewitnesses and to consider certain factors, the judges did no more. None explained to the jury, for example, relevant social science research regarding identification procedures or possible effects of police suggestion.

Reforming Eyewitness Identification Procedures

There is every reason to think that these eyewitness misidentifications may be part of a larger problem that continues to this day. Observers have called eyewitness misidentifications the "leading cause" of wrongful convictions.[141] There is a reason why there were so many eyewitness misidentifications among the DNA exonerations. DNA testing is particularly helpful in rape cases, where there is biological material collected from the victim that can be tested. In turn, many rape cases involve eyewitnesses. In rape cases, the case will not easily go forward unless the victim can identify the culprit. However, very few suspects are charged

with rape or murder and fewer are convicted.[142] Other crimes that many more people are convicted of each year, such as robbery, also commonly involve eyewitness identifications, but usually do not have evidence that can be tested using DNA. We simply do not know how common eyewitness misidentifications are for those other types of crimes.

Still more worrisome, the types of suggestive and unreliable eyewitness identification procedures used in these exonerees' cases have been in wide use for a long time. Police did not begin to adopt any written eyewitness identification procedures at all until recently, much less sound procedures and training. Archival studies of police identification procedures have found that suggestive procedures, such as showups, are used frequently and appear to bias eyewitnesses.[143] Nor have very many judges or prosecutors actively sought to improve the quality of eyewitness identifications, although this is changing, as Chapter 9 will describe.[144]

For more than thirty years, beginning with pioneering work by psychology professors Elizabeth Loftus and Gary Wells in the mid-1970s, social scientists have used hundreds of laboratory and field experiments to study eyewitness memory. A vast body of work has uncovered flaws in eyewitness identification procedures and the Supreme Court's *Manson* approach.[145] Courts admit identifications despite highly suggestive procedures based on factors that do not correspond to reliability, such as certainty, which may be the product of suggestion. Police may intentionally suggest a suspect to a witness, but they may also give inadvertent cues that can corrupt an eyewitness's memory.

There is one straightforward way to ensure that police do not engage in suggestive conduct during a lineup procedure. That is to use a double-blind procedure, in which the administering officer does not know which person in the lineup or array is the suspect, so he cannot influence the witness, intentionally or not. The eyewitness must also be told that the police officer does not know which person in the lineup is the suspect, so the eyewitness does not perceive any behavior from the officer as a cue, correctly or not. Eyewitness researchers have long recommended requiring double-blind lineups as the most crucial reform of all.

It should be no surprise that in these exonerees' cases, double-blind procedures were not used. Only one of these eyewitnesses, in Dennis Brown's case, misidentified a defendant in a double-blind procedure.

However, his lineup had another problem: the victim was not told the suspect might not be present. Brown was poor, seventeen years old, and he had been offered thirty dollars by a police officer to be a "volunteer fill-in" in a lineup. He was unlucky to have been in the wrong lineup at the wrong time; the victim identified him, probably to the surprise of the police.[146]

Adopting double-blind lineups is cheap, and more police departments have now adopted this reform.[147] All that police need to do is bring in another officer to administer the lineup. Increasingly, police rely on computerized arrays using databases of photos with automated instructions to witnesses. There is also a clever low-tech way to make a double-blind array that some states recommend: simply place each photo in a folder and shuffle the stack of folders, so that the witnesses can look inside the folders to view the photos, but the officer cannot see which photo the witness is looking at.[148]

Other reforms are also inexpensive but important. The lineup itself should be constructed so that the suspect does not stand out. Lineups in which all of the suspects are presented at the same time, in person or in a photo array, may run the risk of "comparison shopping."[149] The eyewitness must be told that the suspect may not be in the lineup. Officers must document the descriptions and certainty of eyewitnesses.[150] As described, almost none of these identifications used those best practices.

The judge at Habib Abdal's trial told the jury, "Guilt or innocence is in your hands and in your hands alone." He then told them more than many judges do. He instructed the jurors to "exercise extreme caution," and try to assess whether the victim's identification was accurate or was made "by virtue of any suggestions or prompting."[151] Despite strong evidence of an unreliable identification made under sustained police pressure, the jury deliberated for about five hours and then convicted Abdal. Exonerees' cases provide a series of powerful examples of how common but flawed and suggestive police procedures can contaminate the memory of an eyewitness. Judges, not just police, should also be attentive to risks of error. They could conduct a more searching inquiry than under the *Manson* test, to ensure that police use sound procedures or face consequences, such as pointed instructions to jurors or perhaps even the

exclusion of a tainted identification. Reformed eyewitness identification procedures are finally starting to be adopted, as I will discuss in Chapter 9, and they are important. DNA exonerations show how jurors can be convinced that "seeing is believing" even when the eyewitness on the stand points to an innocent man.[152]

Flawed Forensics

I N JULY 1977, police in Homewood, Illinois, came across a young woman, disheveled and walking by the side of the road. She told police she had been raped. Following the standard practice, police took her to a hospital for examination. Medics combed her pubis for any loose hairs, they used cotton swabs to sample fluid from her vagina, and they preserved her stained underwear. They assembled this evidence in a standard collection box, called a rape kit, and sent it to a lab for analysis.

Meanwhile, police worked with the victim to prepare a composite drawing of the attacker—a white man with long hair. Since they had no suspect, police showed her books of mug shots. She selected one, a mug shot of Gary Dotson, whom she later identified in a lineup. Dotson's appearance differed from the mug shot in an obvious way—he had a large mustache. But this case is not at all like the cases discussed in the last chapter, in which suggestive or unreliable identification procedures may have led to a misidentification. This victim later admitted she made up her injuries and her accusation of Dotson as part of an elaborate ruse to conceal from her parents consensual intercourse with her boyfriend.[1]

At Dotson's trial in 1979, the victim, as expected, pointed him out in the courtroom and identified him as her attacker. Only one other witness

testified for the State—a forensic analyst.[2] The term *forensic science* means the use of science to help answer legal questions. In criminal cases, forensic methods are frequently used to analyze crime scene evidence. Most forensic analysts in the United States work for the police, at law enforcement crime laboratories. This analyst worked for the Illinois Department of Law Enforcement. When he testified in Dotson's case, he began by claiming, falsely, that he had done "graduate work" at the University of California at Berkeley. He had in fact "only attended a two-day extension course there."[3] Unfortunately, his testimony did not improve in its accuracy.

He next discussed his analysis of hairs collected in the rape kit. In 1977, before DNA testing had been invented, most of what forensic scientists did was to compare objects from crime scenes: hairs, fibers, fingerprints, bite marks, tool marks, or bullet casings. Using a microscope, they looked at the objects side by side. The analyst would then reach a subjective conclusion about whether the sets of objects looked alike or not. A conclusion that an object is definitely different is called an "exclusion," since the object is found not to be part of the group of similar objects. An exclusion can be definitive. If the defendant's hair is blond but the hairs from the crime scene are brown, then the analyst would say that the defendant is "excluded"—he could not be the source of brown hairs. An analyst may also find an "inclusion," if the object is included, or is part of a group. If the defendant has brown hair and the crime scene hairs are also brown, then the defendant is included in the group of people who could have left those hairs—but that inclusion may not say much. After all, the group of people that have brown hair is enormous. Finally, an analyst may also find that all of the evidence is inconclusive. For example, hairs from the crime scene might be in such poor condition that they are unsuitable for analysis.

This analyst told the jury that he found "several pubic hairs" that were not like the victim's but "were microscopically consistent" with Dotson and "could have been originated from the same source." What did any of that mean? Did the hairs just look "similar" to those of Dotson? Dotson was included, but in how large a group of people? Could just a hundred other people have the same type of hair? Could a million other people have the same type of hair? Or were these microscopic

characteristics so unusual that only Dotson could have been the perpetrator?

The analyst could not have answered those questions, even if the defense lawyer had tried to ask them. The analyst's scientific-sounding terminology may have impressed the jury, but the jury might have thought differently had they known that there was no scientific definition of what it meant for someone to conclude that hairs are "consistent" with each other. All it meant was that the analyst looked at the hairs and thought they looked alike. To this day, no one has done any study of what portions of the population share particular microscopic hair characteristics. It could be that many thousands or millions of people share some type of hair characteristic.

The technique of hair comparison is an unreliable method. What does it mean for a method to be unreliable? A method is unreliable if it does not produce consistent or accurate results. Hair comparison consists in an analyst's own personal opinions. Two analysts could (and do) disagree about whether hairs seem to them to be "consistent" or "similar." Nor is there any definition of what those terms mean. Studies have found very high error rates in hair comparison. Scholars have called on courts to limit the use of such unreliable methods.[4] Nevertheless, judges continue to allow jurors to hear about such unreliable evidence, even in serious criminal cases like Dotson's.

The same analyst also used a second forensic method that *was* reliable. ABO blood-typing, which is called serology, was used widely in sexual assault cases in the 1970s and 1980s. A person's blood type, whether A, B, AB, or O, does not change during his or her lifetime. Frequencies of those blood types were derived from well-established and scientifically valid databases. Most people are called "secretors," because their blood type can be detected not only in their blood but also in their other bodily fluids, including semen. Unlike hair comparison, serology was a reliable method. An analyst could use serology to definitively exclude someone, not based on a subjective opinion but because the person's blood type did not match the material tested. An analyst could also find that a person was included, and could explain what that meant by telling the jury how a person fell within a percentage of the population that shares a blood type. However, many millions of people might also share that blood type.

At Gary Dotson's trial, the analyst testified that he analyzed the vaginal swabs collected at the hospital. He testified that Dotson was Type B, and that so was the source of the semen. Type B is a type shared by only 11% of Caucasians. This appeared to be suggestive, although certainly not conclusive, evidence of Dotson's guilt. It narrowed down the group of possible culprits to 11% of the population.

Unfortunately, the analyst's conclusions were unsound. The analyst never told the jury that the victim was also Type B and that her fluids were mixed in the sample. The Type B substances observed might not have come from the rapist at all. The Type B substances could have come entirely from the victim. In fact, they most likely did, since it was quite common that the material from the victim would overwhelm, or "mask," any material from the semen. Based on the testing technology at the time, nothing more could be done with the evidence. The source of the semen could have had any blood type at all. The semen could have belonged to any man in the world. It was false and highly misleading to tell the jury that only 11% of the population (including Gary Dotson) could have been the source and to imply that 89% of the population was excluded.

Although serology was a reliable method, the *conclusion* that the analyst drew from the evidence was a false one. I call such testimony "invalid," because the term *validity* refers to whether claims or inferences are supported by the evidence. In Gary Dotson's case, the analyst went on to offer the jury a second invalid conclusion about the blood evidence. He not only claimed to *include* Dotson, by falsely saying that Dotson was part of a group of Type B people that could have been the source of the semen, but he failed to *exclude* Dotson.

He turned to analysis of the victim's underwear. Here he was confronted with a problem. Type A material was found in stains in several places on the victim's underwear. Since both the victim and Dotson had Type B blood, the A material could not have come from either of them. The analyst testified: "Unfortunately for us there are lots of materials; dust, wood, leather, certain kinds of clothes, different cloth materials, detergents in materials" that could explain the presence of the Type A substances.[5] He speculated that contamination somehow created the Type A substances.

This testimony was simply false. The analyst should have told the jury that the A substances could not have come from the victim or Dotson

and that Dotson was excluded. The analyst's testimony refused to recognize evidence of innocence. In his effort to disregard clear evidence of innocence, the analyst was willing to misstate the fundamental basis of blood-typing. As pioneering forensic scientist Edward Blake explained in his report on the case years later, the analyst could test other portions of the stains to examine whether contamination had really occurred. If it were actually the case that contamination could never be ruled out, and blood substances could spontaneously appear from contact with everyday materials, then "ABO typing of biological samples" would have always been an "inherently unreliable" type of analysis.[6]

Dotson's defense lawyer never questioned or objected to any of this wildly inaccurate testimony. Not having obtained an expert, Dotson's public defender may not have realized that the hair comparison method was unreliable or that the analyst's conclusions about the serology were invalid.

During the closing arguments, the prosecutor exaggerated the science even more, claiming that the analyst had "matched" Dotson's hairs to those found on the victim. The analyst had not gone that far, but had only said that the hairs were "similar" and "could have" come from Dotson. The term *match,* used by the prosecutor, implied that Dotson's hairs were identical to those found on the victim. The defense lawyer did object to that statement. However, the judge denied the motion, thereby permitting the suggestion to the jury that perhaps the hairs really did match.

The jury convicted Dotson of rape in 1979. He was sentenced to twenty-five to fifty years in prison. The victim subsequently recanted. She admitted that she fabricated her accusation to conceal from her parents that she had consensual sex with her boyfriend at the time. However, after three-day televised clemency hearings in 1985, Illinois governor James Thompson denied Dotson a pardon despite the victim's recantation.[7]

DNA testing was Dotson's last hope. Edward Blake would later perform testing showing both the innocence and guilt of many convicts. Blake found that the DNA results excluded Dotson as the source for the male genetic profile, and that the victim's boyfriend was included. The governor still refused to pardon Dotson, but based on the DNA

results, the trial court vacated his conviction and he was exonerated in 1989.[8]

Unreliable and Invalid Forensics

The pervasive use of forensic science in exonerees' cases provides a study in contrasts. One story to tell about science is triumphant—DNA technology developed by innovative scientists set these innocent people free, literally saving some of their lives. Yet in the Introduction, I posed the question: Why didn't forensic science show that these people were innocent at trial? Some forensic science did tend to show innocence at trial. Most of the forensics did not. Indeed, forensic science played a role in most of these exonerees' original convictions. Exoneree Roy Brown aptly said: "Junk science sent me to prison, but real science proved my innocence."[9]

I focus on the exonerees who had a trial, and whose trial records could be located, because by reading these trials one can see, as in Dotson's case, what the forensic analysts actually said on the witness stand. Forensic evidence was present in 74%, or 185, of the DNA exonerees' cases. Some of those had no trial, or no forensic evidence was presented by the prosecution, but for most, 169 exonerees, analysts testified for the prosecution at trial. Of those, I was able to locate 153 trials where analysts testified for the prosecution.[10] The forensic testimony was fairly evenly distributed across the different crimes that exonerees were convicted of, and it was the second most common type of evidence, after the eyewitness evidence discussed in the last chapter.[11]

The prevalence of forensics did not surprise me. After all, most of the cases, like Dotson's, were rape cases in which potentially important forensic evidence was collected in a rape kit. I expected to find that forensic analysts provided the best evidence they could, but that they were limited by the technology available at the time. Instead, when reading these exonerees' trials, I found that even by the standards of the 1980s, when most of these trials took place, forensic analysts should have known that the evidence they presented was unsound. There were two recurring types of problems with the forensics: reliability and validity.

First, many of these exonerees were convicted based on forensic methods that were unreliable. Serology was the most common technique used, in 116 cases, and DNA testing had been conducted at the time in 20 cases. While those are both reliable techniques, other methods that were used were not reliable. Gary Dotson was just one of 75 exonerees who had testimony at trial concerning microscopic hair comparison. Other methods were used, including fingerprint comparison (20 cases), bite mark comparison (7 cases), shoe print comparison (6 cases), and voice comparison (1 case). When analysts use each of those methods, they make a detailed but subjective comparison of objects from the crime scene with those from the defendant. Each method is, in the words of a landmark report by the National Academy of Sciences (NAS), "supported by little rigorous systematic research to validate . . . basic premises and techniques."[12] Each is based on an opinion that two objects are "similar" or "consistent" or that they "match." Although scientists and scholars have criticized many of those forensic methods due to errors,[13] evidence of unreliability, vague terms used for conclusions, and lack of scientific rigor, most are still in wide use today.[14]

Second, many of the cases involved invalid conclusions drawn from the evidence. In 61% of the trials where a forensic analyst testified for the prosecution, the analyst gave invalid testimony. The analysts did this across a wide range of forensic methods, ranging from serology, in which 58% of the testimony was invalid (67 of 116 trials); to hair comparison, in which 39% was invalid (29 of 75 trials); to bite mark comparison, in which 71% was invalid (5 of 7 trials); to shoe print comparison, in which 17% was invalid (one of six trials); to fingerprint comparison, in which 5% was invalid (1 of 20 trials). As in Gary Dotson's case, in which the analyst misstated the meaning of the ABO blood-typing, even if the underlying method is reliable, the jury can be misled if the analyst exaggerates the evidence. Not only did analysts typically reach invalid conclusions about serology, a reliable method, but of cases with DNA testing, 17% had invalid testimony (3 of 18 trials). All of this invalid testimony had something in common. All of it made the forensic evidence seem like stronger evidence of guilt than it really was.

Invalid and unreliable forensics were so prominent in these cases that they raise more troubling questions about the use of forensics in crimi-

nal cases more generally. How can analysts testify in such a patently unscientific way without any consequences? As judges have long recognized, forensic evidence can play an important role in criminal trials. Juries may give special weight to testimony by forensic scientists. The Supreme Court has cautioned that "[e]xpert evidence can be both powerful and quite misleading because of the difficulty in evaluating it," and judges talk about the "talismanic significance" that jurors may attribute to expert evidence.[15] That is why judges must conduct a "gatekeeping" inquiry, to ask whether a method is reliable and valid, before allowing an expert to take the witness stand. The Supreme Court's decision in *Daubert v. Merrell Dow Pharmaceuticals, Inc.* instructs judges to ask whether an expert's method has a valid and reliable scientific foundation.[16] And that is what judges routinely do in civil cases where money damages are in dispute.

However, there is a reason why so many experts used unreliable methods and gave invalid conclusions in these exonerees' cases, and why such testimony is still allowed. Even unreliable methods—or worse, methods rejected by the scientific community—have long been permitted in criminal courtrooms. *Daubert* had not yet been decided in the 1980s when most of these exonerees' trials took place. Nor have matters changed much since that time. *Daubert* has not been meaningfully applied in criminal cases where life or liberty is at stake. Once judges decide, without looking very carefully, that the methods are acceptable, they do nothing if experts provide exaggerated conclusions on the witness stand. Judges do not examine the validity of the conclusions that forensic analysts reach.[17] Why have judges ignored basic requirements that expert testimony be reliable and valid?[18] Judges assumed that forensic analysts adhered to scientific standards. In the rare event that one crossed the line, then judges assumed that cross-examination by the defense lawyer would illuminate the inaccuracy and help the jury to understand the truth.[19] As one crime lab director conceded, judges "have given us a free ride."[20]

Who Are Forensic Analysts?

In civil cases involving disputes about money, there is a phrase, the "battle of the experts," referring to conflicts between expert witnesses

testifying for opposite sides about scientific or technical matters. There is rarely any battle of the experts in a criminal case. Instead, the presentation of forensic evidence is almost entirely one-sided. Almost all of the analysts testify for the prosecutors. Almost all of them work for the police, at state or local law enforcement crime laboratories.[21] There are over 350 crime laboratories in the United States. Law enforcement agencies operate the vast majority as state or regional laboratories, though some are operated by local governments in large metropolitan areas.

These analysts, therefore, report to law enforcement and see themselves as working for law enforcement. An extreme example from several exonerees' cases was Fred Zain in West Virgina, who asked to be addressed as "Trooper," and who wore a police uniform and gun even though his job was to supervise a crime lab. Studies have suggested forensic analysts may be subtly or sometimes not so subtly biased by their role as analysts working for police and prosecutors.[22] Scientists design experiments that are blind, so that not all of those involved know certain aspects of the experiment, to prevent the influence of bias (conscious or not) on their work. In contrast, forensic analysts do not do their work blind. They receive information about the crimes being investigated that may have nothing to do with the forensic analysis being conducted, such as the fact that a suspect confessed, or the prior criminal record of the suspect. As the U.S. Supreme Court has put it, a forensic scientist may not be "neutral" because an analyst "responding to a request from a law enforcement official may feel pressure—or have an incentive—to alter the evidence in a manner favorable to the prosecution."[23]

Some analysts, such as Joyce Gilchrist of the Oklahoma State Police, have since been the subject of searching audits and investigations, but most have not.[24] Gilchrist testified in four exonerees' trials. She hid evidence, altered reports, and offered conclusions on the stand that hairs were unique and certain to have come from the defendant. U.S. senator Orrin Hatch, commenting on the need to provide new resources for forensic sciences, referred to the Gilchrist scandal, noting, "[W]e are all troubled by allegations that mistakes by a police chemist in Oklahoma helped send innocent people to prison. This isolated situation should not be used unfairly to indict the thousands of forensic scientists who perform their work professionally and responsibly."[25] While I agree that

we should not indict an entire group of people based on the bad acts of one person, the sad truth is that the invalid testimony in DNA exoneration cases did not involve just a few "bad apples."[26] Almost *all* of the analysts who delivered invalid testimony did so in one trial each. These cases included invalid testimony by 81 forensic analysts employed by 54 laboratories, practices, or hospitals from 28 states.[27]

One cannot know what these analysts were thinking at the time, or what their state of mind was, based on the trial materials. Some may have simply been inexperienced or poorly trained. They may have been susceptible to cognitive bias based on their role working for law enforcement and based on the other information that they were given about the cases they worked on. One also wonders how these analysts testified in their other cases. Each one of these analysts could have testified in many cases each year. For example, the next section presents invalid testimony by an analyst in exoneree Neil Miller's case. He said that he had testified "at least a thousand times."

Other analysts were themselves supervisors. Indeed, Gilchrist was a supervisor who ran the Oklahoma City serology unit and established their new DNA lab; prosecutors commended her work and wrote her letters of appreciation. Later audits uncovered problems with missing evidence and mishandling of evidence in the lab, and cited the fact that the office had "no operating, procedure, or safety manuals."[28] One wonders about her training and supervision of others. If analysts lacked adequate training or supervision, then one wonders about their testimony in other cases. One wonders about testimony by their colleagues, with whom they would have been in close contact; most crime laboratories do not employ more than a dozen analysts.

The next sections describe the types of unreliable and invalid forensics that convicted these innocent people, beginning with serology, which was used most often in exonerees' cases, and then the techniques used less frequently.

Serology

Conventional serology, using ABO blood-typing, was the most common type of forensic analysis in these exonerees' trials, and it was present in

116 trials. There was invalid testimony in 58% of the cases involving se-
rology (67 of the 116 trials). Unlike some other disciplines, serology was
grounded in sound science and empirically validated population data—in
other words, it was a reliable method. This makes it all the more disturb-
ing that the analysts in so many of these trials either did not understand
or exaggerated the clear boundaries of the science when they offered
their conclusions. The most common single scientific error made during
all of these trials involved the same straightforward problem of "mask-
ing" that arose in Dotson's trial. Fifty-one trials involved that same basic
error, in which the serology evidence was in fact inconclusive because it
was consistent with the victim, but that was not what the analyst told the
jury.

A telling example is in the case of Neil Miller, who was wrongly con-
victed of a rape. The victim was examined in a hospital after reporting
the crime and a vaginal swab was collected. Such swab stains are mixed;
they may include the victim's fluids and semen from the assailant. Mixed
stains presented a serious challenge. The victim's own genetic markers
could overwhelm or "mask" any markers from semen. It could be impos-
sible to detect the blood type of the assailant.[29]

In Miller's criminal trial, the forensic analyst from the Boston Police
Department testified that the substances he found "had to be deposited
by a Group O individual," and "[a]pproximately forty-five percent of the
population are Group O individuals." Yet the victim was also Type O,
so all of the substances could have come from the victim. The analyst
had no information at all about the rapist. The entire male population
was included and none was excluded.

That testimony was particularly remarkable, because of a coincidence
(or maybe not a coincidence at all): the same analyst testified in the trial of
another DNA exoneree, Marvin Mitchell. The evidence in Mitchell's case
also raised the problem of masking, and there the same analyst *did* explain
the problem to the jury—where doing so assisted the prosecution. He ex-
plained why Mitchell, who had Type A blood, was not excluded by a test
of the vaginal swab consistent with the victim, a Type O. He testified:

> Mr. Mitchell could not be excluded. No secretor could be excluded
> from depositing that stain because the stain may have been too di-

luted or graded [*sic*] to pick up Mr. Mitchell's blood type. So I cannot exclude him, but I cannot say that I found the A blood group type. In other words, again no secretor can be totally excluded from the stain.

Even in Mitchell's case, he did not accurately explain the evidence. He erroneously implied that as a secretor, a person whose blood type can be detected in his body fluids, Mitchell was in a subset of a population that could be the source. He never told the jury that no person, whether a secretor or not, could be excluded.

A range of additional errors were made in serology cases. For example, in several exonerees' cases, analysts wrongly divided frequencies in half. In Perry Mitchell's case, the semen came from a Type O secretor, and O secretors comprise about 35% of the population. The serologist divided the accurate statistic in half and testified that only 17.5% of men could have contributed the semen and thus 82.5% of the relevant population was excluded. However, the population statistics on blood types are identical for both sexes; 35% of men are O secretors and 35% of women are O secretors. There was no valid reason to divide that statistic in half.

Microscopic Hair Comparison

Forensic hair microscopy, the type of hair comparison conducted in Gary Dotson's case, was the second most common type of analysis in these exonerees' trials. Seventy-five exonerees had such testimony. In all but fifteen trials, the testimony was used to show the guilt of the defendant. In twenty-nine cases, the testimony was invalid. Forensic hair microscopy involves the side-by-side comparison under a microscope of head and pubic hairs found at a crime scene with dozens of head and pubic hairs plucked and combed from the victim and suspects. Hair examination has long been important in police investigations, because hairs are so commonly and readily transferred to skin or clothing.

However, the method of forensic hair comparison is unreliable. While we might have some intuitions about what percentage of the population has different hair colors, the microscopic characteristics that analysts

compare cannot be observed with the naked eye. Unlike in serology, where we know how many people have Type A or Type O blood, no scientist has studied how often hairs have particular microscopic characteristics, like smooth versus rough cuticles, or large versus small pigment granules. As the NAS report put it, "[n]o scientifically accepted statistics exist about the frequency with which particular characteristics of hair are distributed in the population."[30] And unlike in serology, where two analysts should not disagree whether tests show that someone has Type A blood, hair analysts can disagree about whether sets of hairs share microscopic characteristics. Proficiency tests of hair examiners dating back to the 1970s have found very high error rates ranging from 28 to 68%.[31]

There is no agreed-upon set of characteristics that analysts look for when they compare hairs. The NAS report explained, "[t]here appear to be no uniform standards on the numbers of features on which hairs must agree before an examiner may declare a 'match.'" Indeed, the reason why analysts look at large sets of hairs, and not just single hairs, is that there is often wide variation in the characteristics of the hairs on a single person's body. The NAS report, using strong language, stated that any effort to link a defendant to hair evidence has "no scientific support."[32]

One of the few judges to intervene and suggest that there is a problem with such unreliable analysis was the federal judge reviewing Ronald Williamson's habeas petition. In 1995, not knowing Williamson was innocent, the judge took an important stand against faulty forensic testimony and ruled that testimony finding hairs to be "consistent" was erroneous, and that hair comparison testimony was too error prone, "scientifically unreliable," and too grounded in the experts' "subjective opinion" to be admissible.[33] That decision postponed his execution and paved the way for the DNA testing that exonerated Williamson in 1999. However, other courts have not followed suit to bar or limit the use of such unreliable hair comparisons.

These exonerees' cases also provide a large body of examples of just how unreliable hair comparison can be in practice. We now know the hairs from these crime scenes were not in fact from these innocent defendants. In quite a few trials, the errors were particularly egregious, because the analyst falsely concluded that not just one hair, but a large set

of hairs, all came from the wrong man. For example, Jimmy Ray Brom-
gard was exonerated by DNA testing after fifteen years in prison in Mon-
tana. The evidence at his trial consisted of an identification by the vic-
tim, who was one of a few eyewitnesses to testify she was not sure of her
identification, and the hair comparison. Arnold Melnikoff, then the di-
rector of the Montana State Crime Laboratory, had compared more than
thirty hairs and found that they all "matched" Bromgard's hairs.[34]

Not only is hair comparison an unreliable method, but analysts also
often reached conclusions that were invalid, in an effort to make their
conclusions sound more powerful. Twenty-nine exonerees had invalid
testimony concerning hair comparison. For example, Melnikoff's testi-
mony was not only grossly in error but also invalid. He testified that be-
cause both Bromgard's pubic and head hairs were a "match" with those
from the crime scene:

> Well there are actually two mutually exclusive events because they
> come from different areas of the body, and their characteristics are
> not necessarily the same. So if you find both head and pubic hair
> there you have one chance in a hundred for the head hair matching a
> particular individual and one chance in a hundred for the pubic
> hair. If you find both it's a multiplying effect, it would be one chance
> in 10,000.

He testified similarly in other cases, such as exoneree Chester Bauer's
case, stating:

> To have them both match, it would be the multiplication of both fac-
> tors so as an approximately using that 1 out of 100, you come out
> with a number like 1 chance in 10,000. Multiply 100 100. It becomes
> a very highly improbable situation . . .[35]

There is no scientific research about what percentage of the population
shares microscopic hair characteristics. The analyst made up probabili-
ties based on his own personal estimates. He then multiplied those con-
cocted probabilities by the types of hairs that were "matched," as if each
represented independent events. The probabilities of two events can

only be multiplied if the events are statistically independent, and the outcome of one event does not influence the outcome of the other. There is no research on the question of statistical independence for head and pubic hair. It may be that a person's head and pubic hairs tend to share microscopic characteristics.

Another example of invalid testimony, where the analyst tried to dress up hair comparison as sound science, is Timothy Durham's case. There the analyst testified that the particular reddish-yellow hue of both his hair and the crime scene hair were only found in "about 5 percent of the population." The analyst did not provide scientific support for that statistic, nor could one do so.[36]

During William Gregory's trial, an analyst from the Kentucky State Police testified that the hairs "more than likely" belonged to Gregory. In part this was based on a finding of what she called "ovoid bodies" in the hairs, which she said were "kind of an unusual characteristic." The analyst explained:

> *A.* I told you, there is no statistics on this. I can tell you this is the first time I have ever had a negroid origin hair that has not had a medulla in it.
>
> *Q.* What percentage of people have ovoid bodies in them?
>
> *A.* This is probably the first time I have ever seen an ovoid body in a human hair. I have seen them in cattle hair before.

The analyst added that while "hairs from brothers and sisters" might share some characteristics, "you wouldn't see that kind of an overlap in two people you would just pick off the street." Finally, although she testified that the hairs had an "unusual" characteristic, she admitted "there is no statistics [*sic*] on this."[37]

In two exonerees' cases, the analyst went even farther and simply concluded that the defendant's hairs were found at the crime scene. In Curtis McCarty's case, Joyce Gilchrist ended her testimony with an explosive statement. Based on examining McCarty's hairs and hairs from the crime scene, she concluded that "he was in fact there."[38] Similarly, in Larry Peterson's case, the analyst found that all of the questioned hairs examined were identified as either "belonging" to the victim or to Peter-

son.[39] No research remotely supports making such strong conclusions based on hair evidence.

Some of the analysts in these exonerees' cases did not reach invalid conclusions. They admitted that there was no research on how many people might also share the same hair characteristics as the defendant. However, in thirty-one cases, although the testimony was valid, the analysts used vague and potentially misleading terminology. They said that the hairs were "consistent" or "similar" or they were a "match." They could not explain what those terms meant.

Most were following the standard practice at the time. At a 1985 symposium convened by the FBI, the community of hair comparison analysts adopted several standards. They discouraged use of the term *match,* because it might imply a comparison as detailed as a fingerprint "match." Instead, they decided that the strongest statement that could be made is that hairs are "consistent" with the defendant's or "could have" come from the defendant. They advised that an examiner should not make "any statements about the probability that a specific hair could have come from someone other than the person to which it was associated."[40]

While the effort to provide standards for hair comparisons was commendable, even a statement that hairs are "consistent" or "similar" is confusing and can be misleading. After all, the jury may think that "consistent" means a perfect "match." The jury may think that the characteristics making the hairs "consistent" are rare. The analyst testifying in the Central Park Jogger case was asked whether thousands or millions of people could share the same hair characteristics. He explained, accurately, that "I really can't give you a number because there hasn't been any research along those lines."[41] The analyst cannot explain how relevant any similarities are, precisely because he cannot say if ten or a thousand or a million other people might also have similar hairs.

It is hard to understand how judges can so routinely allow forensic analysts to give such vague and unreliable testimony. The NAS report emphasized "the problem with using imprecise reporting terminology such as 'associated with,' which is not clearly defined and which can be misunderstood to imply individualization."[42] This problem extends far beyond hair comparisons (which are themselves conducted less often

today, since mitochondrial DNA testing can sometimes be conducted on hair evidence). Analysts conducting fiber comparison, tool mark comparison, bullet comparison, tire tread comparison, and a host of other methods still in wide use all lack any standard terminology and use similarly vague language to characterize conclusions. Since the methods are unreliable and are not grounded in sound scientific research, it is hard for an analyst to say anything about what it actually means to reach a conclusion that, in her opinion, two objects are "similar" or "consistent."

DNA Testing

Prosecutors complain that jurors are exposed to television portrayals in shows like *CSI: Crime Scene Investigation* and they think that forensic analysts are infallible and capable of using technology to solve any crime. Prosecutors say they see a "CSI effect," where jurors will not convict unless there is strong forensic evidence of guilt. Yet in these exonerees' cases, the reverse often occurred, and jurors convicted in spite of strong forensic evidence of innocence. Twenty exonerees had DNA testing at the time of their conviction, and sixteen of them had DNA tests that showed innocence, while four had DNA tests that appeared to show their guilt. In one case, the exoneree pleaded guilty despite DNA test results that excluded him. The other fifteen exonerees had testimony at trial about DNA test results that excluded them, but despite that powerful DNA evidence of innocence, the jurors or—in some cases without juries— the judges still convicted.[43]

Why did they convict these innocent people? Eight of them had confessed; the jurors or judges may have credited the confession over the DNA. They may have credited thinly supported accounts, as in Jeffrey Deskovic's case discussed in Chapter 2, of how the semen could have come from another person. In five cases, defense witnesses presented the DNA results that excluded the defendant. Although in some cases, the DNA analysts worked for state crime laboratories and routinely testified for the prosecution, the prosecutors nevertheless tried to object to the testimony to keep the jury from hearing about the DNA evidence of innocence.

DNA testing is not immune from invalid testimony, and three exoner-ees, Gilbert Alejandro, Chad Heins, and Josiah Sutton, all had invalid prosecution testimony describing DNA test results. Gilbert Alejandro's case involved invalid DNA testimony by the infamous Fred Zain, who testified in Bexar County, Texas, that he had obtained DNA test results inculpating Alejandro. He told the jury "they could only have originated from him."[44] That testimony was invalid. Although he told the jury that "the beauty of DNA testing is that it can give you a hundred percent cer-tainty," that is not the case. DNA testing is based on statistics about the percentage of the population that shares each genetic characteristic that is tested. The analyst must calculate what percentage of the population could be expected to randomly match each characteristic in a genetic profile (those characteristics are particular locations on the DNA strand that are called "loci"; thirteen loci are now typically tested). The num-bers may be very high, because DNA testing focuses on genetic charac-teristics that vary widely. Analysts can sometimes conclude that one per-son in many millions or billions could be expected to randomly have the same DNA profile. However, it is invalid to conclude that the DNA could only have come from the defendant, rather than present the relevant sta-tistic. In Alejandro's case, an internal inquiry concluded that Zain did worse—he had in fact not finished doing the DNA tests in the case. Later tests excluded Alejandro.

Another exoneree trial involving DNA evidence illustrates inaccurate uses of statistics. In the Josiah Sutton case, the victim was raped by two men in the back seat of her car. Semen was present in the vaginal swab and on the stain removed from the back seat where the rape occurred. The Houston Police Department Crime Laboratory analyst presented highly misleading DNA results.[45] The analyst provided invalid testi-mony as Zain did in Alejandro's case, testifying, "No other two persons will have the same DNA except in the case of—of identical twins." The jurors were not told what percentage of the population would be expected to randomly match the particular DNA profile. Instead, the jury was left with the misimpression that the DNA evidence uniquely identified Sutton.

The analyst left something even more important out of her testimony and reports. The lab notes actually showed that Sutton was not the

source of one of the stains; he was excluded.[46] Five years later, new DNA tests conclusively established Sutton's innocence, and he was freed.

Another DNA case, Timothy Durham's, involved a serious laboratory error and an error in the interpretation of the DNA test results.[47] Errors persist, even though DNA testing is now state of the art. These cases provide a vivid reminder that even evidence as reliable as DNA evidence, if presented in an invalid way in the courtroom or misinterpreted in the laboratory, can cause a wrongful conviction.[48] Innocence Project cofounder Peter Neufeld commented that although DNA testing can be "a truth machine," nevertheless "any machine when it gets in the hands of human beings can be manipulated or abused."[49]

Bite Mark Comparison

Bite mark comparisons provide perhaps the most notorious of all the forensic techniques used in these exonerees' cases. In seven cases exonerees were convicted based on bite mark comparisons, and in five of those cases the testimony was invalid. In the other two cases, vague terms like "consistent" and "similar" were used. That should come as no surprise. Forensic odontology, or bite mark comparison, is a discipline with no objective criteria at all. The discipline of "forensic odontology" involves interpretation of lacerations, abrasions, and bruises of questionable origin on decomposing skin. Such bite mark work is "based on the assumption that every person's dentition is unique," though this assumption has not been tested.[50] But even if true, the uniqueness of teeth is far easier to identify when comparing pristine wax molds of teeth made in a dentist's office. Forensic odontolists admit that skin is a "poor impression medium" for bite marks, and particularly in what they euphemistically call a "dynamic" biting situation. It can be hard to say whether a few marks come from a human bite and not some other kind of abrasion related to decomposition or the fatal attack. Experts regularly disagree not only about whether a bite mark matches a defendant, but whether a mark comes from a human bite at all.[51]

For all of those reasons, the NAS report described how "no scientific studies support" the assumption "that bite marks can demonstrate suf-

ficient detail for positive identification." More damning, the report con-
cluded that "[s]ome research is warranted in order to identify the circum-
stances within which the methods of forensic odontology can provide
probative value."[52] Somehow judges appear unconcerned by the scien-
tific disrepute of bite analysis, and "no reported case has rejected bite
mark evidence."[53]

In the cases of Kennedy Brewer, Ray Krone, Willie Jackson, and Rob-
ert Lee Stinson, odontologists testified they were certain that the defen-
dant left the bite marks.[54] Such testimony was erroneous and without
scientific support. Ray Krone's case was particularly troubling, because
he was sentenced to death, and the central evidence at his trial was faulty
bite mark evidence. Two experts concluded that the defendant made the
bite mark on the victim. A forensic odontologist presented the bite mark
evidence at trial, along with a dentist who was just beginning to serve as
the police department's odontologist. The odontologist presented a
highly inflammatory and unusual video with images of the dentist hold-
ing molds of Krone's teeth to the marks on the deceased victim's body.
The odontologist gave the jury probabilities at trial:

> And it turns out that on average a tooth can be in about 150 different
> positions, each one of which is easily recognizable. And if you are
> looking at a tooth in that kind of detail, then you can see that very
> quickly. Just having two teeth, the possibilities of two teeth being in
> the same position, it would be 150 times 150, whatever that is. Maybe
> 1200 or something like that.[55]

Actually 150 times 150 is 22,500, but those numbers made up on the fly
merely led to the ultimate conclusion. The odontologist then told the
jury in no uncertain terms that Krone had left the bite marks:

A. That's as nice a match as we—as we really ever see in a bite mark
case.

Q. By "nice" do you mean accurate?

A. Yes. That was a nonscientific term. This is really an excellent
match, and would be held in high regard by forensic odontolo-
gists. Now there's a wiping action just to show the same thing.

Again, high correlation. I mean, that is—that tooth caused that injury.

On cross-examination he added, "we are talking about a specific individual, and these teeth are unique." The dentist similarly testified, "I say that there is a match. Okay? I'm saying there's a definite match."

Not only was that testimony erroneous and unsupported, but the defense never learned that, before trial, police had initially consulted an FBI odontologist who after examining the bite marks concluded that Krone's teeth were very different from the marks. He said, "It could not have been clearer . . . Ray Krone had two higher teeth than his incisors that would have marked when he bit. Those weren't there in the evidence."[56]

The same odontologist reappeared in Robert Lee Stinson's case in Wisconsin, testifying that there was "no question" that his teeth were a "match" to the bite marks and that the evidence was overwhelming. He agreed with the "very good work-up" of a colleague, who testified the bite marks "would have to have been made by Robert Lee Stinson." Stinson was exonerated by postconviction DNA testing in 2009. A review of the bite mark analysis in the case later criticized the testimony as having no scientific basis and found that the analysts "should have excluded Robert Lee Stinson."[57]

These cases vividly show how, while "there is no quantitative base for bitemark analysis," analysts still offer conclusions that express near certainty.[58] The guidelines of the American Board of Forensic Odontology (ABFO) long permitted its members to render conclusions expressing near certainty—they could conclude that a bite mark matches a criminal defendant to a "reasonable medical certainty" and "high degree of certainty," explaining that the intended connotation is a "virtual certainty; no reasonable or practical possibility that someone else did it."[59] No scientific criteria exist for what observations and analysis could permit an expert to draw such conclusions.

The guidelines added that while experts may not convey "unconditional certainty," they may express "reasonable medical certainty," and noted that it was "acceptable to state that there is 'no doubt in my mind' or 'in my opinion, the suspect is the biter' when such statements are prompted in testimony." The guidelines recommended that experts

should exaggerate their findings in response to questioning. Perhaps in response to criticism, the ABFO revised its guidelines in 2009 to say: "Terms assuring unconditional identification of a perpetrator, or without doubt, are not sanctioned as a final conclusion."[60] However, little has changed. The guidelines still allow invalid conclusions, such as that a person "beyond a reasonable doubt" made a bite or "more likely than not" made a bite. And not only are the guidelines faulty, but the underlying method is still unreliable.

Shoe Print Comparison

One exoneree, Charles Fain, had invalid shoe print testimony at his trial. The shoe print comparison method is unreliable and it is subjective. While it can provide useful evidence if the defendant's shoes do not match prints from the crime scene, it is not clear what it means for the defendant's shoes to look similar to those from the crime scene. After all, shoes are mass-produced objects that can be expected to leave similar prints. At Fain's trial, an FBI agent testified that the make of the shoe print was consistent with Fain's, and "It was possible that this shoe made this impression."[61] Not satisfied with his initial cautious, although vague, conclusion, he added that although it was a common type of boat shoe sole, wear patterns individualized the print:

> *Q.* Now, did you indicate that the wear characteristics are put there by a gait of a particular individual?
> *A.* You would have to have the same characteristic walk as the individual who owned those shoes.

No research suggests that the effect of gait on the sole of a shoe is unique. He added that analysts could go even farther to say that wear patterns on shoes "correspond exactly."

Unfortunately, that is the case. Other analysts might go farther on the recommendation of the Scientific Working Group on Shoeprint and Tire Tread Evidence, which offers the guideline that an examiner can find an "[i]dentification (definite conclusion of identity)."[62] The guideline explains, "This opinion means that the particular shoe or tire made the

impression to the exclusion of all other shoes or tires." Thus, the guidelines that these analysts use allow them to reach invalid conclusions.

Voice Comparison

David Shawn Pope's case involved the use of a totally discredited forensic discipline, voice comparison, an unreliable method that should have disappeared from our courtrooms decades ago. Analysts use a spectrograph, an instrument that generates a visual pattern depicting an audio recording using lines that represent the frequency and intensity of the sound wave over time. The NAS issued a report in 1979 concluding that using voice spectrograph analysis to identify individuals "is not adequately supported by scientific data." The FBI then stopped permitting its agents to testify using such analysis. However, some judges continued to allow such testimony.[63]

In Pope's case, the victim of a 1985 rape in Garland, Texas, received several messages on her answering machine shortly after the crime. The Dallas County police arrested Pope after the victim identified him in a lineup. The State retained an expert, who testified that he found "10–15 similar patterns" shared by a recording of Pope's voice and the recording from the victim's answering machine. He concluded that "the original producer of these was the same individual."[64] The defense also retained an expert, who cited to the NAS report and testified that studies showed that spectrography "is totally unsuitable as a tool for identifying voices with any degree of accuracy." Nevertheless, Pope was convicted and spent fifteen years in prison before DNA testing exonerated him. If judges simply ignore scientific research that utterly discredits a forensic technique, such erroneous convictions should come as no surprise.

Fingerprint Comparison

While twenty exonerees had prosecution testimony concerning fingerprint comparison, in all but one of those cases the analysts testified that the prints excluded the exoneree. Unlike the others, Stephan Cowans was convicted in part due to an erroneous fingerprint identification. A Boston police officer was shot by a civilian, and during his escape, the

assailant picked up a glass mug and drank from it. The police lifted two latent fingerprints from the mug. After Cowans became a suspect, a Boston Police analyst compared Cowans's known ink thumb print to one of the latent prints and declared a match. After Cowans was exonerated by postconviction DNA testing conducted on the glass mug with the fingerprint and on a baseball cap the perpetrator left at the scene, the district attorney asked the Massachusetts State Police to reexamine the thumb print. The State Police declared that Cowans was clearly excluded. The Boston Police then hired an external auditor to conduct an independent investigation. The audit team had four members, all experts in fingerprint comparison. The auditors reached the unanimous conclusion that the analyst had realized at some point prior to trial that Cowans was excluded, but that he concealed that fact and instead told the jury that the print matched Cowans's.[65]

We have seen how many exonerees had testimony concerning forensic methods that were unreliable, like hair and bite comparison testimony. In addition, in 61% of the exonerees' trials, analysts testifying for the prosecution reached conclusions that were invalid and overstated the evidence to make it seem like stronger evidence of guilt than it really was. There was invalid testimony both by analysts using reliable methods like serology and DNA, and by analysts using unreliable methods like hair comparison.

How about the 39% of these cases that did not have invalid forensic testimony—what were those cases like? In more than half of those cases, or thirty-one of the sixty cases, all of the forensic evidence presented was inconclusive (seventeen cases) or tended to show innocence (seventeen cases) or both. Such testimony obviously did not play a significant role in the conviction. In 12% of the cases (19 of 153 cases), analysts did not overstate the evidence by reaching invalid conclusions. Instead, they used terms like "match" or "similar" or "consistent" that were vague and potentially misleading.

Next, I turn to additional problems beyond reliability and validity, including analysts who concealed evidence, made errors in the lab, or failed to test evidence.

Concealing Forensic Evidence

If there were so many problems apparent just from the testimony of analysts on the stand at trial, how good was the work they did in the laboratory? For one, we do not usually know whether analysts concealed forensic evidence that would have shown innocence. In twenty-two cases, the State either failed to disclose to the defense exculpatory data, or analysis, or outright fabrication of evidence.[66] These are only those cases that have come to light. We do not know whether other evidence of innocence has been concealed to this day or was destroyed long ago.

Recall Earl Washington Jr.'s case from Chapter 2; he was a borderline mentally retarded man who had falsely confessed to a brutal murder. His lawyer never brought up forensic evidence at his trial, but one reason was that at least one piece of forensic evidence had been concealed from him. An analyst working for the Virginia Bureau of Forensic Science had tested stains on a central piece of evidence, a blue blanket found on the murdered victim's bed, and found Transferrin CD, a fairly uncommon plasma protein that is most often found in African-Americans. The analyst even ran a second test to double-check the result. The next year, when Earl Washington Jr. was arrested, they tested his blood and found he did not possess the unusual Transferrin CD. The State did not give the defense the report indicating Washington was excluded by that characteristic. Instead, the State gave the defense an "amended" report. Without having done any new tests, the altered report stated that the results of the Transferrin CD testing "were inconclusive."[67] The original lab report came to light decades later when Washington filed a civil rights lawsuit after his exoneration.[68]

In Roy Brown's case, the defense presented an expert who concluded that the bite marks were inconsistent. Among other manifest differences, one mark showed impressions of six teeth from the upper bite. Roy Brown did not have six upper teeth. He had missing teeth—he had only four upper teeth in his mouth. The prosecution never disclosed that the New York State Police had earlier concluded that the marks were clearly inconsistent with Brown's teeth. Instead the prosecutor called to the stand an odontologist who found the bite marks similar to "a reasonable

degree of dental certainty" and, while noting inconsistencies, called them "inconsistent, but explainably so in my opinion."[69]

In Gene Bibbins's case, a Baton Rouge City Police analyst testified at trial that any comparison between Bibbins's fingerprints and a print found on the window at the crime scene was inconclusive, calling the prints "unidentifiable. You can't—they aren't any—there aren't any prints on there that we can use." When asked, "Did you double-check your conclusion with the state crime lab?" and "did they have the same results," she answered, "Yes, Ma'am."[70] That testimony was false. The state crime lab's finding and report had excluded Bibbins. Other cases involved concealment of exculpatory information regarding hair comparison. In William Gregory's case, not only did the analyst testify about the supposedly unusual characteristics in his hair, but she concealed that at least one hair was found not to be consistent with Gregory's hair.[71]

Gross Errors in Analysis

We also do not know how many analysts made errors in the laboratory in exonerees' cases. Only a few exonerees had the evidence in their cases retested or reexamined. Scandals involving faulty work at some of our nation's preeminent crime laboratories have led to investigations, audits, and efforts to provide independent oversight.[72] Some of the gross errors uncovered in these cases suggest a lack of adequate quality control. Most crime laboratories do not routinely conduct blind proficiency testing or independent audits. They chiefly rely upon peer review of casework.

In only a few exonerees' cases was there an audit or an effort to examine whether errors were made in the lab. In some cases, errors happened to surface when the DNA testing was conducted. For example, in several exonerees' cases, the analysts reported that they did not try to do serology testing, because there was no semen in the sample to test. Yet when later examiners reviewed the evidence using the same tool, a simple microscope, they saw abundant semen. In Larry Peterson's case, "[a]lthough the New Jersey State Police Laboratory had reported that there was no semen in the victim's rape kit," the Serological Research Institute, before

conducting postconviction DNA testing, "identified sperm on her oral, vaginal, and anal swabs."[73] Other cases involved faulty test results. In the Ford Heights Four case, a Chicago Police Department analyst reported that Dennis Williams was a Type A secretor, but Edward Blake retested the evidence postconviction and found that he was in fact a nonsecretor.[74]

Failures to Conduct Elimination Testing

The consequence of the faulty forensic analysts in many of these cases was not only that an innocent person was sent to prison, but that real perpetrators remained free. Sometimes the real culprits committed additional crimes. And in at least some of these cases, the forensic analyst tested the very person who was later shown by DNA testing to be the guilty party, and they mistakenly concluded he could *not* have been the culprit.

For example, in Ronald Williamson's case, a supervisor at an Oklahoma State Laboratory testified unequivocally that he had compared the hairs of the State's witness Glen Gore with those at the crime scene. He testified, "I did direct comparison with the unknown hairs," and when asked if any of Gore's hairs were microscopically consistent with the questioned hairs, he testified, "No, sir."[75] Later, during Williamson's appeal, the Tenth Circuit reviewed the lab report, which revealed that the analyst "did not compare Mr. Gore's samples with unidentified hairs."[76] Indeed, the analyst had also testified about a "match" of seventeen hairs, including both scalp and pubic hairs. Later it was determined that none of the hairs belonged to Ronald Williamson, nor to the other individual charged in the case, Dennis Fritz. Instead, Glen Gore was shown by postconviction DNA testing to have been the actual perpetrator.[77]

Similarly, in the Robert Miller case, Joyce Gilchrist excluded a suspect who was later identified by DNA testing and indicted.[78] In the Beatrice Six case, the four suspects who confessed had all been excluded by serology testing, although analysts claimed, without any scientific basis, that some mixture of several of them could account for the evidence. However, early on in the case, police had focused on another man, a

convicted rapist who had been seen near the victim's apartment the night of the murder. He lived in Oklahoma City, so the Beatrice police asked the Oklahoma City crime lab to obtain samples from him and test them. Once again Joyce Gilchrist botched the tests, mistakenly excluding the suspect. Six people would then be wrongly convicted, and years later that original suspect was identified by DNA testing as the actual culprit.[79]

Also troubling, some experts made clear during their trial testimony that they only performed the specific test requested by police or prosecutors, rather than all of the tests that could shed light on the guilt or innocence of the defendant. In several exonerees' cases, DNA tests could have been conducted at the time, but were not. For example, in Marlon Pendleton's case, his lawyer asked to do a DNA testing, but the Chicago Crime Laboratory analyst represented that there was insufficient material present to conduct DNA tests, and the judge denied the motion. Years later an expert tested the evidence, proving innocence and noting that there was enough material to have conducted testing back in 1992 when Pendleton was convicted.[80] In Neil Miller's case, the prosecutor said that serology testing on the sheet from the victim's bed did not match either the victim's or Miller's blood type. However, he explained that the victim's roommate had a boyfriend "who sometimes stayed overnight."[81] The prosecution never had the boyfriend's blood type tested, which could have been easily done before trial. Later postconviction DNA testing revealed that the semen stain was not from the boyfriend but was from the rapist, who was not Neil Miller.[82]

Lawyers and Judges

After hearing about all of this unreliable, invalid, and erroneous forensic analysis, one naturally wonders what role lawyers played in allowing it to happen. Prosecutors elicited the testimony. Did they help the forensic analysts prepare and encourage them before trial to testify in an invalid way? We do not know, but since prosecutors sometimes summarized in their opening statements how they expected the analysts to testify, they were certainly sometimes aware of what that testimony would conclude. In addition, in eighteen exonerees' cases, as in Gary Dotson's case, the

prosecutors themselves exaggerated the science in their closings arguments. The ethical and criminal procedure rules regarding closing statements include "few standards for proper prosecutorial argument," and though prosecutors may not misrepresent facts in evidence, they may make arguments concerning inferences to be drawn from the facts.[83] There may be a fine line between properly drawing inferences and misstating facts. Judges typically order a new trial only in egregious cases in which the conduct "so infected the trial with unfairness as to make the resulting conviction a denial of due process."[84]

Many of these exaggerations may have left the jury with a faulty impression of what the science had actually shown. The Illinois courts granted Steven Linscott a new trial based on a finding of egregious prosecutorial misconduct during closing arguments concerning the forensic evidence. The appellate court damningly held that the prosecutor "simply made up" a claim that was contrary to what the analyst had said and purported to make the serological evidence far more powerful. In affirming, the Illinois Supreme Court noted, "A prosecutor must confine his arguments to the evidence and to 'reasonable inferences' that follow from it . . . We believe that the prosecutor in the instant case contravened this fundamental rule."[85] Despite that sharp rebuke, the court did not recommend any disciplinary action against the prosecutor.

In all of the other cases, judges provided no remedies. In Drew Whitley's case, the analyst, a laboratory manager at the Allegheny County Crime Laboratory, examined a number of very short shaved or cut hair fragments found on a stocking apparently worn by the perpetrator as a mask. The analyst, though finding similarities, admitted the hair fragments were unsuitable for comparison; "Because these hair fragments were so small, I could not make the statement that they were microscopically consistent . . ."[86] During closings, the prosecutor claimed that the analyst had said there was "no doubt those hairs came from Drew Whitley." In fact, she had specifically rejected that conclusion. When the prosecutor had himself asked her, "You can't say it belongs to the defendant," she had answered, "That is correct." Despite telling the jury the opposite of her actual testimony, the prosecutor embellished further:

But it's only when the scientists come in and say, hey, we have a stan-
dard, we know this hair to be of Drew Whitley and they compare it
all microscopically. Exact. No doubt about it. (Pointing.) Him.

The defense attorney asked for a mistrial: "That is absolutely, positively
not the evidence; and that is the most vital part of this whole case; and
for him to say that constitutes prosecutorial misconduct . . . She never
said that [the hairs] came from my client, Your Honor." The judge
equivocated, stating, "I do recall that she answered my question as she
couldn't say exactly who those hairs belonged to . . . I don't know if she
did say it. I don't recall." When the prosecutor claimed he did hear such
a statement, and asserted, "It's the jury's responsibility to remember
things," the judge provided a curative instruction, merely telling the jury
to resolve any discrepancy themselves.[87]

Just as important as the question whether prosecutors encouraged
this testimony is the question why defense lawyers did not effectively
challenge it. Defense lawyers rarely made any objections and they
rarely effectively cross-examined forensic analysts who provided in-
valid science testimony. Indeed, in forty-seven cases, or half of the
ninety-three cases involving invalid forensic testimony, the defense
lawyers failed to ask any questions at all about the areas in which the
analyst testified erroneously. In at least twelve cases, defense counsel
failed to ask for DNA testing that could have proved their client's
innocence.

Defense experts testified in only twenty-one of the exonerees' trials.
Perhaps defense attorneys could not be expected to understand the evi-
dence without access to their own experts. Judges frequently deny the
defense funding for experts in criminal cases, even where the forensics
are central.[88] Nor is it easy to find an expert, since most forensic analysts
work for law enforcement at crime labs and they usually will not testify
for the defense. Curtis McCarty did have a defense expert from the Kan-
sas City crime laboratory, who disagreed with the Oklahoma lab analyst
testifying for the prosecution. The Oklahoma lab then complained to
the Kansas City lab, which barred their analyst from testifying again as a
defense expert.[89] In criminal cases, the presentation of forensic science
testimony is almost always one-sided.

Reforming Forensic Science

Professor Eric Lander, a leading geneticist, commented in 1989 that "forensic science is virtually unregulated—with the paradoxical result that clinical laboratories must meet higher standards to be allowed to diagnose strep throat than forensic labs must meet to put a defendant on death row." Two decades later, little has changed. Forensic testimony involving unreliable methods and invalid conclusions are still routinely allowed in our courts. Nor has DNA technology solved those problems. Although DNA testing is now widely available in sexual assault cases, in the overwhelming majority of criminal cases, labs still use methods like those used in these exonerees' trials.[90]

Over half of the 250 exonerees, or 128, had one or more of the problems discussed in this chapter: invalid, unreliable, concealed, or erroneous forensic analysis.[91] Of the prosecution's forensic analysts testifying at these exonerees' trials, 61% provided invalid testimony. Still more exonerees had analysts use unreliable methods, and sometimes it came to light that analysts concealed forensic evidence or made lab errors. This presents a grim picture of forensics in serious criminal trials.

Although the cases of these exonerees cannot tell us whether unreliable and invalid forensic analysis was common at the time of their trials, there is every reason to think that it was and also that it persists today. One can readily find cases with the same unreliable and invalid forensics.[92] In published opinions, judges discuss invalid testimony just like that in these DNA exonerees' trials.[93] Despite decades of scholarship questioning the reliability of many of these forensic disciplines, judges routinely permit testimony offering unreliable methods and invalid conclusions.

These exonerees' cases also show how we cannot depend on the adversary process to correct forensic errors. Few exonerees' lawyers cross-examined analysts concerning invalid testimony. Few obtained their own experts, since judges routinely deny funding for defense experts. Prosecutors, moreover, sometimes gave the jury false accounts of the forensic evidence. In the few cases in which the defense challenged unreliable and invalid forensic science, judges denied their motions.

Because of these structural deficiencies in our criminal justice system, the responsibility for adopting sound scientific practices has rested with forensic scientists themselves. Yet these wrongful convictions have typically not led to audits or reform. In Gary Dotson's case, for example, there was no official response to the invalid forensic testimony at his trial. There was no audit ordered of the Illinois Crime Laboratory. A series of other Illinois exonerations also involved erroneous or invalid forensic testimony. A decade later, an Illinois Governor's Commission recommended creation of an independent crime laboratory, separate from law enforcement. In 2003, the General Assembly failed to adopt that reform. The laboratory is now peer accredited but still has no independent oversight. As Rob Warden and Locke Bowman of the Center for Wrongful Convictions pointed out, the City of Chicago paid $36 million to settle a lawsuit brought by the Ford Heights Four, who were convicted in part based on invalid forensic testimony and then exonerated by DNA testing. It costs cities a lot of money when crime labs are negligent, and that alone justifies the cost of adopting reforms.[94]

The few audits that have been conducted in the wake of exonerations have uncovered systemic problems. Michael Bromwich led an investigation of the Houston crime lab, sparked by two DNA exonerations, and his team uncovered hundreds of cases involving invalid analysis.[95] An NAS report uncovered invalid testimony by FBI analysts who testified for decades that bullets had "come from the same box" without empirical support.[96] More should be done to examine the methods and conclusions of forensic analysts, because the unscientific testimony in these exonerees' trials may be part of a worrisome problem extending far beyond known wrongful convictions.

There is also reason to be optimistic: the issue of reliability and validity in forensics has finally attracted some attention. The American Bar Association issued reform principles,[97] and judges increasingly scrutinize forensic evidence.[98] Meanwhile, Congress asked the National Academy of Sciences (NAS) to examine ways to improve the quality of forensic science.[99] Indeed, I began my research on the use of forensics in these exonerees' trials after I received a request to look into the matter from the NAS.

In 2009, the NAS recommended sweeping reforms in a landmark report. It found that, apart from DNA testing, no other forensic discipline "has been rigorously shown to have the capacity to consistently, and with a high degree of certainty, demonstrate a connection between evidence and a specific individual or source."[100] That is, no other technique is as reliable. The NAS report described how research must be done to provide a reliable scientific foundation for techniques like hair comparison and bite mark comparison. That research has not been done. The NAS concluded, "The bottom line is simple: In a number of forensic science disciplines, forensic science professionals have yet to establish either the validity of their approach or the accuracy of their conclusions." The NAS called on Congress to fund basic research. The NAS report also advocated the creation of an entity to establish national forensic science standards to regulate reports and testimony. The NAS report cited to wrongful convictions as a reason to adopt reforms, stating that "[n]ew doubts about the accuracy of some forensic science practices have intensified with the growing numbers of exonerations resulting from DNA analysis (and the concomitant realization that guilty parties sometimes walk free)."[101] We will see whether strong federal legislation emerges.

In the meantime, judges should not permit unreliable or invalid testimony in courtrooms. The U.S. Supreme Court recently highlighted these problems, with Justice Antonin Scalia writing in *Melendez-Diaz v. Massachusetts* that the Sixth Amendment right to confront adverse forensic experts is important in part because concerns have been raised about the reliability of forensic methods and validity of forensic testimony.[102] As the Court indicated, however, the right to cross-examine a witness is not enough.[103] Judges should not permit experts to testify about unreliable and unvalidated techniques, and they should not permit experts to exaggerate their conclusions.

Scientists, judges, and lawyers must all address the two problems identified in these exonerees' cases: the lack of reliability of many forensic methods, and the invalid conclusions that analysts may reach.[104] Scientists can use the opportunity to restore our confidence in forensic science by establishing a sound foundation for its presentation in the courtroom. Crime laboratories should establish sound quality controls and indepen-

dent oversight and auditing. Judges should not allow testimony about unreliable methods. Lawyers should scrutinize such testimony, push for independent experts, and object when analysts cross the line on the stand. Unless all sides overhaul the practice of forensic science, the same unreliable techniques and invalid testimony will continue to contribute to wrongful convictions.

Trial by Liar

T HINGS WERE LOOKING BETTER for David Gray. He had been arrested and tried for a rape in Illinois. But at the end of Gray's trial in 1977, the jury could not reach a verdict. It was a hung jury. Why?

The prosecution case had started strong. The victim identified Gray and testified that she was "absolutely positive" that he had attacked her. The culprit had come once before to look at a motorcycle her son was selling. A few days later, the same man returned to look at the motorcycle. This time, he sat on the motorcycle and grabbed the rearview mirror, and then asked to come inside to use the telephone. There, he brutally raped and stabbed the victim thirty-three times with a knife from the kitchen. She said that her attacker had worn very flashy disco-era shoes—she described them as "Shiny plastic wineish colored shoes, with high heels." He also grabbed and ripped the telephone off the wall.[1]

However, Gray had evidence of his innocence. Police dusted the rearview mirror of the motorcycle for fingerprints, and they found two prints—which did not match David Gray or anyone else. The police also dusted the telephone for fingerprints, and the print they found did not match Gray.[2] The forensic analyst found the serology evidence inconclusive, but the hairs from the crime scene did not match Gray or the victim.[3] The victim's neighbor said David Gray looked like someone he

spoke to a few days before the attack. But he did not identify Gray at a photo array, saying that Gray looked familiar, but he could not be sure.[4]

Gray also had a strong alibi. Gray's employer testified that he was at work as a janitor at the Salvation Army all day on the day that the victim had said he had first looked at the motorcycle, as his boss's time sheet confirmed. The day of the crime, he was with a group of relatives throughout the day: his girlfriend, her mother, and his own parents.[5] His girlfriend noted that Gray never wore fancy shoes with high heels, insisting that he had just two pairs of shoes: black work boots and suede dress shoes.[6] Maybe that alibi evidence, combined with the other evidence, explained why the jury remained at an impasse.

After a hung jury, the prosecution can ask for a new trial before a new jury. This is because although double jeopardy would otherwise prevent the state from prosecuting someone twice for the same crime, the first prosecution is considered incomplete due to the hung jury. The prosecutor, the assistant state's attorney for Madison County, Illinois, and one of the county's "best-known prosecutors," decided to pursue a second trial. He immediately formed a plan. He needed a new star witness.

So the prosecutor paid a visit to the jail.[7] He later recalled that he "talked to other prisoners, who were in jail with David Gray, to ascertain if they knew anything." He wanted to find out "if Gray had made any admissions, concerning the rape case."[8] He found a man in the same cell as Gray, who was twenty-two years old and in jail for burglary.[9] Gray's cellmate would become a crucial witness in Gray's retrial.

David Gray faced a new trial in October 1989. There was not only a new star witness, but also a new prosecutor. At Gray's retrial, the new prosecutor was "widely regarded as dean of the area's prosecutors."[10] Why was there a new prosecutor? The prosecutor who handled the first trial had helped to secure the cellmate as a witness against Gray. He likely could not prosecute the case anymore, because he was now a witness, based on his own interviews with the cellmate-turned-jailhouse-informant.

The jailhouse informant came to the trial prepared. He had written several pages of notes from his conversations in the jail cell with David Gray, which he gave to the prosecutors. At trial, the informant testified that Gray had given a detailed description of the general features of this brutal crime: "once inside the house, his friend raped the lady, and he

said that after he raped her, he went into the kitchen, and got a knife out of the drawer, and, after that, he said that he stabbed the lady a lot of times." They then "went through the purse and found the checks," and then left.[11] The presence of a second attacker was contrary to the victim's account. The victim gave the culprit all of her money, and offered him a blank check from her billfold, but he did not take it.[12] However, she was raped in her home and stabbed many times with a kitchen knife.

Then in a very brief portion of his testimony, the jailhouse informant described three key facts, as follows:

> *Q.* Okay, did he say anything about a telephone?
> *A.* Oh, yes. He jerked—one of them jerked the phone off the wall.
> *Q.* Okay, did he tell you what color of the shoes he had on?
> *A.* Wine colored.

Those facts were crucial to the prosecution case. First, the informant said he could confirm the most unusual feature of the victim's description of her attacker: the wine-colored shoes he wore. Second, the attacker had violently ripped the phone off the wall. Third, the informant added a new detail: he said that Gray admitted that he "had some gloves or somethin[g] on his hands." This could explain why no fingerprints matching Gray were found on the telephone.[13]

Next, the informant bolstered the uncertain identification by the victim's neighbor, who had said that Gray merely looked familiar. The informant claimed that Gray told him in jail that he had tried to burglarize the victim's house a few days before, but "he seen a man next door, and he talked to the man next door."[14]

Leaving no stone unturned, the informant finally addressed Gray's alibi. Gray's employer and his parents had all testified about his whereabouts the day of the crime. The informant said Gray bragged that "he could account for everything but one hour, and his folks were gonna take care of that for him."[15] The informant suggested that Gray had admitted to staging his alibi by encouraging his parents to testify falsely.

These striking details could have come from the prosecutor or police, but the informant and the prosecutor denied that any facts were fed. The prosecutor from the first trial, testifying as a witness, explained that the

"[o]nly fact that I told him, prior to him telling me anything, was that it was a rape case." He agreed that the informant's information would have had to come from Gray.[16] Similarly, the informant was asked whether the prosecutor said "anything about the nature of the facts, or anything else?" and he answered, "No, he didn't say nothin." He was then asked, "So, he didn't tell you about the maroon shoes?" He answered, "No, he did not."

We do not know if the informant "was being told what the facts were" by a prosecutor or the police. Other inmates in the jail could have also heard about the evidence at Gray's first trial and passed on the details by word of mouth. Gray's defense attorney argued that the informant spoke to police months after a preliminary hearing, and at that hearing, conducted long before trial, "there was testimony in Court about the shirt and shoes and the telephone, and it was a well known story around here, wasn't it?" The informant denied having heard any of those facts, but he did agree that inmates were generally familiar with things going on at the courthouse. He had incentives to try to locate that information. Because they can obtain substantial leniency by helping prosecutors, informants may engage in aggressive efforts to turn on other inmates.[17]

What did this informant get in exchange for providing the prosecution with so much help? The informant said he received nothing. He explained that he had "more or less" testified out of his sense of duty as a "good citizen."[18] However, he was a repeat jailhouse informant. He was facing three years in prison and had much to gain from helping the State. In his closing statement, the prosecutor minced no words, and called the informant "a bum"—but added that "he's been used in the past, too, and the information that he has provided has been very reliable, in other situations. This is not uncommon, in law enforcement"[19] The prosecutor noted that the informant had every reason to lie, stating: "[I]f he thought it would do him any good at all, he would lie . . . He's a thief, he's a burglar, he's a liar, and not only that, but just a few days before he was talked to, he had been sentenced to three years in the penitentiary, and he was petrified, afraid to go to the penitentiary."[20]

The prosecutor from the first trial who first located the jailhouse informant denied he gave any promises of a deal, at least when they first spoke. For his part, the informant said that when he first spoke to the

prosecutor that he had already heard Gray admit his guilt.[21] The prosecutor stated that maybe a vague understanding had been reached with the informant, but that there was no deal. He testified, "I know there was nothing definite said or offered, but I don't know whether I may have said something like, 'It won't hurt you,' or something like that. I just can't remember."[22] A prosecutor is obligated under the Supreme Court's ruling in *Brady v. Maryland* to tell the defense about evidence that could be used to question the truthfulness of a witness, including promises or deals made with a witness. However, the prosecutor denied that there was a deal with the informant, so he had nothing to disclose to the defense.

Those denials ring false. Although the informant was sentenced to three years, he served only seven months. He testified at Gray's trial that "they told me all I would have to do was six or seven months, whatever they felt was enough time on the burglary."[23] In fact, he was told that he would be let out a few weeks after he testified at the Gray trial.[24] All of these substantial benefits, though, were supposedly provided in gratitude for the help he had provided in other cases, and had nothing to do with his upcoming testimony in the Gray case. He claimed, "They told me that I was getting out, no matter what. The told me that I didn't have to testify" in the Gray case.[25] The judge denied the defense motion to suppress the informant's testimony.[26]

The prosecutor acknowledged that the informant had good reasons to lie. However, he did not agree that the testimony was worthless. To the contrary, he emphasized that the informant provided reliable information in Gray's case. How could the prosecutor know that? He claimed that the informant reported admissions from Gray that only the true attacker could have known. During the closing arguments, the prosecutor argued:

> Number one, he had heard David Gray, talking in the jail, when he was a cellmate with him and bragging about, yeah, he had done it. He referred to the fact, number one, that he ripped the phone off the wall. That's a fact that would have been unknown to any person, other than police officers, members of the State's Attorney's Office, [the defense attorney] or Mr. Gray . . . He had wine shoes, that he was there, at the time of the commission of the offense . . .[27]

The prosecutor also emphasized that these facts were in some respects inconsistent—the victim did not describe a second attacker—thus "[i]f he was being told what the facts were, his story would have been right down the line with the facts, and it wasn't. He was hearing the version of David Gray, and he was not even hearing the accurate facts." Although the State admitted the informant would "say just about anything, to get out of prison,"[28] those allegedly nonpublic facts strengthened their case.

After all, the informant testimony was the only evidence corroborating the victim's identification. Recall how the forensic analysis of the fingerprints, semen stains, and hair either was inconclusive or it did not match David Gray. However, the informant's testimony could explain the lack of fingerprints on the telephone. Gray had strong alibi testimony, but the informant's testimony could explain that away too.

The jailhouse informant's carefully crafted lies may have made the difference between the hung jury at the first trial and the conviction at the second trial. At his second trial, David Gray was sentenced to sixty years in prison. He served twenty years before being exonerated by DNA testing in 1999. As for the informant, when asked about the case years later, he said he no longer remembers David Gray having ever admitted his guilt to him.[29]

Informants and Jailhouse Informants

Informants have never been thought to be particularly reliable sources. At common law, evidence from "persons of infamy" was not allowed at a trial. Use of informants was later defended as a necessary evil. The Supreme Court, quoting Judge Learned Hand, has noted that while "[c]ourts have countenanced the use of informers from time immemorial," it is because "in cases of conspiracy, or in other cases when the crime consists of preparing for another crime, it is usually necessary to rely upon them or upon accomplices because the criminals will almost certainly proceed covertly."[30] In organized crime or drug prosecutions, reliance on informants is pervasive and sometimes necessary to penetrate a closed criminal enterprise by encouraging participants to cooperate or "flip." However, these exonerees were convicted of rapes and murders that were not the work of a criminal organization. Nor were these informant

statements recorded and carefully documented as in a meticulous orga-
nized crime investigation. Most common in these exonerees' trials was
testimony by a different kind of insider—jailhouse informants. Informants
who are already in jail and testify against cellmates have long been con-
sidered notoriously unreliable sources.[31]

When I began looking at the exonerees' cases, I knew that informants
may lie in exchange for a prosecution deal. It would come as no surprise
if that occurred in the exonerees' cases. I found that 21% of the exonerees
(52 of 250 cases) had informant testimony at their trials. Of the 52 that
had informants, 28 were jailhouse informants; in addition, 23 had code-
fendant testimony and 15 had testimony by confidential informants or
cooperating witnesses (some had more than one type). In almost all of the
cases, the informant reported incriminating statements allegedly made
by the defendant.

When I began reading the transcripts of what these informants actually
said at trial, I uncovered a different and more troubling problem. These
informants claimed that the exonerees not only admitted guilt but knew
details about the crime, which the prosecutor or police claimed only the
culprit could have known. Just as exoneree confessions were contami-
nated by disclosure of inside information, so were these informant state-
ments. Unlike in the interrogation setting, these informants came forward
later during an investigation. Often they surfaced close to the time of trial.
They may not have always obtained their information from police, but
they sometimes may have obtained it from prosecutors, or perhaps jail-
house sources.

I was most amazed by how the most aggressive informants delivered
"made to order" statements neatly molded to the litigation strategy of the
State. Their testimony included details designed to undermine the de-
fendant's alibi, address weaknesses in the prosecution's case, or enhance
prosecution evidence. If the fingerprint evidence was inconclusive, the
informant testified that the defendant confessed to wearing gloves. If an
eyewitness could not identify the defendant, the informant testified that
the defendant shielded his face on purpose. These cases suggest the need
for judges to carefully screen testimony by such informants. Few states
require any review of such testimony, nor do they require careful docu-
mentation of contacts with informants. One wonders whether jailhouse

informant testimony in particular should be permitted at all, but such testimony certainly deserves rigorous scrutiny.

Jailhouse Informants in Murder Cases

Prosecutors frequently use informants, and they can be indispensable. In investigations of criminal enterprises, like organized crime groups or drug gangs, the only way to obtain inside information is to secure the cooperation of a person on the inside. As the Ninth Circuit Court of Appeals put it, "Without informants, law enforcement authorities would be unable to penetrate and destroy organized crime syndicates, drug trafficking cartels, bank frauds, telephone solicitation scams, public corruption, terrorist gangs, money launderers, espionage rings, and the like."[32] Police and prosecutors use the cooperation of such witnesses to pursue the "big fish" and to break up close-knit criminal enterprises. More broadly, police depend on the conscientious assistance of community-minded citizens to report crimes they witness or hear about.

The types of cases that these exonerees were convicted of did not involve use of cooperators or informants to infiltrate a criminal enterprise. These cases, typically murder prosecutions, sometimes relied on tips from concerned citizens in the community. However, they also used informants who had more selfish motives. The cases with informants were concentrated in the murder prosecutions: thirty-two were in cases that involved a murder and a rape, nine involved murder, and eleven involved a rape. The cases involving jailhouse informants were even more disproportionately murder cases. The jailhouse informants claimed to have overheard the defendant, whom they had never met prior to being incarcerated together, confess to a crime. Eighteen of the twenty-eight cases involving jailhouse informants involved a murder and a rape, and six involved a murder.

In murder cases, unlike in rape cases, there is often no victim or eyewitness who can identify the perpetrator. A confession becomes all the more critical to solving the case, and if the defendant will not confess during an interrogation, then police may rely on jailhouse informants to secure admissions of guilt. The informant may get a better deal from prosecutors for helping to solve a more serious murder case. As law

professor Samuel Gross explains, "[I]f the witness is lying to get favors unrelated to the crime at issue, he will do much better if it is a big case, which usually means a murder, or better yet, a capital murder."[33]

Just four of the 171 exonerees convicted of rape had jailhouse informants at trial. The four rape cases were all cases in which the jailhouse informant's testimony was used to bolster a victim who had difficulty identifying the defendant. Prosecutors knew that David Gray's case was weak, because they had a hung jury. In Bruce Godschalk's case, one victim was initially uncertain about her identification and the other victim could not identify him at all. In Kenneth Wyniemko's case the attacker had worn a stocking mask, and forensic evidence excluded him. In Wilton Dedge's case, the victim initially described a much larger and taller man.

Though informants provided false inculpatory information in many exonerees' cases, this is not to say that prisoners do not sometimes tell each other the truth when they talk about their cases. Indeed, Clark McMillan found evidence of his innocence in jail. When he was first arrested, he spoke to the man in the next cell, David Boyd. McMillan told him what he had been charged with, and Boyd responded that he should not worry, because he (Boyd) "was good for that crime." When McMillan tried to introduce that helpful jailhouse testimony during habeas proceedings, he had no luck. Twenty-three years later, DNA testing excluded McMillan and matched Boyd.[34]

Jailhouse informant testimony, as the Gray case illustrates, is chiefly regulated in two ways. First, under the U.S. Supreme Court's decision in *Brady v. Maryland,* the prosecution must disclose to the defense information about any promises or deals that could be used to challenge the informant's truthfulness. As the Supreme Court held in one of its early due process decisions, *Napue v. Illinois,* the prosecution cannot sit by idly while a cooperating witness falsely denies the existence of a promise by the prosecution to provide leniency in exchange for that testimony. The prosecutor must correct the record if the informant lies about a deal.[35]

Second, the Supreme Court in *Massiah v. United States* held that the defendant has a right to have a lawyer present during questioning by an informant that is already reporting to the police. That is, if there was a

formal deal with the prosecution and the informant was planted to get information, the defendant has a right to counsel.[36] With a lawyer present, an inmate will be much less likely to talk to an informant. The Supreme Court carved an exception to the *Massiah* rule: even if the State does unconstitutionally plant an informant in an inmate's cell, the informant can still be put on the stand to challenge the truthfulness of the defendant's testimony.[37] Regardless, police and prosecutors have an incentive to keep deals with informants highly informal. The deals are rarely in writing, they are often not negotiated with lawyers present, they can be subject to change, and they are typically conditioned on continuing cooperation.[38]

The Supreme Court has done little to ensure the reliability of informant testimony, making clear that it leaves "the veracity of a witness to be tested by cross-examination."[39] But cross-examination did not uncover the contamination of these informants' statements, just as cross-examination did not typically bring to light the contamination of confessions, the effect of suggestion on eyewitness memory, or the invalid presentation of forensics in these exonerees' trials.

In the rest of the chapter, I turn to what these informants said. I first discuss the jailhouse informants, then the testimony of codefendants, and finally, testimony by confidential informants or cooperating witnesses.

Deals with Jailhouse Informants

Jailhouse informants were the most common type of informant in these exonerees' trials. These jailhouse informants invariably testified that they had no contact with law enforcement until after they heard the incriminating information. Only two of the twenty-eight jailhouse informants admitted they made deals with the State. The informant in John Kogut's trial admitted that police promised him "if you tell us, you know, what you know, we'll see if we can get you a shorter term in jail."[40] In Wyniemko's trial, the informant admitted receiving a plea deal in exchange for his testimony, through which he would spend one year in county jail rather than the fifteen that he had faced.[41]

The other jailhouse informants all denied that there was any explicit promise of a benefit in exchange for their testimony—though many

acknowledged they did obtain a more favorable outcome in their case for one reason or another. In Dennis Williams's trial, the informant testified: "There was no promises."[42] In Drew Whitley's trial, the jailhouse informant was asked, "Has anybody promised you anything in exchange for your testimony, sir? A. No, sir."[43] In some cases the informants denied a deal, but admitted that they hoped to obtain a benefit from testifying. In Wilton Dedge's case, the informant denied any deal was struck, but was asked, "Now, you are hoping for some consideration from your testimony in this case, are you not?" and responded, "I hope it will look favorably to the Parole Board, yes sir."[44]

In some cases, like David Gray's, the State's denials that a benefit had been promised ring hollow. At Calvin Washington's trial, the State introduced testimony by a litany of cooperating witnesses, including two jailhouse informants. Washington's lawyer called them "a parade of liars." He noted that since the forensic evidence excluded Washington, all of the State's evidence came from "Rapists. Burglars. Thieves. Habitual criminals. People who escape from custody. Right down the line. And they are putting you on the spot by asking you to subject a man to the possibility of death based on this."[45] One member of that parade met Washington at the McLennan County Jail. That informant was facing charges of theft and unlawfully carrying a weapon. He claimed he received no deal of any kind. In fact, he said that the officer "told me he would get back with me, and he never did get back with me."[46] The informant then testified: "Hasn't nobody made me no offers." Yet it emerged during cross-examination that his two felony convictions were "dropped . . . down to a misdemeanor." Though he could have received life in prison, he instead got "nothing" more than the four months he had already served. He explained, implausibly, that "I got nothing because they had no evidence."[47]

Similarly, in Steven Barnes's case, the informant received eight months for several felonies after reporting his cellmate's statement. Barnes's defense lawyer incredulously argued to the jury that though the informant denied any deal, "that's the first time in my life I have ever heard of a guy with a record that long that didn't go to State prison."[48]

Some of the informant's denials may have been accurate. Prosecutors would typically not make any firm promises before trial for two reasons:

first, because any such promises would have to be disclosed to the defense and would further undermine the credibility of the informant; and second, because prosecutors may not want to make any firm promises until they actually hear the testimony and receive the cooperation. Prosecutors can get around the rule that they must disclose deals to the defense by leaving any deal vague and waiting to provide leniency until after the trial is over.[49]

We do not know how many more of these informants did later obtain leniency. There may be no written record of a deal, journalists may not have investigated the matter after the exoneration, and one cannot usually tell from looking at judicial records, because prosecutors in their discretion may have informally dropped charges or pursued more lenient charges or a shorter sentence. In some cases, years later, the exonerees' lawyers managed to uncover the existence of a deal. For example, the State's most important new witness at Rolando Cruz's second trial was a jailhouse informant. The informant testified that Cruz had described the victim's gruesome murder in detail, and that when he read an article in the "Chicago Lawyer" in which Cruz asserted his innocence, he became angry and contacted the prosecutor. He denied receiving any promises of leniency from the prosecutor. However, he received a resentencing after his testimony in the Cruz case. The prosecutor testified on behalf of the informant at his resentencing hearing by describing how he "voluntarily provided testimony in the trial of Rolando Cruz" but admitting that the informant was "a calculating individual" who wanted to be sure before testifying in the Cruz trial that the prosecutor would help him at his resentencing hearing. The Illinois Supreme Court concluded in its opinion reversing Cruz's conviction that the informant had falsely denied having a deal with prosecutors.[50]

Similarly, in Ronald Williamson's case, a jailhouse informant was a crucial witness, who described how Williamson confessed in detail to a brutal rape and murder. She was also an informant in another murder case, and denied receiving any leniency or compensation in both trials; however, she had most of her sentences for three felony convictions suspended and never paid her fines. The federal district judge found that Williamson's lawyer was ineffective for failing to attack her credibility based on that evidence of her motivation for testifying.[51]

Rather than promise leniency, in some of these cases, prosecutors may have used sticks and not carrots. That is, informants may have feared that should they not cooperate they would face harsher treatment. This would particularly be true if the informant had a possible connection to the crime. In Calvin Washington's case, another informant later explained in a subsequent statement to a defense investigator that the police "kept pressuring me" by saying "that I might be charged with Capital Murder. I don't need no capital murder charge—I don't even know when she died or whatever."[52] He added that he was worried "since I'm on parole you know."[53]

Jailhouse informants also denied that they were planted in the same cell or vicinity in order to elicit incriminating information. For example, in Charles Fain's case, a man was in the same jail cell in the Canyon County jail for "four or five days."[54] He later asked the jailer to be moved to another cell because Fain's talk of "sexual conduct with little children" "just made me sick at my stomach." It would violate Fain's right to a lawyer for police to place the informant in that jail cell to interrogate Fain. Yet this informant admitted that an officer spoke to him beforehand and said, "they had a reason" for his being placed in the cell. The judge looked into the matter, and asked the jailer specifically whether he had been instructed "to plant him in there as a witness," and the jailer said no.[55] However, the police officer testified that the informant had offered to gather information, but the officer refused, saying it would be illegally obtained, since the defendant was represented by a lawyer.[56] Despite the evidence that the informant was put in the cell after offering to obtain information about the case, the judge ultimately concluded that "there is no evidence to establish that this was a covert or subterfuge on the part of the state to plant [the informant] in this cell."[57]

Specific Facts

Even when jailhouse informants deny they are testifying to get a deal, it can be obvious to jurors that they are not the most trustworthy or altruistic witnesses. What made the testimony of these informants powerful was that they described how these exonerees supposedly told them specific details that only the true perpetrator could have known. All but two

of these twenty-eight jailhouse informant statements included such specific details concerning the crime. The two cases of Roy Brown and Steven Barnes involved bare admissions that they committed a murder, but no further details. In Barnes's case, for example, the informant claimed to have made a reference to a girl, and said that Barnes replied, "You mean the one I killed," but he then corrected himself to say, "I mean the one I am accused of killing."[58]

The other jailhouse informants reported that the exoneree confessed to details concerning the crime. Bruce Godschalk had falsely confessed to police, and at his trial, the State also claimed that he had confessed to a fellow inmate. The informant testified, "And one time he was mentioning about how he didn't finish the job in the one, you know, and this is a little embarrassing, and that the lady said . . . She was saying something like, 'My boyfriend was coming home.' And he said—he told me that he got scared and left."[59] One of the victims had described just such an encounter.

Others described the murder weapon. During Ronald Williamson's trial, the jailhouse informant described Williamson as admitting how the victim was killed: "He was telling—I guess in the bullpen, the guys back there—that he—he said he shoved a coke bottle up her ass and her panties down her throat."

Williamson interrupted: "You are lying. I ain't never said nothing like that in my life. I did not kill this girl, and I call you a liar." Williamson's lawyer told him: "Be still."

The district attorney, meanwhile, needed to correct the record. It was not a coke bottle, but a ketchup bottle that was found at the crime scene. The prosecutor asked, "let me ask you about the details you were just relating. As far as your memory goes, are you sure about the objects that he stated he used. You said coke bottle." The informant answered, "He said a coke bottle or catsup bottle or bottle . . ."[60] Williamson continued to interrupt, calling her a liar, and eventually the judge called a recess so he could calm down.

The entire time that the jailhouse informant was testifying during John Restivo's trial, Restivo was "muttering under his breath," and "calling this person a liar and shaking his head from side to side."[61] The judge asked counsel to tell him to stop doing so; Restivo commented that he

was sorry, but "When I hear somebody lying through their teeth . . ."[62] The informant then described Restivo's confession, that along with two accomplices, he had raped the victim, his accomplice "strangled her after with a scarf," and that they then "dumped the girl by some railroad tracks."[63] As in the other cases, each of those details was corroborated by crime scene evidence.

Several informants specifically denied having learned of the facts from anyone other than the defendant. In Drew Whitley's case, the informant claimed, "He said the girl was shot in the back" and "he said he took the gun and threw it over a hillside near McDonald's into Kennywood Park." The informant was asked, "At that time had you any other information concerning a killing at McDonald's?" and he answered, "Not until he came to talk to me."[64]

In Charles Fain's case, the prosecution introduced testimony by two informants. The first claimed he did not even know what Fain had been arrested for.[65] He then testified that Fain confessed to picking up the victim and was "molesting her," and "when she got away, she tripped and fell and she hit her head, her forehead. He said, 'A knot come up on her about the size of a golf ball.'" This injury was consistent with the autopsy. He went on to say, "He wasn't satisfied and finished with what he was doing, so he went back and got his satisfaction. Then he took her and put her in the ditch. He carried her to a ditch and held her head under water." The victim was indeed found drowned in a ditch. He testified that Fain even drew maps of where the murder took place, that Fain "wadded them up and was going to flush them down the toilet," but he rescued the maps, and "picked them up out of the toilet and put them in my pants so he couldn't see them."[66] A second informant similarly testified that Fain said "he had caught the girl, and had placed her in some water . . . and then he had left . . ."[67]

During closing arguments, the prosecutor emphasized that the first informant testified that Fain told him about a "golf ball sized lump that came on her head," and that he held her head under water, and noted, "I believe you have seen the photographs of that bruise on her forehead; and that he drowned her in the water."[68] The prosecutor added that the jury should especially credit the fact that there were two informants: "[W]e have the statements made by . . . Not one, but two persons, and

I believe the old rule is that in the mouth of two or three witnesses shall everything be established. This defendant committed those crimes."

Similarly, in Chad Heins's case, two jailhouse informants testified for the State. The prosecutor emphasized the specific and nonpublic facts that the informants relayed—"What rings true . . . other than the fact they didn't get any deal or compensation from testifying? The words they claimed he used. Remember . . . neither one of them knew anything about the facts of this defendant's case."[69]

How did this happen, that so many jailhouse informants could report false admissions that contained such detailed crime scene facts? It is hard to uncover what actually transpired. Obviously, unlike other witnesses, such as eyewitnesses, jailhouse informants can only come forward after a person is arrested. As a result, they often speak to police after the investigation is well under way, sometimes close to the time of trial or even, as in Gray's case, after a first trial. In Miguel Roman's case, the jailhouse informant came forward just as the trial was coming to a close; the prosecutor moved to reopen the case to allow the informant's testimony. The later in the case, the more facts about the case have been uncovered and made public to more people, and the informant has more sources for that information. During an interrogation of a suspect, police may know what the crime scene looked like and they may have some initial forensic reports, perhaps eyewitness accounts. But by the time police speak to a jailhouse informant, they may know much more about the case. In addition, prosecutors, and not just police, may talk to the informant. One troubling scenario is that the crime details that these informants repeated could have come from police or prosecutors.

Second, the exonerees may have themselves been the unwitting source. While these innocent people would likely not have falsely admitted their guilt to a jailhouse informant, they may have known a fair amount about their own case by the time they were in jail. They may have talked to their cellmates about their case and why they hoped to win at trial. They may have explained why they were innocent and why the police were wrong to suspect them. A clever informant could turn that information around to fabricate a story that the defendant had admitted his guilt.

There is a third possibility. The informants may have learned about a case from public sources or through a jailhouse network. In cases like

David Gray's, where there had already been a hearing or a trial, word may have gotten around about what evidence was presented in the courtroom. In Calvin Washington's case, for example, a witness told the defense that "the 'jailhouse rumors' were that a certain State's investigator, who testified at the trial, could help an inmate 'get out of jail quick' and that an inmate should see him 'before you see your lawyer.'"[70]

Bolstering the State's Case

The most enterprising jailhouse informants did not just know specific facts about the crime. They knew the facts that the prosecutors had been unable to prove any other way. Their statements were neatly tailored to fit the prosecution strategy at trial. Their testimony bolstered shaky prosecution witnesses, or undermined defense alibi witnesses, or explained weaknesses in the forensic evidence. The jailhouse informant became a sort of jack-of-all-trades, able to plug all of the holes in the State's case.

Bruce Godschalk's trial provides a case in point. He was tried for the rape of two separate victims. Neither was wearing her glasses during the rape. One saw the attacker only in a small mirror and had trouble identifying him from a photo array, although at trial she testified she was "absolutely" certain Godschalk was the rapist. Nor did that victim describe any facial hair—but Godschalk wore a mustache. A second victim could not identify Godschalk at all.[71] The informant testified that Godschalk had not only confessed to him, but he bragged about how he had made sure that the victims would not be able to identify him, saying that "they couldn't identify him and stuff, because they didn't get a good look at him, only in a mirror, right?"[72]

Wilton Dedge was convicted of rape in Florida, but then his conviction was reversed on appeal and he was granted a new trial. Dedge had a powerful alibi. Eight coworkers at a garage had testified that he had been repairing auto transmissions the entire day. His workplace was a long drive from the town where the victim was raped.

Nor was the case against Dedge very strong. The appeals court noted that the victim's identification of him was "equivocal." She described her attacker as big and muscular, about six feet tall and 180–200 pounds. That was a far cry from how Dedge looked. He was five foot five inches

and 125 pounds. The State's other witness was a dog, named "Harass II." That police dog supposedly identified Dedge's scent in a "dog scent lineup," in which the dog was given the victim's sheets from the crime scene.[73] We should not blame the dog—the police department dog handler later had his work in cases around the country discredited. Indeed, the same dog handler also produced a false dog scent identification in exoneree William Dillon's case.[74]

The prosecutors located a new witness for the second trial: a jailhouse informant who had met Dedge only once, during a three-hour ride in a prison transport van. The informant claimed that in that short time, Dedge had confessed in great detail. Dedge admitted to raping a woman in another town, "off a dirt road off U.S. 1," which accurately described where the victim lived. Yet Dedge's coworkers said he was at work all day. How could Dedge reach that far-off small town in the middle of the day?

The informant described an implausible high-speed adventure. He claimed that Dedge described fooling his alibi witnesses into thinking he was at work, but that in fact he had slipped away. "So when they testified about him being there at work, as far as they knew they were telling the truth because when he did return back to work, he didn't—no one seen him come back in, either, he just eased his way back into the thick, and it was about quitting time, anyhow, the end of the day." That did not explain how he could have made his way to a far-away town and back without them noticing. But he claimed that Dedge "he had the trip . . . down pat where he could make it in fifteen minutes."

How could that be done? Dedge had a Kawasaki motorcycle. And according to the informant, "he cracked the throttle all the way open there and he said in a very short time the cable started bounding real bad, and the cable snapped. And he said he knew he was going way over a hundred and sixty miles an hour at that time."[75] The prosecutor then called as an expert witness to corroborate the account, a motorcycle racer; he explained that at speeds of over 126 mph, an odometer can break off.[76]

The informant claimed that Dedge said he had intentionally gotten in a fight that evening to establish an alibi; "he had danced with some biker's old lady, and the biker got mad, they got into a fight which caused a ruckus, and the police came and made a police report, and that further established his alibi."[77]

The informant also undermined the defense attempt to challenge the victim's identification; she had initially described a large man having attacked her, where Dedge was not large. "[H]e said, that shows you what a dizzy bitch that she is, that she can't even get her details right. He said— that's when he said, look at me, because I'm only five foot six and a hundred and thirty-five pounds."[78] Adding a final note, painting the defendant as confident that his various ruses would succeed, he claimed that Dedge bragged "he was confident he would win his new trial."[79]

The prosecutor emphasized in the opening arguments that the informant had uncovered how Dedge "had basically pulled one over on his alibi witnesses," because "he had a Kawasaki 900, that he did a hundred and sixty getting back, that he broke the speedometer, that it actually sheared off and quit operating because he was going so fast."[80] Indeed, almost every prosecution argument was bolstered in one way or another by the informant's remarkable testimony.

Of course, it all turned out to be an elaborate lie. After years of fighting to obtain DNA testing, and after multiple DNA tests that all proved his innocence, Wilton Dedge was exonerated by DNA testing in 2004, after serving twenty-two years in prison.

As for the informant, he had been facing murder charges, but had also testified in two codefendants' cases and in an unrelated murder case. He pleaded guilty and had 120 years taken off his sentences for testifying against Dedge and the other inmates.[81] The informant said at Dedge's trial that he had come forward not because he expected any deal, but because he was so upset by violence against women. But it emerged after Dedge's exoneration that the informant may have been no stranger to such violence. He had been charged with raping his stepdaughter, before Dedge's trial. The existence of that child rape case had never been disclosed to Dedge's lawyers, and it lay dormant for thirty years. The informant was prosecuted only after Dedge was exonerated and the stepdaughter came forward again. In 2004, the informant received life in prison for the child rape.[82]

Similarly, in Nicholas Yarris's case, the jailhouse informant claimed to have heard a series of details that helped the State with their entire case. The informant testified that Yarris told him, "If I had the chance again, I never would have killed the girl" but offered no details concern-

ing the murder itself. However, the informant instead reported details that strongly corroborated the testimony of an eyewitness, the victim's coworker.[83]

That victim's coworker had testified that she worked at the Tri-State Mall with the victim. She testified she had seen Yarris seven or eight times before the victim's death, and that he had worn "dirty jeans."[84] The day of the murder she did not see Yarris. She said that Yarris saw her a few days after the murder and said, "I heard she was raped," a detail which the police said had not been made public. (Recall from Chapter 2 that Yarris also reportedly confessed falsely to the police and offered that same detail.) However, at the preliminary hearing the eyewitness was not sure whether Yarris was the man she had seen.

The informant testified that Yarris told him "that he was at the mall a couple of times and there was a girl there that seen him at least twenty-five times and she wouldn't be able to identify him, and he don't see how they could place him at the mall."[85] The district attorney argued that Yarris's admissions in jail must have been accurate, since those details could not have been known by anyone but Yarris. He argued, "Where does that come from? Is that in any of the newspaper reports?"[86]

Yarris had several alibi witnesses at trial, including a neighborhood grocery store owner and his family. The informant also implied that Yarris was asking alibi witnesses to commit perjury for him. And "he asked me, he says, if one of my alibi witnesses are caught lying, he says, could they be convicted of perjury."[87]

The informant also addressed the forensics. The serology did not conclusively link Yarris to the crime. Yarris was Type B, and any Type B or Type AB could be the source, including approximately 13% of males. The informant testified that Yarris admitted that the Type B material did in fact come from him.[88]

In several other cases the informants enhanced the forensic evidence. For example, recall how in David Gray's case the informant explained the lack of fingerprints on the victim's telephone by claiming Gray confessed to wearing gloves. In Kenneth Wyniemko's case, the informant explained that he had admitted that he "got rid of everything" and had worn latex gloves, which was used to explain how the forensic evidence had excluded Wyniemko. Similarly, in Charles Fain's case, the informant addressed the

State's lack of forensic evidence by testifying that "Mr. Fain had stated that the detectives were going about his case all wrong, and that he had cleaned his car out numerous times, and he cleaned it out so good that they would not be able to detect anything in his automobile." The prosecutor emphasized in closing arguments how the informant described Fain's car cleaning, and how "this was quite a joke with him, because he had cleaned his car out so many times that the detectives could not get one piece of evidence on him."[89]

Stated Motives for Testifying

Some of these informants were repeat informants. The informant in David Gray's case, who was well known to the prosecutors, is one example. In Wilton Dedge's case, the informant had also testified in several other cases. On appeal, Dennis Halstead asked for a new trial, arguing that his right to counsel was violated since the informant who testified against him was already working for the police; the court rejected his appeal, ruling "the mere fact that the informer in this case had previously acted as a police informant does not establish that he was presently acting as an agent of the police."[90]

Informants rarely admitted that they were testifying because they hoped for some gain. Instead, these informants often gave high-minded motives for testifying that belied their likely motives. Some informants claimed they were testifying as public-minded citizens. The informant in Yarris's case clearly could benefit from testifying, as he spoke to prosecutors before his sentencing for a crime that might particularly trouble prosecutors: the burglary of a prosecutor's home (his sentencing was then postponed until after Yarris's trial). Yet he said, "I did it because it could have been my wife or children, okay?"[91] In Charles Fain's case, the informant stated he was offered no promises of leniency, or benefits of any kind, explaining, "The reason this was done, and the reason I done it, is because I have two nine-year-old girls of my own, sir."[92] In Calvin Washington's case, an informant claimed he came forward on his own, after talking with Washington during Bible study about "repenting" and "and being saved,"[93] and he added he "came to the State because I have a wife, I have a mother, and I have a sister."[94] In John Restivo's case, the infor-

mant testified that he was not a "snitch" but was "doing what I feel is right."[95]

Some informants described personal motives for testifying against the defendant, aside from leniency from the State. The informant in Dennis Williams's case noted that he believed that the defendants were involved with an assault on the informant's wife.[96]

In Dennis Fritz's case, the informant emphasized the dangers that an informant faced to show what personal risk he was taking because he supposedly wanted to do the right thing. He said "you'll be labeled as a snitch, and they'll give you a hard time. And most of the time, they try to make punks out of you down there . . . They try to turn you into a homosexual and try to rape you or something just because you testified for the State." He told the jury that he kept a pencil in his sock, fearing he would be attacked in his sleep.[97]

These jailhouse informants, as unsavory as they may have appeared to a jury, and as transparent as their motives to testify may have been, nevertheless may have been quite effective witnesses, because they could offer admissions that seemed to be so convincingly corroborated by the crime scene evidence—and in some cases, that carefully bolstered all of the weak points in the prosecution case. I turn next to codefendant testimony, and then to other confidential informants and cooperating witnesses who also testified that exonerees had made incriminating statements to them.

Codefendants

Codefendants, charged with helping to commit the same crime, may be offered a deal to cooperate with prosecutors, testify against their accomplices, and receive a more favorable sentence. Of the fifty-two exonerees that had informant testimony, twenty-three had codefendant testimony.

In three trials, the codefendants knew quite a bit about the crime and could easily relay information about how it was committed—because they were the actual perpetrators, and were later implicated by postconviction DNA testing. In each of those cases, the codefendant was in fact guilty but successfully shifted some of the blame to an innocent man. In Bruce Nelson's case, the actual perpetrator, Terrence Moore, had confessed but

also told the police that Nelson was the one who initiated the rape and who committed the murder.[98] In Dana Holland's case, the perpetrator was his uncle, who was tried with him and found not guilty by the judge.[99] In Arthur Mumphrey's case, a codefendant who confessed and testified against Mumphrey in exchange for a reduced sentence later had his guilt confirmed by postconviction DNA testing along with Mumphrey's brother Charles (who had confessed to police yet was inexplicably not prosecuted).[100]

In all of the remaining codefendant cases, the codefendants were themselves also innocent. As mentioned in Chapter 2, seventeen exonerees confessed and testified against codefendants, who were subsequently exonerated by DNA testing.[101] Several of those high-profile cases were discussed in Chapter 2, for example the Central Park Jogger case, in which five youths variously implicated each other after lengthy interrogations and were later exonerated by postconviction DNA testing.

In the Ford Heights Four case, Paula Gray had testified that she committed a brutal double murder along with four others: Kenneth Adams, Willie Rainge, Verneal Jimerson, and Dennis Williams. A court granted Jimerson a new trial ten years later, when his lawyers uncovered that Paula Gray testified falsely when she said she received no leniency from prosecutors. While she was a frightened, mentally retarded youth who had also falsely confessed, the prosecutors had the obligation to set the record straight at trial. Indeed, the State eventually conceded that it should have disclosed the existence of a deal; "the jury did not know that the People had agreed to drop the murder charges against Paula if she testified against defendant, Williams and Rainge." In the case of Jimerson, Gray's testimony "was the *only* evidence to link the defendant to these crimes."[102] Verneal Jimerson is the only exoneree to have had a conviction reversed based on a claim related to codefendant testimony.

After his new trial was granted, DNA testing exonerated Gray, Jimerson, and the other members of the Ford Heights Four. The DNA tests also implicated the real killers, who had been located by three Northwestern University college students working with journalism professor David Protess. They had found reliable witnesses who did know who the real murderers were. One witness had even told the police just days after the crime that he had seen the real murderers commit the crime, and he gave a detailed statement, but the police never followed up.[103]

Cooperating Witnesses

In fifteen trials, there was testimony by cooperating witnesses who told police they heard the exoneree admit guilt. These were not all concerned Good Samaritans in the community. Although these witnesses were not in jail, some hoped to obtain benefits from law enforcement not unlike the jailhouse informants. Some were potential suspects and may have sought to cooperate to avoid being prosecuted. Some sought reward money. Most described the exonerees having confessed in detail to the crime.

One of those witnesses was the actual perpetrator, whom DNA testing later implicated as the murderer. At a preliminary hearing for both Dennis Fritz and Ronald Williamson, who faced the death penalty for a brutal murder in Oklahoma, the actual perpetrator, Glen Gore, testified and said that he had seen Williamson dancing with the victim at a bar where she was last seen the night of her murder. He described how Williamson had supposedly "kept asking her to dance with him, and she didn't want to dance with him." Gore described the victim looking over her shoulder while dancing with Williamson, tapping Gore, saying "save me," and asking for a dance. Gore's account of the evening ended with him dancing with the victim—whom he had murdered.[104]

The other witnesses and informants had no way of knowing what happened at the crime scenes, but the level of specificity in many of their statements suggests that police may have contaminated the investigation. For example, Kenneth Waters supposedly told two ex-girlfriends a series of details, including that the victim was murdered by a stabbing, that she was elderly and German, and that money and jewelry were taken. One of those ex-girlfriends had allegedly been told that she would be charged as an accessory and would have her children taken away from her if she did not incriminate Waters.[105] William Dillon's ex-girlfriend also testified against him, but she recanted weeks after the trial, stating she had testified falsely because she was threatened with twenty-five years in prison and also disclosing that she had sex with the lead police investigator the night he first interviewed her about the case.[106]

In Roy Criner's case, three people told police they heard him admit to using a screwdriver to threaten a hitchhiker into performing oral sex on

him. These accounts were inconsistent and none resembled the details of the actual murder. Further, one of the three, Criner's boss, testified at trial about this hitchhiker story. However, he told journalists years later that both he and his wife had made clear to the police that Criner was at work stacking logs when the crime occurred. It was "physically impossible" for Criner to have committed the crime. He was never asked about this at trial, and recalled that the police "only wrote down what we said that was bad for Roy."[107]

Thus, although it is often crucial that cooperating witnesses in the community come forward to help police solve crimes, police can also exercise undue pressure over them, and in some cases, police may have disclosed crime scene facts to them.

Reforming the Use of Jailhouse Informants

These exonerees' trials suggest that we should not place undue faith in the process of a criminal trial to uncover informant lies.[108] To prevent wrongful convictions based on false informant testimony, the Supreme Court has relied on "established safeguards of the Anglo-American legal system [that] leave the veracity of a witness to be tested by cross-examination, and the credibility of his testimony to be determined by a properly instructed jury."[109] In very few of these cases were deals with prosecutors or details of law enforcement interviews disclosed. In almost all of these cases, though, the informant described a detailed—but false—account of a confession.

Several exonerees' attorneys asked the judge to keep out the jailhouse informant testimony at trial, but none succeeded. Perhaps the most arbitrary judicial ruling admitting jailhouse informant testimony was in Drew Whitley's case. The informant was on death row and facing execution. Yet the judge instructed the attorneys that they could not bring up the fact that he was sentenced to death or that he was even in jail. The judge ruled that they could bring up that he was on "court supervision" and psychiatric care, and had to describe any conversation between them as if it somehow occurred on the street and not in jail.[110] Nor did the judge let the defense lawyer bring out that at the informant's own trial he had huge memory blocks and could not remember even confessing to the police. These memory lapses were highly relevant, since the informant did

not come forward until five or six months after the crime occurred. He explained: "I forgot about it until I read in the paper about it" but later wrote to the prosecutor because "it was on my conscience." He admitted having memory problems, though he said, "I remember what yesterday was, a week before, two weeks."[111] The jury never heard any of this evidence of the informant's unreliability.

Judges could have instead required prosecutors to disclose the details of any conversations with informants, to shed light on whether there was in fact a deal, and to shed light on how it was that the informant came to hear details about the crime. It was not surprising, though, that these judges did not closely examine the testimony by these informants. Traditionally, judges do not require any such examination of informant testimony, and even since these wrongful convictions have come to light, very few jurisdictions have adopted any reforms. California requires that the jury be instructed on the potential unreliability of jailhouse informant testimony, while Oklahoma requires "complete disclosure" of any negotiations between prosecutors and the informant.[112] Illinois, in response to death row exonerations in cases involving jailhouse informants, now requires that the judge conduct a "hearing to determine whether the testimony of the informant is reliable."[113] Only a handful of states have adopted these reforms. Such efforts are modest improvements. No state requires videotaping conversations to ensure that case information is not suggested to the informant. Few jurisdictions limit the use of informants to cases where they are necessary and reliable.

Tailor-made statements by jailhouse informants provided powerful but false evidence of guilt. If informant testimony is to be permitted, then it should be subject to far more searching review. Statements could be videotaped. Prosecutors should be forbidden from entering posttrial deals or securing informal benefits not disclosed to the defense. Discovery could be enhanced. The prosecution should be required to disclose prior cooperation by a jailhouse informant. All information concerning any deals should be formalized and provided to the defense. These trials illustrate how wrongful convictions can result if informant testimony is freely admitted without meaningful scrutiny or precautions.

William Dillon was exonerated after spending twenty-seven years in prison. After he was finally released, a hearing was held to decide whether the State of Florida would compensate him, and if so, for how much.

There he again met the jailhouse informant who had testified against him at trial. The informant had claimed Dillon reenacted the murder in the jailhouse bullpen, showing how he pinned the victim down and punched him in the face on a deserted beach. Twenty-seven years later, the informant tearfully apologized. He described how police officers sat on either side of him and coached him. One asked questions, while the other stated the desired answers. The officers wrote a statement with just their words that the informant parroted back. The entire statement was fabricated. For his contributions to this frame-up, the informant avoided prison for a rape charge. Twenty-seven years later, he finally apologized to Dillon, saying, "I'm very sorry." They shook hands. He explained that the police "put everybody on the spot." Dillon told him, "I understand, believe me."[114]

Innocence on Trial

T HE SMALL TOWN OF CULPEPER, Virginia, was shaken by the grue-
some rape and murder of a nineteen-year-old woman in June 1982.
Two of her infant children were present when she was raped and stabbed
thirty-eight times. The bedroom walls and floor of her apartment were
smeared and splattered with blood. She collapsed outside screaming
"help me" and "he hurt me." Police and her husband arrived before the
ambulance. She was able to tell them only that a black man attacked her.
She quickly died. Eyewitnesses saw a black man climbing a fence, and
newspapers ran a composite sketch. For more than a year, police had no
leads. The case was a "top priority" with local and state police. But they
were "fairly frustrated" and called the case "a big puzzle."[1]

Earl Washington Jr. was a black, borderline mentally retarded farm-
hand. In May 1983, during a night of drinking and arguing with rela-
tives, he broke into an elderly neighbor's house. He hit her with a chair,
ran off with her gun, and shot his brother in the foot. Found crying in
the woods, he was arrested. Police suspected an attempted rape initially
(the neighbor later denied any such thing), and began to question him
about several unsolved rapes. As I described in Chapter 2, Washington
confessed to all of the crimes he was asked about, but in the other cases
the victims told police he was not the assailant, or the confessions were

deemed totally inconsistent with how the crimes occurred. Police also asked him about the crime in Culpeper. During a two-hour interrogation, later followed by an interrogation by state police familiar with the case, he also confessed to that brutal murder. He signed a typed confession statement that consisted primarily of him saying "Yes, sir" to whatever the police asked.

Now the case moved rapidly. The State announced that it would seek the death penalty. Death penalty trials, because of their seriousness, are on average far longer than the typical felony trial. The transcript of this trial, however, was quite short. Earl Washington Jr. was convicted in Virginia after a trial lasting less than five hours, and he was then promptly sentenced to death. He was tried as "Earl Junior Washington"—he could not correctly write his own name. Apparently the authorities did not write his name correctly either. At a brief pretrial hearing, a state psychologist testified and found him competent to stand trial. After a day of jury selection, the trial began the morning of January 19, 1984.

The opening statements were very brief. The Virginia Commonwealth's prosecutor described the gruesome rape and murder of the victim. He emphasized that Washington had not only confessed but had told police "a number of different things that could only have been known by somebody who actually had committed the offense."[2] The prosecution then called fifteen witnesses. They described the confession in detail, the injuries suffered by the victim, and the investigation of the case.

The defense called just two witnesses: Earl Washington Jr. and his sister. Virginia has statutory limits on fees paid to lawyers for indigent defendants that are still among the lowest in the country.[3] Not satisfied with his public defender, his family hired a private lawyer. However, that lawyer had never tried a death penalty case, and it showed. The entire defense case occupied only forty minutes.

Earl Washington Jr. was innocent and on trial for his life. How did he try to convey his innocence to the jury? On the witness stand, Washington protested his innocence. He said he did not understand many of the things written in his confession statement, which, as I described in Chapter 2, included striking crime scene details about a torn shirt that had been found in the dresser drawer of the victim's bedroom. He denied having said some of the things that police testified he had said during his

interrogations. He had no strong alibi. He could not remember any particular day in June 1982. After all, he was borderline mentally retarded. Nor would most people remember a particular day more than a year and a half earlier. Washington recalled that he was out of work that month and said that he was probably "at home cleaning up in the yard" the day of the crime.[4]

In the closing statements, the defense had one last chance to make a compelling case that Washington should not be convicted. Washington's lawyer offered few arguments, and did not discuss many facts either. He did not mention any of the glaring inconsistencies in the confession. For example, Washington did not correctly describe the race of the victim. When police asked him, "Was this woman white or black," he had answered, "Black." She was white. Washington's lawyer did little more than remind the jury that "The primary thing for you to decide is whether or not this gentleman, this man, Earl Washington did it." He never claimed that Washington was an innocent man.[5]

The next morning, on January 20, 1984, the jury deliberated for only fifty minutes before concluding that Washington was guilty. Next, there was a sentencing phase, a separate portion of the trial where both sides could present evidence concerning whether Washington deserved a death sentence. The prosecutor vividly described "the suffering and the agony" of the victim, and how "two of her children were right there" during the gruesome murder, while the third child came home from school and saw her mother lying in a "pool of blood." The defense simply presented Washington's sister and the state psychologist who had found Washington competent. In closing, he told the jury that "[h]is life is in your hands." The jury quickly sentenced Washington to death.[6]

The prosecution case rested on the apparent strength of Earl Washington Jr.'s confession. The obvious defense was that this confession, by a mentally retarded individual, was unreliable, false, and the product of police suggestion. His lawyer never made those arguments. The lawyer did not request funding for an expert to review whether mental retardation affected the reliability or voluntariness of the confession.[7]

Nor did the defense lawyer understand the forensic evidence. The semen-stained blanket from the victim's bed was blood-typed, and that rudimentary technique had ruled out Washington. The lawyer later said

that while he saw the forensic reports, he "was not familiar with the significance" of the analysis. The prosecution may have also engaged in misconduct. As I noted in Chapter 4, it emerged years later, after Washington filed a civil rights lawsuit and obtained access to the prosecution files, that the State had concealed crucial evidence of innocence, including forensic evidence, from the defense.[8] Although Washington was innocent, the jury heard very little evidence of innocence. Instead, they heard about a detailed confession. Washington would come within nine days of execution. I will describe in Chapter 8, which shows how the 250 exonerees obtained their exonerations, a series of miraculous and chance interventions that later saved Earl Washington Jr.'s life.

The Defense Case

We have heard quite a bit about the prosecution evidence at these exonerees' trials, but not about the general characteristics of the trials, such as their length, nor the cases that these innocent people's lawyers mounted in their defense. When I first began looking at the trial transcripts, I expected to find that actually innocent defendants would try to assert their innocence at trial. I was surprised to find that although innocence played a role in most of these trials, the defenses raised were usually fairly weak. Most of these cases were not high-profile trials. Most were short trials for rape. Since almost all were cases where the rapist was a stranger, a central issue was identity—who was the stranger who committed the rape? Truth was on trial. These jurors first heard the prosecution case. Defense lawyers tried with varying success and skill to undermine the prosecution evidence that their client was the culprit.

However, what followed the prosecution case was typically a very short defense case that did little to present the jury with an alternative account. Three reasons explain why the defense case was usually so weak. First, the defendants had little ability to locate evidence of their innocence. The primary investigators of crimes are the police; they work for the prosecution, and their work may be well under way or completed by the time that these people even became suspects. Second, it is inherently difficult to convincingly prove that one did not commit a crime. It is not easy to have an alibi. One may not remember what one was doing

on an unremarkable evening many months ago. Indeed, it might be suspicious if one did have a vivid recollection of that night. Third, the defense lawyers often did not effectively challenge the prosecution case. The defense called, on average, less than half as many witnesses as the prosecution. Defense lawyers retained few experts, in comparison to the prosecution. Most of these innocent people could not afford an attorney, much less expert witnesses, and most had lawyers assigned to them. Lawyers may not have known that these cases were not ordinary, that their client's protests of innocence were actually true. And while we do not know how often this occurred, in some exonerees' cases, the police or prosecutors concealed evidence of innocence from the defense lawyers.

In this chapter, I explore each of those challenges that these innocent people faced in mounting a meaningful defense at trial, even though they could truthfully proclaim their innocence.

Before Trial

The last chapters have all discussed the trial evidence used by the prosecution, such as confessions, eyewitness evidence, forensics, and informant testimony. The State has a head start in assembling its case, since long before any criminal trial takes place, the police and prosecutors conduct an investigation. In contrast, very few of these exonerees had lawyers at the time that crime was being investigated. Most did not obtain a lawyer until after they were arrested. A few were found near the crime scene and identified on the spot by a victim, but most became suspects after some time had passed. While we do not know precisely how all of these people first came to the attention of the police, we do know that some were presented to a victim because, as prior offenders, their photos were on file with the police. Others came to the attention of police because their behavior was suspicious, informants provided their names, or they came forward to talk to the police about the case and then reportedly falsely confessed.

By the time defense lawyers were involved, witnesses may have been harder to locate and the police may have largely closed their investigation. Indeed, these trials took place an average of about one year and three months after the crime. That delay may have affected the reliability of

the evidence, particularly the memory of eyewitnesses, which can be expected to fade over time.

The press also played a role leading up to these trials. Eyewitnesses sometimes saw news reports about a crime or composite drawings that other witnesses had prepared, and seeing these images may have contaminated their memory and increased their certainty. Likewise, studies have shown that jurors are far more likely to convict in cases in which there is pretrial publicity.[9] Sensational coverage may highlight gruesome aspects of the crime, which may bias jurors. Extensive coverage fueling public outrage may also increase pressure on police to close cases, and on prosecutors to win them or face the anger of voters when they are up for reelection. Moving the trial to a different courthouse when there is extensive pretrial publicity might help, but judges denied every motion that these innocent people made to transfer the venue.

Guilty Pleas

Some exonerees had no trial at all; 6% of the exonerees (16 of 250) pleaded guilty and agreed to have no trial. (Nineteen pleaded guilty, but of those, three were also convicted at a trial on separate charges).[10] While we do not know all of the reasons those exonerees pleaded guilty, what we do know suggests that these exonerees had the same problem as those who did have a trial: they lacked compelling evidence that they were innocent, while the prosecution had already investigated the case and had seemingly powerful evidence of their guilt.

Ten of the sixteen who pleaded guilty had already confessed. Several initially litigated their cases, but after the judge ruled that the confession would be admissible, they decided to plead guilty. Others pleaded guilty because they had falsely confessed and agreed to testify against other innocent individuals in exchange for a more lenient sentence; their cases were described in Chapter 5.

As in the cases of the exonerees who did have trials, the defense lawyers may have played a role. Christopher Ochoa, for example, recalled his lawyers pressuring him to plead guilty, telling him that his detailed confession to a rape and murder was so compelling he might receive the death penalty. They told him there was "no way an innocent person

would give such a detailed statement." He later said that although his lawyers probably "believed [he] was guilty," he also had the impression that "it was less work" for them if he would plead guilty. He was offered a life sentence for his testimony against his also-innocent codefendant, Richard Danziger.[11]

John Dixon had asserted his innocence to police and later regretted pleading guilty. He asked to retract the plea and asked for DNA tests, arguing they could prove his innocence. The judge denied the requests, noting, "It is not uncommon once having plead guilty there's a change of heart."[12] Anthony Gray also tried to withdraw his guilty plea. He was mentally disabled, had falsely confessed, and then had accepted a wildly unfavorable plea agreement. He pleaded guilty to the most serious crimes charged and agreed to receive the maximum sentence, life in prison, which could have been imposed at a trial. His lawyer discussed this agreement with him for less than an hour. The American Bar Association has documented the problem of poor defendants receiving what have been nicknamed "meet 'em and plea 'em" defense lawyers.[13] The judge denied Gray's request to withdraw his guilty plea, and DNA testing exonerated him seven years later.[14]

The small percentage of guilty pleas makes these DNA exonerees very different from typical criminal defendants, who overwhelmingly plead guilty. More than 95% of all criminal cases result in a guilty plea. The numbers are lower for felony rape (83%) and murder (69%) but are still quite high.[15] In this unusual set of cases where we now know that the defendant was actually innocent, the number of guilty pleas may be so low because of the defendants' knowledge of their own innocence. In many of these cases, because of the seriousness of the charge, the prosecutors may not have always offered bargains that were palatable to an innocent defendant. Several exonerees later explained that they could not bring themselves to plead guilty for a crime that they did not commit. It is one thing to agree to falsely admit to having committed a crime if the crime is relatively trivial and the sentence is a year in prison, but it is another thing entirely if the result is life in prison and being known forever as a rapist or murderer. For example, James Lee Woodard, who served more than twenty-seven years in prison, had been offered a plea bargain for just three years, although he was charged with murdering his girlfriend. He

told his lawyer at the time, "We go to trial," and explained that he turned down the deal because "I know one day that I was gonna have to die, and I didn't want to go before God saying I did something that I didn't do."[16]

Perhaps these innocent people would have spent far less time in prison if they had accepted plea bargains. Indeed, the reason we know about these particular innocent people is in part because they refused to accept plea bargains, and so they received far harsher sentences after a trial. If James Lee Woodard had served three years in prison, he would have been released in 1984 and might not have bothered to pursue DNA testing a decade later when it became possible to do so.

Just as the cases of exonerees show that innocent people can falsely confess, they also show us that innocent people can plead guilty. Although people who plead guilty swear in court that they understand that they are admitting their guilt and the consequences of doing so, DNA testing has shown that innocent people can plead guilty for some of the same reasons that innocent people can falsely confess. They succumb to pressure from prosecutors or even from their own defense lawyers. They believe that pleading guilty is a better option than the severe sentence they might receive at a trial. They may have previously confessed, they may be vulnerable or mentally disabled, or they may feel as if they have little choice but to plead guilty.

However, the cases of these exonerees cannot tell us how many innocent people plead guilty. Just because few of these exonerees pleaded guilty does not mean that wrongful convictions are less of a problem for people who plead guilty than for those who have a trial. It may be that many others were also innocent, but they never asked for DNA testing, because they understood the system better, they were less principled about asserting their innocence despite the risks at a trial, or they had more talented lawyers, and as a result, they obtained favorable plea bargains and served short sentences. We know very little about such cases, and judges do not look closely at them. After all, when one pleads guilty, one typically waives the right to file an appeal or a habeas petition. Many states also refuse to allow people who plead guilty to pursue postconviction DNA testing.[17]

Our criminal justice system is a plea-bargaining system. Prosecutors resolve the vast majority of cases using plea bargaining—but these exon-

erations vividly illustrate how not all who plead guilty are in fact guilty. The plea-bargaining system deserves far more careful scrutiny.

Innocence on Trial

We have good reasons to think that "in criminal jury trials, the evidence matters."[18] Jurors place great value on the types of evidence common in these trials: eyewitness testimony, police testimony, confession testimony, victim testimony, and forensic testimony.[19] As described in the previous chapters, although that evidence now looks quite flawed, at the time it may have appeared powerful. The confessions and informant testimony appeared to include details about the crime scene that only the true culprit could have known. The eyewitnesses appeared confident about their identifications, which impresses jurors, as I discussed in Chapter 3. The forensic analysts may have exaggerated the evidence, but as I described in Chapter 4, the jury rarely heard anything about such flaws.

Moreover, those pieces of prosecution evidence can all reinforce each other to make the case appear even stronger. Police sometimes secured confessions by telling the suspect that forensic evidence tied them to the crime. An officer did that in the Central Park Jogger case, where the forensic evidence later turned out to be quite weak, and largely excluded the defendants; however, it was used to produce a seemingly strong confession. Even if the medical examiner could not be sure what the murder weapon was, if the injuries were consistent with the use of a knife, the exoneree then confessed to using a knife (as in Ronald Jones's case); or if an informant claimed the exoneree admitted to using a knife, then the evidence would suddenly fit together in a seemingly convincing way. The evidence can cross-contaminate in ways that cannot easily be detected. A victim may have been unsure about her lineup identification, though there may be no record of it, but if police told her that forensics all matched the suspect, then her certainty would probably increase.

Similarly, when jurors consider all of the evidence, not only does the strength of the evidence matter, but its coherence may also matter. The prosecutors present the most coherent story they can by describing why they believe the defendant committed the crime. They could do that particularly compellingly in the rape cases where the victim could herself

describe what happened and then, at the end of that account, identify the defendant as the perpetrator. However, they could also present the testimony of a host of others who could all describe what had happened and why the defendant had been connected to the crime: the police who investigated the crime scene, forensic analysts, family members of the victim, eyewitnesses, informants, doctors who treated the victim, and medical examiners who investigated the cause of a death or the victim's injuries.

A jury's confidence in that account of guilt may be heightened where the defense fails to or is unable to offer a credible competing story about innocence.[20] The problem encountered by these innocent people and their lawyers was that they typically had no way to convey their innocence in a believable way. Asserting innocence was all that many exonerees could do. Many simply had no compelling proof of their innocence. That does not mean they didn't try. More than 90% of the exonerees for whom trial transcripts were obtained (190 of 207 trials) asserted their innocence at trial. The few who did not directly assert innocence simply argued that the State had not proved that they were guilty beyond a reasonable doubt.

The trials began with the opening statements by the lawyers. Most defense lawyers proclaimed their client's innocence in their opening statements. For example, Richard Alexander's attorney opened with innocence, telling the jury "this is a case of misidentification." Miguel Roman's lawyer closed, saying, "There's no greater injustice than a man found guilty of something that he didn't do. Nothing is more horrifying, in our system of justice."[21] Others, perhaps figuring that the evidence was weak, did not emphasize innocence. Recall how Earl Washington Jr.'s lawyer did not assert innocence and simply asked for the mercy of the jury. Most exonerees were also tried alone; the vast majority of criminal trials involve single defendants.[22] However, as described in Chapter 2, some exonerees were convicted in joint trials, in some of which not all of the defendants claimed their innocence, but rather some pleaded guilty and implicated other innocent people in their false confessions.

Following the typically brief opening statements, the prosecution presented its case, and then, after it rested, the defense presented its case. The defense often had a very limited case, which kept these trials short.

Earl Washington Jr.'s trial of less than two days, in which the defense case was forty minutes long, was in many respects quite representative. Although it was a death penalty case, and only 17 of the 250 exonerees were sentenced to death, it was of a length similar to many of the exonerees trials, and it involved a similarly tepid defense case. One study has found that typical rape trials average a little more than a day long, while murder trials average thirty-three hours, with capital murder trials longer than that.[23] The exonerees' cases fit this pattern: almost all of these criminal trials were less than a week long, and the average length was five days. Only the murder trials and particularly the capital trials tended to be longer. The defense opening and closing statements were typically shorter that those of the prosecution, and they called fewer witnesses.

In some exonerees' trials, the defense literally made no affirmative case; the defense lawyers simply rested their cases as soon as the prosecution finished, putting on no witnesses of their own. Carlos Lavernia and Thomas McGowan's cases are examples.[24] More typically, the defendant testified on his own behalf and offered an alibi, perhaps with a few witnesses in support. On average, defendants presented six witnesses, with the prosecution on average presenting fourteen witnesses, more than twice the number presented by the defense. Some defense lawyers did not do a vigorous job of investigating and representing their clients, although, as I will discuss, it is hard to know from available records what they did or did not do and what they could have done differently. Some had little time to prepare. For example, Kenneth Wyniemko's lawyer was appointed so late that he had only a weekend to prepare before the five-day trial.[25]

Innocence can be claimed in two main ways at a trial: through an alibi defense or evidence of third-party guilt. Alibi defenses, raised by 68% of the exonerees who had a trial that could be obtained (140 of 207 trials), involve calling witnesses to testify that the defendant was not at the crime scene. Claims of third-party guilt were raised by 14% of the exonerees who had a trial (30 of 207 trials) and involve evidence pointing to another individual as the culprit. Those two types of defenses can be supported by physical evidence, by testimony of witnesses, or by testimony of the defendants themselves, if they choose to take the witness stand.[26] These exonerees took the stand to proclaim their innocence in

53% of these trials (110 of 207 trials). Exonerees also had forensic evidence that provided evidence of their innocence in 14% of these trials (30 of 207 trials). I will discuss each type of defense in the sections that follow.

Weak Alibis

Did these innocent people have compelling evidence supporting their alibis? About two-thirds of the exonerees, or 68%, offered an alibi defense (140 of 207 trials). Alibis are often distrusted by jurors, because criminals are all too able to make up some kind of alibi, even a seemingly plausible one. Nor is it very easy for people to remember what they did at a specific time many weeks, months, or more in the past. That is particularly true for an innocent person who did nothing improper on that day and would have no special reason to recall it. As Brandon Moon's lawyer argued at trial, "A guilty man knows what happened. He can explain it away. An innocent man wasn't there. He doesn't know what happened. He can't help explain it away, because he has no earthly concept of what occurred."[27]

Most alibis are also weak. Studies suggest that very few alibis are corroborated by physical evidence, like credit card receipts or tickets. Most are instead corroborated by witnesses, but those witnesses are usually family members, who would have a reason to lie to help their loved ones, and therefore tend to be distrusted by jurors.[28] We do not usually know whether police made a real effort to investigate the alibis when these innocent people first became suspects. Maybe stronger evidence of innocence existed at the time and it was never investigated or was lost.

At the time of trial, most exonerees had weak alibis. Almost none had physical evidence to support their alibis. Of the 140 exonerees who asserted an alibi, 121 had alibi witnesses. The others had only their own testimony to describe what they were doing at the time of the crime. Many exonerees did not work, so they had no records of being at work that day or coworkers who could say they were at work. Most could only offer family members who testified that the defendant was at home with them when the crime occurred. Many of the crimes were rapes that occurred at night, when there would have been few witnesses about, and

when even their family members might have been asleep and unaware of whether they were home.

Such alibis were vulnerable to prosecution attacks and could even be turned into a liability. The State could argue that an alibi was concocted and that this was evidence of the defendant's deception. For some of the crimes, particularly the murders where the time of death could not be established precisely, it could not be determined exactly when the crime occurred. Without knowing the time that the crime took place, one would have to establish an alibi over a long and vaguely defined time period.

A few exonerees did have remarkably strong alibis and yet were still convicted. Timothy Durham had perhaps the strongest. Durham was far from Tulsa, Oklahoma, at the time the rape he was convicted of occurred. He was at the Pan American skeet shooting competition in Dallas, Texas, the day of the crime. He had eleven alibi witnesses testify on his behalf. It was a large shooting match, "one of the very top shoots in the country," as one witness explained, and the various witnesses described how they ran into him throughout the two-day competition along with his parents.[29] Then the defense introduced credit card receipts for the gas they bought during the drive, the dinner the Durhams ate together, and the clothes Durham bought while in Dallas.[30] The prosecution argued that these witnesses either colluded or were mistaken. And the prosecution also had something that appeared to have been much more powerful—not just the victim's identification of him as the culprit, but DNA test results pointing to Durham. In fact, as described in Chapter 4, that DNA result was false and caused by a lab error.

Some exonerees only had their own testimony to support their alibis. Anthony Michael Green, for example, testified that the night of the crime he was running races with friends on his street and was later with his girlfriend—but the defense called no witnesses to support those assertions.[31] Rickey Johnson said he did not leave home the night of the crime because of pain in an abscessed tooth and that the next day he had gone to the dentist. Yet the dentist's wife, who was also his office manager, said that records did not show that he had been to the dentist in the days before or after the crime.[32] James Richardson initially said he was driving around for two hours in the early morning hours because he wanted to get a special type of Dr Pepper bottle that he preferred. Yet he was the

first person at the crime scene next door to his house (where he rescued the young daughter of the victim from the fire set by the culprit).[33]

A few had no alibi at all, because they conceded they were present at the crime scene. Hector Gonzalez was at the crime scene where a man was murdered; he said he was in a large crowd outside a nightclub that observed the murder but had no role in it. At sentencing, Antonio Beaver told the judge that he really wished that his alibi witness had shown up at trial, saying "it would've helped . . . he's the guy that, you know . . . used to take me back and forth to work."[34] Arvin McGee complained that his attorney did not call any of his alibi witnesses, telling the judge that as a result, "I was a sitting duck."[35]

Pointing to Another's Guilt

Making a case that one is innocent is also not easy if one cannot point to another person who did commit the crime. Fewer exonerees, only 14% (30 of 207 cases), argued that some other person had actually committed the crime. Several other exonerees attempted to introduce such evidence, but judges barred them from doing so. In most states, a judge may exclude evidence of another person's guilt if it is not adequately supported. The U.S. Supreme Court in *Holmes v. South Carolina* established a due process right to present such a defense, but the Court ruled that judges may still exclude such evidence if they decide it is too weak to be admissible.[36]

Claims of third-party guilt have not received much judicial or scholarly attention, maybe because few succeed in presenting them.[37] After all, the defense does not usually have substantial investigative resources and may have no knowledge of other leads. Most surprising, a few exonerees had, at the time of trial, identified the real perpetrator, the person who DNA testing later showed was the culprit. Such cases suggest that police investigating the crime may have ignored sound evidence that could have lead them to the real culprit. Frederick Daye's lawyer called to the stand the mother of David Pringle, the other man charged with the crime. She testified to her son's acquaintance with a man who matched the eyewitness's descriptions of the second attacker.[38] Pringle's cousin testified that shortly after the attack, Pringle's acquaintance acted suspiciously; he offered to sell her two rings that were similar to the rings

stolen from the victim.[39] None of that testimony provided concrete evidence of Pringle's guilt. However, postconviction DNA testing confirmed that Pringle was in fact the culprit. In Byron Halsey's case his lawyer insinuated that a neighbor was the culprit, which postconviction DNA testing later proved to be the case.[40]

Robert Clark was charged with raping a woman and stealing her car, a maroon Oldsmobile Cutlass. He was caught driving the victim's car, but eventually told police he got the car from his friend Tony Arnold. Clark's lawyer argued that Arnold, who matched the victim's initial description of the attacker far better, was the actual rapist. Indeed, Arnold was brought into the courtroom, where a witness identified him as the man she had seen driving a maroon car just like the victim's, which she thought was unusual, since he was unemployed and had no car. Postconviction DNA testing proved that Arnold was in fact the culprit, but in the meantime, Clark had spent twenty-four years in prison, and Arnold had continued to commit a string of rapes in Georgia.[41]

Ronald Williamson's lawyer argued that prosecution witness Glen Gore "was the last known person to see" the victim alive, noting, "Wouldn't you think he'd be a prime suspect?"[42] Recall from Chapter 5 the macabre account that Gore had given of how the victim reached out and asked him to dance with her, to "save" her from Williamson's requests for dances. Postconviction DNA testing confirmed Gore's guilt. Other perpetrators were all too willing to shift the blame to an innocent person. In Bruce Nelson's case, the actual perpetrator, Terrence Moore, had confessed but implicated Nelson as lead participant in a rape and murder. In Arthur Mumphrey's case, DNA tests confirmed the guilt of a codefendant who had confessed and testified against him in exchange for a reduced sentence.

In these troubling cases, police had the real culprit in their sights, but focused on the wrong man. The police files from the investigation are typically never disclosed in full and we do not know what leads police may have neglected to follow. In some cases, the defendant, though now known to be innocent, may have been the lead suspect for good reason, say because the eyewitness identified him. We do not know in how many other cases police were so focused on innocent people that they ignored leads that could have pointed them to the true culprit. Clearly, police

should be open to investigating alternative suspects and scenarios, rather than rushing to a judgment that might cause a wrongful conviction while the criminal goes free.

Testifying to Their Innocence

Not only did these innocent people try to develop alibis and evidence of third-party guilt, but they could also rely on another source of evidence of innocence: themselves. At more than half of these exonerees' trials or 53% (110 of 207 trials), the exonerees took the stand at trial to claim their innocence, and perhaps also develop an alibi defense. They faced a delicate task. They desired to convey their innocence, but also compassion for the victim. Many were not eloquent or accustomed to public speaking. They may have hoped to earn some sympathy from the jury, but the jury had just heard about the serious crimes they were accused of committing.

Most asserted their innocence briefly and without flourish or excessive emotion. Dennis Brown denied committing the rape at trial, saying, "I wouldn't do nothing like that," and "No, sir. I was raised better than that." He commented that as for the victim, "I feel sorry for her, what somebody else did, because I didn't do it."[43] Similarly, Charles Chatman was asked, "Did you rape that woman that night in her house like she says?" and he answered, "No, sir, I didn't and that's the honest truth."[44] Thomas Doswell testified: "With God as my witness, I did not rape this woman."[45] Clarence Elkins testified succinctly, "Yes, I am innocent."[46] Dennis Fritz gave a longer statement protesting his innocence. He was asked, "Dennis, did you kill [the victim]?" He answered:

> No, I did not. I did not kill [the victim], and I don't know anything about the death of [the victim] whatsoever. I've been locked up over in that county jail for 11 months on circumstantial evidence, and I'm the kind of person that I've never taken a life. I've never thought about taking a life. I've never wanted to rape a woman. I've never had any thoughts of this kind of activity in my life.[47]

Exonerees not only protested their innocence, but many of those who had falsely confessed also testified and recanted their confessions. Sev-

enteen of the thirty exonerees who falsely confessed and were convicted at a trial did so. For example, Bruce Godschalk explained that the officers "started questioning me down at the station and I was quite upset, and I was denying it most of the time, and I thought they would let me go," once he confessed.[48] Ronald Jones, whose story we heard in Chapter 1, testified that he confessed to the detective "[b]ecause it seemed like the only way he was going to stop beating me."

At sentencing hearings, which were transcribed in only some of these trials, at least fifty-seven exonerees reaffirmed their innocence, often in particularly moving terms, begging for the mercy of the court. Ronald Jones said, "I just wanted to say that I am sorry for the grief and the pain that [the victim's] family had to go through, and I am sorry for the grief and pain my family had to go through, and that's it."[49]

Most kept their testimony brief. Anthony Capozzi stated, "Judge I never did these crimes and I'm innocent."[50] Larry Fuller testified at greater length, stating: "I can only consider myself as being a victim of circumstances, something that I must accept, but I cannot change . . . I would like to receive, because I come here believing in the word of justice, justice with eyes, not justice that would be blind."[51] Kirk Bloodsworth, the first person exonerated from death row, gave a formal statement:

> I, Kirk Noble Bloodsworth, did not commit this crime . . . I have never in my history have ever had a violent act, especially on a child . . . I think this has been a travesty of misjustice all the way around, not to put the Honor on the spot or anybody else in this Court. They have to do their job. Somebody told them what to do, and then it comes down the line. All's I'm saying is Your Honor, I did not commit this crime on July the 25th 1984. If I had have, it would have been stated from the start.[52]

As an innocent person facing the death penalty, he not only sought mercy but had to constrain his own anger over his predicament. Others also managed to address the judge with a graciousness that in retrospect seems remarkable. Douglas Echols explained, "I didn't rape that lady. I didn't kidnap that lady. I didn't rob that lady. I didn't do none of the

accused, you know, but I'm not angry for whatever you did, you know. God bless you."[53]

Several also appealed to God to save them. Calvin Ollins told the judge: "I want to say that I was found guilty for something that I didn't do. And I always tell myself that I will be out one day and that God will do something for me."[54]

In contrast, after the verdict was read, James O'Donnell had another understandable reaction—he exploded with anger and directed expletives at the judge and jury. He then composed himself and said: "I am really sorry for my outburst. I tried to be as civil as possible. I would never do a crime like this. And my life is over now as I know it, my wife and kids' life. I don't understand how the jury did this to me. It's really not right, what they did. I was home in bed. I was sleeping. I would never hit a woman. I have a wife. I never hit my kids, ever. I never forced a woman to do anything in my whole life. That's the God's honest truth . . . It's just—I'm very sorry for my outburst. Don't take my life away, please."[55]

In the Central Park Jogger case, Korey Wise was removed from the courtroom after hearing the prosecutor's opening statement, when he cried: "No. No. No. Can't take this. O, Lord. Jesus. No . . . It's wrong. It's wrong. No. No."[56]

Stephan Cowans told the police officer who identified him as a man who shot him, that "with all due respect, I'm very disappointed in what happened to you and whatever, but you know as well as I know I'm not the man who did this to you." Cowans added, "I also have a family. I have people who love me, also. For you to do this to me—as a Boston police officer, you know, I just wish you the best . . . But I think this goes around, and goes back to other innocent people, with all due respect."[57]

At the trial of Michael Evans and Paul Terry, the judge noted during sentencing that "both defendants walked into this courtroom with a swagger" as evidence that neither exhibited any signs of remorse. Their attorney tried to respond, "I think that is clearly indicative of innocence, that you don't feel remorse for something you didn't do."[58]

Taking the stand is risky for those who have prior convictions. Most of those who did not testify likely chose not to because they had prior convictions that could be used to discredit them. For example, Leonard McSherry did not testify in a case in which he was convicted of raping a

seven-year-old girl. This was no surprise. He had a prior conviction for kidnapping and raping a six-year-old girl. Law professor John Blume has found that "many demonstrably innocent defendants did not testify at trial because, had they done so, they would have been impeached with their prior convictions."[59] Those who did testify ran that risk, and the juries heard about their prior convictions. Lacking any other evidence of innocence, they may have testified and taken that risk because otherwise they had no case at all.

Defense Forensics and Experts

Beyond witness evidence, forensic and expert evidence also sometimes provided these innocent people with evidence of their innocence. Forensic evidence of innocence was prominent in 14% of these exonerees' trials (30 of 207 trials). Some exonerees tried to obtain DNA testing at the time of their trial and could not, but in other exoneree trials, the forensics excluded them, and jurors discounted or ignored that forensic evidence of innocence. As discussed in Chapter 4, fifteen exonerees were excluded by DNA testing at the time of trial but were still convicted. Fifteen more exonerees were excluded by all of the forensics in their cases, not DNA, but other types of forensic evidence, such as serology, hair, fiber, or fingerprint evidence at the time of trial.[60]

Most exonerees had no experts of any kind. Most simply presented alibi witnesses or the defendant's own testimony. Only sixty-two exonerees retained experts, not all of whom were permitted to testify at trial. Most were forensic analysts, and several testified regarding eyewitness memory or examinations of defendants regarding their competency to stand trial or ability to voluntarily confess.

In contrast, the State in almost every trial presented experts, including forensic analysts and treating physicians or medical examiners. The State had experts in at least 187 trials, often two or three or more experts. In only seven trials was it clear the State did *not* retain experts.[61] Why such a striking imbalance? The State can easily obtain experts. Teams of experts, such as medical examiners and forensic scientists, work full time for law enforcement or the state. On the other hand, indigent criminal defendants, except for the very rare defendant who is wealthy, face

great difficulties securing funding for experts, and most do not have experts at trial. Rulings by the U.S. Supreme Court do not clearly entitle defendants to experts even in many circumstances when they badly need them to present a meaningful defense.[62]

The defense cases were deficient in several different ways, ranging from the number of witnesses, to their expertise, to the limited nature of their testimony, usually simply repeating an alibi that was itself fairly weak. A first reason for the weakness of the defense was that defendants cannot easily investigate the crime themselves. While the police had been investigating the crime since it was reported to them, these defendants had no reason to think about the day of the crime, much less seek assistance from a lawyer, until they became suspects or were arrested. The prosecution had substantial investigative resources, including police and crime lab analysts. In contrast, although criminal defendants are entitled to lawyers at trial, they often do not receive experts and have no investigative team.

Second, it is hard to prove a negative, that the defendant did not commit a crime. Although the prosecution could present a compelling story of how a serious crime occurred, and then seemingly powerful evidence that this defendant was the one that committed the crime, the defendant faced an uphill battle trying to prove that he did not commit the crime, but that some other unknown person did. Absent any evidence about who that other person was, the defendant could present an alibi. That was difficult to do, where most crimes occurred at night, and where it would be hard to remember what happened so long before. The defendant's own word that he did not commit the crime may not be particularly compelling, since a guilty person can claim to be innocent.

Third, I discuss in the next sections a final reason why these defendants did not have stronger cases: the lawyers. Although a talented attorney might have made a more compelling case for innocence, these defendants did not always receive particularly good defense lawyers. In addition, misconduct by prosecutors sometimes made the job of the defense lawyers more difficult. In some of these cases, evidence of innocence was concealed from the defense.

Ineffective Assistance of Counsel

How well did these exonerees' defense lawyers perform? Were they in part responsible for causing wrongful convictions? It is not easy to answer those questions, but there is certainly no shortage of evidence of subpar work by some of these defense attorneys. To take an egregious example, Jimmy Ray Bromgard was represented by a lawyer who he recalled was nicknamed "Jailhouse John Adams," a contract attorney retained by Yellowstone County, Montana. The lawyer had been "adjudicated ineffective on prior occasions by federal court" and was "often found at a bar playing cards when he was supposed to be in court representing his clients."[63] Consistent with his apparent reputation, that lawyer "met with him once before trial, hired no investigators or scientific experts, filed no motions to suppress evidence, made no opening statement, failed to prepare Mr. Bromgard for his testimony and, after indicating he would appeal, did not."[64] Adams even got Bromgard's name wrong while addressing prospective jurors. Adams said, "You go by the name of Ray Bromgard, don't you?" Bromgard, who goes by Jimmy, said, "No."[65]

The case against Bromgard hinged on an eyewitness identification and forensic evidence. Bromgard could have had a strong defense. The victim admitted she was "not too sure" that he was the one that raped her, and the forensic evidence was false and unscientific, as an FBI scientist found in a subsequent examination. But Bromgard's lawyer never even filed a pretrial motion to challenge the victim's identification, nor did he conduct any pretrial investigation of the forensic evidence or of anything else. Bromgard was convicted and sentenced to forty years in prison, and he spent fifteen years in prison until DNA testing proved his innocence. For years after his conviction, Bromgard tried to raise the issue of his attorney's shoddy representation. The Montana courts dismissed his claims of ineffective assistance of counsel.[66] How could that be?

In its watershed ruling of *Gideon v. Wainwright,* the Supreme Court ruled that a criminal defendant has a right to counsel in a felony trial. But having a right to a lawyer does not mean that one has a right to a good lawyer. Many states and localities have long provided inadequate indigent defense funding, with predictably persistent poor assistance of trial counsel as a result.[67] Yellowstone County, Montana, like many

counties in the United States, had no public defender's office. Instead, it paid four contract attorneys, including John Adams, a flat monthly rate regardless how much effort they put into their clients' cases, and with no oversight of their work. Bromgard unsuccessfully sued the county for maintaining a grossly inadequate system for representation of indigent defendants, but settled claims against the state for $3.2 million, the largest civil rights claim it had ever paid. In 2005, Montana finally created a state public defender's office.[68]

Previous reports have suggested that the systemic lack of funding for indigent defense in the United States leads to shoddy representation and miscarriages of justice. Poor lawyering appears to have played a crucial role in these exonerees' cases, but studying the degree to which substandard lawyering mattered raises many challenges. For one, take a case like Bromgard's, where the exoneree's lawyer did little investigation or preparation, and may have performed badly at trial. Precisely due to his lawyer's ineffectiveness, one cannot tell from the trial records what powerful arguments and evidence an effective lawyer would have presented to the jury. All one can say is that the trial lawyer did not put on a strong case. In addition, as I will discuss in Chapter 7, it is very difficult to win a postconviction claim like Bromgard's, alleging that the trial lawyer was ineffective. It must be shown that the lawyer's performance was so grossly deficient that it was unreasonable and could have altered the outcome at trial.

One exoneree asserted his right to adequate counsel at trial. Robert Stinson stood up in court and asked the judge for a new lawyer. He explained:

> I would like to move the Court, with all due respect, for new counselor for the following reasons.
>
> One . . . my counselor has been misrepresenting in my case due to the fact that there are quite a lot of facts, important facts, that he has not brought out on cross-examination.
>
> I feel he is ill counseling me to the degree that he only took my case two weeks ago. There was not enough time for him to have prepared for a trial in my best defense.
>
> Three, we have a personality conflict and cannot come to any agreement on anything.
>
> Your Honor, I'm facing life for something I did not commit.

The judge denied Stinson's request, and sure enough, he was sentenced to life in prison for a crime he did not commit.[69]

Most exonerees were indigent and could not afford to hire a lawyer. Of those for whom information could be obtained, seventy-eight had court-appointed attorneys, seventy-one had public defenders, and fifty-three retained counsel.[70] Those who retained their own lawyer often did not have effective counsel either, nor could they hire expensive lawyers. Earl Washington Jr.'s counsel was an example. Similarly, Nicholas Yarris retained a lawyer, for just $1,500, to represent him in his capital murder trial.

I have described a series of areas in which these exonerees' lawyers did not present a strong defense case, including the failure to present strong alibis. The forensic evidence was another glaring area in which defense lawyers were ineffective. As discussed in Chapter 4, in about half of the ninety-three cases in which prosecution forensic analysts provided unscientific or invalid forensic testimony, defense lawyers failed to ask any questions about the areas in which an analyst misled the jury. Almost all exonerees who confessed had their trial attorneys move to suppress the confession at trial, but very few obtained experts to show how the confession could have been coerced or produced by suggestion. After all, state courts routinely deny funding for such experts.

Only one DNA exoneree, Donald Wayne Good, chose to represent himself at his third and final trial (his first ended in a hung jury and his second conviction was reversed). Even an inadequate lawyer might have been a better choice. Good repeatedly interrupted to ask for the assistance of his legal advisor to help him question witnesses, and in response the judge would order him gagged and cuffed.[71]

Prosecutorial and Police Misconduct

We have looked at the role played by the defense lawyers, but how about their adversaries, the prosecutors—did they engage in conduct that contributed to these wrongful convictions? The U.S. Supreme Court has described how a prosecutor is obliged to do justice, and "while he may strike hard blows, he is not at liberty to strike foul ones" or use "improper

methods calculated to produce a wrongful conviction."[72] A number of these exonerees were victims of prosecutorial misconduct that crippled the defense's ability to put on a meaningful case. However, it is also a real challenge to describe, much less accurately study, what might constitute prosecutorial misconduct. As with defense lawyering, the criminal procedure standards are extremely forgiving. The most common prosecutorial misconduct claims that exonerees raised after they were convicted were claims that prosecutors concealed evidence from the defense and that prosecutors misled the jury during their opening or closing arguments.[73]

By its nature, misconduct involving concealed evidence may remain hidden. We typically do not know what prosecutors had in their files, much less what they failed to show to the defense. We may rarely learn about violations of the rule established by the Supreme Court in *Brady v. Maryland,* which requires that prosecutors provide to the defense evidence that is "material and exculpatory"; in other words, evidence that tends to show innocence or help the defense case, for example, by allowing the defense to undercut the credibility of a witness. The defense may not find out about that evidence if prosecutors learn about evidence from the police but do not provide it to the defense. Scholars and journalists have gathered information on reported prosecutorial misconduct over the years, and they have documented violations leading to troubling reversals in death penalty and homicide cases, for example. However, another reason why prosecutorial misconduct often remains hidden is that it is rarely investigated. It is almost unheard of for prosecutors to be disciplined or sanctioned for misconduct.[74]

Police misconduct may also play a role that is largely hidden. Indeed, it may be hard to tell whether it was police or prosecutors that engaged in misconduct. Prosecutors cannot fulfill their duty to provide the defense with evidence of innocence if police never give that evidence to the prosecutors. However, police misconduct is also very hard to define or to study. Just as we usually do not know what prosecutors had in their files, we rarely find out what police had in their files. Indeed, exonerees claimed in some cases that police destroyed evidence helpful to their cases or that they engaged in other misconduct, such as illegal searches and seizures, all without any success.[75] As discussed in Chapter 4, law

enforcement typically employed the forensic analysts that gave invalid or unreliable testimony, and in some cases, when the evidence in the case was later retested, it came to light that analysts had concealed evidence.

Although more may remain hidden to this day, we do now know that in many of these cases the defense was never told about significant evidence. As I will describe in Chapter 7, twenty-nine exonerees uncovered evidence posttrial or postconviction and argued that their cases should be reversed because prosecutors had violated *Brady* by failing to disclose material exculpatory evidence that would have helped them to put on an adequate defense. Four of them had their *Brady* claims granted by a judge even before they obtained DNA testing; the others' claims were denied.

But years later, a host of additional possible *Brady* violations came to light. As I will discuss in Chapter 8, many of the exonerees, after they were vindicated through DNA evidence, filed federal civil rights cases asking for financial compensation for their ordeals and demanding that the police or prosecutorial practices that led to their wrongful convictions be changed. This large group of exonerees blamed police misconduct for their wrongful convictions; such cases invariably allege police misconduct, since prosecutors typically enjoy civil immunity for their acts. Such cases can be hard to win, but they can shed considerable light on police and prosecutorial misconduct. In a federal civil rights case, unlike a criminal case, the parties are entitled to gain access to evidence, including not only documents but people as well. Prior to trial, the lawyers can ask witnesses questions under oath (a "deposition") and pose written questions to the other side that must be answered under oath ("interrogatories"). The lawyers of the few exonerees who filed civil rights cases often made document requests for the entire police files and the State's case files and obtained and examined them. At least seventeen exonerees brought claims alleging *Brady* violations, although many of those cases settled without a determination of the merits of the claims.

Lawsuits were not the only way in which new evidence of *Brady* violations came to light. In thirty-one additional cases, lawyers, journalists, scientists, or state investigators uncovered new information. For example, in four cases it later came to light that police had hypnotized eyewitnesses who misidentified exonerees. In at least twenty-two cases, it

emerged that police failed to disclose forensic analysis helpful to the defense. In still other cases, it later emerged that informants who had denied receiving any kind of deal had in fact obtained a deal. In still other cases, prosecutors or police had concealed evidence supporting the defendant's alibi or evidence of third-party guilt.[76] For example, Clarence Elkins discovered only years after his trial that police had notes from an interview with a man who lived right next to the murder site, who made self-incriminating remarks—and whom DNA testing later identified as the victim's killer.[77]

After Thomas Doswell's exoneration, an eyewitness provided his civil rights lawyers with an affidavit explaining that her identification was the product of more nefarious coercion. Doswell had argued at trial that the photo array procedure was suggestive, particularly since there was an "R" written just on his photo. Years later, the witness explained that she actually could not identify the assailant. She had seen him for only a few seconds. She could not identify Doswell in the photo array, even with the "R." The detective told her he was angry, frightening her, and telling her not to tell anyone that she could not identify anyone. She explained that the reason she picked out Doswell at trial was because when the detective drove her to the courthouse, he insisted that she identify Doswell. She was "afraid of him" and succumbed to his pressure.[78]

We may never know whether more evidence of innocence or of official misconduct was concealed. These examples that have come to light, however, certainly challenge the idea of a trial as a fair contest between the State and the defense.

Prosecution Closings

After the defense completed its case, prosecutors delivered closing statements, as did the defense, which summarized the evidence and the arguments for each side. Prosecutors almost always countered any claim of innocence quite directly in their closings arguments. Some responded forcefully and with outrage. They used the claim of innocence against the defendant, to argue that the defendant was not only guilty, but a liar. In Thomas McGowan's case, the prosecutor argued that there had "Not been one inconsistent statement. She is telling the truth. We do not have

the wrong man."[79] In Anthony Green's case, the prosecutor argued, in response to his alibi, that "The defendant is a fraud, a phony and a liar. It's real simple, it's as clear as could be. The defendant is a rapist and aggravated robber."[80] In Chad Heins's case, the prosecutor made fun of the defendant, arguing, "Move over, Chubby Checkers because the twist has been reinvented in this courtroom by that defendant right there. And he's taking every single thing he could that proves his guilt and he's tried to twist it and turn it and make it into what he wants it to be."[81] The prosecutor in Arthur Lee Whitfield's case made a slipup, and told the jury, "We don't want any innocent man (sic) to go free," which he presumably did not mean to say (so the helpful court reporter added the "sic" to the transcript), and then he added, "but Arthur Lee Whitfield is not innocent."[82]

Exonerees argued during their appeals that prosecutors crossed the line during their closing arguments, by making statements designed to inflame the passions of the jury. Three exonerees succeeded in bringing claims that prosecutors rendered the trial unfair during closing arguments, For example, in Curtis McCarty's case, the prosecutor had argued, "I wonder if [appellant] was grinning and laughing that night when he murdered [the victim]." When defense counsel objected to the prosecutor stating his personal view that "I want justice, ladies and gentleman, and justice is . . . that [appellant] be convicted of murder one," he further argued, "He killed that girl. He needs to pay for it." The appeals court did find that to be prosecutorial misconduct, noting that "It is improper for a prosecutor to express his personal opinion of the guilt of an accused."[83] However, such claims are very hard to win. Lawyers are given a wide berth to make their arguments. One must show that the arguments were so egregious that they infected the entire trial with unfairness. For example, in Ronald Taylor's case the defense objected to several statements. The prosecutor had asked the jury, "Do you want this defendant, the bottom line, to go home with you today and go down that elevator with you? Is that what you want? Because that is what a not-guilty verdict will do." The prosecutor had added, "Do you want him out there cruising in his silver '76 Oldsmobile in your neighborhood tonight?" The appeals court approved such statements as a "proper plea for law enforcement."[84]

Judges and Juries

We will never know the details of what went on during deliberations of the jurors, after the prosecution and the defense presented their cases and made their closing arguments, and after the judge gave the jury instructions on the law. The jury room is often referred to as a "black box": the jurors go in, they decide how to resolve the case, and they come back out to the courtroom and give their verdict without reasons for it. But jury rooms are black boxes that occasionally have small windows.

Despite the secrecy of the jury room, we sometimes do have some information about what jurors focused on if they asked the judge a question during deliberations, or more dramatically, if they were deadlocked or could not reach a verdict. We know that some jurors were troubled by weak evidence, because they could not convict these innocent people. Nine exonerees were tried more than once because their first trial ended with a hung jury that was dismissed because it could not reach a verdict.[85] Two of those exonerees had three trials because of hung juries and mistrials. In addition, fifteen exonerees were tried more than once for a different reason—their convictions were reversed on appeal or postconviction. A total of twenty-three exonerees had multiple trials on the same offense (one exoneree had both a hung jury and a reversal on appeal), with eighteen exonerees tried twice and five more exonerees tried three times.[86] As Chapter 7 will describe, all of these innocent defendants were reconvicted until DNA testing finally exonerated them.

Questions from jurors were not always transcribed, and sometimes that portion of the transcript was missing, but in thirty-nine of these trials, the jurors did ask questions. Rather than ask for clarification about the law or the judge's instructions, they typically asked about the evidence in the case. They did so in thirty-two cases, whereas in just thirteen cases they asked questions about the law or the jury instructions. The jurors usually asked to see exhibits or transcripts of testimony, and often focused on important issues. For example, in Roy Brown's case, in which the bite mark testimony was central, the jury asked to review the testimony of the bite mark experts and to see the photographs of the bite marks.[87] In Anthony Capozzi's trial, the jurors asked to have the victim's initial description of the attacker reread; that description did not partic-

ularly resemble Capozzi.[88] In Chad Heins's case, the jurors asked to see a chart explaining the DNA evidence; the judge denied the request because the chart was not admitted into evidence, but the jurors were right to be confused, since the analysts had failed to correctly explain the statistics in that case.[89] In Jerry Watkins's trial, the jurors asked to read again the testimony of the jailhouse informant.[90]

In a few cases, jurors spoke about the case after the trial. A few jurors later spoke to the press about their deliberations. In Rolando Cruz's case, for example, one juror later told the press that "half of the jurors had their minds made up before the trial even started" and that the jury foreman announced that because "[the defendants are] here, they must have done something," and that the deliberations were "a mere formality, so we might as well get on with it."[91] Arvin McGee's third trial is a striking example of what we can discover when jurors speak out after the trial. McGee's first trial had ended in a mistrial, and the second trial ended with a hung jury. After all, the victim had initially identified another photo, and McGee claimed he was physically incapable of committing the crime, having had hernia surgery days before it occurred.[92] Now, at his third trial, in Tulsa, Oklahoma, in 1988, the jurors reported difficulty reaching a verdict after several hours in the jury room. The judge instructed them to continue to deliberate "in a spirit of fairness and candor." This time, the jury returned a guilty verdict.

However, one juror came forward shortly after the trial and long before the DNA testing to say she did not support the guilty verdict. She had remained silent because there was a "lot of pressure" from other jurors. Two other jurors had voted to acquit but changed their minds. For hours, the other jurors told her that the defendant had their names and might rape their family members, and that this rapist could not go free on the streets. They took the "not guilty" jury forms away from her. The hold-out juror finally told them "whatever you want to do, you go ahead and do it." She remained silent without signing the guilt verdict form, but without objecting. The defense moved for a new trial based on these revelations. The judge denied the motion.[93] McGee was not exonerated until more than fourteen years later, in 2002.

In Eric Sarsfield's case, as in McGee's and several other exonerees' cases, the jury was initially deadlocked. After "several votes" and a day

of "active deliberation" the jurors came to the judge in frustration, saying, "We are all at an impasse." The judge gave them antideadlock instructions, reminding them of the reasonable doubt standard that the State must satisfy and encouraging them to try to arrive at a verdict. The jury deliberated again for several hours and returned a guilty verdict.[94] We don't know how they eventually reached a guilty verdict, but we do know that at least some of the jurors initially resisted.

The selection of the jurors may have affected the outcomes in some of these cases. Practices for selecting a jury vary quite a bit. The size of the panel from which the jurors are picked varies, as does the number of challenges that each side can make to dismiss jurors. Courts have different practices for what questions can be asked of prospective jurors during voir dire.

In the trial of Kenneth Adams, Willie Rainge, and Dennis Williams, all three of whom are black, prosecutors had struck all black jurors during jury selection. One prospective juror announced to the judge, "It's obvious the state's attorneys want an all-white jury," and "They don't want me here," resulting in applause for the prospective juror by the courtroom audience. When the judge restored order, five more prospective jurors stated that they also felt the prosecutor was targeting black jurors—and each person who complained was then removed from the jury panel. The final jury had eleven whites and one black woman; a second jury that decided whether Williams and Rainge should be sentenced to death was all white.[95] In Calvin Johnson's case, the all-white jury took forty-five minutes to deliberate and convict him of one of the two rapes he was charged with. Tellingly, a year later he was acquitted of the second rape before a racially mixed jury, even though that jury heard about his conviction of the first rape. We know that several black exonerees had all-white jury trials, including Marvin Anderson, Calvin Johnson, and Anthony Hicks. However, for most of the cases, I could not obtain transcripts of the jury selection process, and even where I could, there was typically no way to discern the jury's composition from those records. I also found that twenty-one exonerees challenged the jury selection in their case on appeal or postconviction. As I describe in Chapter 7, none had any success in doing so.

A final insight into decision making can be gleaned from the few cases in which a judge, not a jury, determined guilt or innocence and from the

cases where judges made comments during sentencing. Twelve exoner-
ees had no jury, but instead a "bench" trial before a judge. Those trials
are fascinating because, unlike jurors, judges publicly explain the rea-
sons why they convict. For example, in Chapter 2 I discussed the judge
in Nathaniel Hatchett's case, who explained why he decided to convict
based on Hatchett's confession, but despite DNA tests that ruled out
Hatchett as the rapist. In Willie Davidson's case, the judge stated that he
found Davidson guilty based on the victim's identification and the foren-
sic evidence. However, he appeared confused by the forensic evidence,
understandably so, because the analyst had presented invalid testimony.
He said that the serology evidence "had the type of a non-secretor. The
defendant is a non-secretor. That by itself isn't totally conclusive. Forty-
two percent are of that." Actually, 42% was not a correct percentage, since
due to the problem of masking described in Chapter 4, any male could have
been the source of the semen.[96] In Richard Johnson's case, the judge com-
mented that the victim, who was initially uncertain when she first identified
Johnson, "was not mistaken, no matter what the defendant says."[97] Other
judges did not provide lengthy explanations of their reasons; for example,
in Bruce Dallas Goodman's case, the judge briefly stated that he was "per-
suaded" by each of the prosecution witnesses, and therefore, "finds the de-
fendant guilty as charged."[98]

We have another window into the decision-making process because
judges, and not juries, often decided what a convicted person's sentence
would be. When sentencing, judges may comment on the case and give
reasons for the length of the sentence. Perry Mitchell was convicted after
the jury deliberated for just an hour, and afterwards the judge told the
defendant that he would impose the maximum sentence of thirty years,
stating: "I am convinced until we do have a neutering law serious crimes
of violence will continue to happen. I know what neutering does to ani-
mals." He added that rapists like Mitchell should suffer "surgical ampu-
tation of the male penis for the simple reason it has been my experience
in approaching the year of 72 that the rapist is a repeater."[99]

We know, then, very little about the process that juries (and judges)
went through in determining guilt. We do not have a recording of what
the jurors said to each other in the jury room. We do, however, have
something important: we know what evidence was presented to the jury
in the trial, because for most of the cases, we have the trial transcripts. We

know what stories these innocent people's defense lawyers told the juries, and having described how the defense typically presented a short and fairly weak case we can begin to understand why these juries and judges believed that so many innocent people were guilty.

The Tilted Playing Field

All of these trials revolved around the question of innocence, and these innocent people did not present a strong defense, in contrast to the prosecution, which had access to substantial investigative resources, and presented confession, eyewitness, forensic, and informant testimony that often seemed powerful at trial. I have described how, first, these people had little ability to locate evidence of their innocence. Second, it is difficult to prove that one did not commit a crime, particularly without any evidence of who actually did commit the crime. One must somehow account for all of one's actions on a day in the past that was not eventful at the time. Third, the defense lawyers in these cases often did not effectively challenge the prosecution evidence or try hard to develop a more compelling alibi. Moreover, evidence of innocence was sometimes concealed from the defense. If indigent defense were better funded, if courts insisted on higher-quality representation for the poor, if lawyers for the poor had better access to investigators and experts, if police and prosecutors provided broader disclosures of evidence and faced sanctions for misconduct, then perhaps the playing field would be more even.[100] As I will discuss in Chapter 9, few such changes have been made in response to these exonerations or otherwise. These problems are deeply ingrained and they implicate the entire structure of our criminal justice system.

The closing statements that concluded Dennis Fritz's trial encapsulated the dynamic in so many of these exonerees' cases. Dennis Fritz faced the death penalty but could not afford to hire an attorney. He later recalled, "[l]ike a lamb going before the slaughter, I was forced to settle for a court-appointed civil lawyer who specialized in bankruptcy and personal injury."[101] The defense case largely consisted of Fritz's own testimony. In contrast, the prosecutor had presented more than twenty witnesses, including a series of forensic experts.

The defense closings at the sentencing stage were three paragraphs long, with his lawyer stating only, "I'll be very brief. I've never stood before 12 people before and asked for a gentleman's life . . . I would ask you to search your soul and come forward with a verdict that you can live with."

In contrast, the prosecutor emphasized, "I'm going to ask you to come back in this court and say, Dennis Leon Fritz, you deserve to die for what you did."

Fritz himself interjected during the prosecutor's closing argument: "I didn't kill [the victim]."[102]

After deliberating for just two hours, the jury announced its sentence: life in prison. The vote of a single juror saved him from the death penalty. Fritz later wrote about how he contemplated the torment of facing a lifetime of imprisonment, asking, "What had I done so wrong in my life that I should deserve this kind of punishment?" He told himself, "However long it takes to prove my innocence, I will not give up."[103] Twelve years later, postconviction DNA testing exonerated him.

Judging Innocence

I N 1992, Kennedy Brewer's girlfriend's three-year-old daughter was abducted from their Macon, Mississippi, home, and was raped and murdered. Police immediately suspected Brewer and arrested him even before the victim's body was found. He had been home babysitting that evening, and there was no evidence of a forced entry, although the window where the victim had been sleeping was open. In 1995 Brewer was convicted of murder and sexual battery and sentenced to death. DNA testing was not used at the time of trial, because the semen sample from the victim's body was deemed insufficient for testing. The chief evidence of Brewer's guilt came from marks on the victim's body. The medical examiner concluded that those marks were human bite marks. Forensic dentist Michael West concluded that nineteen bite marks on the victim's body came from Brewer's teeth. West said he was certain, and before the jury he added his calling card flourish, "indeed and without a doubt." At the time, West had already been removed or had resigned pending expulsion from two associations of forensic dentists due to his unreliable methods and conclusions.[1]

Years later, analysts examined the evidence in Brewer's case and determined that the marks were not human bites at all. They were bites from insects. This was logical. The victim's body had been in a creek for two days, in hot May weather in Mississippi.[2]

In 1998 Brewer's appeal was dismissed by the Mississippi Supreme Court.[3] He asked for a new trial and had brought a battery of claims, including: claims of prosecutorial misconduct at trial; objections to the jury instructions; a challenge to the adequacy of West's credentials; and a challenge to the judge's refusal to let the jury see a videotape showing West manipulating the victim's skin when matching the bite marks. Brewer also claimed that he was innocent. He argued there was not enough evidence of guilt to legally support the jury's verdict. The court emphasized when it rejected all of those claims that there was sufficient evidence of Brewer's guilt; "the child's body was covered with bite marks, which were confirmed by the State's expert as being inflicted by Brewer."[4] The U.S. Supreme Court declined to review the case in 1999.[5]

After four years, his appeal was now complete. Brewer then filed a state postconviction petition. States typically permit a second round of challenges to a conviction, often to give the convict a chance to bring claims that were not or could not be raised during the appeal. Brewer now argued that his lawyer had been unconstitutionally denied access to DNA testing at the time of trial in 1995. He disputed the State's contention that the sample was insufficient for DNA testing.[6] Because it was not clear from the record why DNA testing was not done at the time of trial, and due to a procedural default, the Mississippi Supreme Court dismissed his petition in 2000. After all of the state proceedings are over, convicts can also file a habeas corpus petition with a federal judge to challenge their conviction, although these petitions are very rarely successful. However, Brewer did not pursue federal habeas corpus.

Instead, Brewer kept trying to get DNA tests, which the prosecutors were not willing to conduct. In 2000, the Mississippi Supreme Court issued an order sending the case back to the trial judge for DNA testing. In 2001, the results excluded Brewer and produced a single unknown male DNA profile. The Mississippi Supreme Court again heard the case, and in light of these DNA results, sent the case to the trial court for an evidentiary hearing.[7] This time, the trial judge vacated Brewer's conviction, meaning that the conviction was nullified and Brewer was granted a new trial. He was not yet exonerated, however, because the prosecutors could still decide to try him again.

The prosecutors announced their intent to try Brewer again, but did nothing. He remained in limbo, languishing in jail for five years. Only in 2007, after the Mississippi attorney general intervened, additional DNA testing was conducted, which confirmed the guilt of one of the original suspects, a man named Justin Albert Johnson. Johnson then confessed. Thirteen years after his trial, in February 2008, Brewer was finally released based on this accumulated evidence of his innocence and he was exonerated.

Brewer, like many others, experienced agonizing delays in his quest for an exoneration, even after it was clear that the wrong man was convicted. By 2000, when DNA testing was ordered in Brewer's case, the technology had advanced to the point that it could provide a conclusive answer to the question of his guilt. However, despite the availability of this powerful tool, prosecutors opposed the DNA testing and then, once the testing did exclude Brewer, opposed his release, and as a result he spent eight more years in prison. Like most exonerees, Brewer obtained no relief from judges prior to getting DNA testing.

Kennedy Brewer served fourteen years in prison between his trial and his exoneration. That was about the average prison stay of these exonerees. Compare Brewer's experience to a far less typical exoneration case, that of Curtis McCarty. Curtis McCarty, in contrast, served far more time than the average exoneree—twenty-one years. Although he suffered in prison for many more years, in another respect the judicial system performed better in McCarty's case. In Brewer's case, judges never granted any relief until after the DNA testing. McCarty was one of twenty-one exonerees who actually had success challenging his conviction even before obtaining the DNA testing that ultimately proved his innocence. McCarty's conviction was reversed twice based on challenges to forensic science testimony by the Oklahoma City Police Department crime laboratory analyst Joyce Gilchrist, discussed in Chapter 4.

First, McCarty had his 1986 conviction and death sentence reversed in 1988 because of hair testimony that was invalid. Gilchrist had testified that she could tell, based on hairs found at the crime scene, that McCarty "was in fact there." The court reversed the conviction, noting "[w]e find it inconceivable why Ms. Gilchrist would give such an improper opinion, which she admitted she was not qualified to give."[8]

The victory was short-lived. Prosecutors decided to try McCarty again, and he was convicted again in 1989. When he appealed again, Gilchrist's testimony at his second trial was not found to be grounds for a reversal (this time she wisely did not claim that "he was in fact there").[9]

However, a judge vacated his conviction a second time in 2005. Over fifteen years after his second conviction, McCarty's lawyers had discovered new misconduct by Gilchrist. She had altered and fabricated laboratory reports. She had excluded McCarty as the perpetrator, so she then changed her reports to claim a match, and when asked to produce the hairs examined, said that she had destroyed them. The court emphasized that "Ms. Gilchrist's actions alone warrant a new trial."[10] A first round of DNA testing in 2002 had excluded McCarty. Now, as a third trial date approached, the Innocence Project secured still more DNA tests that excluded him. McCarty was finally exonerated in 2007, after serving twenty-one years in prison.[11]

Long delays between the conviction and the ultimate exoneration were typical in the 250 exonerees' cases. When most of these people were initially convicted, DNA testing was not yet commonly available. Although early forms of DNA testing were available by 1989, exonerations occurred very slowly in the years that followed. It took an average of fifteen years from the time that these innocent people were convicted to their exoneration. Figure 7.1 shows the number of exonerees convicted and exonerated each year. The convictions are heavily concentrated in the 1980s, with a few in the 1970s and a few convictions occurring in the 1990s but trailing off after 2000. Although the first exoneration occurred in 1989, exonerations did not begin to climb in earnest until the mid-1990s. The numbers then dramatically increased starting in the late 1990s, almost a decade after the first exoneration.

Criminal appeals and postconviction review can take a long time. It took these exonerees an average of six and a half years after their conviction to exhaust all of their appeals and habeas proceedings. Some cases, like McCarty's, went on for decades. In this chapter, I explore the lengthy appeals and postconviction process that accounted for the longest delays in the years that passed until their eventual exonerations. Like Brewer, most exonerees had no luck claiming their innocence or challenging the trial evidence until they finally obtained DNA tests.

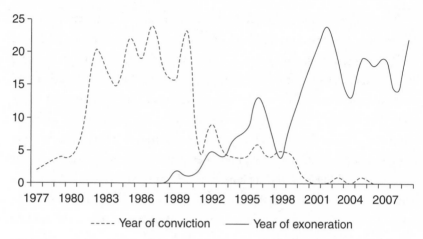

Figure 7.1. Number of exonerees convicted and exonerated per year

Why was it so hard for these innocent people to challenge their flawed convictions?

Challenging Trial Evidence

Mistakes occur in many trials. Sometimes a judge admits a piece of evidence that, under the rules of evidence, should have been excluded, or misstates the legal standard the jury is to apply. Sometimes a prosecutor or defense lawyer misspeaks in a closing statement, misquoting a witness or referring to evidence that the judge asked the lawyers not to mention in front of the jury. One of the most difficult tasks of a judge is deciding which mistakes matter and which mistakes do not. Chief Justice Roger Traynor, of the Supreme Court of California, poetically described the plight of the postconviction judge confronted by thousands and thousands of claims of trial errors: "Errors are the insects in the world of law, traveling through it in swarms, often unnoticed in their endless procession. Many are plainly harmless; some appear ominously harmful. Some, for all the benign appearance of their spindly traces, mark the way for a plague of followers that deplete trials of fairness."[12] The job of the judge is to pinpoint those harmful errors and remedy injustice, but to screen out inconsequential errors that did not cause an unfair trial.

The cases brought by DNA exonerees, who we now know to have been innocent, provide a unique opportunity to assess how well judges sort out harmful errors from the harmless. The previous chapters have described the serious errors common in these exonerees' trials, from flawed eyewitness identifications and contaminated confessions to exaggerated forensic testimony. Now we can examine how well the criminal justice system handled the cases of these innocent people *after* their trials and convictions.

When I reviewed the records in these exonerees' cases I asked myself why the judges hearing these cases on appeal or habeas review did not correct these errors, long before DNA testing entered the picture. The question assumes that these people could somehow show a judge that they were innocent even without getting DNA testing. But at a more fundamental level, the question assumes that after a conviction, higher courts will review the trial record and look for mistakes, to make sure that a miscarriage of justice did not occur.

That second assumption is not a very good one. Judge Jerome Frank and Barbara Frank, in their 1957 book about wrongful convictions, called the notion that the court on appeal will correct the mistaken conviction of the innocent the "Upper Court Myth." They pointed out that the appellate court "knows no more than the jury and the trial judge" and has a limited role. It is "obliged to accept the jury's verdict" and must typically accept the testimony of the witnesses as true rather than reconsider the case based on a cold record.[13] In the decades after they wrote, a criminal procedure revolution has changed the face of appellate and postconviction litigation, creating a host of new avenues to challenge a conviction, but still, very few cases are ever reversed on appeal and postconviction review—no more than 1% or 2%.[14]

When I first began looking at the judicial rulings in exonerees' cases, I thought that perhaps the judges in these cases had taken them more seriously than most. The exonerees earned high numbers of reversals—a 13% reversal rate—in criminal appeals and postconviction proceedings they brought *before* they obtained the DNA testing that exonerated them. This percentage was much higher than the 1%–2% reversal rate that is typical in postconviction cases. Even before the DNA testing, I thought, judges saw fatal flaws in *some* of these exonerees' convictions. However,

I then discovered that this 13% reversal rate was not unusual. The reversal rate in these exonerees' cases was no different from the reversal rates of other rape and murder trials.[15] The grim implication is that rape and murder trials may simply produce higher rates of reversible errors.

To figure out what went wrong in these cases, I needed to study them in detail. Our criminal justice system does not collect in one place all of the records for a criminal case as it progresses. It is hard to get complete information about the life cycle of a criminal case. I tracked down as much information as I could about each stage in the review process following these exonerees' convictions, including each criminal procedure claim they raised postconviction and each ruling a court rendered on each of their claims. Because courts issued written decisions in about two-thirds or 66% of the cases (165 of 250 cases), combing through this mass of opinions does not tell us what happened in every case, but it can allow us to make some generalizations about how courts judged innocence. I studied only the exonerees who had judges issue written decisions explaining their rulings during their appeals and post-conviction proceedings.[16] After all, in cases where they chose not to write an opinion, we do not know the reasons why judges ruled the way they did, and we often cannot even tell what claims they ruled on.

A troubling story emerged when I looked closely at the claims that exonerees made and the rulings they received during their appeals and postconviction proceedings. Many exonerees did not challenge the central types of evidence supporting their wrongful convictions—or if they did, judges did not think it was worth mentioning in their written opinions. Of the exonerees who did receive written decisions during appeals and postconviction, one-third (55 of 165 cases) challenged none of the central facts that supported their convictions.

When these innocent people *did* challenge the evidence that had led to their convictions, they were very rarely successful. A look at the exonerees with written decisions who were convicted based on particular types of evidence sheds light on this fact. For example, how many convicted based on eyewitness misidentifications challenged those identifications postconviction? Of the 124 exonerees who were convicted on the basis of an eyewitness identification and obtained a judge's written decision, only 56% challenged the eyewitness identification (70 of 124 cases).

Only 7% were successful (5 of 70 cases). Similarly, only 32% of those who had forensic evidence at trial challenged the forensic evidence (36 of 112 cases) and 17% succeeded (6 of 36 cases). Only 36% challenged informant testimony (16 of 45 cases) and 25% succeeded (4 of 16 cases). The largest proportion, 59%, challenged false confessions (13 of 22 cases), but only 8% had any success (just 1 of 13 cases).

We now know that this trial evidence was flawed, and that many of those errors were in fact the kind that Chief Justice Traynor called "ominously harmful." However, the judges reviewing these exonerees' claims during appeals and postconviction often called those errors "harmless" and even referred to the perceived strength of the prosecution case and the likely guilt of the petitioners. These innocent people had no better success raising claims asking for a new trial on the basis of evidence of their innocence; all such innocence claims were rejected.

How did these innocent people go about challenging what had happened at their trials? Why did so many of them fail to bring factual challenges? And when they did appeal or seek habeas relief, why did judges fail to see that they were innocent? In the next sections, I will start to explore these issues, beginning with how exonerees tried to challenge the evidence presented at their trials.

False Confessions

Recall from Chapter 2 that almost all of the exonerees who falsely confessed challenged their confessions at trial, typically by claiming that the police coerced them into making the confession statements. To my surprise, after their trial, several of the people who falsely confessed no longer challenged their confessions, even when they were otherwise appealing their convictions. Of the twenty-two innocent people who were convicted based on false confessions and had written decisions in their cases, only seven raised Fifth Amendment claims that their confessions were involuntary, and three more alleged their confessions were obtained in violation of *Miranda*. None of these claims was successful.[17]

The only successful claim was a kind of claim that can only be brought on appeal or postconviction—that the trial lawyer provided ineffective assistance by not sufficiently attacking the validity of the confession at

trial. Three of the exonerees made such claims relating to their confession, and one of those three, Ronald Williamson, obtained a reversal. But in that case, the lawyer did much more than simply fail to challenge the co-erced confession, which was admitted despite Williamson's manifest mental illness; he also failed to challenge invalid forensic testimony, among other failures. Indeed, before trial he had begged the judge to let him withdraw from the case. "I can't represent him Judge; I just can't do it," his lawyer had insisted. "I'm too damned old for it, Judge. I don't want anything to do with him, not under any circumstances."[18]

When exonerees did bring challenges to their confessions directly, courts emphasized the seeming reliability of the confessions. In many of the cases, courts noted the reliability of these confessions when denying relief, often by highlighting the nonpublic and corroborated facts that played such an important role at trial. The courts often also cited the "overwhelming" nature of the evidence against the defendants, describing in detail the nonpublic and "fully corroborative" facts they each supposedly volunteered.[19] For example, the Illinois Supreme Court stated that Alejandro Hernandez "did not present an argument which convinces us that he learned the details of the crime contained in his 'vision' from law enforcement officers."[20]

In nine more cases, the exonerees allegedly made self-inculpatory statements to police but not a full confession to any of the crimes. Four of those exonerees also brought coerced confession claims regarding their statements to police.[21] None of these alleged voluntary statements, as re-ported by police or witnesses, were successfully challenged on appeal or postconviction, likely because a claim of coercion would be difficult to make for a statement that was putatively volunteered.

Thus, although 59% of the exonerees who falsely confessed and had written decisions did challenge their confessions (13 of 22 cases), only one of them succeeded, where the trial lawyer failed to challenge the confes-sion but also made a series of other mistakes and omissions. In contrast, courts often cited the seeming reliability of these detailed confessions when denying relief on these and other claims. The contamination of these confessions, described in Chapter 2, not only made the convictions a foregone conclusion but also made it very difficult for these innocent people to challenge those confessions on appeal or postconviction.

Eyewitness Identifications

Although the vast majority of these exonerees, 67%, were convicted based on eyewitness identifications (190 of 250 cases), some did not even challenge those identifications, and few who did succeeded. Of those exonerees who were convicted based on a mistaken eyewitness identification, 56% of those who obtained a written decision postconviction brought a claim challenging the identification (70 of 124 cases).

As described in Chapter 3, many exonerees were identified based on suggestive eyewitness identification procedures. Indeed, the most common type of claim involving eyewitness testimony was that police improperly indicated to the eyewitness who the suspect was. Thirty-nine exonerees brought such a claim. None were granted. Four exonerees asserted their right, established by *United States v. Wade,* to have a lawyer present at a postarrest lineup; none of the claims were granted.[22]

Some exonerees raised other less direct claims. For example, rather than claim that an eyewitness identification was unreliable, one might indirectly assert that the attorney was ineffective for failing to challenge the eyewitness testimony. Thirty exonerees made indirect challenges to the identifications, such as for ineffective assistance of counsel, newly discovered evidence of innocence, or improper jury instructions.

Only a handful, five exonerees, earned reversals based on faulty eyewitness identifications. McKinley Cromedy's conviction was reversed for failure to instruct the jury regarding the dangers of cross-racial identifications. Lesly Jean had his conviction reversed because it was not disclosed that the victim had been hypnotized (and may have first identified him while under hypnosis). The first trial of Ronald Cotton was reversed because the judge had excluded evidence that one of the two victims raped in similar attacks on the same night had identified another person. Michael Evans was granted a new trial because the State did not disclose that police had paid their star eyewitness $1,250. Mark Webb's conviction was reversed because there was evidence that the victim, who had earlier not been able to identify him, violated the rule against discussing the case with other witnesses—she used a bathroom break during the trial to talk to her sister, after which she was then suddenly able to identify him.[23]

None of these unusual cases was a classic example of police using suggestive eyewitness identification procedures, such as a showup, or making suggestive remarks. The only one of the five cases that raises the problems of suggestion and unreliability that were so common in these eyewitness misidentifications, as discussed in Chapter 3, is Cotton's case, where the judges reversed the conviction because they felt the jury should have heard about how an eyewitness had earlier been less certain than she was at trial. Even that was an unusual case, since the eyewitness had not only earlier failed to identify Cotton but she had identified another man.

What about the 44% who did not challenge their faulty eyewitness identifications at all? Some exonerees may have defaulted on any such claim by failing to preserve an objection at trial, but others may have simply decided that such a claim would be futile. As discussed in Chapter 3, the Court held in *Manson v. Brathwaite* that even if the police engage in suggestive procedures so potentially misleading that their conduct violates due process, the identification may still be admitted at trial if it was otherwise "reliabl[e]."[24] Even identifications resulting from highly suggestive procedures may nevertheless be admitted given other indicia of reliability, such as eyewitness certainty. Almost all of these eyewitnesses expressed great confidence at trial that they had identified the right person.

As a result, most exonerees had no successful basis for challenging what we now know to be incorrect eyewitness identifications. For example, in Steven Barnes's case, his photo was the only one repeated in two photo arrays. The court ruled that "the passage of two and one-half years between the two arrays negates any possibility of suggestiveness" and that the witness demonstrated an independent basis for the in-court identification of defendant."[25] Similarly, David Bryson argued that the police engaged in suggestion. In finding no error, the court emphasized how certain the victim was. The court ruled that "Certainly, if T.T. had been hesitant or tentative in her pre-trial identification, the police comments would have rendered the confrontation unnecessarily suggestive."[26] In Anthony Green's case, the court noted that his photo was the only one repeated in two arrays, and in the first, his was the only photo that was a "wallet-type photo," while in the second, his photo stood out as the only

"mug shot" with a physical description. Without discussing suggestive remarks also made to the victim, the court concluded that because her attention was "acute" during the incident, she "in fact made eye contact" with the attacker, and "immediately recognized" him in the arrays, the identifications were properly admitted.[27] Given the reliance of judges on eyewitness certainty, some defendants and their lawyers may have simply decided that a postconviction challenge would be fruitless. Indeed, of the thirty-nine people who did make these kinds of challenges to suggestive identification procedures, none prevailed.

Forensic Evidence

Although forensic evidence was the second leading type of evidence supporting these erroneous convictions, once again few challenged that evidence and even fewer obtained reversals. This seems surprising on its face, where 61% of the prosecution forensic testimony at exonerees' trials was invalid testimony that misstated the relevant scientific principles, and still more cases involved unreliable forensic techniques, vague testimony, and concealed forensic evidence. One would think that clear deviation from scientific principles would be relatively easy to identify as compared, say, to a challenge to an eyewitness whose memory has become irreversibly contaminated. The poverty of the defendants may explain this. Without access to an expensive forensic expert, these defendants' lawyers may not have understood that the forensic testimony was invalid. As a result, they may not have challenged the evidence at trial, which they needed to do in order to preserve the issues for appeal.

Six exonerees did obtain reversals based on challenges relating to forensic evidence at trial, or 17% of the 36 exonerees with written decisions who challenged the forensics in their cases. Three of those exonerees challenged the forensic analysis itself. As I discussed earlier, Curtis McCarty had his conviction reversed twice, the first time because the analyst claimed erroneously that she could tell, based on microscopic hair comparison, that "he was in fact there" at the crime scene."[28] Ray Krone's first conviction was reversed because the prosecution did not disclose until the eve of trial a highly unusual and prejudicial videotape in which the bite mark expert demonstrated the supposed match by holding

molds of Krone's teeth to the deceased victim's body.[29] Testifying of behalf of Steven Linscott, a forensic expert rejected any notion that probabilities can be used in hair evidence. Yet in his closing statement to the jury, the prosecutor asserted that the defense expert had endorsed such probability testimony, which the appellate court in reversing the conviction found to be a "rank, calculated distortion."[30] The three additional exonerees who earned reversals related to the forensic evidence challenged the inadequacy of their defense lawyers for not sufficiently disputing the forensic evidence, but also for other failures unrelated to forensics.[31]

More typical were cases where judges denied relief despite unreliable and invalid testimony by forensic analysts. Thus, in appeals brought by William Rainge and Kenneth Adams, the Illinois appellate court ruled that though "the State said the probability of finding similar hairs from different people was 1 in 4,500," and that statistic had no support, the argument did not "sufficiently mislead a jury as to require reversal."[32] Similarly, the Montana Supreme Court denied Chester Bauer's appeal despite invalid serology testimony that, as I described in Chapter 4, included a litany of errors, including ignoring the problem of masking and by wrongly dividing the offered statistic in half.[33]

These decisions are part of a real abdication of responsibility by judges to ensure that sound science is presented in our courtrooms. Not only did trial judges neglect their duty as gatekeepers to prevent experts from using unreliable methods or offering exaggerated conclusions on the stand, but after the convictions, in the cases where these errors were pointed out, judges looked the other way and dismissively ruled that the testimony was tolerable or probably did not make any difference at the trial.

Informant Testimony

Cases with informant testimony exhibited the same pattern, in which central evidence from trial typically went unchallenged. Of the people convicted based on informant testimony who had written decisions on appeal or postconviction, only 36% challenged informant testimony (16 of 45 cases). Only four of them succeeded. As I described in Chapter 5, we now know that many of these informants testified falsely when they

claimed that the exoneree had told them "inside information" about the crime.

One person, Verneal Jimerson, did win a reversal based on a fabrication claim, not attacking evidence provided by a jailhouse informant but instead attacking the coerced confession of his alleged coconspirator. As described in Chapter 5, in Jimerson's case police concealed that they obtained the testimony of codefendant Paula Gray by offering her inducements. Gray's testimony is now known to be false: she was a juvenile, mentally retarded, innocent, and wrongly convicted along with the four others whom she incriminated in what became known as the Ford Heights Four case.

If most of these people did not directly claim that the informants had fabricated the evidence against them, how did they attack the informant testimony? Rather than claiming that the informant fabricated the story, which would have been impossible to prove, they asserted that they were denied the right to counsel during an interrogation by a government informant (*Massiah* claims), were denied effective counsel at trial (*Strickland* claims), had favorable evidence concealed from them (*Brady* claims), had evidence improperly introduced against them (state law claims), or that the judge failed to properly instruct the jury.[34] Three of these claims were successful.

Darryl Hunt brought a state law claim that the trial judge had violated evidence law rules by allowing a prosecution witness to discuss a prior statement by a cooperating witness that contradicted her testimony at trial, but which was not a sworn statement.[35] Rolando Cruz managed to demonstrate that the jailhouse informant who testified at his second trial had obtained leniency that was not disclosed to the defense, but though this revelation influenced the court, he did not assert a separate claim related to the informant testimony.[36] The federal court granted Ronald Williamson's habeas petition in part because his lawyer was ineffective not just for failing to attack the confession and the forensics, but also for failing to impeach the jailhouse informant with public information that she had served as an informant in his case and another case, and received a suspended sentence for her cooperation.[37]

Jerry Watkins also managed to win a new trial, but ultimately the judge decided not to address whether the police and prosecutors had

concealed the fact that they had offered the informant in his case a deal and had fed him specific details of the crime. The federal judge discussed this evidence at length. Watkins had denied at trial that he had ever confessed in jail, but recalled that "a man he did not know had been in the holding cell the day of his sentencing and had asked him lots of questions about his case." Watkins recalled that he "just kept buggin' and buggin' me trying to see what he could get out of me," and that he finally "got tired of him askin' me so I told him" nothing more than "what charge I was in for."[38] Watkins called as a witness a fellow inmate who heard the informant describe "a scheme for getting out of jail. The plan was to find an unsolved crime, have a confederate research the newspaper coverage," and then convince police he heard about the crime.[39]

After his conviction and during his postconviction proceedings, Watkins submitted a "Motion for Relief from Judgment" that the jailhouse informant signed under oath in October 1987 in his own criminal case. The informant recanted, stating:

> That the State of Indiana did in fact pay (with promises) for this petitioner's testimony, and did in fact show him not only the "death-site," but "grizzely" [*sic*] pictures of the murder in order to inflame this petitioner's feelings towards the defendant (Jerry Watkins), and thus secured (for the state) a statement from this petitioner that could, and was used to obtain a conviction.

He went on to say that he was cheated and that "the Courts [of] the (State of Indiana) and (Jerry Watkins) were cheated as well."

The court concluded that if this motion was true, it was "explosive." If the informant had received the "detailed information" about the murder from police or a prosecutor, "that information utterly destroys the state's case against Watkins" and it "described an intentional corruption of the criminal justice system." The court noted that the prosecution had at trial brought in newspaper articles about the case to show that the jailhouse informant had "specific, correct knowledge that he could not have derived from newspaper articles." During the closing arguments, the prosecutor had argued: "Did he research it in the paper as has been intimated? I don't think so . . . it just couldn't happen."[40] Although this

story had a happy ending, because the court reversed Watkins's conviction and granted him a new trial, and he was then exonerated, the federal judge failed to ensure that the prosecutors who allegedly fed facts to the informant were appropriately sanctioned. Although the judge concluded that the "prosecution's failure to disclose such information would amount to suborning perjury and corrupting the judicial process," he declined to investigate further. Because the prosecutors had also concealed a range of evidence that pointed to another culprit (a *Brady* violation), the judge was able to reverse on that ground alone without investigating whether the prosecution had engaged in any unethical behavior concerning the jailhouse informant that should have led to sanctions. Typically, the postconviction judge declined to investigate much less recommend that the prosecutor suffer any consequences at all for potentially grave misconduct.

To return to the questions that I began this chapter with, why did so few exonerees challenge the evidence at their trials, whether it was eyewitness, confession, forensic, or informant evidence, which we now know was so often deeply flawed? Why did so few who did so succeed? The rulings in these exonerees' cases show how the appellate and postconviction process is not designed to review factual errors. Judges view their role chiefly to correct legal errors. Judges are reluctant to second-guess the verdict of the jury. Judges do not offer many legal remedies for factual deficiencies in criminal trials. Even where there has been a clear violation of a legal rule, judges will often insist that the error was "harmless." As law professor Anthony Amsterdam has put it, "there is a remarkable unwillingness to take claims of innocence at all seriously."[41] As we will see in the sections that follow, judges often deny relief because they think the convict is obviously guilty—even if they agree that constitutional rights were clearly violated.

Put yourself in the shoes of the innocent convict. If you know that judges will not take seriously a claim that you are innocent or that the factual evidence at your trial was flawed, then you may focus on trying to raise other claims that might have a better chance of succeeding. You, or your lawyer, may know that judges are more likely to grant procedural claims. Those claims are technical, but may be far more commonly raised at trial and on appeal. They are also easier claims to make. In contrast, to

bring a claim of innocence or to challenge the facts at trial, one may need to reinvestigate the crime, try to obtain additional police files, review the forensic evidence, track down alibi witnesses, or hire an expert to assess the defendant's mental capacity or confession statements. All of that work is difficult and expensive. Nor will defense lawyers likely be held accountable for their failure to develop a factual record either at trial or on appeal. All of this in turn reinforces the unwillingness of judges to take innocence-related claims seriously. Even in cases where such claims are raised, where neither law enforcement nor defense lawyers develop crucial facts, perhaps due to underfunding, courts may be placed in a difficult position, asked to judge innocence based on a sketchy record and years after the trial took place.[42]

Exonerees also ran afoul of the myriad technical obstacles that courts have erected postconviction, including rules requiring that claims be exhausted in precise ways and that proper objections have been asserted at trial. While such procedural errors may be the lawyers' fault, the petitioner—here, the wrongfully convicted person—usually bears the consequences. I next turn to those complex rules surrounding appeals and postconviction proceedings to show how they stymied the efforts of these innocent people to obtain reversals in their cases.

Stages of Criminal Review

Which courts review a conviction after a criminal trial? After a conviction, the convict can raise claims at three different stages of review: the direct appeal, state postconviction proceedings, and federal habeas corpus. The direct appeal occurs immediately following the conviction. Every convict is entitled under the U.S. Constitution to file an appeal and to have a lawyer (often his trial lawyer) represent him on appeal. They can raise a host of claims related to the evidence admitted at trial, together with state law and federal constitutional claims. First, a motion for a new trial is filed with the trial judge, and if the judge rejects the motion, an appeal is filed with state intermediate courts and the state supreme court. If all of those state courts deny the appeal, which they typically do summarily and without writing an opinion, then the convict has an opportunity to ask the U.S. Supreme Court to review the case.

Once the appeal has gone through this process, the conviction is said to be final. Any proceedings that follow are called "postconviction," because they occur after the conviction is finalized, although they are also commonly called "state habeas." Such review is optional, and states do not need to make it available, although all do make some type available. It is also called "collateral," or secondary, because it is separate from the appeal, and often allows the convict to raise new claims that could not be raised before or are based on new evidence outside the trial record.

Although states do not have to provide a lawyer to the postconviction petitioner, and most convicts proceed without a lawyer, or pro se, this is not easy to do, since the rules for filing postconviction petitions can be byzantine in their complexity. There are rules about the proper use of the trial record, a host of detailed timing rules, notices that must be filed, and affirmations that must be sworn under oath. Claims must be preserved in the right form and they must be "exhausted," or filed at the first available opportunity. Any technical error can result in the rapid dismissal of the petition. Most petitions are summarily dismissed based on these technicalities. And those are just the procedural rules. If a petitioner representing himself from prison actually manages to master the deadlines, correct forms, and other technical requirements, he still must act as his own lawyer to figure out what substantive legal claims he might raise. But postconviction law is one of the most difficult areas to master: the claims themselves are extremely difficult, the standards are often unclear, the cases are contradictory, and the law varies among jurisdictions and it changes over time. Most pro se petitioners simply don't stand a chance. Further, one of the real difficulties in studying how judges handle these petitions is that so few rulings are in written form. Most judges simply "rule from the bench," dismissing the petition orally, or rule by writing a very short statement denying the claims without giving any reasons.

State postconviction review runs again through the state courts, beginning with the trial court, up to the state supreme court, and if the petition is denied, the convict may again seek certiorari from the U.S. Supreme Court. Once this review is complete, the petitioner can turn from the state to the federal courts. A federal habeas corpus petition may be filed in a U.S. district court, with possible appeals to a court of appeals,

followed by a third opportunity to seek certiorari from the U.S. Supreme Court. Federal courts will examine petitions only where all of the claims have already been presented to the state courts, and they are very deferential to the factual and legal findings of the state courts. Every step of the way, judges become more deferential to the findings of the judges that came before, making it more and more difficult to raise new claims or new evidence of innocence.

Completing all three levels of review takes time—many years—and very few convicts pursue all of those types of review. All of the 165 exonerees for whom written decisions from their appeals or postconviction proceedings could be located pursued direct appeals. By the time they filed their state postconviction petitions, the number still pursuing relief through the courts had dropped below half: only 43% of them filed such a petition (71 of 165 cases). And only 21% took the next step (35 of 165 cases), filing a federal habeas petition, although this number is actually quite high for this stage of litigation, as generally only 1% to 2% of state inmates file a federal habeas petition.[43] One explanation for the high percentage of habeas filings among these exonerees may be that most received long sentences, so they had the time and the incentive to pursue even the slowest and lengthiest challenges to their convictions. For many convicts, by the time their case has wandered its way through the courts on both a direct appeal and a state habeas petition, they have finished serving their prison sentence and they see no need to file a federal habeas petition.

The U.S. Supreme Court did not hear all of these petitioners' claims, but it did rule on 38 petitions filed by these innocent people. It summarily denied each of these petitions without giving reasons, except Larry Youngblood's. In Youngblood's case, the Court heard oral arguments and issued a written opinion explaining why it rejected his claim that he should receive a new trial because law enforcement failed to properly preserve biological evidence from the crime scene. Twelve years later, DNA technology had improved enough that the very evidence that had been degraded through law enforcement's negligence was testable. The DNA tests exonerated Youngblood.[44]

Reversals, Retrials, and Vacated Convictions

Some of the exonerees did meet with partial success during their appeals and postconviction process, but this success was usually short-lived. Some of the exonerees obtained a "reversal," which I define as an order upheld on appeal that results in the grant of a new trial and a vacating of the conviction or convictions. Among these actually innocent individuals, obtaining a reversal did not usually end their ordeal. Juries wrongly convicted them multiple times. Twenty-one exonerees of the 165 with written decisions in their cases received reversals, for a 13% reversal rate. But fifteen of these exonerees were retried after the reversal of the original conviction. All of them were convicted again. Thirteen exonerees had two trials, and two—Rolando Cruz and Alejandro Hernandez— each endured three trials before being freed as a result of DNA testing. Six more exonerees had no retrials because DNA testing was conducted and exonerated them before their scheduled retrials. (As discussed in the last chapter, nine exonerees also had retrials for a different reason— because of hung juries.)

The reversals were concentrated among the cases of exonerees who had been sentenced to death. Of the twenty-one exonerees who received reversals, eight were in capital cases while thirteen were in noncapital cases. This is no surprise. As documented in the landmark study by James Liebman, Jeffrey Fagan, and Valerie West of all capital cases from 1973 through 1995, there are extremely high reversal rates (68%) in all capital cases, both in state and federal postconviction review.[45] The reversal rate just in the capital cases among exonerees was quite high, 47% (eight of seventeen cases). If one removes the capital cases from the analysis of these exonerees' cases, the reversal rate falls from 13% to 9%.

Judges granted most of those reversals during the direct appeal. Of the twenty-one who received reversals, sixteen received them during the direct appeal, one during state habeas review, and four during federal habeas review. Changes in the law did not play an important role, since it did not significantly change during this time period.

Criminal cases in general have a much lower reversal rate than the 9% that the noncapital cases had here. Studies have shown that approximately 1% of federal postconviction petitioners receive relief, with similar figures

(1% to 2%) in state courts.[46] I wondered, however, whether the reversal rate is higher for rape and murder convictions. To figure out whether the 9% reversal rate was typical of the kinds of serious rape and murder convictions at issue in the exonerees' cases, in a prior study I constructed a group of randomly selected rape and murder cases from the same time period and the same states, one for each of the noncapital cases with written decisions among the first 200 exonerations. The "matched comparison group" reversal rate was almost identical to the exonerees' rate: 10% instead of 9%.[47] Exonerees fared no better postconviction than the randomly selected rape and murder cases.

The similarity in reversal rates could be because serious rape and murder convictions share a reversal rate of about 9%. The trials for murder and rape may simply be more error prone than other less serious and less complex criminal trials. A second and related explanation may be that judges accurately detected innocence in some exonerees' cases and so reversed their convictions, and that in a similar percentage of the matched comparison group appeals, judges did the same. In the matched comparison group, half of the reversals involved a ruling on a claim challenging the factual evidence at trial. Thus, half of the error rate had something to do with a perception of innocence, or relatedly, weakness of the evidence of guilt, and not procedural errors. As discussed next, most of the reversals in the innocence group were based on such factual challenges. Though we cannot know how many in the matched comparison group are innocent, nor how often judges granting reversals accurately corrected wrongful convictions, the incidence of reversals on factual claims in appeals of serious convictions provides cause for concern regarding the accuracy of such criminal trials. Because DNA evidence is not available in most cases, we can never know how many postconviction petitioners are really innocent.

Cases Where the Innocent Received Reversals

The cases where exonerees did receive reversals deserve special examination, because in those cases courts provided relief without the benefit of DNA evidence. Perhaps those cases can tell us something about how well judges assess innocence in the vast majority of criminal cases in

which they do not have easy answers from a DNA test. Although, as I discussed earlier in this chapter, few exonerees challenged the factual evidence at their trials, most of the select group of innocent people who received reversals had judges grant their claims relating to the facts supporting the convictions.[48] Of the exonerees who obtained reversals, two-thirds involved such factual claims (fourteen of twenty-one cases). Recall from earlier in the chapter that one reversal related to the trial lawyer's failure to challenge the confession, five involved challenges to eyewitness identifications, six related to forensic analysis, and four related to informant testimony (some reversals related to more than one type of evidence).[49]

In three more cases, although the reversals were not related to the reliability of the state's case at trial, they were related to the defense case at trial, and they were based on the trial judge's suppression of evidence of third-party guilt.[50] The other four reversals were for purely procedural claims, such as faulty jury instructions and ineffectiveness of counsel unrelated to failure to suppress or challenge factual evidence.[51]

There is more evidence that in some exonerees' cases judges were focused on evidence of innocence, or weak evidence of guilt. Though it was infrequent, when judges made a statement that suggested that an exoneree might be innocent, typically by way of describing how the state's case appeared quite weak, they often reversed. A court made such a statement for eight of the eighteen reversals. This was not typically an outright finding of innocence, but rather a strong acknowledgment of the flimsiness of the evidence of guilt adduced at trial. For example, in Ronald Williamson's case, his so-called dream confession was admitted at trial despite his manifest mental illness. The federal district court judge vacated his conviction, citing the "weakness of the case" against him, which relied on evidence the court of appeals later called "largely circumstantial and hardly overwhelming."[52] Likewise, in Ronald Cotton's case, the state court also vacated the conviction, noting that the excluded evidence "tended to show that the same person committed all of the similar crimes in the neighborhood in question on that night and that the person was someone other than the defendant."[53]

Supporting this finding, economist and law professor J. J. Prescott and I conducted a series of regressions to break down this data using a

far more comprehensive set of variables than those discussed in this book.[54] We found that exonerees who made claims of innocence on appeal—asserting claims of actual innocence, claims of insufficient evidence, or claims of newly discovered evidence—were more likely to receive reversals of their convictions. This was true even though few prevailed on those particular claims. In addition, exonerees were more likely to receive reversals if they brought claims that challenged the reliability of trial evidence, as opposed to purely procedural claims.

Judges may have perceived innocence in some exonerees' cases, or at least they did not think that those cases had such open-and-shut evidence of guilt. Judges have anecdotally described how they care about the strength of the evidence when considering appeals, and some studies have also suggested that innocence matters to judges examining appeals and postconviction petitions.[55] However, just because judges sometimes grant appeals or petitions because they are concerned about possible innocence does not mean that they do this consistently, accurately, or very often. Judges may far more often act on a bias toward confirming the trial outcome. These exonerees' cases do not give us good reasons to think that courts are good at judging innocence. In most of the cases of actually innocent litigants, judges simply confirmed the trial outcome. Next, I describe how claims of innocence were made and how most failed, with judges instead expressing belief in the convict's guilt.

Judging Guilt and Innocence

As Chief Justice Traynor described, the task of the judge postconviction is to sort the errors that are "plainly harmless" from those that "appear ominously harmful." The U.S. Supreme Court has developed a test for determining whether errors made at a criminal trial were so egregious that a new trial should be granted, called the "harmless error test." Under this test, which was developed in a case called *Chapman v. California,* a court may refuse to grant a criminal appellant a new trial even if mistakes of constitutional magnitude were made in her criminal trial so long as the State can show "beyond a reasonable doubt" that the constitutional error did not contribute to the guilty verdict at trial.[56] The notion is that it would be wasteful to order an entire second trial if the error

was so inconsequential that it did not truly play a role at the first trial. After all, the error would be corrected at the second trial, and the person would just be convicted again.

Harmless error analysis, where the judge replays the entire trial and decides holistically whether an error made a real difference, is notoriously flexible. Judges may be susceptible to confirmation bias. That is, they may—unconsciously or not—credit the evidence supporting the guilty verdict and discount flaws in the state's case. Indeed, a harmless error ruling may also involve a judgment that the error would not have impacted the jury, given outweighing evidence of guilt, though the Court has expressly cautioned against employing harmless error analysis in that improper fashion.[57] Such analysis gives judges even greater leeway to excuse constitutional violations based on their perception that the defendant did it.

Many of the 250 exonerees argued that the trial judges in their cases had made errors that had contributed to their convictions. But in most of their cases, the appellate judges ruled that any errors made at trial were harmless; in other words, mistakes were made, but the defendant was clearly guilty, or regardless whether any mistakes were made, they did no harm. Although these defendants, we now know, did not do it, and some of these mistakes may have played a role in their wrongful convictions, for 30% of exonerees with written decisions a court relied on harmless error in refusing to reverse a conviction (49 of 165 cases). Some of those, 14% of the exonerees with written decisions (23 of 165 cases), had a court agree that a claim had merit, but nevertheless deny relief due to harmless error. Some exonerees, 18% of the exonerees with written decisions (30 of 165 cases), received rulings similar to a harmless error ruling, but under a slightly elevated standard by which the court found that they did not suffer "prejudice" as a result of the trial error. A total of 38% of these exonerees with written decisions (62 of 165 cases) had either a harmless error ruling or a "no prejudice" ruling during their appeals and postconviction (some had both types of rulings).

There is more evidence that some judges were animated by a belief that these innocent people were guilty, and not just that the errors raised were of an inconsequential nature. In writing their decisions, judges sometimes directly labeled these people as guilty convicts. In 47% of

these exonerees' cases with written decisions, courts referred to the likely guilt of the exoneree (78 of 165 cases), typically by describing the reliability of the prosecution's case.

In 10% of these exonerees' cases, courts were so sure of guilt that they called the evidence of guilt "overwhelming" (16 of 165 cases).[58] For example, a court denied Jeffrey Deskovic's appeal, stating, "There was overwhelming evidence of the defendant's guilt in the form of the defendant's own multiple inculpatory statements, as corroborated by such physical evidence as the victim's autopsy findings."[59] What judges considered to have been "overwhelming" varied. At times they did not clearly explain what they meant. In retrospect, many of these cases no longer look so strong at all. However, at the time of the appeal or habeas petition, many cases may have seemed quite strong precisely due to the contamination of the evidence that prior chapters have described.

Taken together, in 62% of these exonerees' cases with written decisions (102 of 165 cases), judges either commented on guilt, found error to be harmless, or found no prejudice. All of this underscores how difficult it is for judges to weigh a cold trial record—but that is exactly what appellate and postconviction judges are called on to do.

In addition to judging evidence of guilt, judges may also rule on evidence of innocence. Judges (typically only state judges engaging in habeas review) may ask whether newly discovered evidence of innocence would have changed the outcome at trial. In limited circumstances, federal courts also examine new evidence of innocence. Only 25% of those with written decisions (42 of 165 cases) raised innocence-related claims, including claims entitling the exoneree to relief based on new evidence of innocence, or *Brady* claims that prosecutors concealed significant evidence of innocence from the defense at the time of trial. Several exonerees raised more than one innocence-related claim.

Judges rejected every claim of innocence in which an exoneree argued that he should be released based on newly discovered evidence of innocence. Only 10% of these exonerees raised state law claims seeking a new trial based on newly discovered evidence of their innocence (17 of 165 cases). None of those exonerees received relief prior to obtaining DNA testing. Typically such claims are difficult to win. One must show that there is a reasonable probability that the newly discovered evidence

would have changed the outcome at trial. Many states provide that such claims based on new evidence of innocence can only be brought within a short time after the trial.[60]

When raising such claims of innocence, 4% of these exonerees brought claims under the U.S. Constitution, citing *Herrera v. Collins* and arguing that their conviction should be vacated based on their actual innocence (6 of 165 cases). Judges rejected all of those claims. This comes as no surprise: no petitioner has ever received relief under that claim.[61] As I will explain in the next chapter, in *Herrera* the Supreme Court only said for the sake of argument that a petitioner might receive relief if he or she could provide a "truly persuasive" demonstration of innocence.[62] While this may come as a surprise, since a right to be freed if one is innocent seems fundamental, the Supreme Court to this day has not decided whether a claim of innocence can in fact be made under the U.S. Constitution. Any right to relief based on innocence remains so conjectural that these six actually innocent people who raised such claims all failed.

Four exonerees out of the forty-two who brought innocence-related claims were granted reversals, all on *Brady* claims. Though *Brady* claims do not provide relief expressly on the ground that the petitioner is innocent, they do relate closely to innocence. *Brady* claims require a showing that the prosecutor failed to disclose evidence of innocence to the defense, and this evidence was significant or "material" enough that there is a reasonable probability that concealing the evidence affected the outcome at trial.[63] Twenty-nine exonerees raised *Brady* claims. As I described in Chapter 6, one cannot know how many exonerees were convicted based in part on prosecutorial or police misconduct. Evidence of innocence that was in the possession of the police or prosecution can stay concealed even after a DNA exoneration.

One might think that DNA evidence would be particularly powerful evidence of innocence at a criminal trial, such that no prosecutor could be allowed to conceal it. Yet in Darryl Hunt's case, the Fourth Circuit Court of Appeals rejected his *Brady* claim, though the State's attorney had told his lawyer at the time of trial that the biological material was "too degraded to be tested." The court held that DNA technology was new at the time and Hunt's lawyer "had equal access to the fluid samples,

and thus he was under an independent duty to pursue testing alternatives."[64] The Fourth Circuit denied Hunt relief, even though initial DNA testing had by that time excluded him. Ten years after DNA tests excluded him, and five years after that Fourth Circuit decision, a cold hit in a DNA database identified the culprit, and Hunt was finally exonerated, in 2005.[65]

Before they had DNA tests, most exonerees did not have new evidence of their innocence to present to a judge, and if they did, it was sometimes not particularly strong.[66] One petitioner, Willie Jackson, did have compelling non-DNA evidence of innocence: the in-court confession of the true perpetrator, his brother. The district court granted his habeas petition, emphasizing that Jackson's brother had convincingly confessed to the crime and that the statute of limitations had not yet expired, but the Fifth Circuit then summarily dismissed the petition. Years later, DNA testing inculpated the brother.[67]

Other exonerees did not or could not bring innocence claims, but they did stake out their innocence in their briefs. For example, Eddie Joe Lloyd did not make a legal claim to relief on the basis of innocence, but in no uncertain terms, he told the court on the first page of his pro se federal habeas brief that he was "'*ABSOLUTELY*', '*TOTALLY*' and '*COMPLETELY INNOCENT.*'"[68]

Still more exonerees, lacking any means to directly claim innocence, did assert in large numbers claims on sufficiency of the evidence governed by the Supreme Court's ruling in *Jackson v. Virginia*.[69] Of the exonerees with written decisions, 42% brought a *Jackson* claim (69 of 165 cases). That claim is not based on allegations of new evidence of innocence, but it argues there was not sufficient evidence presented at the trial to convict beyond a reasonable doubt. Such sufficiency claims sometimes highlighted unreliable factual evidence at trial, thereby providing a quasi-factual challenge, though one based on the context of the entire trial record. In bringing a *Jackson* claim, a petitioner must show that, viewing the evidence in the light most favorable to the prosecution, no rational juror could find beyond a reasonable doubt that the prosecution proved the essential elements of the crime. Perhaps due to this stringent standard, no exoneree who brought a *Jackson* claim received a reversal that was upheld on appeal.

It remains very difficult to obtain relief on a claim of innocence. This explains why few of these actually innocent people raised such claims and why almost none who did succeeded. Although the next chapter will describe how states have introduced new statutes making it easier to claim innocence postconviction, in many respects little has changed since these exonerees brought their challenges. Indeed, in one way, these exonerees had an easier time raising their claims. The enactment of the Antiterrorism and Effective Death Penalty Act (AEDPA) in 1996 imposed a litany of rules that restrict federal habeas corpus review, including strict time limits, limits on filing more than one habeas petition, and requirements that federal judges defer to state court findings, even to the extent that judges must deny relief in some cases where they find that the petitioner's constitutional rights were in fact violated.[70] The AEDPA did not significantly impact these exonerees' habeas petitions, since almost all exonerees filed their petitions before it took effect. The restricted federal substantive review that left some of these exonerees without a meaningful remedy was far more generous than the narrower habeas review that federal judges would provide today.

Ineffective Assistance of Counsel

Ineffective assistance of counsel is one of the most frequently raised claims during postconviction proceedings,[71] and 32% of these DNA exonerees (52 of 165 cases) asserted that their trial was unfair because their defense lawyer was inadequate. The Supreme Court ruled in *Strickland v. Washington* that indigent defendants are constitutionally entitled to minimally effective representation. This representation, however, need only fall "within the wide range of reasonable professional assistance." To win a *Strickland* claim and have a guilty verdict overturned on grounds of ineffective assistance of counsel, a convict must show more. The attorney's ineffectiveness must have materially prejudiced the outcome at trial, so that "there is a reasonable probability that, but for counsel's unprofessional errors, the result of the proceeding would have been different."[72]

Commentators have derided the *Strickland* standard as nothing more than a "foggy mirror" test—if a mirror held under the defense lawyer's

nose during trial would fog up, indicating the lawyer was at least alive and breathing, the lawyer has provided adequate assistance.[73] Rulings evaluating what "reasonable professional assistance" means vary widely. Although higher standards have been imposed in certain death penalty cases, notorious decisions have denied relief despite terribly shoddy representation, including cases in which lawyers literally fell asleep or presented no meaningful case at trial.[74]

Four of the exonerees earned reversals due to grossly ineffective representation of trial counsel. Ronald Williamson, the only exoneree to assert a claim related to a false confession, had his conviction vacated due to a claim that trial counsel failed to show that he was mentally incompetent to stand trial and that another man confessed to the crime, among other failures.[75] The other three, Paula Gray, William Rainge, and Dennis Williams, were all represented by the same lawyer, who was later disbarred for unrelated reasons. Their lawyer failed to even move to suppress central physical evidence, such as hair evidence, and Gray argued that the joint representation of all three created conflicts of interest.[76]

In every other case in which exonerees claimed ineffective assistance, judges ruled that they had failed to satisfy the *Strickland* standard. That does not mean, however, that they received adequate assistance of counsel. After all, judges may conclude that any missteps by counsel did not "prejudice" the outcome, because the prosecution case was more than sufficient to convict. Recall from Chapter 6 how Earl Washington Jr.'s trial lawyer had failed to meaningfully represent him at trial, including by failing to even raise the fact that forensic evidence excluded him. Washington's new postconviction team of lawyers filed state and federal habeas petitions alleging that his trial lawyer was ineffective. His trial lawyer even submitted an affidavit admitting that he simply did not understand the scientific evidence and if he had, he would have litigated the issue. A series of federal judges ultimately rejected his claim, emphasizing that Washington had confessed "as one who was familiar with the minutiae" of the crime.[77]

Other exonerees raised seemingly strong *Strickland* claims that judges rejected. For example, in at least twelve cases, defense counsel failed to ask for DNA testing available at the time of trial that could have

exculpated the defendant—yet only four raised postconviction claims on this subject. One would think that those claims would be particularly clear. The DNA testing could have potentially proven their innocence, as it later did. Yet even among those who raised the issue, only one of the four, Anthony Hicks, received a reversal, and only after the court knew he was innocent because the DNA testing had just been conducted.[78]

Trial records suggest that although other exonerees did not assert *Strickland* claims postconviction, the effectiveness of their trial counsel was limited. Only eleven exonerees raised *Strickland* claims regarding failure of the defense lawyer to adequately challenge eyewitness identifications, and none of them had any success. Only fourteen exonerees made *Strickland* claims regarding failures of defense lawyers to challenge forensic evidence, yet invalid forensic evidence was presented in ninety-three trials, and more often than not, the defense lawyers failed to bring the errors to light. Only one exoneree, Ronald Williamson again, asserted that his defense lawyer failed to properly challenge a confession. This may be because almost all of the defense lawyers did in fact move to suppress the confession. Yet defense lawyers were not necessarily very effective at challenging the confession; as discussed in Chapter 2, they could have far more often introduced experts to show that the defendant confessed due to mental disability or youth, and that the defendant was suggestible.

Thus, just as exonerees often did not challenge the trial evidence during their appeals and postconviction, they also did not often use *Strickland* claims to bring to light the failures of their defense lawyers to challenge the evidence at the trial. When they did, judges usually denied relief, including by finding any error to be nonprejudicial or harmless.

Prosecutorial Misconduct

Not only did exonerees raise claims challenging their trial lawyers as inadequate, but even more raised claims that prosecutors played a role in their conviction. The U.S. Supreme Court has described how a prosecutor is a public servant obligated to ensure that "justice shall be done,"

and not to simply secure a conviction at any cost.[79] It is especially important that prosecutors play by the rules, because they play a dominant role in criminal cases. As described in Chapter 6, the prosecution presented most of the evidence and called most of the witnesses at these trials. Prosecutors had access to all of the evidence that police gathered. As a result, prosecutors also played a crucial part in these wrongful convictions. Exonerees claimed as much on appeal and postconviction, with some success.

Indeed, of the twenty-one exonerees who obtained a reversal before getting DNA testing, ten did so in part based on a claim of prosecutorial misconduct. A range of claims relate to the conduct of prosecutors, and 47% of the exonerees with written decisions (77 of 165 cases) brought such claims. Of those, forty-two involved claims of unduly prejudicial arguments, which as discussed in Chapter 6, are very difficult to win, because of the wide latitude courts give lawyers to make arguments, although three exonerees did obtain reversals on those grounds. As discussed, twenty-nine exonerees also raised *Brady v. Maryland* claims, and four obtained reversals on the ground that the prosecution concealed exculpatory evidence from them.

The U.S. Supreme Court has long held that it is "inconsistent with the rudimentary demands of justice" for a prosecutor to knowingly put on perjured testimony.[80] Just as it is hard for a convict to find out that prosecutors concealed evidence of innocence, a convict may have no way to prove that prosecutors knew that their witness was lying. However, four exonerees brought such claims. and one exoneree, Verneal Jimerson, obtained a reversal on that ground.

Another twenty-one exonerees brought claims that prosecutors improperly selected or rejected jurors. As discussed in Chapter 6, none prevailed on such claims, which are very difficult to win. For example, if the prosecutor moved to strike minority jurors from the pool, a defendant can claim that this was discriminatory, but if the prosecutor can offer any benign reason for objecting to the juror, the claim will typically be denied.[81] Kennedy Brewer, whose story I told at the beginning of this chapter, challenged the way that the prosecutor struck six black potential jurors. Brewer was black and alleged that this pattern was discriminatory. However, the appellate court denied Brewer relief,

citing to the prosecutor's range of reasons to explain each strike; one juror had a "penchant for soap operas," another had prior run-ins with the law, and another read publications that often "railed" against the death penalty.[82]

A few exonerees also brought claims relating to other types of prosecutorial misconduct during the trial. Of those, Ray Krone, whose case was discussed in Chapter 4, obtained a reversal of his conviction, because prosecutors had failed to provide the defense until just days before the trial a provocative and macabre video of the bite mark examiner holding molds of Krone's teeth to the victim's body. Rolando Cruz obtained a reversal on the grounds that prosecutors improperly questioned their own witness.[83]

Thus, not only did many of the exonerees who successfully obtained reversals before they obtained DNA testing make claims challenging the trial evidence, but many of those exonerees also challenged the conduct of prosecutors at their trials. Ten exonerees obtained reversals based on prosecutorial misconduct. Of course, the vast majority of these exonerees failed in their efforts to claim prosecutorial misconduct. Courts were also unwilling to call out prosecutors on misconduct or ethical lapses, and nor did courts recommend any sanction. We saw earlier in this chapter how in Jerry Watkins's case, the federal judge was unwilling to even look into whether the prosecutor had fabricated evidence, though he conceded such conduct "would amount to suborning perjury and corrupting the judicial process." The prevalence of *Brady* violations that came to light years later, allegations of prejudicial prosecution arguments, and other claims of improper conduct in these wrongful convictions, all suggest that we should take the problem of prosecutorial misconduct far more seriously.

Dissents

Did some judges disagree with these rulings denying relief to the innocent, perhaps seeing something that the other judges did not see? Dissents are noteworthy, because they are not common. They show that a judge felt strongly enough that the decision the other judges were reaching was wrong, that she needed to speak her mind and explain why she

voted the other way. Judges authored dissents in 21% of these exonerees' cases (34 of 165 cases). In twenty of those dissents, judges disagreed with their fellow judges' rulings denying exonerees relief. Many of the dissenting judges also commented on possible innocence, usually by noting the weakness of the prosecution's case. For example, in Larry Youngblood's case, Justice Harry Blackmun wrote a prescient dissent:

> Because semen is a body fluid which could have been tested by available methods to show an immutable characteristic of the assailant, there was a genuine possibility that the results of such testing might have exonerated respondent. The only evidence implicating respondent was the testimony of the victim.[84]

Similarly, in Lesly Jean's case, a dissenter wrote that "Unlike the majority, I believe the issue of defendant's guilt is close."[85] In Bruce Goodman's case a dissenter asserted that "[t]here is *no probative evidence* at all that the defendant was at the scene of the crime."[86]

The reverse also occurred: seven exonerees received dissents from decisions in their favor. Some dissenting judges commented on their belief in the exonerees' guilt. For example, in Rolando Cruz's case, a dissenting judge stated, "After two verdicts of guilty and 11 years after the murder, the defendant now gets a third roll of the dice. The pressure on the prosecutor to negotiate a plea . . . may be irresistible. In any event, justice is the loser."[87] Now that postconviction DNA testing was conducted, we know that justice did not lose.

Substantive Errors and Criminal Review

An innocent person who is convicted does not face an easy road to freedom. Judges do not encourage convicts to assert their factual innocence on appeal or postconviction. Judges face profound difficulties when judging innocence postconviction. This is understandable. Judges cannot easily review a "cold" trial record years after the trial took place. Moreover, the hesitance of judges may be warranted. Even if judges hold a hearing to revisit factual evidence, which they rarely do, they find "erosion of memory and dispersion of witnesses."[88] Years after a trial, it may

be too late to find out whether evidence was contaminated or unreliable early on in a criminal investigation.

How many innocent people are there whose cases never make the news because the system works when appellate judges reverse their convictions and there is no need for a DNA exoneration? We cannot answer that question. However, the experiences of these innocent people do not provide good reasons to be optimistic that judges can effectively detect and provide relief to innocent convicts. These exonerees often did not raise their innocence or factual claims. As we saw, very few who did make such claims succeeded. Yet the select few who did obtain reversals may have done so because they did succeed in signaling their innocence to judges who were concerned that something had gone wrong. Far more often, judges found any errors to be harmless, such as by citing the strength of the prosecution case or the defendant's likely guilt. All of this suggests that judges can sometimes identify evidence of innocence when it is put before them, but our current system makes it very hard for such claims to succeed.

What can be done to improve the accuracy of postconviction review? If more resources are provided, they may be most useful during the direct appeals, when less time has passed, when convicts have lawyers, and when sufficiency of the evidence claims can be raised. Most exonerees who did receive relief did so during the direct appeal. Yet given how long it took for evidence of innocence to surface in these cases, we should also examine ways to enhance factual review during postconviction proceedings. Some states have found ways to make it easier to investigate claims of innocence and remedy wrongful convictions. In the remainder of the book, I will discuss several ways to do that, such as by passing new postconviction statutes. New avenues to assert innocence, however, are not enough, unless convicts have the resources to investigate facts and uncover potential evidence of innocence.

The main focus of this book is on reforming criminal investigations to prevent wrongful convictions in the first instance, and not on the postconviction process, which serves as only a backstop. Even an improved postconviction system still must overcome the deep institutional reluctance of judges to reverse criminal trial verdicts. Indeed, not only did these exonerees confront a series of postconviction barriers before they

obtained DNA testing, but like Kennedy Brewer, whose case began this chapter, they also faced the reluctance of prosecutors and judges to allow DNA testing and to exonerate even after the DNA testing demonstrated a person's innocence. The next chapter turns to those obstacles at the end of the road to exoneration.

Exoneration

A STRING OF VICIOUS MURDERS had been committed in the Fort Lauderdale area. Frank Lee Smith became a suspect in the rape and murder of an eight-year-old when residents thought he resembled a composite sketch. He was schizophrenic and had been twice convicted of manslaughter when he was a teenager. At trial, the evidence against him chiefly consisted of testimony by an eyewitness. She testified that she saw him jumping out of the window of the victim's house at around the time of the murder. There was "no doubt" in her mind that Smith was the person she saw. The detective also reported that he duped Smith into making an admission of his guilt. The detective told Smith that the eyewitness saw him commit the crime. Smith reportedly responded, "No way that kid could have seen me. It was too dark." The detective claimed that only a guilty person would know that the eyewitness was a child and that the crime occurred at night in a dark room. Smith denied ever making such a remark. In 1986, the jury convicted Smith and sentenced him to death.[1]

More than a decade passed as Smith pursued appeals and habeas relief, with no success. In 1998, Smith's lawyers obtained a stay of execution and began seeking DNA testing to bolster their case for his innocence. The State's star eyewitness had since recanted her account. She

claimed that prosecutors had pressured her to identify Smith. She said the prosecutor told her that Smith was "dangerous," and "not to worry about my testimony because the man would be locked up and electrocuted the following May . . . I was just feeling so pressured."[2] She said that the man she saw close to the time of the murder was actually another man named Eddie Lee Mosley.[3]

The prosecutor refused to agree to the DNA testing and successfully opposed motions seeking DNA testing for years. Indeed, a detective now claimed, contrary to his earlier testimony in the case, that he had already showed the eyewitness a photo of Mosley and that she had not identified him. The prosecutor's opposition to DNA testing could prevent it from being done. At the time, years after DNA testing had become available, very few states provided a right for an inmate to gain access to DNA evidence postconviction. The evidence was in the custody of the State, and after a conviction, the State could deny access to the evidence or destroy it—even if the evidence could prove innocence.

Unable to gain access to the DNA testing he sought, Frank Lee Smith languished in prison. Meanwhile, two Fort Lauderdale detectives along with Smith's lawyers and an investigator had been investigating Eddie Lee Mosley. They eventually connected him to sixty rapes and seventeen homicides in the area. They obtained DNA testing that linked Mosley to those crimes, including eight rape-murders that Jerry Townsend, another innocent man, had been convicted of. In Chapter 2, I mentioned that Townsend was mentally ill and had falsely confessed to every unsolved murder the police asked him about. With DNA testing implicating a serial murderer and rapist in the area, law enforcement finally consented to test the evidence from Frank Lee Smith's case. DNA testing ultimately confirmed Mosley's guilt and proved Smith's innocence, but the tests were not completed until December 2000.

That was too late. Ten months earlier, Smith had died of cancer on Florida's death row.[4] In pain in the prison hospital, Frank Lee Smith protested his innocence on his deathbed. He died waiting for the DNA testing that he had fought for so many years to obtain. His conviction was vacated posthumously. Jerry Frank Townsend was also exonerated and released, having spent twenty-two years in prison. During those years, Mosley continued his "reign of terror," committing additional murders.

Innocence Project founder Barry Scheck called Mosley a "one man crime wave."[5]

In reaction to Smith's case, Florida passed a statute in 2001 entitling a petitioner to obtain DNA testing and, if the results are exculpatory, a reversal of his or her conviction. Like many states that have enacted new innocence claims in recent years, however, Florida included several restrictions limiting access to testing, such as a requirement that a petitioner satisfy a preliminary showing of innocence to receive DNA testing. For example, the statute barred access to DNA testing to persons who pleaded guilty. Jerry Townsend never would have been able to get DNA testing under the statute, as he had pleaded guilty to several crimes to avoid execution.[6]

Even after passage of that statute, judges in Florida continued to deny DNA testing to people who requested it—including innocent people. James Bain spent more time in prison than any other exoneree—thirty-five years. For eight of those years he sought DNA testing. He began requesting DNA testing in 2001, when Florida passed its statute. He filed five separate handwritten requests from his prison cell, and he was denied each time. He appealed each time, and judges called his requests untimely or improper. Prosecutors argued that there was no "reasonable probability" that the DNA tests would make any difference in his case. He needed a lawyer. When lawyers from the Florida Innocence Project took his case, they finally persuaded a judge to order DNA testing in 2009. With the DNA results excluding him, the prosecutor admitted, "He's just not connected to this particular incident," and agreed the conviction should be vacated.[7]

The Long Road to Exoneration

It is difficult to imagine what it must be like to spend so much time behind bars for a crime one did not commit. As I have mentioned, these innocent people spent an average of thirteen years in prison, and it took even longer, an average of fifteen years from the conviction for them to obtain exonerations.[8] By the time they were exonerated, some of these people were no longer in prison, since they had been released on parole or on bail pending a new trial, but they continued to wait to obtain the

exoneration. Why did it take so long to exonerate these innocent people?

When I began looking at these exonerees' cases, I expected to find that appeals and postconviction proceedings would take many years. After all, by definition, these were people convicted before DNA testing was available, and they would have to wait for it to be developed. I also knew that even when DNA testing became possible, there was often initial opposition to it. Yet until I analyzed these exonerees' cases over time, I did not appreciate just how substantial those delays were, even well into the time period that DNA testing was readily available. I had no idea just how resistant judges and prosecutors would be to the idea that the system might have made a mistake.

Indeed, most of the delays these exonerees experienced occurred while they tried to obtain DNA testing and then an exoneration. Consider the average exoneree's timeline from conviction to exoneration. The average year of conviction was 1987, two years before the first DNA exonerations occurred. The lengthy appeals and postconviction process described in Chapter 7 took on average more than six years and was complete, on average, in 1993. Yet that was less than half of the time these innocent people waited to obtain an exoneration. The first DNA testing that excluded these innocent people was not conducted until, on average, 2000—more than a decade after the first DNA exoneration. Once those DNA test results provided powerful evidence of innocence, these people still faced obstacles; on average, it took more than a year to obtain the exoneration. The average year of exoneration was 2002, long after DNA testing was in wide use and innocence projects had become well established.

The story of Frank Lee Smith, and Florida's halting reaction to his case, helps to explain why it took so long for these people to obtain their exonerations. If prosecutors opposed DNA tests, judges would often not order the tests, and even after states enacted statutes in response to exonerations, prosecutors and judges still let cases fall through the cracks. Ronald Jones's case, discussed in the opening pages of this book, provides another example. Recall that Jones was convicted after police interrogated him and he falsely confessed to a rape-murder he did not commit. After DNA testing became available, Jones asked to be tested,

and the judge refused, asking, "What issue could possibly be resolved through DNA testing?" But Jones persisted, and the Illinois Supreme Court ordered the testing done. Incredibly, even once the DNA testing showed that he was not the perpetrator, he waited for two more years for prosecutors to decide not to retry him and one more year for a pardon. Our system, despite the availability of DNA, still places a series of road-blocks before prisoners seeking to prove their innocence. This chapter describes the long and legally challenging path to exoneration.

Evolving DNA Technology

The fascinating story of the invention of the DNA technology that exon-erated these 250 people explains in part why these particular wrongful convictions came to light, and also when they came to light. One might expect that once DNA testing was invented, innocent people would be able to quickly take advantage of the new technology and win their free-dom. However, we will see that DNA technology is most useful only in certain types of cases, particularly rape cases. In addition, the technol-ogy improved quite dramatically during the decade after the first DNA exoneration occurred, in 1989. More powerful DNA testing techniques took some time to be adopted by crime labs around the country, and the steady advance of DNA technology partially explains the gradual rise in the numbers of DNA exonerations.

The case of Earl Washington Jr., whose trial was described in Chap-ter 6, spans the entire period of time during which DNA testing first be-came available and then advanced to include far more powerful types of testing. When Washington was convicted in 1984, based on his seem-ingly powerful confession, he was sentenced to death and would soon face an execution date. Yet at the time, DNA testing was in its infancy. Three-fourths of the exonerees were convicted before DNA testing was available, and most were also convicted in the 1980s. In the mid-1980s, scientists developed the technology underlying DNA testing. Research-ers discovered that portions of the code in all human nuclear DNA did not perform any known genetic function. This so-called junk DNA was highly variable. Scientists developed technology to splice portions of DNA and then replicate it exponentially using an enzyme chain reaction.

This allowed them to determine with much more accuracy than ever before the likelihood that biological evidence could come from a particular person. Unlike serology, which tended to show that a person was included in a large percentage of the population that shared blood types, DNA testing became powerful enough to show that one person in millions or billions would randomly match a genetic profile.

DNA testing turned out to be of particular use in rape cases. As Chapter 4 discussed, when a woman seeks medical treatment after a rape, hospitals prepare a rape kit that contains a swab from the victim's vagina. Usually, this swab will contain a mixture of skin cells from the victim and perhaps also sperm cells from a rapist. But often, forensic analysts could not tell whether the typically larger amount of material from the victim was "masking" any information from sperm. Testing of the sample often revealed only the victim's type, and if nothing other than the victim's type was found, then the attacker could have been any male, with any blood type.

But forensic scientist Edward Blake made an elegant discovery in the mid-1980s that changed criminal law forever. Blake developed a technique that solved the problem of masking, called "differential extraction." The process took advantage of the fact that sperm cells have thicker cell walls than skin cells. A mild detergent washed the mixed fluid and broke open the skin cells, releasing their genetic material. During this first wash, sperm cells did not break open, because they have thicker cell walls. A stronger detergent was then used to break open the sperm cells, allowing the analyst to test just the genetic profile of the sperm. This technique could rule out any danger that the evidence could have been accidentally contaminated at the crime scene or in the laboratory. Since the sperm cells were isolated, unless there was a reason why someone else could have deposited sperm on the sample, the genetic profile from sperm had to come from the rapist.

This biology explains why DNA testing can be such powerful evidence of either guilt or innocence in stranger rape cases. This also explains why DNA has been used far less often in other kinds of far more common criminal cases, such as assaults, robberies, drug possession cases, or misdemeanor cases that receive no trial. In such cases it may be harder to rule out contamination of the evidence, since other people

aside from the victim and the culprit may have been present at the scene
or had a reason to be in contact with the evidence. Nor is DNA testing as
useful in cases that do not usually make use of forensic evidence, such as
most rape cases, which involve disputes about consent between acquain-
tances and not the identity of the rapist.[9]

The first DNA exonerations in 1989 sparked a criminal justice revolu-
tion, but it took some time for the full impact of DNA testing to be felt.
One reason was that early DNA tests were not very discerning. The first-
generation DQ Alpha DNA testing examined only eight genetic markers
shared by large populations.[10] Typical results would show only that one
in, say, 6% of the population shared a profile, an improvement over blood-
typing, but still not very probative.

By the late 1980s, Earl Washington Jr. had come within nine days of his
execution. The only way to forestall his execution was to file a state ha-
beas petition. But the State did not provide inmates, even death row in-
mates, with lawyers to file state habeas petitions. Another inmate who
was a skilled jailhouse lawyer, finally filed a class action to draw attention
to the plight of inmates, like Washington, who could not possibly be ex-
pected to file habeas petitions on their own. Washington, after all, could
not accurately write his name, much less draft a legal brief. This bold
move caught the attention of lawyers at a New York law firm. A team of
attorneys took on Washington's case pro bono. They filed a habeas peti-
tion arguing that his confession was faulty, forensic evidence excluded
him, and his trial lawyer was ineffective. Those petitions were denied, by
state and then by federal judges.

By 1993, DNA testing was Washington's last hope. After spending nine
years on death row, with all of his appeals and habeas proceedings spent,
Earl Washington Jr. obtained DNA testing using the DQ Alpha tech-
nique. The results did not include him and cast "substantial" doubt on
his guilt, but according to the Virginia Department of Forensic Science
analyst, did not conclusively exclude him either. It was hard to imagine
how the test results, which did not match Washington, had failed to es-
tablish his innocence. During the final hours of his term, Governor
Douglas Wilder commuted Earl Washington Jr.'s death sentence, sparing
him from execution. Yet despite the DNA tests, although Washington left
death row, he remained in prison to serve a life sentence.[11]

As Washington languished in prison, scientists developed still more remarkable genetic tools. By the early 1990s, Restriction Fragment Length Polymorphism (RFLP) testing was developed to identify fragments of DNA by running an electric current through biological material dissolved in a gel medium. This RFLP testing was far more discerning than DQ Alpha testing. It could generate the types of random match probabilities that we are now familiar with, such as figures that one random person in millions or billions or even trillions could be expected to share a profile. However, RFLP testing required a very large quantity of nondegraded genetic material, and interpretation of the results was potentially subjective.[12]

The greatest leap forward in DNA testing technology occurred by the mid-1990s, with the development of modern and much more powerful Short Tandem Repeat (STR) DNA testing. STR testing could be used with a polymerase chain reaction (PCR) to amplify and test minuscule samples, even just a few cells. New capillary electrophoresis technology permitted fast and largely computerized analysis of genetic samples.[13]

In the late 1990s, two other forms of testing, mitochondrial DNA (mtDNA) testing and Y-STR DNA testing were developed, further expanding the kinds of cases where DNA testing could be useful.[14] Both forms of DNA testing have been used to exonerate innocent people. MtDNA testing can be conducted on hairs that have no cells with nuclear DNA attached to them, on which no other form of DNA testing could be conducted. However, mitochondrial DNA is inherited matrilineally, and is shared by relatives, so the results are less conclusive than other kinds of DNA (two cousins, related on their mothers' side of the family, for example, could both be included as possible sources of a sample). Y-STR testing is conducted on the Y chromosome, which is inherited patrilineally. Y-STR testing can be useful if the evidence is degraded and other forms of DNA testing cannot be conducted. Since male relatives share the same profile, two cousins related on their fathers' side would share the same Y-STR profile. Y-STR testing was used to show that Sally Hemings's male descendants shared a genetic profile with male descendants of Thomas Jefferson.[15] Thus, over more than a decade, DNA testing evolved into a powerful set of techniques that can test minute particles of evidence from a crime scene.

One final technological development came with the rise of modern STR DNA testing—the creation of state and then national databases, or the Combined DNA Index System (CODIS), which now contains millions of genetic profiles.[16] Any unknown DNA profile detected in a case can now be entered into the national database system. The databases contain over three million profiles and their size continues to expand, particularly since all fifty states and the federal government enacted laws permitting collection of DNA from those convicted of serious felonies,[17] and now even arrestees and detainees can have their profiles entered into the database.[18]

On Monday mornings at precisely 9:00 A.M., the CODIS database conducts an automatic search to compare all of the millions of profiles against those from unsolved crimes.[19] As new profiles from convicts and arrestees and others are entered into the system week by week, new database matches, or "cold hits," sometimes solve those cases. Those computerized database searches also help to solve the cases that these innocent people were convicted of. In 45% of the DNA exonerations to date (112 of 250 cases), postconviction DNA testing identified the perpetrator, usually through a cold hit in the CODIS database.[20]

These newer technologies finally freed Earl Washington Jr. in 2001. Investigative journalists discovered that a second DNA test excluding Washington had never been disclosed to his lawyers back in 1993 when he was denied full clemency. The Virginia laboratory was now under pressure to test the evidence again using more sophisticated STR testing. They did so, and again "botched" the test results, claiming that they did not exonerate Washington. A "sharply critical" independent audit later concluded that these results were false and were due to political "pressures" not to exonerate Washington.[21]

Another miracle intervened. Washington's steadfast team of lawyers discovered that a second set of slides taken from the victim had been saved from the hospital where she had died. Those slides had never been tested. An outside laboratory tested them using STR DNA testing. The results did not just conclusively exclude Washington. As the Virginia lab then confirmed, the profile matched in a cold hit another man who was serving a life sentence for an unrelated rape. That man eventually pleaded guilty to the crime. Earl Washington Jr. was finally exonerated and freed from prison.[22]

The combination of the development of STR DNA testing and DNA databases led to an acceleration in the numbers of DNA exonerations, from a trickle in the early 1990s, to ten to twenty a year by the late 1990s. Only thirteen people had been exonerated by the end of 1993, when more-advanced STR DNA testing was first available. Only thirty-nine individuals had been exonerated by the end of 1997. In 2007, Jerry Miller became the 200th person exonerated by DNA testing. Just three years later, in February 2010, Freddie Peacock became the 250th person exonerated by DNA, and the last person included in the group I examine in this book.

Do advances in the use of DNA portend the end of DNA exonerations? You might expect DNA exonerations to drop off once DNA testing became common before trial. For now, the number of DNA exonerations per year continues to increase, and fully one-quarter of all DNA exonerations still occur for cases with recent convictions from the 1990s and even the new century. Why is it that there are trials, taking place when DNA testing is routine, where innocent people are still wrongly convicted? In some cases, prosecutors or defense attorneys failed to request that DNA testing be conducted. In others, DNA technology has advanced since the trial to make new types of testing possible. In still more cases, the State concealed the existence of biological evidence, or worse, made testing errors. Although DNA testing is now routinely done during criminal investigations, technology is only as perfect as the people using it, and as long as we have human error we will continue to have DNA exonerations in the future.[23]

The Supreme Court on the Sidelines

The improvement of DNA technology does not explain why Frank Lee Smith could not get DNA testing when it was available, or why so many other exonerees initially had requests for DNA testing denied. Why couldn't they simply ask a judge to provide them with DNA testing, over the objections of prosecutors and police, and then be exonerated once the tests proved they were innocent? The answer is that legal change can be much slower than technological change. During the same time period that DNA technology advanced and these 250 exonerees began to obtain

DNA tests, the Supreme Court repeatedly avoided addressing whether there should be a claim of innocence—a right under the Constitution to obtain a new trial on the grounds that one is innocent.

In a provocative 1970 article, Judge Henry Friendly asked why innocence is "irrelevant" to federal habeas corpus review, rather than being the main preoccupation of judges.[24] A host of constitutional rights can be asserted in federal courts, such as the *Brady* and *Strickland* claims that so many exonerees brought. The one claim that no convict can easily bring is a claim that he is innocent and should be freed for that reason alone. In the decades since Judge Friendly posed the question, evidence that convicts may in fact be actually innocent has mounted. The Supreme Court had every opportunity to recognize a constitutional claim of actual innocence but repeatedly refused to do so. Three Supreme Court decisions, *Herrera v. Collins, House v. Bell,* and *Osborne v. District Attorney's Office,* illustrate the Court's indifferent approach.

In *Herrera,* the Court asked whether a person can avoid execution based on evidence of innocence. In its 1993 decision, the Court assumed for the sake of argument the existence of a constitutional right to challenge a conviction based on "truly persuasive" evidence of "actual innocence."[25] The Court never said what a "truly persuasive" showing consists in, holding that whatever it was, Herrera did not satisfy it. Over the years, lower courts similarly assumed the existence of some undefined right to claim innocence in a death penalty case. Several people later exonerated by DNA testing tried to assert such claims, but with no success. After all, the right was just hypothetical.

In the second case, the 2006 decision in *House v. Bell,* the Court had another chance to actually recognize an innocence claim.[26] Paul House asked the Court to consider new evidence of innocence, including DNA test results. DNA results excluded House as the rapist, but the results also included the victim's husband and so they did not necessarily point to the rapist and murderer's identity. The Court ruled that this evidence of innocence was powerful enough that "more likely than not," a new jury would not convict him.[27] But the Court did not order House released. Why? Because the Court still would not recognize a right to claim innocence. Instead, the Court ruled that this evidence justified the district judge's reconsideration of House's otherwise defaulted claim that his trial

attorney was inadequate. The ruling did give his lawyers time to pursue new DNA tests. By May 2009, a new round of DNA tests on multiple pieces of evidence, including hair and materials from the victim's finger-nails, excluded not only House but also the victim's husband, and pointed to an unknown culprit.[28] House was then exonerated.[29]

The Court's third chance to recognize an innocence claim arrived in the 2009 case of *District Attorney's Office v. Osborne*.[30] A convict, Wil-liam Osborne, sought DNA testing to prove his innocence. The State conceded that the results could "conclusively establish Osborne's inno-cence."[31] Osborne would pay for the testing. The State, however, was Alaska, one of only three states at the time that had no statute ensuring access to postconviction DNA testing. The State adamantly opposed Osborne's request. The Court ruled that Osborne had "a liberty interest in demonstrating his innocence with new evidence under state law,"[32] but still denied him access to the DNA, for unconvincing technical reasons specific to his use of state procedure. The Court also revisited *Herrera,* and again "assume[d] without deciding,"[33] that a claim of innocence exists.

The U.S. Supreme Court has had three major opportunities to explic-itly recognize an innocence claim and refused to do so each time. Perhaps this will change. The Court heard the petition of Georgia death row in-mate Troy Davis and ordered the lower federal court to review evidence of his innocence.[34] It agreed to hear a request for DNA testing by a Texas death row inmate.[35] Yet some people who could prove their innocence may continue to fall through the cracks and fail to obtain DNA testing. For example, in 2009, a Tennessee death row inmate who claimed his in-nocence was executed despite requests for DNA testing.[36] Meanwhile, the Court's abdication of responsibility places the onus on the states. For example, following the *Osborne* decision, Alaska enacted a broad DNA access statute.[37]

The Exoneration Process

Since the U.S. Supreme Court has dodged the issue, it has been state court judges, not federal judges, who have been the ones primarily con-fronted with these exonerees' cases. Initially, as Frank Lee Smith's case

shows, exonerees faced significant obstacles to their claims. However, in recent years, state law has improved in response to these exonerations.

The exoneration process usually began when these innocent people contacted a lawyer. The vast majority of exonerees, 77% (192 of 250 cases), initially sought DNA testing by contacting an innocence project or requesting it through postconviction attorneys. Innocence projects and postconviction attorneys do not request DNA testing for every prisoner who contacts them. The Innocence Project in New York City, for example, pursues DNA testing in all cases in which relevant biological evidence exists and could be useful. In many cases, prisoners contact an innocence project claiming to be innocent, but no evidence can be located to test. Some delay has also resulted from backlogs at innocence projects, which are nonprofit organizations with limited resources. For those without a lawyer, overcoming initial opposition to DNA testing may have been quite difficult. Some exonerees took matters into their own hands when lawyers would not listen. In 10% of these cases (26 of 250), exonerees initially pursued DNA testing pro se, often by filing their own petitions asking a judge for DNA testing.

In 1991 Marcus Lyons walked up the steps to the Chicago courthouse where he had been convicted, dressed in his U.S. Navy reserve uniform and carrying an eight-by-six-foot cross. He proceeded to lift a hammer and start to nail his foot to the cross. He later explained, "I needed someone to listen." He had just been released after spending three years in prison for a rape he said he did not commit. His lawyer never even filed his appeal. As a result, once he was released, he was registered as a sex offender. His courthouse display got him a $100 fine for disturbing the peace, but his efforts paid off—a new lawyer took his case and requested DNA testing, which exonerated him.[38]

All of the 250 exonerees were fortunate that the relevant crime scene evidence was actually preserved in their cases. Law enforcement does not have a strong legal incentive to preserve evidence. Some exonerees struggled to locate the crime scene evidence from their cases. For example, Alan Newton was told that the evidence from the rape that he was convicted of had been lost somewhere in the vast New York City Police Department warehouse. Police said they had made three searches of the barrel where the rape kit was stored. After more than ten years of requests,

another search was ordered. The rape kit was found in the right barrel in the very place where it was supposed to have been kept. The police had apparently never looked. The DNA tests exonerated Newton.[39]

Although DNA exonerations have created a new awareness about the importance of preserving crime scene evidence, here again, the U.S. Supreme Court played a troubling role by providing little incentive to handle evidence carefully. Larry Youngblood claimed that police shoddily stored biological evidence from the rape victim, degrading it and making it impossible for him to have it tested using the serological techniques available at the time. In 1989, the Court ruled that Youngblood could not have a new trial because he could not show that the police had acted in bad faith when they improperly stored the evidence. By 2000, the science of DNA testing had advanced such that the degraded evidence could be tested. The results exonerated Youngblood and produced a cold hit with another individual in the DNA database.[40]

During their appeals and postconviction, twenty-four exonerees claimed destruction of exculpatory evidence, and none had any success pursuing those claims. Like Youngblood, each was later fortuitously able to test degraded evidence or to locate other evidence that could be tested. However, most people who seek DNA testing cannot get it because the evidence was long since destroyed. The Court's "bad faith" test permits police to negligently destroy crucial evidence. As a result, additional protections were needed. Approximately half of the states have now passed statutes requiring the preservation of crime scene evidence.[41]

Even if the crime scene evidence could be located and was of sufficient quality for DNA testing, the exonerees still needed to get permission from law enforcement to test it. The crime scene evidence is typically kept in the custody of law enforcement, which deserves credit for its lead role in quite a few exonerations. In 11% of exonerees' cases (27 of 250), law enforcement or prosecutors themselves initiated the DNA testing. This occurred where law enforcement conducted DNA testing as part of a project to test backlogged evidence, or as part of a program to retest cases where a forensic scientist engaged in a pattern of misconduct, or as part of an unrelated criminal investigation, or, in one case, as a result of an anonymous phone tip. In these cases, the State presented the exonerees with the surprise news that DNA had proved their innocence.

Prosecutors did typically consent to postconviction DNA testing—eventually, but often not quickly. Prosecutors consented to DNA testing in 81% of cases in which information was obtained on the subject (170 of 210 cases) and opposed it in 19% (40 of 210 cases), with no information available in 40 cases. If prosecutors do ask that testing be conducted, they can override any opposition of police. However, prosecutors sometimes consented only after years and years of requests or after the lead prosecutor finally left and a new prosecutor took office. Some consented only at the eleventh hour after a judge was already planning to order the DNA testing. In at least 49% of the cases (122 of 250 cases), the exoneree had to obtain a judge's order to get DNA testing. Although the prosecutors may have eventually supported the requests, no judge's order would have been necessary had prosecutors agreed to promptly conduct testing.

Judges also denied requests for DNA testing that could definitively resolve the question of innocence. Before DNA testing was developed, most judges were not receptive to claims of innocence or requests for access to evidence after a trial. States emphasized the "finality" of convictions, for the understandable reason that except in unusual situations, as time passed after a trial, evidence would get stale, memories would fade, and it would be difficult to revisit the question of guilt or innocence. Judges and legislatures adopted rules requiring that a convict must bring forth newly discovered evidence of innocence within a few years. The notion of finality was sometimes taken to an absurd extreme, barring consideration of new evidence discovered only a few weeks or months after a conviction, or even in cases where evidence had been concealed at trial or neglected due to failures of counsel. As for many exonerees, the refrain of "finality" was repeated over and over for Earl Washington Jr. He had to rely on obtaining clemency from the governor once he obtained DNA testing in 1993 and then again in 2002, because Virginia had a rule that one could assert new evidence of innocence only within twenty-one days of the trial. The so-called 21-day rule was such a short window that the State had all but barred convicts from claiming innocence. Washington's trial was in 1984, so his DNA tests in 1993 came nine years too late to get relief in a court. Most of these exonerees similarly had few avenues for seeking relief from judges after their convictions.

For at least eighteen exonerees, judges initially denied motions for DNA testing (sometimes multiple times), often referring to the evidence of their guilt. Many more such decisions may be unreported. For example, in Bruce Godschalk's case, the judge denied DNA testing because "appellant's conviction rests largely on his own confession which contains details of the rapes which were not available to the public."[42] Similarly, in Byron Halsey's case, the judge denied him DNA testing despite a state law that entitled him to evidence that could reasonably shed light on his innocence. The judge cited his confession as evidence of the "overwhelming evidence of defendant's participation in the crime," and noted that his lawyer offered no alibi or other evidence of his innocence at trial.[43] In Patrick Waller's case, the Texas judge cited the eyewitness identification testimony, denying DNA testing because "three of the four victims unequivocally identified appellant," and also noting that the prosecutor said she would prosecute him again anyway if the DNA testing excluded him. He was exonerated several years later when a new Dallas County prosecutor agreed to conduct the testing.[44]

In Wilton Dedge's case, the trial judge denied his request for a DNA test because it was filed after a two-year statute of limitations; Florida had not yet passed a DNA access statute. When the appellate court affirmed without an opinion in 1998, one judge dissented, with a moving conclusion stating:

> One of my worst nightmares as a judge, is and has been, that persons convicted and imprisoned in a 'legal' proceeding, are in fact innocent. If there is a way to establish their true innocence on the basis of a highly accurate objective scientific test . . . in good conscience it should be permitted. This case calls out for such relief: the evidence of Dedge's guilt at trial was minimal . . .

Recall from Chapter 5 how he had been convicted—despite a strong alibi—based on a dog scent identification, the victim's shaky identification, and an elaborate story by a jailhouse informant. Dedge fought for several more years, and in 2004 he was finally exonerated after DNA test results proved his innocence.[45]

The obstacles to DNA testing have been gradually removed, not because many judges have reconsidered when postconviction discovery

should be granted, but because so many states have passed statutes providing a right to postconviction DNA testing. This change occurred slowly. In 1999, ten years after investigators began to use DNA testing in criminal cases, only New York and Illinois had passed this type of DNA statute.[46] Most of the statutes were enacted in the last five years. Currently, forty-eight states, the District of Columbia, and the federal government have passed DNA access statutes. In at least seventy-one cases, the exoneree obtained testing pursuant to a state statute providing for postconviction DNA testing. States need to do more to provide adequate avenues for claiming innocence, but they have also come a long way.

These statutes are far from perfect. Many require difficult preliminary showings to obtain DNA testing. For example, statutes limit access to DNA testing to persons convicted of certain felonies. Several deny testing to people who pleaded guilty or who did not claim that they did not commit the crime at a trial. Some deny testing if it had not been requested earlier with due diligence; if an innocent person had a trial lawyer that failed to request the testing, then it is the innocent person who suffers the consequences. Two states limit testing to just death penalty cases, which makes little sense because DNA testing is not useful in most capital cases.[47]

Even in states with sensible statutes providing access to DNA testing to those who could potentially prove their innocence, judges sometimes arbitrarily deny valid requests for testing. For example, judges still sometimes cite the evidence of guilt at trial to say that the DNA evidence would make no difference. They argue that because there was an eyewitness, the DNA test would not help. Of course, as Chapter 7 described, scores of judges had similarly denied appeals or habeas petitions based on the seemingly strong evidence introduced at the trials of these 250 exonerees, and they were all wrong.

Other judges concoct speculative scenarios, suggesting that perhaps the victim could have been promiscuous or had sexual intercourse with a consensual partner, which would explain any DNA exclusion. Such hypotheses are often totally implausible. Testing can be done to exclude their partners as possible contributors. If the test results matched a felon in a DNA database, the results would be even more helpful. Such rulings show a lack of understanding by judges of how powerful DNA tests can be in certain cases. Some of these statutes may also be too vague. With

states still sometimes denying access to DNA testing to those who could prove their innocence, the U.S. Supreme Court's failure to recognize a clear right in *Osborne* frustrates people who need DNA testing to prove their innocence.

Upon obtaining DNA test results, the still-incarcerated among the 250 exonerees were finally released. Nevertheless, some waited for quite some time before obtaining their release. Judges refused to set free at least twelve exonerees despite at least preliminary DNA test results excluding them. Each was later exonerated by an executive or a higher court.[48] Perhaps the most high-profile example is Texas Court of Criminal Appeals judge Sharon Keller's cruelly vacuous explanation for her decision not to set Roy Criner free, even though DNA testing excluded him. Keller essentially told the reporters that DNA testing could never sufficiently prove innocence because a scenario could always be constructed to explain away the results. She felt that the DNA evidence would not have "made a difference in the verdict" in Criner's case. The sixteen-year-old victim could have been "promiscuous" in the days before her rape and murder. This allegation of promiscuity was not based on the trial record or any other record, and in fact police had investigated just that subject and concluded that the semen could have only come from the culprit.[49] Criner was pardoned after DNA tests of a cigarette butt found at the crime scene matched the person who was the source of the semen.[50]

Following the postconviction DNA testing, each of these exonerees obtained a vacatur of their conviction, either because a judge ordered a new trial, or a governor gave clemency in the form of a pardon. Prosecutors eventually joined in the motions to vacate the convictions in 88% of cases in which information was obtained on the subject (171 of 194 cases) and opposed the motions in 12% (23 of 194 cases), with no information available (or no vacatur proceedings held) in 56 cases. Again, however, months or years sometimes passed after the DNA test before prosecutors agreed that the person should be exonerated. Sixty-eight received a pardon from their state executive, some because they lacked any available judicial forum for relief. Only 3% of exonerees (8 of 250 cases) received DNA testing and a vacatur through federal habeas corpus—another indication of the small role played by the federal courts. The other exoner-

ees received a vacatur from state judges, typically on the basis of newly discovered evidence of innocence.

The rulings announcing the exoneration are usually unpublished, but the hearings themselves can be dramatic. Exonerees still incarcerated may be walked out of prison to meet their lawyers and loved ones. The press often extensively covers these emotionally charged DNA exonerations. And exonerees may receive something else from the judge: an apology. For example, in James Waller's case, the judge told him, "On behalf of any and all public officials at that time, I want to apologize."[51] In Glen Dale Woodall's case, the original trial judge told him: "I hope that as time goes on and your bitterness fades that you can take that as a badge of honor that you've made it an awful lot easier for the next man and the next man's family, if they are wrongly charged," to get DNA testing performed, and "that's something that you can be proud of for the rest of your life."[52]

Actual Guilt

DNA testing not only exonerates the innocent but it helps law enforcement to identify the guilty. So far, 45% of these DNA exonerations have resulted in the inculpation of the actual perpetrator (112 of 250 cases). The creation of vast DNA databases has made it possible to quickly search for a cold hit with a genetic profile. In sixty-five exonerees' cases a cold hit in a DNA database resulted in identification of the actual perpetrator. In forty-seven cases, the actual perpetrator was identified through other methods, such as police work, or the actual perpetrator came forward to confess and was subjected to DNA testing. For example, in Chris Ochoa's and Richard Danziger's cases, a prisoner named Achim Josef Marino wrote a letter confessing his guilt to then governor George W. Bush, stating, "I do not know these men nor why they plead guilty to a crime they never committed. I can only assume that they must have been facing a capitol [*sic*] with a poor chance of acquittal, but I tell you this sir, I did this awful crime and I was alone."[53]

Particularly striking are cases where the criminal justice system ignored evidence that the defendant was innocent and that, in retrospect, pointed to the actual perpetrator. In Chapter 3, I discussed several

remarkable cases where lineups may have been so faulty that eyewitnesses failed to identify the actual perpetrator in the lineup and instead identified an innocent man. In Chapter 4, I discussed a series of examples where forensic analysts had excluded the very person who turned out to be the guilty party. In Chapters 2, 5, and 6, I discussed cases where informants, codefendants, and witnesses had cooperated or even testified, but were later shown to be the real culprits.

In a few exceptional cases, the exoneree managed to track down the true perpetrator from prison. Roy Brown, who had maintained his innocence for years, found the perpetrator from his prison cell. Recall from Chapter 4 that Brown was convicted in part based on invalid bite mark testimony. Years into his prison sentence, he did not give up. He used New York State's freedom of information laws to gain access to police documents that were never turned over at trial. Some of those reports and witness statements indicated that Barry Bench, the brother of the victim's boyfriend, was involved. Because Brown could not afford an attorney, he filed a motion himself, arguing that this proved his innocence. The judge denied the motion. He then wrote a letter to Bench, telling him that he suspected his guilt and was going to ask for DNA tests to prove it. Five days after receiving Brown's letter, Bench committed suicide by lying down on the tracks before an oncoming Amtrak train. In 2004, the Innocence Project secured DNA testing that excluded Roy Brown. The prosecutor ordered that Bench's body be exhumed and DNA tests confirmed his guilt.[54]

Some of these culprits subsequently confessed or pleaded guilty. At least forty of these perpetrators have been convicted of crimes that they committed while innocent persons were behind bars. They were convicted of approximately fifty-six rapes and nineteen murders after innocent people were convicted of their earlier crimes.[55] The perpetrators may have committed many more crimes, but were not caught or were not successfully prosecuted. The DNA testing that eventually was done probably prevented still more crimes. As with Eddie Mosley, had it not been for the postconviction DNA testing, these people could have continued their crime sprees with impunity. Those cases all highlight how important it is for public safety to make sure that the right person is convicted. Wrongful convictions are a serious law enforcement problem.

Some convicts who request postconviction DNA testing are guilty, and the DNA tests provide powerful confirmation of their guilt. Approximately half of the clients of the Innocence Project have their guilt confirmed by the DNA testing. This is surprising, even shocking—that so many of those who seek DNA testing are actually innocent. In contrast, the others sought DNA testing despite their knowledge of their actual guilt. As Barry Scheck commented, perhaps they did "not want to admit it, or they [were] lying or psychopaths."[56] They may also have hoped for an error in the DNA testing. When I first discovered that about half of the Innocence Project's clients ended up being guilty, I thought it would be interesting to compare their cases to the cases of people who turned out to be innocent. It was a difficult comparison to make. There is no publicly available list of people whose guilt was confirmed by DNA testing. Mainly by searching for newspaper articles, I located over seventy cases in which postconviction DNA testing confirmed guilt, but only very limited information could be found about those cases; for example, only half had written decisions in their appeals, often in capital cases. The unusual features of those who sought DNA testing despite guilt, together with the small size of the group and scarce information about them, prevented any meaningful comparison with cases of exonerees.[57]

The guilt-confirmation group is still important. Legislatures and judges justify denying DNA testing that could reasonably prove innocence by claiming that some set of requests are "frivolous" and made by guilty people.[58] And yes, guilty convicts do request DNA testing. However, DNA tests can put to rest any question of their guilt. Further, the cost of such testing pales in comparison to the cost of imprisoning an innocent person, while the guilty person remains free to commit additional crimes. States spend from less than a few hundred dollars to $1,700 to test evidence from a typical rape kit; costs vary depending on the number of items to be tested and whether an unusually small sample must be tested.[59] This cost is a pittance even compared to the costs of litigating run-of-the-mill criminal appeals. Unlike criminal appeals or habeas motions, DNA testing is fairly quick and when appropriately used can provide clear-cut answers on the question of guilt or innocence. DNA tests are much less expensive than the costs of incarcerating an innocent person, to say nothing of the costs of letting a guilty person remain free.

Earlier I told the story of how Larry Youngblood was exonerated, many years after the U.S. Supreme Court denied him relief. The State of Arizona spent more than $109,000 to keep him behind bars for six and a half years, while the true perpetrator remained free. The DNA test that freed him cost $32.[60]

The Unexonerated

Some convicts obtained postconviction DNA testing, the results provided strong proof of their innocence, and yet they have not been exonerated. Some have applied for pardons but are still waiting to find out what will happen. Many are still in prison. Others have been released from prison but have not yet been exonerated. In Norfolk, Virginia, four men known as the "Norfolk Four" had confessed to a brutal rape and murder. One after another, each was excluded by DNA testing, which matched the genetic profile of a fifth man who confessed to committing the crime and says that he acted alone. Governor Tim Kaine granted each of the four clemency and reduced their sentences to the time they had already served in prison. However, since he did not vacate their convictions, they were not technically exonerated.[61]

Life after Exoneration

In his classic 1932 book *Convicting the Innocent,* the first study of a set of wrongful convictions, law professor Edwin Borchard highlighted "the plight of the innocent victim of an unjust conviction in a criminal case." Borchard argued, "the least that the State can do to vindicate itself and make restitution to the innocent victim is to grant him an indemnity, not as a matter of grace and favor but as a matter of right."[62] Decades later, there is still no safety net for the wrongly convicted. Although the law is improving, and more exonerees continue to obtain compensation, the typical services available to convicts who are paroled are not available to innocent convicts who are exonerated. The job training, housing placement, counseling, treatment, or other reentry services that some states provide to released prisoners are not available to an exoneree.

Most exonerees were not highly educated or highly paid before their false conviction. Interviews with 115 exonerees by *New York Times* reporters in 2007 found that more than half did not graduate from high school, "only half could recall holding a job for more than a year," and many had substance abuse problems and prior convictions.[63] After all, wealthy, employed people with high education and clear records are far less likely to be suspected of crimes, more likely to be able to hire a skilled lawyer, and much less likely to be wrongly convicted. In contrast, the usual suspects, particularly people with prior convictions, are far more likely to be searched, questioned, interrogated, and placed in lineups by the police.[64] Police know that recidivists commit most crimes, and they operate accordingly.

Many exonerees have not obtained meaningful civil compensation for the terrible injuries they suffered. Only 60% have thus far received some kind of compensation for their years of imprisonment.[65] About half of those obtained it by filing civil rights lawsuits against the government. Winning this kind of lawsuit is not easy. Exonerees must be able to show that government officials acted with sufficient fault. They must overcome immunity doctrines that often prevent a person whose civil rights were violated from obtaining any compensation. Such cases may take many years to litigate. At least 46% of the DNA exonerees (116 of 250) filed civil claims, mostly in federal courts. At least 73 who brought wrongful conviction lawsuits received favorable judgments or settlements. Their judgments or settlements were often for many millions of dollars. For example, Ronald Jones, whose story began this book, later received a $2.2 million settlement from the City of Chicago.[66] Arvin McGee, who was described in Chapter 6, endured a mistrial, a hung jury, and a deadlocked jury that finally convicted him at a third trial. In a civil rights case he filed after his exoneration, he was awarded $1 million a year for the fourteen years he spent in prison.[67] Lawsuits do more than just compensate innocent people for the time they were incarcerated. They also provide a wake-up call to law enforcement. Many states and municipalities have reformed their practices after finding out the hard way that failing to use fair procedures can be very expensive.

The law is changing. In part because federal courts have made civil rights claims difficult and time-consuming to litigate, more states have

passed no-fault compensation statutes for those exonerated by DNA. Half of the exonerees who have received some compensation obtained it through such statutes or through special legislative bills.[68] Twenty-five states, the District of Columbia, and the federal government have now passed statutes to provide automatic compensation to the exonerated. The statutes provide compensation far more quickly than lawsuits do, although they range widely in the quality and quantity of the benefits they provide. Most exonerees received less than $50,000 per year of wrongful incarceration under these statutes.[69] Texas now leads the way, having changed its compensation law to provide $80,000 for each year behind bars, lifetime annuity payments, as well as social services like job training, financial advising, tuition credits, and medical treatment.[70]

Some exonerees have adjusted to life after prison, but the psychological impact of a false conviction cannot be underestimated. Ronald Jones explained, "I haven't, still today, been able to adjust to the world. I mean it's like I was on another planet. Now they've got cell phones and computers and all these other things. The closest thing I knew about a cell phone was a telephone on the corner where you could drop a dime in the phone. You can't even drop a dime in the phone no more."[71]

After his twenty-two years in prison, Jerry Frank Townsend walked slowly, "shuffling along with his head down and his shoulders stooped," and was always turning around to look behind to see if someone was trying to ambush him.[72] The psychological harm experienced by exonerees has been little studied. Not only did they suffer from the confinement, overcrowding, and monotony, as well as violence, of the harsh prison environment, but they did so knowing they were innocent. Psychologists have studied the effect of incarceration upon the guilty, but coping with imprisonment may be quite different for a person who knows that he is innocent.

Further, since so many of these exonerees were convicted of rape, they were targets in prison. As one of Jimmy Ray Bromgard's jailers commented, "crimes of that sort are not well received inside," and as a result, "His time was hard."[73] Indeed, those who were released prior to their exoneration had to register in sex offender programs, and some served additional time because they refused treatment as sex offenders. Robert McClendon recalled that he and Joseph Fears refused to enter a

courtroom in which they would be declared sex offenders under a new Ohio law; they were "arguing with people, saying, 'We're innocent!'" Years later both were exonerated by DNA testing.[74]

The interviews with exonerees by *New York Times* reporters found that "most of them have struggled to keep jobs, pay for health care, rebuild family ties and shed the psychological effects of years of questionable or wrongful imprisonment."[75] About one-third of those interviewed had found stable employment, while one-sixth had been rearrested. Exonerees have had trouble obtaining jobs because they have to explain to potential employers why they were in prison, and their stories sound incredible. As Neil Miller put it, "I don't believe that anyone really understands what the word 'exonerated' means. Every time I go to a job and I fill out the application and I explain to them that I was exonerated, I always get . . . 'That word, what does that word mean?'"[76] Keith Turner says, "I keep a copy of my pardon on me. Every job, you have to explain yourself. You have to put it on there—rape conviction—because they check it. I always write, 'I'll explain at the interview.'"[77]

"All I got was a basic form letter apologizing for what happened, not admitting they did anything wrong," Wilton Dedge said. "But it seemed pretty hollow, after all the names they called me in court. They weren't man enough to step forward and apologize to my face. That disappointed me."[78] Others did receive that apology. For example, in Brandon Moon's case, the prosecutor put it simply: "I know we can't give you back your years . . . and for that I'm extremely sorry."[79]

Others have been re-arrested since their exoneration. Many had prior criminal records, but may simply have known no other life after years of incarceration. Steven Avery had served eighteen years before being exonerated of a rape when DNA testing excluded him and included another man. However, three years after his release, he was charged and convicted of murder. This time DNA inculpated him.[80]

Some died not long after being exonerated. Kenneth Waters was exonerated in large part because of his sister, Betty Anne Waters. She was a high school dropout who, after her brother's wrongful conviction, put herself through high school, college, and law school, determined to litigate her brother's case and prove his innocence. With the Innocence Project's help, she did, only after years of fighting for access to the DNA

evidence. Months after his exoneration, Kenneth Waters tripped and fell to his death outside her house.[81]

Victims after Exoneration

Exonerations can also powerfully affect victims and the families of victims. They are confronted with the realization that an innocent man was convicted, perhaps now becoming aware that the true perpetrator has never been found and that the closure they thought they had achieved was an illusion. Others learn that the perpetrator was inculpated by DNA testing. Some remain convinced that the right person was convicted, despite DNA evidence of innocence. The victim in Victor Burnette's case put it bluntly: "I know what I saw . . . And those tests can be wrong. I mean, lab tests fail every day." She added, "What is the good of bringing this back up? . . . What am I going to say? 'Oh, I must've made a mistake. Let him go.' I don't care what happens to that man . . . I don't want this brought back up any more."[82] Similarly, the victim in Brian Piszczek's case commented, "I'm still 100% sure it was him," adding, "I was there. I know. I don't care what those DNA tests say."[83]

At least six eyewitnesses formally recanted their identifications and provided the exonerees' lawyers with statements during appeals or postconviction. None of the efforts to introduce that new evidence of innocence resulted in a conviction being reversed. A few of the victims came forward after DNA testing was conducted to say that they believe they did in fact misidentify the defendant. Jennifer Thompson, the victim in Ronald Cotton's case, described how police made remarks that reinforced her misidentification of Cotton. Though she now knows he is innocent, she still sees his face when she pictures the rapist. She has coauthored a book with Cotton and lectures with him on the need for improved eyewitness identification procedures.[84]

In James Curtis Giles's case, in which the victim described a shorter, younger man and did not describe his two prominent gold teeth, after DNA testing the victim told the prosecutor that "She has a vivid memory of James Curtis Giles, but she is no longer certain that the memory of that face is emblazoned in her head from viewing the lineup and testifying and seeing him at trial or from witnessing his face at the offense."[85]

The eyewitness in Steven Avery's case explained in an interview that police remarks following her identification enhanced her certainty; "I think my confidence that I had selected the right person was boosted when I was told that the person they arrested was the suspect that they had in mind."[86] Few victims have spoken about these cases, so we do not know whether such misconduct occurred in other cases.

A Shorter Road to Exoneration

Just as these exonerees faced a hard road along the way to their exoneration, their path is not easy once freed. The exonerated often endured years of litigation and other obstacles before they successfully obtained DNA testing. Indeed, many faced barriers to obtaining relief even after the DNA exonerated them. The DNA testing then reopened these cases, for the victims who had to revisit painful events, but also because the DNA tests often identified the actual culprits. In response, the states have themselves revisited many of the legal obstacles that so substantially delayed exoneration for these 250 innocent people. Although federal courts still provide no clear avenue to claim innocence, almost all states have now passed laws providing access to DNA testing. Even after exoneration, some of these people had to continue to struggle in the courts for years to obtain meaningful compensation for their injuries. That too has changed, as states have enacted statutes to more quickly compensate the wrongly convicted.

Nevertheless, the experiences of these exonerees illustrate how often law enforcement, lawyers, and judges failed to take claims of innocence seriously when they should have. We should continue to expand access to postconviction DNA testing. We should ensure that biological material from criminal cases is preserved, so that DNA testing can be done in more cases. And we should ensure that judges carefully and promptly consider claims of innocence.

Turning back to the story of Habib Abdal, whose conviction due to a flawed eyewitness misidentification began Chapter 3, we can see how even in a state with some sound procedures, barriers can delay justice for the innocent. Abdal had fought for years to obtain DNA testing. He was forty-three and not a young man when he was convicted (recall that the

eyewitness had initially expressed great uncertainty about the age of her attacker). The judge denied his request for DNA testing in 1989. At the time, New York had not yet enacted one of the first statutes that entitled convicts to DNA testing if it could reasonably prove their innocence. Finally, in 1993, a federal judge, one of the first in the United States to do so, ordered that the DNA testing be performed.[87] Even after the results conclusively excluded him, for years prosecutors resisted dismissal of the indictment, arguing that perhaps there was another rapist who left his DNA and Abdal had also raped the victim without ejaculating. There was a problem with this new speculative theory: the victim had always been clear that one and only one man raped her. And the DNA showed that the man was not Habib Abdal.

Once he was finally exonerated, Abdal recalled that in 1999, "When they let me out, they gave me $40 and an old pair of dungarees with a broken zipper . . . They told me, 'Get out of here. You're a free man.'" That was not the end of his story. New York also had one of the first statutes, passed in 1984, designed to compensate the wrongly convicted. In 2002, he received a settlement from the State of New York. He received two million dollars to compensate him for sixteen of the years he spent in prison. He had initially refused to settle because he wanted his day in court and the opportunity to tell a judge what wrongs he suffered, but terminally ill with cancer, he accepted the settlement. In 2005, he died.[88]

Reforming the Criminal Justice System

I N 1995, Ronald Cotton's exoneration in North Carolina received national press coverage. His DNA exoneration was followed by those of Joseph Abbitt, Keith Brown, Dwayne Dail, Darryl Hunt, Lesly Jean, and Leo Waters, all in North Carolina. The state's response to this drumbeat of DNA exonerations was dramatic: it changed the structure of its criminal justice system. Justice I. Beverly Lake Jr., then chief justice of the North Carolina Supreme Court, decided that preventing future wrongful convictions would be his legacy. Before he retired in 2006, he helped to create the first entity designed to prevent wrongful convictions in the United States, the North Carolina Actual Innocence Commission. Chief Justice Lake called it "probably the most important thing I've done."[1]

Chief Justice Lake's intrepid law clerk, Christine Mumma, helped to design a commission that involved all of the key actors in the state, and she later took the reins as its executive director. Though convened by the state supreme court, it is independent of the judiciary with thirty active participants, including law enforcement officers, prosecutors, defense attorneys, social scientists, victim's advocates, law professors, and judges. The chief justice asked the commission to do two things: "review our criminal justice system for potential changes" to prevent wrongful

convictions, and "establish a mechanism for objective review of credible innocence claims."[2]

The commission, founded in 2002, quickly charted new ground on both fronts. At first, the commission proposed standards recommending sequential and double-blind identification procedures, since eyewitness misidentifications were a "leading factor" in the North Carolina exonerations. That set of best practices was used to train all North Carolina law enforcement officers. At the commission's suggestion, the state legislature then enacted the Eyewitness Identification Reform Act.[3] The law provided that all lineups in the state were to be conducted by an independent, blind administrator, and sequentially. New instructions were to be given to all eyewitnesses before viewing a lineup, including a warning that "[t]he perpetrator might or might not be presented in the lineup," and that "[i]t is as important to exclude innocent persons as it is to identify the perpetrator."[4] The law also regulated the way that lineups are created. It required that a "lineup shall be composed" to ensure that the suspect "does not unduly stand out from the fillers" and that the fillers "shall resemble, as much as practicable, the eyewitness's description of the perpetrator in significant features, including any unique or unusual features."[5] The law required something else that was almost never done in the exonerees' cases: the eyewitnesses were to be asked to express their confidence, in their own words, and this statement was to be documented, if practicable by using a video camera.

After the passage of this landmark eyewitness reform legislation, the commission did not rest, but moved on to study reforms to prevent false confessions. At the urging of commission members, North Carolina enacted laws in 2008 that required the recording of interrogations in homicide cases, enhanced the preservation of evidence and access to DNA testing, and expanded postexoneration support for the wrongfully convicted.[6]

The commission then turned to the set of problems raised in Chapter 7—the inadequacies of existing methods for factual review of postconviction innocence claims. It proposed that a new Inquiry Commission be created to review innocence claims, similar to bodies created in the United Kingdom and Canada. The United Kingdom, in 1997, created a Criminal Cases Revision Commission to serve as an independent execu-

tive agency with full subpoena power to review convictions. It cannot reverse convictions, but refers cases to appellate courts, recommending that convictions be vacated.[7] Similarly, in Canada a person can request that the minister of justice convene a Criminal Conviction Review Group (made up of attorneys from the Department of Justice) to examine cases and make recommendations to the minister. The minister can then order a new trial or hearing, or refer a case to a court. The minister can order a formal inquiry examining what caused a wrongful conviction. Several of those inquiry reports have recommended and led to the implementation of sweeping reforms.[8]

There was no such mechanism anywhere in the United States to respond to a wrongful conviction until, after several years of consideration, legislation enacted in 2006 created the proposed North Carolina Innocence Inquiry Commission. When he announced the creation of the Inquiry Commission, Governor Mike Easley announced, "As a state prosecutor for more 15 years, I know that law enforcement's greatest nightmare is to have an innocent person in jail or on death row."[9] An eight-member panel reviews criminal convictions. Unlike postconviction courts that can become tangled in complex procedural bars or harmless error rules, the commission just asks whether a person is innocent and should be exonerated.

The Inquiry Commission panel members serve three-year terms and include a judge, prosecutor, criminal defense lawyer, sheriff, victim's advocate, and members of the public. Its director helps to develop rules for deciding which cases to review and coordinates the investigations. If five panel members agree that a defendant deserves judicial review, the state supreme court's chief justice appoints a three-judge panel, who may overturn the conviction if they unanimously agree the defendant showed "clear and convincing evidence" of factual innocence. The Inquiry Commission has recommended judicial review in several cases and has screened hundreds.[10] In 2010, the Inquiry Commission recommended that based on "clear and convincing evidence" of his innocence, Gregory Taylor be exonerated, and after the three-judge panel agreed, he became the first person exonerated thanks to an innocence commission in the United States.[11]

Outside North Carolina, states have not established bodies designed to review innocence cases. More than ten other states have created or at

least begun to create innocence commissions, but most lack any formal power and few have done so much as issue a report. For example, a Connecticut Commission on Wrongful Convictions has a purely advisory role. A California commission recommended a detailed and comprehensive set of reforms, which the legislature passed—but which Governor Schwarzenegger promptly vetoed, saying "current criminal procedures provide adequate safeguards."[12] Perhaps such commissions will become influential over time. So far, none approach the successes in North Carolina.[13]

Criminal Procedure Reform

Two decades into the DNA revolution, exonerations are reshaping criminal procedure. North Carolina created a new institution to respond to wrongful convictions, but other states, including Illinois, New Jersey, Ohio, and West Virginia, have adopted different types of systemic reforms and in very different but perhaps equally effective ways. Across the country, prosecutors, police officers, defense lawyers, and judges have developed new procedures in response to exonerations.

Why have DNA exonerations had such an impact? Perhaps they embody a special kind of error. Serious criminal cases are reversed on appeal, but those kinds of errors usually do not receive the front-page headlines that DNA exonerations receive. What sets DNA exonerations apart from typical reversals of convictions, or even from exonerations that do not involve DNA, of which there have been many more?[14] Perhaps the cutting-edge science of DNA technology captivates the public. Or perhaps people find it surprising that innocence can sometimes, with the benefit of DNA, actually be indisputable, making people more suspicious than ever before that our criminal justice system can make terrible mistakes.

Public fascination with DNA exonerations may also have to do with the way that DNA technology enters a case from the outside. Wrongful convictions were not uncovered because the criminal justice system worked. In these cases, by definition, there was no exoneration until after the DNA testing. Part of the gripping drama in these exonerees' stories is how DNA finally succeeded when all else had failed for so many years. As law professor James Liebman has pointed out, DNA takes on

the quality of "divine intervention," where if not for "the sheer accident that a biological sample happened to be available, the miscarriage never would have been discovered."[15] Many of these exonerees' trials looked unremarkable at the time they were convicted. Indeed, as we have seen, the cases against many of them looked unusually strong, due to contamination of the evidence. DNA testing shows how all cases can fail, ranging from the most serious capital case, to rapes, to a handful of robberies, including cases with flimsy evidence but also many with seemingly strong evidence, and in every type of jurisdiction, with all sorts of police departments, judges, jurors, and lawyers.

These DNA exonerations also came to light at a time that criminal sentences had grown much harsher and the prison population had skyrocketed. Since the late 1970s, the United States has had the highest incarceration rate and the largest prison population in the world.[16] The grace of genetic technology has revealed some prisoners as innocent, but it has done so haphazardly, in just a few cases that happened to be amenable to DNA testing. This has not happened in the vast bulk of criminal cases, which unlike rapes and murders do not usually involve biological evidence and remain impervious to the truth of DNA. We are left wondering how many others are innocent.

Despite the costs that wrongful convictions impose on exonerees, victims, and the public, states have generally refused to ask what went wrong in these exonerees' cases, perhaps because they do not want to further shake our faith in the criminal justice system. As Innocence Project founders Barry Scheck and Peter Neufeld have pointed out, "In the United States there are strict and immediate investigative measures taken when an airplane falls from the sky, a plane's fuel tank explodes on the runway, or a train derails," but, "The American criminal justice system, in sharp contrast, has no institutional mechanism to evaluate its equivalent of a catastrophic plane crash, the conviction of an innocent person."[17] The North Carolina experience is the exception to the rule. Few exonerations were followed by administrative reviews, blue-ribbon commissions, inquiries, audits, or any official efforts to find out what happened and why.

However, as I will describe in this chapter, our criminal justice system is finally starting to look forward to consider reforms. A series of

inadequate criminal procedure rules are implicated by these wrongful convictions, as each chapter has developed. In Chapter 2, I discussed the U.S. Supreme Court's "voluntariness" test for reviewing confessions, and how it fails to take into account the reliability of confessions. In Chapter 3, I discussed the Court's flimsy *Manson* test for reviewing eyewitness identifications, and how highly suggestive procedures may be excused based on evidence of "reliability," such as the eyewitnesses' confidence. Chapter 4 discussed how the Court's *Daubert* ruling requires that scientific evidence be reliable and valid, but how that requirement has simply been ignored by criminal courts. Chapter 5 described how informant testimony is not regulated, except in the sense that informants may not be planted and deals with informants must be disclosed, which was not always done in these exonerees' cases. In Chapter 6, I described how the Supreme Court's *Strickland* test does not ensure that adequate lawyers are provided to indigent defendants, and similarly, how *Brady v. Maryland* does not ensure that defendants receive evidence of innocence, although the full extent of concealment of exculpatory evidence cannot be known.

Chapter 7 discussed how not only does criminal procedure fail to ensure that accurate evidence is presented at trial, but accuracy is even less of a concern postconviction, in which judges rarely correct legal errors but they almost never revisit facts. Chapter 8 discussed how, postconviction, these innocent people faced a string of legal obstacles to obtaining DNA testing and their exonerations.

Each of those chapters showed how our law of criminal procedure could be reformed to prevent future wrongful convictions. A change in the U.S. Supreme Court's interpretation of the protections afforded to criminal defendants under the U.S. Constitution would result in a nationwide shift in the practices of law enforcement and courts in criminal cases. But the Supreme Court has not yet reconsidered any of the criminal procedure rules that played a role in these cases, and as it does not regularly reconsider long-standing rules, it may be quite some time before it reconsiders any of these. Instead, the legal response to wrongful convictions is likely to be fragmented, as the fifty individual states and more than 17,000 law enforcement agencies experiment with their own reforms.[18] In this final chapter, I show that knowledge of wrongful con-

victions is changing how states and localities seek to improve accuracy in criminal cases. Many of these changes reflect the problems that I found when I reviewed the exonerees' trial transcripts. I explain which reforms show the most promise and how much work still needs to be done.

Interrogation Reforms

As we saw in Chapter 2, false confessions are one of the most disturbing causes of wrongful convictions. Recall Eddie Joe Lloyd, who was interviewed by police while involuntarily committed in a Detroit, Michigan, mental hospital with a preliminary diagnosis of bipolar affective disorder. It was plain that he was a vulnerable and mentally disabled individual. However, he had contacted police with information about a gruesome rape and murder. His mental illness included "delusions that he had a special ability to solve crimes."[19] The detective "provided me with quite a bit of information about the case," Mr. Lloyd later recalled. "He said, 'What kind of jeans was she wearing?' I said, 'I don't know.' He said, 'What kind do you think?' I said, 'Jordache.' He said, 'No, Gloria Vanderbilt.'" Lloyd said that the detective "guided him through a sketch of the garage" where the crime occurred, among other details. "The emphasis was on, 'You want to help us, right?' he said. I said, 'Sure, I want to help any way I can.'"[20] The prosecutor said that the crime scene "was secured, no one else was allowed in . . . Aside from [the investigating officers], the only other person who would have known that was the killer, Mr. Lloyd."[21]

Just as in other exonerees' cases, if Lloyd's entire interrogations had been recorded, it would have been apparent at the outset that Lloyd knew nothing about how the crime occurred. Instead, Lloyd served seventeen years in prison, until DNA testing exonerated him. Videotaping is inexpensive and can shed light on what really happened in the interrogation room. When Lloyd brought a civil rights lawsuit against the Detroit Police Department seeking compensation for his wrongful conviction (which he reportedly settled out of court for more than four million dollars), the police department also entered a consent decree requiring that all interrogations in crimes that carry a penalty of life imprisonment without parole should be videotaped.[22]

In the 1990s, before DNA exonerations were so numerous, the only states to require videotaping of confessions were Alaska and Minnesota. That has changed, in large part because the false confessions of these exonerees vividly illustrated the costs of the failure to record entire interrogations. Eleven states and the District of Columbia now require or encourage electronic recording of at least some interrogations by statute, and seven more state supreme courts wrote opinions either requiring or encouraging the recording of interrogations.[23] At least 500 police departments now videotape interrogations. Police in those departments have reported positive experiences with videotaping and say that recording does not discourage a suspect's cooperation.[24] The videotape can simplify disputes over whether facts were fed or a confession coerced. As one federal judge put it, "I don't know why I have to sit here and sort through the credibility of what was said in these interviews when there's a perfect device available to resolve that and eliminate any discussion about it."[25] In addition, a recording can "serve to protect police officers against false allegations that a confession was not obtained voluntarily."[26] As the Detroit police chief commented, "It's a protection for the citizen that's being interrogated. But from a chief's point of view, I think the greatest benefit is to police because what it does is provide documentation that they didn't coerce."[27]

While we can expect this beneficial reform to continue to take hold, as it should, recording entire interrogations alone is not enough. Just because an interrogation has been recorded doesn't mean that it wasn't coercive or unreliable. Indeed, the recording may show that there was coercion or contamination through the disclosure of facts. Judges should carefully review recordings to assess the voluntariness and reliability of interrogations. Police should adopt precautions for interrogations involving vulnerable juveniles or mentally disabled suspects. A new focus on accuracy can help to safeguard the reliability and legitimacy of confessions.[28]

Eyewitness Identification Reforms

Like the problem of contaminated confessions, the problem of contaminated eyewitness identifications can also be remedied. Thanks to DNA

exonerations, eyewitness identification reforms are finally starting to happen. Psychologist Gary Wells commented that although he and other social scientists had conducted research on eyewitness memory for decades, "before DNA they pretty much ignored the studies."[29] That has changed, with New Jersey leading the way.

The New Jersey Supreme Court became involved in these issues when, although it did not realize it at the time, it was confronted with the case of an innocent man. It would respond by dramatically reshaping New Jersey criminal procedure and acting, in effect, like an innocence commission. The triggering event was exoneree McKinley Cromedy's case. His lawyer had argued at trial that Cromedy had been misidentified, telling the jury in the opening statement that "the evidence will show, not that she's a liar, but that she's mistaken, that her identification is wrong and it's a misidentification."[30] The victim, a white college student, had been raped by a black man in her apartment. A few days later, she had helped a police artist draw a composite sketch of a black man with a full face and a moustache, and she looked at thousands of photos of black men who had been arrested. One of those photos was of Cromedy, and in fact the police had him in mind as a suspect because he had been seen in the area, but she did not identify him.

Almost eight months after the rape, she saw Cromedy crossing the street. She thought he was her attacker, partly because of his appearance but also because of his unusual way of walking due to a limp, "a swagger," as she put it.[31] She called the police, who called her back fifteen minutes later to say that they had picked up a man matching her description. She then went to the police station and positively identified Cromedy as her attacker. The police officer explained, "I've had a lot of experience with identifications and I'm not going to lead somebody. I asked her to see if she recognized this person."[32] Yet there was no justification for conducting an inherently suggestive showup in which she viewed Cromedy one-on-one from behind one-way glass.

McKinley Cromedy's lawyer argued that the identification was improper, saying that the showup was "like true or false, and to me that is about as suggestive as a procedure you can have . . . She knows somebody was picked up. What could be more suggestive?" The judge ruled that the identification was admissible, emphasizing, "she was very certain

of her identification," and noting that her composite drawing looked like Cromedy and that "Mr. Cromedy has a very, very unique style of walking. It's a combination of a swagger and a roll."[33] Cromedy's defense lawyer asked for a special jury instruction, asking the jury to consider "whether the cross-racial nature of the identification has affected the accuracy of the witness's original perception and/or accuracy of a subsequent identification."[34] The trial judge denied the request. The victim pointed to Cromedy in the courtroom and agreed she was "absolutely sure" he was her attacker.

Cromedy was convicted. On appeal, though, the New Jersey Supreme Court reversed his conviction. The court ruled in 1999 that "forty years" of empirical studies documented a risk of heightened error when white eyewitnesses try to identify black subjects. The court noted that some courts, such as in California, Massachusetts, and Utah, had permitted such instructions. The court ruled that under the facts of his case, it was "reversible error not to have given an instruction that informed the jury about the possible significance of the cross-racial identification factor, a factor the jury can observe in many cases with its own eyes."[35] The court reversed McKinley Cromedy's conviction without knowing that he was in fact innocent. After the ruling, the prosecution agreed to conduct DNA tests. The results excluded him and he was exonerated. The victim later commented, "I couldn't believe that I was wrong."[36]

In response to such exonerations, New Jersey began a project of revamping its criminal procedure rules. The New Jersey attorney general's Office issued guidelines to all law enforcement agencies in the state requiring that detailed procedures be followed when eyewitnesses are asked to identify a suspect.[37] These guidelines were a landmark reform. New Jersey became the first state in the country to adopt double-blind lineups. No longer would the officer administering the procedure know who the suspect is. All lineups would use sequential photo arrays, where photos are shown one at a time to prevent "comparison shopping." Eyewitnesses were to be instructed that the perpetrator might not appear in the lineup. The results were to be recorded, including the witnesses' certainty at the time of the identification procedure (recall from Chapter 3 how many eyewitnesses in exonerees' cases were absolutely certain at trial but were not so certain at the time of the lineup).

In 2005, the New Jersey Supreme Court went further. The court convened a special committee to study the problem of false confessions. The court then issued a state rule requiring that all custodial interrogations in homicide cases be electronically recorded. The next year, in 2006, the court expanded this rule to require that police similarly record or document all eyewitness identifications.[38] The court noted, "Misidentification is widely recognized as the single greatest cause of wrongful convictions in this country." In 2007, the court addressed jury instructions. The court adopted a Model Jury Instruction charging all jurors not to rely on "the confidence level" of an eyewitness, at least not "standing alone." Jurors are cautioned: "Although nothing may appear more convincing than a witness's categorical identification of a perpetrator, you must critically analyze such testimony. Such identifications, even if made in good faith, may be mistaken."[39]

Finally, the court asked that a special master explore something more fundamental: the U.S. Supreme Court's *Manson* test for evaluating admissibility of eyewitness identifications.[40] The master held hearings, with the participation of the New Jersey Office of the Public Defender, Attorney General, Association of Criminal Defense Lawyers, and the Innocence Project. He recommended that the court adopt a new test for evaluating eyewitness identification evidence and require pretrial hearings to evaluate all eyewitness identifications.[41] As a result, the court may over time completely alter the way that eyewitness identifications are conducted, documented, and litigated.

Most other states have not adopted such reforms. For example, in Kirk Bloodsworth's case, the first death row DNA exoneration, the Court of Appeals of Maryland had upheld the trial court's refusal to allow expert testimony on the dangers of eyewitness misidentifications. The trial judge excluded this testimony on the grounds that such evidence would be unnecessary and would "confuse or mislead" the jury.[42] We now know, of course, that the jury was in fact gravely misled when it believed the eyewitnesses in that case. Yet that decision is still the law in Maryland. Other judges have become more open to questioning reliability of eyewitness identifications, by providing juries with cautionary instructions concerning eyewitness error, or admitting expert testimony explaining social science research concerning misidentifications.[43]

Six states, Illinois, Maryland, North Carolina, Ohio, West Virginia and Wisconsin, have passed statutes in response to these misidentifications.[44] Other states, such as Georgia, Vermont, and Virginia, recommended studying the problem further, while still additional jurisdictions and departments have adopted voluntary guidelines.[45] All of this marks the beginning of a sea change, where for so long police had no written procedures at all on identifications, and worse, they routinely used unreliable and suggestive techniques. Local police departments also increasingly adopt double-blind and sequential procedures. The Dallas Police Department, in response to more DNA exonerations than any other jurisdiction has had, adopted sequential and blind lineup procedures, as well as limiting the use of showups and requiring documentation of eyewitness procedures.[46] Since so many of these DNA exonerations involve eyewitness misidentifications, and because decades of social science research support use of double-blind and documented lineups, police will likely continue to gradually adopt improved procedures. It is crucial that they do so. Nor should our constitutional criminal procedure permit grossly suggestive procedures so long as the identification appears "reliable." Judges could impose consequences if the police fail to ensure that sound identification procedures are used; at least, they could provide jurors with careful instructions on the nature of eyewitness memory and sources of error, particularly if suggestive procedures are used.

Forensic Science Reform

Flawed forensic science, like unsound eyewitness identification procedures, played an outsized role in these wrongful convictions, and yet reform has been especially slow in coming. One telling example is Glen Woodall's exoneration, which led to a series of court decisions reforming the state crime laboratory, but slowly, and over more than a decade. Woodall was convicted based on eyewitness identifications that were not very strong, since the attacker wore a mask and neither victim saw his face, but also based on flawed forensic testimony by Fred Zain of the West Virginia Crime Laboratory. Zain had claimed that 6 in 10,000 people could have committed the crime, when in fact, due to the problem of masking, the evidence could have entirely come from the victim. Any male could have been

the rapist. Zain also offered the scientifically unsupportable claim that crime scene hairs "very highly likely" came from Woodall. Five years later, Woodall was exonerated by DNA testing.[47]

Woodall promptly filed a civil rights lawsuit. An initial inquiry by the state's insurer and an internal audit found no other errors. However, when Woodall's civil suit settled for a large but undisclosed sum, a prosecutor requested another audit.[48] After all, Zain had conducted grossly erroneous analysis, made up results, and offered unscientific evidence on the stand. There was no reason to think Woodall was the only victim of this junk science. Zain was a supervisor—he had been promoted to chief of serology at the laboratory. What did Zain do in other cases? What were the analysts he supervised in the lab doing? How many other people were falsely convicted based on such flawed science?

The state's highest court, the West Virginia Supreme Court of Appeals, convened an extraordinary investigation. The court appointed the Honorable James O. Holliday, a retired judge, to supervise an investigation of the crime lab. Judge Holliday asked scientists from the Laboratory Accreditation Board of the American Society of Crime Laboratory Directors (ASCLD) to investigate the policies, procedures, and work of the laboratory. The ASCLD team concluded that fraud by Zain was "the result of systematic practice rather than an occasional inadvertent error." The auditors found irregularities in most of the cases reviewed and recommended a more searching inquiry into more cases the lab had handled.[49] Judge Holliday found shocking failures. The lab had no written quality assurance program or procedures for auditing the work of analysts. There was no routine proficiency testing of lab technicians. The lab had no technical review of the analysts' work and no procedures manual, and the testing procedures used were unscientific. There was inadequate recordkeeping. There was a total breakdown in supervision and training, which went unnoticed for years; after all, Zain was responsible for supervision and training.

The court ordered the state to file within sixty days a report outlining the steps it would take to obtain accreditation of the laboratory. The court ordered an inquiry into all cases in which Zain presented evidence (more than 133). The prisoners would be notified that their cases were under review. The court would presume that Zain's involvement tainted

their cases. All cases in which Zain's evidence "would have been sufficient to support the verdict" would be reversed. Nine more convictions were reversed.[50]

The saga did not end there. After all, the court's order did not address the work by other analysts in the lab, some of whom were supervised by Zain. All of the analysts had worked without proper supervision or quality assurance. The court concluded in 2006 that there was evidence of larger impropriety in the laboratory going beyond Zain's cases. While the court did not find intentional misconduct by other serologists, it found errors that were "frequent, recurring and multifaceted, spanning the spectrum of examiners," and that the errors represented "a divergence from good science and on occasion ethical conduct" raising "a strong inference that the problems were systemic in the Serology Division."[51] Again, that was no surprise, but it took the court thirteen years to get there. Slowly, though, the court's efforts led to reform of the crime laboratory and reinvestigation of old cases.

Most of the few crime lab audits that have been conducted have, as in West Virginia, uncovered systemic problems and additional errors. Audits have been conducted at the FBI laboratory, and laboratories in California, Illinois, Maryland, Michigan, Missouri, New York, North Carolina, Ohio, Oklahoma, Texas, Virginia, and Washington, among others. Following two DNA exonerations that both involved the flawed use of forensic science, the Houston Police Department crime laboratory underwent a particularly extensive audit, hiring attorney Michael R. Bromwich to lead an independent investigation. Meanwhile, the audit reviewed more than 3,500 cases and conducted a comprehensive review of crime lab operations. Auditors uncovered hundreds of cases involving improper serology analysis beyond the two DNA exonerations that sparked the investigation. Auditors found that 21% of serology cases examined were flawed and 32% of DNA cases examined were flawed, including those of four death row inmates. They found that analysts routinely claimed to find "inconclusive" results, when actually the results conclusively ruled out the suspect.[52] The audit reports led to a shutdown and "massive restructuring" at the crime laboratory, and meanwhile the Houston district attorney created a new unit to review convicts' claims of innocence.[53]

The systemic problems uncovered by such audits suggest that there may be similar problems festering in other jurisdictions, including those in which invalid and unreliable forensic analysis played a role in wrongful convictions. Yet, most of the jurisdictions have never audited their crime labs. In its report on the use of forensic science in criminal cases, the National Academy of Sciences (NAS) proposed that there should be a national independent scientific agency tasked with investigating errors and assuring that standards are complied with. A few states have created independent bodies to review their crime laboratories.[54] However, most have not.

While many state and local crime labs now voluntarily participate in ASCLD/LAB (a voluntary peer accreditation and review organization),[55] voluntary programs run by crime lab directors themselves, although a positive step, fail to address one of the most important problems in these wrongful conviction cases—the lack of consistent, scientifically valid guidelines for conclusions. Nor does such accreditation provide for independent and blind auditing of crime lab work. For example, despite years of accreditation of the North Carolina state laboratory, ASCLD/LAB never noticed systemic problems that were later uncovered after a scandal. This was no surprise. ASCLD/LAB examined actual cases only once every five years, and its reviewers would only look at the cases handpicked by the lab supervisors.[56] In response to the NAS report, the forensics community can adopt clearer standards.[57] However, unreliable techniques also require additional scientific research before they can be dependably used in our courtrooms. All labs should be subject to external oversight, including regular and blind audits. In addition, crime labs should be independent from law enforcement, so that they do not report to police. All examiners should be blind-tested for proficiency. The defense should have access to underlying bench notes and laboratory reports, and to their own defense experts. In short, our entire system of forensic science requires a complete overhaul. Judges could also help, by following the mandates of the Supreme Court's decision in *Daubert,* which requires that only reliable and valid methods and conclusions are presented to a jury. Careful judicial rulings could create the incentives for crime labs to adhere to higher standards, but so far judges have largely abdicated their responsibility as gatekeepers of sound science in criminal cases.

Jailhouse Informant Reforms

Unlike the other types of evidence that contributed to these wrongful convictions, the use of jailhouse informants has not received serious scrutiny. Criminal procedure rules do not closely regulate reliability of informant testimony. Nor do many states require reliability hearings, enhanced disclosure, or jury instructions regarding jailhouse informants. California requires that the jury be instructed on the potential unreliability of jailhouse informant testimony, as do several other states, most notably Oklahoma, which also mandates "complete disclosure" of any negotiations between prosecutors and the informant.[58] Illinois requires that the trial judge conduct a hearing to evaluate the reliability of an informant, before the trial, as do courts in Oklahoma and Nevada in some circumstances.[59] Such efforts are modest improvements.

Guy Paul Morin was convicted of a rape and murder of a nine-year-old girl in Ontario, Canada. At his trial, two jailhouse informants claimed they overheard him cry out at night from his jail cell that he had killed the little girl. Years later, DNA testing exonerated Morin, and it emerged that not only did the jailhouse informants lie, but that despite testimony to the contrary, they had received deals from the prosecution in exchange for the testimony. In response to this high-profile exoneration, the Supreme Court of Canada recommended that judges warn jurors about the unreliability of jailhouse informants. Ontario's attorney general now limits the use of jailhouse informants to cases approved by a committee of senior prosecutors, and only if "justified by a compelling public interest" and "founded on an objective assessment of reliability."[60] Such reforms have been adopted in the United States only in Los Angeles. After a scandal in the late 1980s involving a jailhouse informant who lied when testifying in dozens of cases and then showed reporters how he had concocted false admissions by other inmates, the Los Angeles County District Attorney's Office imposed guidelines to "strictly control" use of informants and created a database to track the use of informants.[61] Far more needs to be done.

Judges could assess the reliability of informants before permitting them to testify. More important, since contaminated informant testimony may appear uncannily reliable, all conversations with jailhouse informants could be electronically recorded to ensure that case information is

not disclosed and that any deals are documented. The defense should be told of prior testimony and cooperation by the informant, and all information concerning any leniency deal between the informant and prosecutors should be formalized and disclosed up front. Prosecutors can adopt guidelines requiring the careful use of informants and careful documentation of their statements. Our criminal procedure should be reformed to prevent the abuse of informant testimony—particularly jailhouse informant testimony.

Death Penalty Reforms

Revelations of innocent persons on death row have permanently altered the death penalty debate. Regardless of whether one believes that the death penalty is justified in some circumstances, the knowledge that innocent people have been sentenced to death can shake one's confidence that the death penalty can be soundly imposed. Few of the DNA exonerations involved crimes that carried the death penalty. Seventeen of the exonerees were sentenced to death, and several came within days of execution. However, as we have seen, the vast majority of capital cases do not involve biological evidence that can be DNA tested. The exonerees' cases suggest others on death row might also be innocent. Capital convictions are notoriously reversal prone, and as discussed in Chapter 7, many of these exonerees had their convictions reversed even before they were exonerated. Six of the seventeen death penalty exonerations involved jailhouse informants. Seven involved false confessions, three of which were confessions by mentally disabled persons. Eleven were cases in which the postconviction DNA testing not only exonerated the defendant but identified the actual perpetrator.[62]

Those few but powerful examples of DNA exonerees who faced execution, despite the flawed evidence in their cases, have influenced judges and policymakers. For example, in *Baze v. Rees*, Justice Stevens announced his opposition to the death penalty, citing evidence from DNA exonerations. He wrote that "given the real risk of error in this class of cases, the irrevocable nature of the consequences is of decisive importance to me. Whether or not any innocent defendants have actually been executed, abundant evidence accumulated in recent years has resulted

in the exoneration of an unacceptable number of defendants found guilty of capital offenses."[63] Federal district judge Jed Rakoff struck down the federal death penalty, arguing that "We now know, in a way almost unthinkable even a decade ago, that our system of criminal justice, for all its protections, is sufficiently fallible that innocent people are convicted of capital crimes with some frequency."[64] But his ruling was later reversed by the Second Circuit Court of Appeals.[65] Perhaps these seventeen exonerees' cases have had an outsized impact because they are part of a much larger group of 138 death row exonerations, most not involving DNA testing.[66] Polls also suggest that exonerations may explain lagging public support for the death penalty.[67]

Reacting in part to these exonerations, states in numbers not seen in decades have adopted reforms and even moratoria on the death penalty. This began in Illinois, with then governor George Ryan announcing a moratorium and, on his last day in office, commuting the sentences of all prisoners on the Illinois death row. The Illinois Commission on Capital Punishment, the first innocence-related commission in the United States, issued a report with eighty-five detailed recommendations for reform, some of which were adopted. The Illinois Commission then became a model for efforts to create a "bullet-proof" and more accurate death penalty. On the other hand, the presence of highly probative scientific evidence, such as DNA, can also reinvigorate support for the death penalty. After all, in some cases, as Justice Scalia has noted, it can provide a "scientific means of establishing guilt" and a "highly effective way to avoid conviction of the innocent."[68] A Maryland law followed that approach, narrowing the death penalty and limiting its imposition to cases with certain types of forensic or video evidence, including videotaped interrogations.[69] The hope was to limit death sentences to cases with more reliable evidence. Similarly, the Massachusetts Governor's Council on Capital Punishment recommended a series of reforms that would, if the death penalty were reinstated, limit it to cases where there was greater confidence in the accuracy of the verdict. The proposal failed and the death penalty was not reinstated.[70] In states like Florida, Texas, and Virginia that do carry out the death penalty and have large death rows, and that have also had high-profile death-row DNA exonerations, no such reforms have been adopted.

Prosecution Reforms

As then U.S. attorney general (and later Supreme Court justice) Robert Jackson famously put it, "[t]he prosecutor has more control over life, liberty, and reputation than any other person in America."[71] Prosecutors have far more power today, due to the rise of plea bargaining, severe sentencing guidelines, and mass incarceration. With their broad discretion and expansive power, prosecutors may be the people best situated to effectively prevent wrongful convictions.[72]

Dallas County has had more DNA exonerations than any other local jurisdiction in the United States (19 of the 250 exonerees). This does not necessarily mean that the quality of justice was worse there. Part of the explanation is that the crime lab regularly used by Dallas County routinely saved forensic evidence from rape cases in the 1980s. A few prosecutors have adopted reforms and conducted case reviews to locate additional erroneous convictions. None has done so more aggressively than Dallas County district attorney Craig Watkins. He hired a former innocence project attorney to create a "Conviction Integrity" unit to look at possible wrongful convictions. The office policy is to conduct postconviction DNA testing. The office adopted reforms in lineup procedures and now videotapes interrogations. The office also adopted an "open-file" policy providing the defense with access to prosecution files.[73]

Because the Supreme Court's ruling in *Brady v. Maryland* only requires prosecutors to disclose material exculpatory information, prosecutors need not turn over everything to the defense, or even all of the evidence that might shed light on innocence, but rather only the evidence that they decide is sufficiently "material." Prosecutors need not disclose anything at all in cases resolved by a guilty plea. As a practical matter, that means that prosecutors can encourage an innocent person to plead guilty to a lesser charge out of fear of the harsher consequences that might result if the case went to a jury, even if the police or prosecutor know that there is evidence the person is innocent, without ever sharing that evidence with him or her. Open-file policies provide enhanced discovery to the defense, although how open they actually are depends on the policy and practice of the prosecutor's office. In theory, open-file policies can increase accuracy by improving the flow of information from police to

prosecutors as well as to defense lawyers. Indeed, if defendants are confident that there is *not* helpful evidence in the file, they may be more willing to settle, thus saving the state the cost of a trial.

Other prosecutors' offices have pushed for reforms. In Minnesota, the Ramsey County district attorney's office hosted a statewide conference on improving eyewitness identification practices.[74] The offices of several state attorneys general have issued reformed eyewitness identification policies and recommendations on videotaping interrogations.[75] The Suffolk County, Massachusetts, district attorney's office convened a task force and adopted eyewitness procedure reforms after a series of DNA exonerations (including the Neil Miller case discussed in Chapter 3). They credit the new eyewitness procedures with helping to convince jurors that they have arrested the right person.[76] Some prosecutors' offices have conducted inquiries postconviction to identify what went wrong, such as the prosecutor's report on Jeffrey Deskovic's false confession. Those offices are exceptional. Most prosecutors have not investigated what went wrong after an exoneration, nor have they altered their policies in response.[77]

Defense Reforms

In contrast, defense lawyers may be some of the most poorly situated to prevent wrongful convictions, unless steps are taken to improve the quality and funding of government-provided lawyers for defendants who cannot afford to hire a lawyer. In the past, criminal procedure did not focus on the reliability of trial evidence, because judges trusted the "crucible of the court," in which the cross-examination of talented attorneys would test the evidence before the jury. That trust in the trial process may have been misplaced. In all too many of these trials, the prosecution did not have a strong adversary. Chapter 6 described how these innocent people often received a weak defense. Even in these fairly serious felony trials, and even where the State's evidence was deeply flawed, the defense often did not expose those flaws. They did not have funding to hire experts or investigate leads, such as possible evidence of innocence.

Many jurisdictions grossly underpay the lawyers they provide to poor criminal defendants, but it is not easy to demand that the government

reallocate resources for politically unpopular criminal defendants. In some jurisdictions, there is no public defender office to take responsibility for an error. The court-appointed lawyer who took an innocent person's case may have by then retired (or sometimes even been disbarred). A few exonerees, like Jimmy Ray Bromgard, have filed civil rights lawsuits following their exonerations, seeking improved indigent defense systems; few have succeeded. Some jurisdictions have made notable efforts to improve training of defense lawyers, create public defender offices, expand the defendant's access to evidence available to the prosecution, and broaden access to investigators and expert witnesses. Yet although exonerations have highlighted the problem, already extensively documented by studies of the woeful state of indigent defense services, in many jurisdictions the problem remains unchanged.[78]

Federal Reforms

In contrast with states and localities, there is much less to say about what the federal government has done in response to DNA exonerations. Congress did enact an Innocence Protection Act in 2004 designed to help prevent wrongful convictions. The act, among other things, created a right for federal convicts to access DNA testing, rules to require preserving biological evidence in federal criminal cases, and funding for better representation in state death penalty cases. Kirk Bloodsworth, the first death row DNA exoneree, spoke out repeatedly in favor of the legislation's passage. A section of the act was named after him, creating a Kirk Bloodsworth DNA Testing Program providing grants to states to conduct postconviction DNA testing. Yet Bloodsworth, along with exonerees Marvin Anderson and Charles Chatman, returned to the U.S. Congress in 2008 to testify at hearings that were called to investigate why the Department of Justice (DOJ) had yet to distribute any of the funds to the states. Worse, although Congress had expanded the Paul Coverdell grant program that gives crime labs funds to improve their work, the DOJ ignored a key requirement that to be eligible states must have independent entities to investigate allegations of serious negligence or misconduct by crime labs. For years the DOJ did not enforce that requirement (nor has DOJ done so as of this writing).[79]

Other reform efforts are progressing slowly. Congress appropriated funds for the National Academy of Sciences to study the needs of the forensic science community. The NAS report, as discussed in Chapter 4, called for an overhaul of forensic science and the creation of a federal National Institute of Forensic Science. It remains to be seen whether Congress will enact legislation to implement those recommendations.

The DOJ has a mixed record in fostering criminal justice accuracy, shifting only slightly from one administration to the next. For example, the DOJ opposed enactment of the Innocence Protection Act.[80] The DOJ did convene the Commission on the Future of DNA, a working group to promote standards on preservation of biological evidence, and convened a Working Group for Eyewitness Evidence that recommended reformed identification procedures.[81] The DOJ could do more, including by studying and implementing reforms. In jurisdictions plagued by systemic error, the DOJ could discourage future constitutional violations by suing police departments.

The federal courts have also remained on the sidelines. Few exonerees obtained relief or access to DNA testing from federal courts. Federal courts have not reconsidered the criminal procedure rules surrounding eyewitness identifications, confessions, forensic science, and informants, which permit grossly unreliable evidence at trial. Well into the DNA age, the U.S. Supreme Court has still not recognized a claim of innocence under the U.S. Constitution. Perhaps over time federal judges will take heed of lessons learned from these exonerations.

The Tip of the Iceberg Revisited

These 250 exonerations cannot tell us how many people have been wrongly convicted in the United States. That is one of the most haunting features of these exonerations. If known exonerations are the tip of an iceberg, we do not know how big the rest of the iceberg is. We cannot know.

Some hardened souls will remain untroubled by DNA exonerations. For example, Justice Scalia has suggested that known wrongful convictions are an inconsequential percentage, an error rate of ".027 percent—or, to put it another way, a success rate of 99.973 percent," if one divides exonerations by the fifteen million felony convictions during

the same time period.[82] But should we really be so reassured by the numbers?

If you eat at a fine restaurant and complain of a large bug in your soup, you are not reassured if the waiter tells you, "Don't worry, it will not happen again too often. There have only been a few hundred reported cases of bugs in soup in the United States. While human error is inevitable, with millions of bowls of soup served every year, we have an unparalleled sanitary soup rate." The waiter adds, before turning away with a flourish, "Because we found the bug in your soup, the system worked."

You had better ask to talk to the manager. The restaurant did not find that bug—you did. The system did not work. What system was there? The waiter did not tell you what the restaurant does to keep its soup insect-free. Even if it is true that there are just a few hundred reported cases of bugs in soup nationwide, how good are those reports? Perhaps they rely on the restaurants' own willingness to report bugs in their soup. How often do less- fancy restaurants check for bugs? Perhaps health inspections of soup began just a few years ago. Perhaps only some kinds of restaurants or types of soup are inspected. If nothing unusual explains how this bug got there, perhaps it happens all the time. You also ask yourself how many customers decide it is not worth complaining about a bug in their soup. You then lose what remains of your appetite by wondering how many customers do not notice bugs because they swallowed them.

Similarly, it is not reassuring to point out that millions of felony convictions do not result in exonerations. In fact, the argument raises even more cause for concern, because not only are those millions of cases not a relevant comparison group, but we have never examined those millions of felony convictions. The unremarkable criminal trials of so many of these exonerees looked no different than those of countless others.

Instead of comparing the number of known exonerations to the number of known felony convictions, we might instead ask how high the exoneration rate is for the types of cases that typically result in exonerations: rapes and rape-murders.[83] DNA exonerations fall within a narrow band of cases that are a fraction of 1% of felony convictions. Most DNA exonerees were convicted of a rape in the 1980s, before DNA testing was available. DNA testing is done chiefly in rape cases, and rape convictions that result in prison sentences make up less than 2% of felony convictions.[84]

However, the right comparison group for DNA exonerees is even smaller. Exonerees were almost all convicted of rapes involving a stranger-perpetrator, in which there was a real question about who committed the crime. They were almost all convicted at a trial, unlike most convicts who plead guilty. They received long sentences; on average they served thirteen years before DNA exonerated them. There is no good data on rape convictions in the 1980s. We do know that only about a quarter of rape prosecutions involve stranger-perpetrators, and rape convicts overwhelmingly pleaded guilty and received much shorter prison sentences than these exonerees did.[85] So the right control group for the exonerees would be stranger-rape cases from the 1980s in which the defendant took his case to trial. The number of these cases is much, much lower than the fifteen million total felonies cited by Justice Scalia, most likely in the low tens of thousands, making the number of exonerations quite troubling.

Error rates may be far higher. Recall from Chapter 1 that a federal inquiry in the mid-1990s, when DNA testing before trial first became common, found that 25% of suspects were cleared by DNA tests. In contrast, most people convicted in the 1980s before DNA testing was common may not have been able to get DNA testing. Most would have already served their time by the time DNA testing was invented. If they did happen to hear about DNA testing and tried to get it, they may have been refused access, because there was no established way to get access postconviction. They may have given up hope, perhaps for good reason. In addition, crime scene evidence was not usually preserved in the 1980s. Law enforcement routinely destroyed the rape kits that could have allowed broader use of postconviction DNA testing. Some jurisdictions did preserve evidence in the 1980s. If one of these jurisdictions were to conduct a full-scale DNA audit on cold cases, it could make history, but none has done so yet.[86]

Even if known exonerations do represent a high error rate among comparable cases, far more troubling are the vast numbers of cases involving other types of crimes that cannot be examined using DNA and where we just do not know how many have been wrongly convicted. As powerful as DNA testing is, it is limited to a small set of mostly rape convictions, mostly from the 1980s, in which the evidence happened to be preserved. Those rape cases both overstate and understate the prob-

lem. They overstate the problem because those particular types of rape cases are no longer as much of a risk for wrongful convictions, now that DNA testing is routine in criminal investigations and particularly in rape cases. They understate the problem because they do not tell us about the vast majority of criminal cases, in which the underlying problems remain and DNA testing cannot be used to prevent wrongful convictions.

The problems that occurred in these cases—contaminated confessions and eyewitness accounts, shoddy forensic analysis, and the use of inmate informants—are just as likely to infect nonrape cases where DNA will never be available. Tens of thousands of cases each year involve eyewitness identifications, in which police used many of the same error-prone procedures as in these exonerees' cases. Just as a rape victim can pick out an innocent person in a photo array due to suggestive remarks by the police, an eyewitness to a robbery can pick out the wrong person due to such remarks. The vast majority of forensic work by crime labs involves techniques similar to those used in exonerees' trials, raising the same questions of reliability and validity. Just as a forensic analyst can exaggerate the importance or meaning of blood tests to a jury in a rape case, a ballistics expert can exaggerate the significance of similarities between a bullet and a particular make of gun in an armed robbery case.

No DNA test will correct these problems. Rather than trying to calculate an error rate for criminal trials—an impossible task given the unavailability of DNA testing in most cases—we need to do what we can to prevent the dangers that these exonerees' cases can warn us about. We cannot know how big the iceberg is. But we can try to figure out what errors in the exonerees' cases are also likely to be occurring in other cases, even the ones that aren't amenable to DNA tests.

Systemic Errors

The Supreme Court said in its *Osborne* ruling, denying a request for postconviction DNA testing, that our criminal justice system, "like any human endeavor, cannot be perfect. DNA evidence shows that it has not been."[87] But just because the system is a "human endeavor" does not mean that we blithely accept that things will go wrong. The question is whether human

failures are the result of a few incompetent people, or whether they instead represent a larger systemic problem that can be solved. It would be very disturbing if malicious people intended to frame these innocent defendants. But in some ways it would be a relief: those bad actors would also be an isolated problem—a few "bad apples." When organizations make a serious error, a superficial explanation, that an employee was a "bad apple," does not tell us whether bad supervision or practices played a role. The trial records in the exonerees' cases suggest that perhaps not all but certainly most of the police, prosecutors, forensic analysts, and others in these cases acted in good faith and followed standard practices.

Well-intentioned people may make errors precisely because they see themselves as members of a group. Modern psychology has shown that in a host of ways, our beliefs and hopes and desires influence what we perceive and how we reason and behave.[88] Such effects are termed "cognitive bias." Cognitive bias can occur where people tend, for example, to see themselves in a positive light. In criminal cases, for example, police may see themselves as doing justice by only investigating the guilty. The result can be "tunnel vision" or confirmation bias. Once people form a belief, they tend to adhere to it and look for evidence that fits, or confirms, their preconceived idea. When police form a hunch that a suspect is guilty, they may then without realizing it discount any evidence that does not jibe with their prior belief in the suspect's guilt.[89] We saw in Chapter 2 how detectives downplayed inconsistent details in interrogations and instead emphasized that the suspect had volunteered accurate details. We saw in Chapter 4 how forensic analysts in case after case inflated their statistics and conclusions that evidence supported guilt, and discounted evidence of innocence.

A remarkable study of fingerprint analysis highlighted how cognitive bias can alter conclusions of experts. The authors, Itiel Dror, David Charlton, and Ailsa Peron, gave five senior fingerprint experts a pair of prints that those same experts had declared to be a "match" in 2000. Other experts, unknown to the five participants, verified that they were indeed a match. This time, when asked if the prints matched, four out of five of these experts changed their mind and now called the prints non-matches. What changed? This time these five experts were also given a piece of outside information. They were told that these were the prints

that had been falsely matched by the FBI to crime scene prints left by the terrorist involved in the Madrid bombings. In that embarrassing and high-profile mistake, the FBI initially targeted an innocent man from Portland, Oregon, before realizing his prints did not match. Although fingerprint experts sometimes claim infallibility, most of these experts changed their conclusions because they received outside information. The title of the study put its point well: "Contextual information renders experts vulnerable to making erroneous identifications."[90]

Cognitive biases are not at all unique to police or forensics work, and they can be counteracted. Scientists routinely use blind studies to counteract bias. Experiments use placebo groups, because test subjects may be subject to bias. Double-blind eyewitness identification procedures do precisely that; it is important that the officer does not know who the suspect is, but also that the eyewitness knows that the officer does not know. Forensic scientists do not do their work blind and with blind audits, as some have recommended, and the result may be that, as in the fingerprint study, they hear irrelevant case information that biases their conclusions. Thus, the analyst in Frederick Daye's case agreed at trial that before she did any blood testing she was told about a range of facts surrounding the victim's ordeal.[91] Sometimes the existence of outside information leads the expert to forgo giving an opinion altogether: I noted in Chapter 2 how in Lafonso Rollins's case, the crime lab decided not to do DNA testing because he had already confessed.

Good managers try to get at the "root cause" of the problem. To do that, they ask questions about what went wrong and what could prevent it. Those questions are typically not asked after exonerations. Take as an example the case of Jimmy Ray Bromgard, which is representative of how many jurisdictions respond to exonerations. He was convicted based on invalid forensic testimony by the manager of the Montana crime lab, whose unscientific testimony was discussed in Chapter 4. This was no isolated error. Chester Bauer and Paul Kordonowy were also wrongly convicted based on testimony by the same analyst. Those three DNA exonerations have not yet led to an examination of the other cases the analyst worked on, much less statewide reforms. The State disregarded a formal request that an audit be conducted, following a review of the Bromgard case by top scientists. The Montana Supreme Court refused to

order an audit. The attorney general refused to investigate the lab either, saying it would be an "expensive, tedious process."[92]

In most jurisdictions, officials similarly found errors too "tedious" to be worth investigating. In some, it was apparent long before the DNA exoneration that there was a larger problem, and yet no action was taken. In Oklahoma, as early as 1988, a series of state courts found that forensic analyst Joyce Gilchrist presented misleading if not false evidence. The courts took no further action to investigate Gilchrist or the lab. In 2001, the governor finally ordered review of the thousands of cases she had worked on—only after six wrongful convictions had come to light through DNA testing.[93]

It is hard to imagine an error of greater significance in our criminal justice system than a wrongful conviction. Yet the response to these errors has often been inaction. What explains this? Part of the problem is that no one is "flying the plane." Criminal justice is fragmented. Local police have separate and sometimes overlapping authority, as do prosecutors. Centralized judicial review occurs in the very few cases that go to a trial, and judges typically examine possible problems in individual cases, but not across patterns of cases.

In addition to fragmentation, our criminal justice system also suffers from a lack of accountability. No institution is eager to self-criticize, but most institutions also cannot afford to simply ignore serious mistakes. Criminal justice actors may be the exception. Police know that a shooting may result in a civil rights lawsuit and immediately convene top brass to investigate. However, police or prosecutors often do not respond to wrongful convictions, since they face no consequences for doing nothing. Civil lawsuits for wrongful convictions face often insurmountable obstacles, and disciplinary actions against police and prosecutors who engage in misconduct, much less criminal prosecutions, are almost unheard of. Since criminal justice actors are not held accountable, they have no incentive to ask why errors happen or to fix the underlying causes. As a result, the same well-meaning but unreliable work and the same flawed procedures may result in countless other flawed convictions.

Preventing Wrongful Convictions

The U.S. Supreme Court's complacent remarks about the inevitability of error in "any human endeavor" should trouble us. Human error may be inevitable, but it can be minimized. As in any human endeavor, errors in the criminal process should not be cavalierly ignored, but should be investigated and prevented. A landmark study of medical error by the National Academy of Sciences, titled "To Err Is Human," shows how human error can be taken seriously, and it raises parallel problems with effective solutions. Obviously doctors have very different jobs than police, forensic analysts, judges, prosecutors, and defense lawyers. Just as a wrongful conviction is a tragedy, incorrect diagnoses or medical mistakes can also result in grievous errors. Just as in the criminal justice system, medical errors are frequent, and reported errors are the tip of the iceberg because many people either do not know that their medical caregiver made an error or do not bother or cannot afford to report the error or file a lawsuit if they do know. And just as a lack of centralization causes a lack of accountability in the criminal justice system, the "decentralized and fragmented nature of the health care delivery system" causes unsafe conditions.

The solutions offered to the medical profession in the NAS report are illustrative here. The NAS suggested shifting the focus "from blaming individuals for past errors to a focus on preventing future errors by designing safety into the system." It called for systemwide efforts to collect information about errors and design systems to prevent them. The NAS report concluded, "to err is human, but errors can be prevented."[94]

A system as simple as a checklist can save lives. Infections are a leading cause of death in hospital intensive care units, and one procedure that can lead to potentially deadly bloodstream infections is the routine use of a catheter. Dr. Peter Provonost began a safety initiative in Michigan focusing on following a list of five steps when using a catheter. The first step was simple: making sure to wash one's hands. When doctors were trained to follow the five steps, and had their compliance checked and discussed monthly, the rate of blood infections dropped sharply, falling to zero in many hospitals. A study of the initiative estimated that nearly 1,800 lives had been saved over four years. A straightforward

system served to remind doctors of something as basic as remembering to wash their hands, a step that may seem trivial, but focusing on that problem saved thousands of lives in a hospital setting.[95]

In a criminal investigation, police must collect accurate information, not to diagnose illness but to solve and punish crimes. Yet criminal investigations lack a quality control supervisor on the job. There is no process for collecting and analyzing information about errors. The criminal justice system lurches forward in assembly line fashion, processing massive numbers of cases in stages, with a range of actors siphoning off cases by exercising discretion at each stage. The process begins by almost exclusively relying on the memory and notes of detectives, and not on careful records or electronic recordings. Lawyers then rely on poorly reviewed forensic tests in which the underlying records are not disclosed, or on the fragile and fading memory of witnesses. The farther a case moves down the assembly line, from police investigations, to prosecutor's charging, to defense investigation, to plea bargaining, to trial, and to appeals and postconviction review, the harder it is to undo an error. Once a confession is contaminated, judges and others cannot easily unravel what transpired—unless the interrogation is videotaped.

The reforms that I have advocated in this book share a family resemblance. At their core, they each involve placing less reliance on unreliable human memory and decisions early on in the criminal investigations. None of these problems are new. Law professor Edwin Borchard described eyewitness misidentifications and false confessions in his classic book on wrongful convictions—written in 1932. Judges have discussed potential for error in criminal procedure rulings dating back several decades. What makes these wrongful convictions so troubling is that research has exposed how we routinely rely on unreliable evidence in criminal cases. Yet solutions are available, and they all involve safeguarding the reliability of evidence.

There is the fear of the unknown—that changing criminal procedure rules to focus on accuracy might be counterproductive, creating new biases or perverse incentives that could result in more guilty people going free. But if it is true that the vast majority of suspects are guilty, improved documentation may strongly benefit the State. The assembly line process also makes mistakes by letting the guilty go free—as it did in all of these

exonerees' cases. Prosecutors depend on the flow of reliable information from police and they complain about inadequate note taking and record-keeping. Along with police departments, prosecutors have pushed for the adoption of checklists and documentation protocols, to improve the quality of evidence used to convict the guilty.[96] A checklist reminding police to write down crucial information like the confidence of the eyewitness or reminding them to videotape the confession can prevent costly mistakes, just as the checklist for intensive care doctors reminding them to wash their hands can prevent potentially deadly infections.

We know from decades of social science that double-blind eyewitness procedures reduce errors with no appreciable effect on true identifications. There is no evidence that videotaping interrogations discourages true confessions, but videotaping helps to ward off spurious challenges to true confessions. There is no evidence that improved quality assurance and scientific standards reduce the accurate use of forensic evidence. Other systemic reforms are untested—and they should be tested. In particular, since so many cases are resolved in plea bargains, we should far more carefully scrutinize guilty pleas premised on unreliable types of evidence.

We can also learn from successes and not just failures. In the vast majority of criminal cases, DNA testing cannot be conducted or cannot answer the question of identity. In the typical robbery, for example, no biological material tied to the attacker may be left at the crime scene. Yet robberies may be just as error prone. After all, they usually involve eyewitness identifications, and such eyewitnesses may have even less of an opportunity to see the culprit than in a rape.[97] Even in cases in which no DNA testing can be done, errors can still be documented. If an eyewitness identified a lineup filler, one can be fairly sure a mistake was made. If a suspect confesses, but it turns out that he was in prison when a crime occurred, police will typically let him go. If forensic evidence clears a suspect long before a trial, that person needs no exoneration. Successes in catching errors early on in an investigation deserve recognition, and such near misses can teach us important lessons about what can go wrong.

Over time, near misses will teach us more, while DNA exonerations may fade away, although slowly. Now that DNA testing is common before a trial, many thousands of innocent people each year are cleared

before a trial and do not need to be exonerated. DNA exonerations still occur regularly, but fewer are a result of recent criminal cases. Yet about one-quarter of all DNA exonerees were convicted at a time when DNA testing was available. Their lawyers failed to ask for DNA testing, the State hid the fact that biological material existed, or DNA testing was done but botched. DNA technology continues to improve, and as it improves, DNA testing is increasingly available in more types of crimes, such as robberies or other felonies. Nevertheless, a unique window into causes of error will begin to close. That makes it all the more important to learn what we can from this remarkable set of DNA exonerations.

Lessons from Exonerations

The jurors in the trial of Ronald Jones, whose story began this book, were instructed by the judge at the end of the trial, before they began their deliberations, "You have before you evidence that the Defendant made statements relating to the offenses charged in the Indictment." The judge added, "It is for you to determine what weight should be given to the statements. In determining the weight to be given to a statement, you should consider all of the circumstances under which it was made."[98]

The jurors that decided Jones's fate could not fairly judge the evidence. They had no record of what transpired during the interrogation. Jones proclaimed his innocence, but was not believed. After all, the detectives described a detailed confession and presented the written confession that he signed. Similarly, the trial judge saw no problem with the confession, even though Jones alleged police beat him and then spoon-fed him the crime details. The appeals courts all denied relief. The evidence of guilt seemed overwhelming, precisely because the confession was contaminated. What makes the trials of exonerees so frightening is that they show how the case against an innocent person may not seem weak. The case may seem uncannily strong. Without DNA, it can be impossible to turn back the clock on a criminal prosecution gone wrong.

A lesson from these exonerees' criminal trials is that once central evidence is contaminated at the earliest stages of a case, the damage cannot be easily discovered or reversed. "What's done cannot be undone," as Lady Macbeth put it, while sleepwalking and unsettled by her own grave

and irreversible wrongs. It is too late after police disclose facts during an interrogation, leak facts to informants, conduct shoddy eyewitness identifications, or reach unscientific conclusions in forensic reports. It is too late months later at a trial or years later when a habeas petition is filed. It is too late in the countless criminal convictions for which no DNA testing can be done. Yet these are not "things without all remedy" to be put out of mind, for even if we try to go back to sleep, some errors will return to haunt us.[99] Errors must be remedied before fiction contaminates fact.

Kirk Bloodsworth wrote in a letter to Congress, "I am dedicated to making sure this never happens to anyone else. I will continue my quest to find solutions to our broken and flawed criminal justice system."[100] Should we be pessimistic or optimistic about actually fixing the flaws in our criminal justice system? Wholesale forensics reform may be somewhat expensive, yet the federal government provides hundreds of millions of dollars to crime labs to eliminate their backlogs, a worthy goal, but one that should not be the exclusive goal of federal grants.[101] And simple and inexpensive reforms have not been universally adopted. A majority of police departments have not reformed eyewitness identification procedures and do not videotape confessions. The defense lawyer in Ronald Taylor's case put the point well, making light of the failure to document eyewitness identifications: " 'We don't record it because it costs the Houston Police Department too much money.' Think about it. A ninety-cent tape versus the cost of convicting an innocent man."[102]

Ronald Jones also had his travails recounted on the floor of the United States Senate. After his exoneration, U.S. Senator Russell Feingold detailed "what happened in Illinois to Ronald Jones" and he concluded, "The system doesn't work. It has failed us."[103] Even so, Congress did not pass any reform measures. But the Illinois legislature did enact a package of reforms, including one that could have prevented Jones's false conviction: mandatory videotaping of interrogations in homicide cases. Although our law of criminal procedure remains vulnerable to error, solutions are available. Confession, eyewitness identification, forensics, and access to DNA reforms are all slowly gathering momentum across the country. Wrongful convictions have altered the popular consciousness, changing the attitudes of everyone from jurors to voters, lawmakers, judges, scientists, police, defense lawyers, and prosecutors.

In this book, I have shown how the criminal justice system convicted the innocent. The errors in these exonerees' cases were not isolated accidents. They were caused by systemic failures. Their cases display clear patterns that can tell us how to make the system far more accurate. We cannot give the 250 exonerees back the years they spent in prison for crimes they did not commit. But we can dedicate ourselves to learning from what went wrong.

Appendix

Notes

Acknowledgments

Index

Appendix

In this book, I present a wealth of information concerning the cases of the first 250 people exonerated by DNA testing. Each chapter contains a separate study of one aspect of the cases of these innocent people. While a complete summary of all of the information collected would be far too long, I have made detailed summaries of all of the data available online at http://www.law.virginia.edu/innocence. Here I present a visual overview of the book, with charts and graphics that display the findings in each chapter. Second, I provide a description of the methods used to collect all of this information and then to analyze it.

Chapter 1, the introduction to the book, describes the general characteristics of these 250 exonerees. As shown in Map A.1, DNA exonerations have occurred throughout the United States, in thirty-three states and the District of Columbia.

I obtained trial materials in 88% of the cases of those who had a criminal trial. I then described how, because DNA testing can most readily be used in rape cases, most exonerees were convicted of rape, with some convicted of murder and a handful of other crimes. Figures A.1 through A.4 display some of these features of the 250 exonerees' cases.

Chapters 2 through 5 discuss the prosecution evidence at trial. Figure A.5 is an overview of the types of evidence discussed.

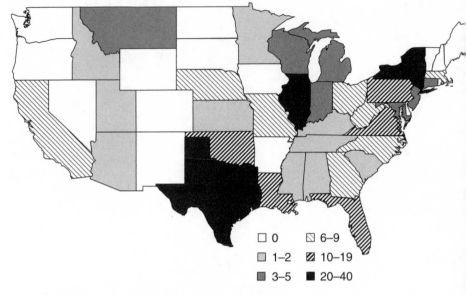

Map A.1. DNA exonerations in the United States

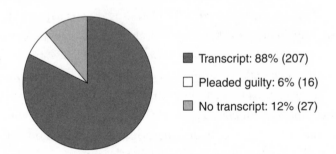

Transcript: 88% (207)

Pleaded guilty: 6% (16)

No transcript: 12% (27)

Figure A.1. DNA exoneree trial materials

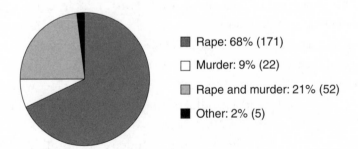

Rape: 68% (171)

Murder: 9% (22)

Rape and murder: 21% (52)

Other: 2% (5)

Figure A.2. Crime of exoneree conviction

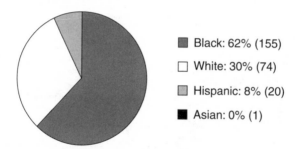

Figure A.3. Race of exonerees

Figure A.4. Year of conviction

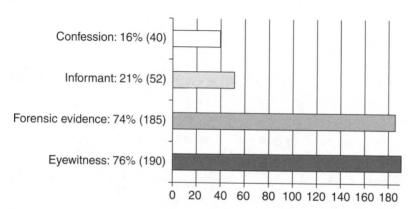

Figure A.5. Evidence supporting exonerees' convictions

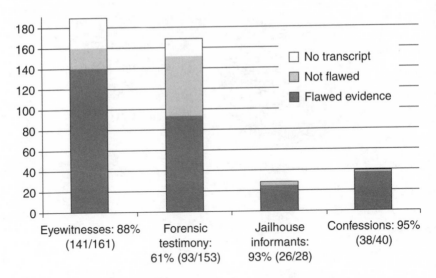

Figure A.6. Flawed trial evidence

Figure A.6 summarizes some ways that the trial evidence was found to have been flawed, due to use of suggestive eyewitness procedures or an uncertain eyewitness, contamination of a confession statement or inculpatory statement to a jailhouse informant, or invalid conclusions by a prosecution forensic analyst at trial.

The two most common types of evidence supporting these convictions were eyewitness identifications and forensic evidence. Most of the trial records involved either suggestive or unreliable identifications, shown in Figure A.7. Similarly, most forensic testimony by prosecution analysts was either invalid (61%) or vague (12%), as shown in Figure A.8.

Figure A.9 summarizes the information discussed in Chapter 3, concerning the eyewitness testimony at these exonerees' trials. Some cases had more than one feature.

Figure A.10 breaks down what types of forensic testimony were presented by prosecution analysts at the trials examined and, as detailed in Chapter 4, what proportion of each type involved invalid conclusions. Many cases had more than one type of forensic evidence.

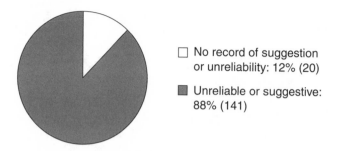

Figure A.7. Unreliable and suggestive identifications

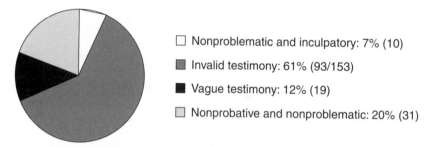

Figure A.8. Invalid and unreliable forensics

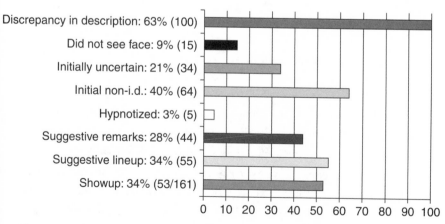

Figure A.9. Eyewitness misidentifications

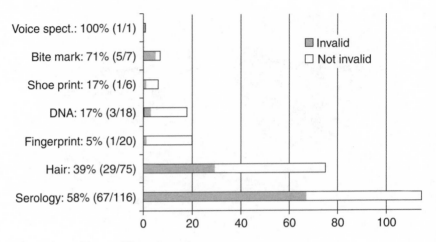

Figure A.10. Types of forensic testimony

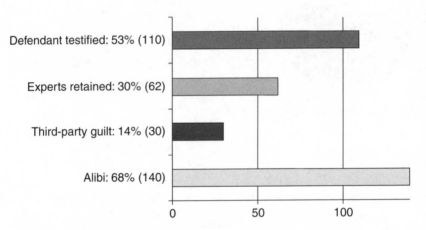

Figure A.11. The defense case at trial

Chapter 6 turns to the defenses that exonerees raised at their trials. Figures A.11 and A.12 depict the types of defenses raised and types of defense lawyers who represented these innocent defendants.

Chapter 7 develops how in the cases with written decisions on appeal, many exonerees did not challenge the trial evidence and very few who did so succeeded. Figure A.13 shows how most challenges to trial evidence were unsuccessful or no challenge was brought at all. However,

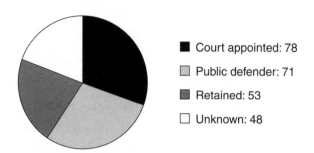

Court appointed: 78
Public defender: 71
Retained: 53
Unknown: 48

Figure A.12. Type of defense lawyer

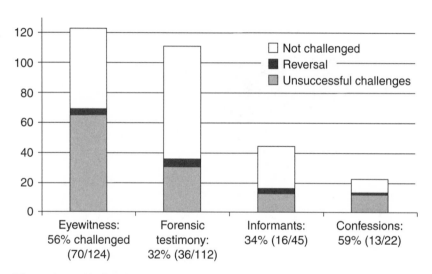

Figure A.13. Challenging evidence postconviction

the reversal rate was likely typical of that for similarly serious criminal convictions.

Chapter 8 develops how exonerees faced additional delays obtaining DNA testing and an exoneration and how postconviction testing often identified the culprit (see Figures A.14 and A.15). I also discuss the average time line to exoneration, from the conviction, to the end of the postconviction process, to the first DNA exclusion, to the eventual exoneration. The time line shown in Figure A.16 displays the average years when each of those events occurred.

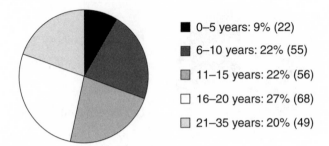

Figure A.14. Number of years to exoneration

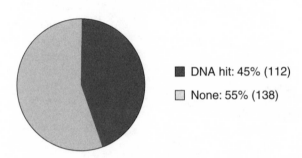

Figure A.15. DNA identified real culprit

Figure A.16. Average timeline from conviction to exoneration

THE 250 EXONEREES

The project of this book began with a remarkable list—a list of 250 names of people exonerated by postconviction DNA testing. By exonerated, I mean that a court or executive vacated the conviction based on newly discovered evidence of innocence, and either there was no trial and the indictment was dismissed, or, in two cases, there was an acquittal at a new trial. In each case, new DNA testing conducted after the conviction excluded the defendant, and in 112 cases the DNA tests also confirmed the guilt of another person.

The authoritative list of DNA exonerations is maintained by the Innocence Project at Cardozo Law School and can be viewed on their website, together with brief descriptions of these cases.[1] I have checked their list as others, as well as by conducting an extensive set of news searches. The Innocence Project list has been complete and accurate, as well as conservative in its criteria for inclusion of cases. The only DNA-related exonerations that I uncovered that were not included on the Innocence Project list were a handful of cases in which the Innocence Project determined that the DNA testing did not play a substantial role in the exoneration (the most high-profile of which is the Paul House case discussed in Chapter 8). I have adopted the same conservative view of what constitutes a DNA exoneration. This list does not include, for example, cases in which DNA testing excluded a person and charges were dismissed before trial, cases in which there was an exoneration but it was not substantially based on DNA evidence, and cases in which there has been no exoneration despite DNA evidence of innocence. The list is not static. New DNA exonerations occur regularly. Occasionally a new DNA exoneration comes to light, that occurred years before but had not been reported in the news. I stopped examining new DNA exonerations when the 250th DNA exoneration occurred in February 2010.

DNA testing is not infallible. Indeed, DNA testing errors contributed to the convictions of three of these exonerees. As with any forensic technique, errors can arise from flawed interpretation of results and from mishandling of samples at a crime scene or in a laboratory. However, DNA testing is uniquely probative of the identity of a rapist. Although it

is possible that an erroneous DNA test could lead to the exoneration of a guilty person, these high-profile cases are closely scrutinized. Judges and prosecutors are not eager to reverse a conviction and often duplicative DNA tests were conducted. In addition, in 112 cases, the DNA tests not only excluded, but also identified the actual perpetrator. We can be quite confident that these convicts are actually innocent.

<div align="center">DATA COLLECTION</div>

I was able to collect such a large set of trial materials from these exonerees' cases with substantial assistance of others, to whom I am extremely grateful. I collected several types of documents. Most time-consuming was obtaining trial transcripts for 207 of the 234 exonerees who had criminal trials. Substantial selections from those trial records have been posted online as a research resource. For thirteen of the sixteen who pleaded guilty, I also located documents, such as pretrial hearings, testimony in codefendant trials and confession statements. I obtained police reports, including interrogation transcripts, for some exonerees as well. The information collected for each of these chapters, with appendixes describing the findings concerning false confessions, eyewitness testimony, forensic testimony, and informant testimony, can be viewed online.[2] They are far too detailed and lengthy to be reproduced here.

Second, I also obtained confession statements, laboratory reports, and police reports where available from prosecutors, postconviction lawyers, and innocence projects. Third, I collected all written judicial decisions from exonerees' appeals and postconviction proceedings. The methodology for reviewing the claims raised and ruled upon in those rulings is described in some detail in my study "Judging Innocence," and data is also available in a detailed appendix that has been updated online.[3]

Fourth, limited data was collected from news reports. Data concerning events following the postconviction review, such as requests for DNA testing, dates when DNA testing was obtained, whether prosecutors consented to DNA testing, and whether exonerees obtained civil settlements, was all collected chiefly from news reports. Much of that information was also supplemented by queries to members of the Innocence Network and the Innocence Project, who were centrally involved in efforts to

secure postconviction DNA testing and could supplement and error-check this data. Data concerning characteristics of exonerees, such as their race, or the race of victims, was also supplemented by queries to the Innocence Project and the Innocence Network.

All of the more than 200 trial transcripts were scanned. Law student research assistants conducted the initial coding for each of the sets of data analyzed. I personally reviewed all of this coding. Peter Neufeld also reviewed the coding of the forensic science testimony, as we coauthored a study of that data. Several scientists reviewed our methodology and answered questions about particular testimony. I have made underlying data available online, as discussed.

The eyewitness data was blind-coded in 60 cases, or half of the cases that had then been obtained (ultimately 161 trials with eyewitness testimony would be located). The eyewitness data involved asking questions about (1) suggestion, or whether police used a suggestive identification procedure, and (2) reliability, or whether the eyewitness had admitted earlier uncertainty or described a person who looked different from the exoneree in some clear and significant way (such discrepancies in appearance, however, did not play an important role in the analysis). The interrater reliability score was high, and I thank Jessica Kostelnik for her help in calculating the score.[4]

Due to the broad scope of the data analyzed and collected, I did not use multiple coders or obtain interrater reliability scores for all of the other scores of questions coded. However, the high interrater reliability score on the eyewitness data gives me confidence as to the remaining coding, which involved questions far more discrete and not requiring significant interpretation or subjective evaluation. For example, much of it coded such concrete questions as what date did the trial begin, was there an expert who testified for the defense, was a confession introduced at trial, and did the person bring a *Brady* claim postconviction. For all coding, more than one student looked at each set of data that was coded. I then reviewed each set of data coded and read all of the underlying trial transcripts and written opinions myself.

One complicating feature of the analysis of the 250 exonerees is that materials could not be obtained for all exonerees. Further, in different chapters of this book, I look at different subgroups of exonerees. The size of the relevant subgroup is different depending on the question being asked. In Chapter 2, where the central question is how many exonerees falsely confessed and had confession statements with detailed facts, I look at the subgroup of forty who falsely confessed. I was able to obtain trial transcripts or case records for the entire set of forty exonerees who falsely confessed. In contrast, Chapter 3 chiefly examines not all 190 cases in which there was an eyewitness identification, but rather the subset of 161 cases involving eyewitnesses in which trial records could be located. Only in those cases could the trial records be reviewed to assess what identification procedures were used and whether the certainty of the eyewitness had changed before trial. Chapter 7 examines only the 165 exonerees' cases in which written judicial decisions were located, since only in such cases can one know what claims the judges ruled on and what reasons they gave for their rulings.

Sometimes I also discuss the entire group of 250 exonerees. When I do so, I state this in the text or in the notes. Examples of information obtained for all 250 exonerees include exoneree race, state of conviction, crime of conviction, years until exoneration, types of evidence supporting their convictions, whether they obtained DNA testing upon consent of the prosecutor, whether testing inculpated the actual perpetrator, and whether they obtained compensation.

SELECTION AND GENERALIZABILITY

DNA exonerees are a unique and clearly "selected" sample. Throughout I make clear that one cannot use their experiences to generalize, nor to make strong conclusions about how our system treats the innocent more generally or how many people are wrongly convicted. Indeed, what makes these exonerations troubling is that we simply do not know to what extent the same problems occur in the vast majority of criminal cases, in which DNA testing cannot tell us whether there was a wrongful conviction.

These DNA exonerations largely consist in convictions in cases involving stranger-rapists, at a trial, in the 1980s, and resulting in lengthy sen-

tences, because those are the cases in which DNA testing was not done at trial but years later could shed light on who committed the crime. As discussed in Chapter 9, there was not adequate data from the 1980s, when most exonerees were convicted, concerning others convicted of sexual assaults. For example, we do not know how many people were convicted at a trial of nonacquaintance rape in the 1980s and served more than ten years in prison. The only comparisons made with "matched" cases involving nonexoneration cases were quite limited in nature. I concluded that similarly serious rape and murder cases involving reported decisions in "matched" cases involved a statistically insignificant difference in reversal rate. I found that similar trials in three states during the 1980s included some of the same types of invalid forensic testimony. Because DNA exonerations occur through such an unusual set of circumstances, they are not susceptible to more robust comparisons. No more was done to compare exonerees' cases to matched reported cases, since the records on those cases were insufficient and did not often include adequate information.[5] Where possible, however, I compared these cases to data concerning felony convictions, habeas corpus litigants, crime laboratory work, confessions, and eyewitness identifications more generally.

Additional work was conducted to assess the robustness of findings describing how these exonerees litigated their cases. In collaboration with Professor J. J. Prescott, this data on the case characteristics of exonerees was comprehensively examined using regressions, and using many different specifications and groups of variables. We wanted to be sure that the prior analysis did not suffer from any omitted variable bias and hoped that new relationships within the data might be uncovered. The work developing those results is discussed in Chapter 7. J. J. Prescott and I looked at what characterized cases in which exonerees obtained reversals prior to obtaining DNA testing. We found evidence that courts more often reversed the convictions of exonerees who claimed innocence or who litigated substantive claims related to the trial evidence. We have also found that claims of innocence, and substantive claims generally, were associated with shorter durations from conviction to exoneration.

More work should be done to examine these exonerations and no doubt more will be done. I hope that the information and analysis in this book will assist others in studying and learning from wrongful convictions.

Notes

1. Ken Armstrong, "Part 6: The Far Limb of the Law," *Chicago Tribune,* December 18, 2002.
2. Sharon Cohen, "Last-Minute Exonerations Fuel Death-Penalty Debate," *Los Angeles Times,* August 15, 1999, A-1.
3. Trial Transcript, 779, 832, 862, 886, 1152–1153, People of the State of Illinois v. Ronald Jones, No. 85-12043 (Ill. Cir. Ct. July 12, 1989).
4. Ibid., 912.
5. Ibid., 1212, 1223 (July 17, 1989).
6. Edward Blake, who conducted the testing, found a "large quantity of spermatozoa" on the vaginal swab, suggesting that the sperm came from the person who murdered the victim shortly thereafter. See Forensic Science Associates, Illinois v. Ronald Jones Report (June 11, 1997), 8.
7. Ken Armstrong, "The Trials of Dick Cunningham: A Death Row Lawyer's Search for Mercy and Redemption, Chapter 9: Sunrise," *Chicago Tribune,* December 23, 2002, 1.
8. Ibid.
9. Jones Trial Transcript, 1092–1094 (July 13, 1989).
10. Ibid., 1142, 1151, 1160; ibid., 64 (July 14, 1989).
11. See ibid., 1089, 1124 (July 13, 1989).
12. Ibid., 1213 (July 17, 1989).
13. Ibid., 951–954 (July 12, 1989).
14. Those five additional exonerees were convicted of other crimes, such as robbery or attempted murder.

15. Most striking, 75% of innocent rape convicts were black or Hispanic, while one study indicates that only approximately 30% of all rape convicts are minorities. See Sean Rosenmerkel, Matthew Durose, and Donald Farole Jr., U.S. Department of Justice, Bureau of Justice Statistics, *Felony Sentences in State Courts, 2006* (2009), table 3.2. Chapter 3 discusses several possible explanations for this racial disparity.

16. Herrera v. Collins, 506 U.S. 390, 420 (1993) (O'Connor, J., concurring); see also ibid., 398–399 (citing to "constitutional provisions [that] have the effect of ensuring against the risk of convicting an innocent person").

17. Edwin M. Borchard, *Convicting the Innocent: Errors of Criminal Justice* (New Haven, CT: Yale University Press, 1932), vi.

18. Hugo Adam Bedau and Michael L. Radelet, "Miscarriages of Justice in Potentially Capital Cases," 40 *Stan. L. Rev.* 21, 87 (1987).

19. The highest numbers were in Texas (40), followed by Illinois (29), New York (25), Virginia (11), Florida (11), Oklahoma (10), Pennsylvania (10), California (9), Massachusetts (9), and Ohio (8). The states with the most exonerations may not have the most error-prone criminal courts. New York and Illinois have the oldest innocence projects and enacted the first statutes to provide access to postconviction DNA testing. Texas and Virginia, on the other hand, happened to preserve biological evidence in some 1980s cases. This suggests that many factors explain why exonerations occur in some states more than in others.

20. See Brandon L. Garrett, "Judging Innocence," 108 *Colum. L. Rev.* 55, 56–58 (2008). The story of the founding of the Innocence Project is told in *Actual Innocence,* a book that compellingly describes the stories of the first DNA exonerees and proposes a series of increasingly adopted reforms. See Barry Scheck, Peter Neufeld, and Jim Dwyer, *Actual Innocence* (New York: Signet, 2001). This book takes up Barry Scheck, Peter Neufeld and Jim Dwyer's invitation to scholars and others to take on "the job of figuring out what went wrong . . ." Ibid., xxiii. Before becoming a law professor, I had the privilege to work for Peter Neufeld and Barry Scheck at the law firm then called Cochran, Neufeld & Scheck, LLP, from 2002 to 2004. I represented several DNA exonerees pursuing civil wrongful conviction actions after their exoneration.

21. Harry Kalven Jr. and Hans Zeisel, *The American Jury* (Chicago: University of Chicago Press, 1966), 32.

22. Several exonerees' trials could not be obtained because their cases were sealed when they were exonerated or had already been sealed to protect the identity of the victim. For others, the records have been lost. In many jurisdictions, the courthouse does not keep copies of trial transcripts, and the court reporter who transcribed the proceedings retains the records. Some of those reporters retired, passed away, could not be located, or no longer had the records. For some exonerees, jury instructions or closing statements were not transcribed, and for most, jury selection and voir dire were not transcribed or obtained. As the Appendix describes, I have made available online much of the data described in this book. See http://www.law.virginia.edu/innocence.

23. Herrera v. Collins, 506 U.S. 390, 416 (1993).

24. United States v. Chronic, 466 U.S. 648, 656 (1984).

25. In these 250 DNA exonerees' cases, at least 27%, or 68, received a pardon. For 84%, or 210, exonerees, a court vacated the conviction. There is an overlap because for some the pardon was a step that followed an exoneration by a court but was necessary in order to obtain compensation. In all but eight of the cases involving a court-ordered vacatur, a state court vacated the conviction. In the eight cases it was a federal court. In two cases, those of Gerald Davis and of Robert Miller, the prosecutor retried the exoneree even after the postconviction DNA testing excluded them and the court vacated the conviction. In each of those cases, the exoneree was acquitted at the retrial.

26. See Glenna Whitley, "Chains of Evidence," *Dallas News-Observer,* August 1, 2007 (describing how Dallas County's private crime lab, the Southwestern Institute of Forensic Sciences, was required to preserve evidence to maintain its accreditation).

27. Lauren Kern, "Innocence Lost? Despite Its Increasing Importance, DNA Evidence Routinely Gets Destroyed Here," *Houston Press,* November 30, 2000.

28. Naftali Bendavid, "Ashcroft Pledges $30 Million to Whittle Down DNA-Test Backlog," *Chicago Tribune,* August 1, 2001.

29. See Edward Connors et al., U.S. Department of Justice, *Convicted by Juries, Exonerated by Science: Case Studies in the Use of DNA Evidence to Establish Innocence After Trial* (1996), xxviii–xxix, 20 (reporting the results of a 1995 DNA laboratory survey, finding a 25% exclusion rate among the more than 10,000 cases tested by the FBI, omitting inconclusive cases, and a higher 30% exclusion rate among the more than 10,000 cases tested by state, local, and private laboratories); see also William S. Sessions, "DNA Evidence and the Death Penalty," *Jurist,* May 30, 2007 (noting that those statistics have remained "roughly the same" over time). Chapter 9 further discusses legal debates and scholarship concerning error rates and wrongful convictions.

2. CONTAMINATED CONFESSIONS

1. Trial Transcript, 1155, 1207–1208, 1534, State of New York v. Jeffrey Deskovic, No. 192-90 (N.Y. Sup. Ct. Dec. 4, 1990).

2. Deskovic Trial Transcript, 1143, 1151–1152.

3. Report on the Conviction of Jeffrey Deskovic, 2, 13 (2007), available at www .westchesterda.net/Jeffrey%20Deskovic%20Comm%20Rpt.pdf.

4. Deskovic Trial Transcript, 1183.

5. Ibid., 693.

6. Deskovic Report, 2.

7. Deskovic Trial Transcript, 1034.

8. Ibid., 1186.

9. Ibid., 1167, 1185, 1429, 1512–1513.

10. Deskovic Report, 3.

11. Ibid., 19.

12. Deskovic Trial Transcript, 1492.

13. Ibid., 1507–1508.

14. Ibid., 1513, 1537.

15. Ibid., 1521.

16. Deskovic Report, 3–4.

17. People v. Deskovic, 607 N.Y.S.2d 696, 697 (N.Y. App. Div. 1994).

18. Fernanda Santos, "Inmate Enters Guilty Plea in '89 Killing," *New York Times,* March 15, 2007; Tony Aiello, "Deskovic Vindicated; 'Real' Teen Killer Confesses," *WCBSTV.com,* November 15, 2006.

19. Fernanda Santos, "DNA Evidence Frees a Man Imprisoned for Half of His Life," *New York Times,* September 21, 2006, A-1.

20. See Saul Kassin and Lawrence Wrightsman, *The Psychology of Evidence and Trial Procedure* (Beverly Hills, CA: Sage Publications, 1985), 78; Fred E. Inbau et al., *Criminal Interrogation and Confessions,* 4th ed. (Gaithersburg, MD: Aspen Publishers, 2001), 412.

21. Jonathan Bandler, "Deskovic Files Federal Lawsuit over His 15-year Wrongful Imprisonment," *Journal News* (White Plains, NY), September 18, 2007.

22. John Henry Wigmore, *A Treatise on the Anglo-American System of Evidence in Trials at Common Law,* 2nd ed., vol. 2 (Boston: Little, Brown, 1923), § 835, 867.

23. Saul Kassin et al., "Police Interviewing and Interrogation: A Self-Report Survey of Police Practices and Beliefs," 31 *Law & Hum. Behav.* 381 (2007).

24. See Kassin and Wrightsman, *Psychology of Evidence,* 67–94; Richard A. Leo and Richard J. Ofshe, "The Consequences of False Confessions: Deprivations of Liberty and Miscarriages of Justice in the Age of Psychological Interrogation," 88 *J. Crim., L. & Criminology* 429 (1998); Corey J. Ayling, "Corroborating Confessions: An Empirical Analysis of Legal Safeguards against False Confessions," 1984 *Wis. L. Rev.* 1121, 1186–1187 (1984). For experimental work concerning false confessions, see, e.g., Saul Kassin and Katharine Kiechel, "The Social Psychology of False Confessions: Compliance, Internalization, and Confabulation," *Psychological Science* (1996); Saul Kassin and Holly Sukel, "Coerced Confessions and the Jury: An Experimental Test of the 'Harmless Error' Rule," 21 *Law & Hum. Behav.* 27 (1997); Saul Kassin, "On the Psychology of Confessions: Does Innocence Put Innocents at Risk?" 60 *Am. Psychol.* 215, 223 (2005).

25. See Major Joshua E. Kastenberg, "A Three-Dimensional Model for the Use of Expert Psychiatric and Psychological Evidence in False Confession Defenses Before the Trier of Fact," 26 *Seattle U. L. Rev.* 783 (2003).

26. See Richard A. Leo, *Police Interrogation and American Justice* (Cambridge, MA: Harvard University Press, 2008), 166 (calling on scholars to examine "the postadmission portion of police interrogation" and noting that "it has received far less attention from scholars, lawyers, and the media").

27. Thirty of the forty exonerees were convicted at a trial. The ten who pleaded guilty were: Marcellius Bradford, Keith Brown, James Dean, Anthony Gray, William Kelly, Chris Ochoa, Debra Shelden, Ada JoAnn Taylor, David Vasquez, and Thomas Winslow. For all of the thirty convicted at a trial, trial materials were obtained. Of those

who pleaded guilty, five had trial materials because they testified in codefendants' trials or were tried for additional crimes that they did not commit. Bradford, Dean, Ochoa, Taylor, and Shelden testified at trials against others they had implicated. Although Brown, Gray, Kelly, Vasquez, and Winslow pleaded guilty and did not testify in a trial, I obtained court files and documents describing their confession statements (including a video of part of the interrogation in Winslow's case). I note that Jerry Frank Townsend pleaded guilty to some offenses but was tried for two of the crimes he confessed to.

28. The forty cases all involved an exoneree interrogated in a custodial setting who reportedly delivered self-incriminating statements and admissions of guilt to police, though not necessarily to all of the charged acts. These forty cases do not include nine exonerees who reportedly made self-incriminating remarks volunteered to police outside of custody and that were not full admissions to having committed any of the charged acts. The characteristics of the forty cases are summarized in an appendix accompanying my article "The Substance of False Confessions," which is available online at a University of Virginia School of Law Library research collection webpage together with relevant portions of these forty exonerees' interrogation records and trial transcripts. Written confession statements were obtained for twenty-eight exonerees. See www.law.virginia.edu/html/librarysite/garrett_falseconfess.htm. My prior article did not include the cases of two exonerees, Keith Brown and Anthony Gray. I have since located a copy of Keith Brown's quite detailed confession statement (although a second statement the he wrote himself was markedly inconsistent and was not detailed). Gray "had given a detailed confession." Attorney Grievance Comm'n v. Kent, 653 A.2d 909, 917 (Md. 1995). Although the court file did not include the audio or written confession statements, it referenced how he confessed to having stood watch when the victim was murdered. News reports as well as conversations with Gray's lawyer and former prosecutors involved in the case confirmed that his confession statements were detailed but also contained certain inconsistencies with crime scene evidence. See Todd Richissin, "Trying to Right an Injustice; Murder: A Defense Attorney and Calvert County State's Attorney Say a Man Has Been Wrongly Imprisoned for the Past Seven Years," *Baltimore Sun,* February 6, 1999, 1A.

29. I first explored these false confessions in a law review article. See Brandon L. Garrett, "The Substance of False Confessions," 62 *Stan. L. Rev.* 1051 (2010). I stopped examining new exonerations after February 2010, when the 250th DNA exoneration occurred. I note that three subsequent exonerations all apparently involved false and contaminated confessions. Exoneree Ted Bradford had provided a false confession reported to have included "details that would only be known to the rapist." Mark Morey, "Jurors Find Bradford Innocent of Rape," *Yakima Herald-Republic* (Yakima, WA), February 11, 2010. Exoneree Anthony Caravella initially confessed with details inconsistent with the crime, but over a series of interrogations was reported to provide accurate details, including information "suggested to him by leading questions." Paula McMahon, "DNA Result Just One Troubling Aspect in Convicted Man's Case," *South Florida Sun Sentinel,* September 4, 2009. Exoneree Frank

Sterling's false confession was also reported to have included inside information about the crime. Rachel Barnhart, "Innocence Project: Frank Sterling Cleared of Manville Murder, Christie Confesses," *WHAM.com,* March 28, 2010.

30. Arizona v. Fulminante, 499 U.S. 279, 296 (1991) (quoting Bruton v. United States, 391 U.S. 123, 139–140 (1968)); see also Mark Costanzo, Netta Shaked-Schroer, and Katharine Vinson, "Juror Beliefs about Police Interrogations, False Confessions, and Expert Testimony," 7 *J. Empirical Legal Stud.* 231 (2010).

31. Gross et. al., "Exonerations in the United States 1989 Through 2003," 95 *J. Crim. L. & Criminology* 523, 544 (2005).

32. Leo, *Police Interrogation,* ch. 5.

33. Trial Transcript, 1292, State of Oklahoma v. Robert Lee Miller, Jr., CRF-87-963 (Okla. D. Ct. May 15–17, 1988).

34. See, e.g., Leo, *Police Interrogation,* 243 (reviewing literature, and concluding, "Since the late 1980's six studies alone have documented approximately 250 interrogation-inducted false confessions").

35. Barry C. Feld, "Police Interrogation of Juveniles: An Empirical Study of Policy and Practice," 97 *J. Crim. L. & Criminology* 219, 315 (2006) ("Police in this study concluded three-quarters of interrogations in thirty minutes or less, and none exceeded one and one-half hours."); Richard A. Leo, "Inside the Interrogation Room," 86 *J. Crim. L. & Criminology* 266, 279–280 (1996).

36. The twenty-one cases are those of: Marcellius Bradford, Rolando Cruz, Anthony Gray, Paula Gray, Travis Hayes, Alejandro Hernandez, David Allen Jones, Ryan Mathews, Antron McCray, Robert Miller, Christopher Ochoa, Calvin Ollins, Kevin Richardson, Yusef Salaam, Raymond Santana, Jerry Frank Townsend, David Vasquez, Douglas Warney, Earl Washington Jr., Ronald Williamson, and Korey Wise. In at least eight of those cases that person subsequently confessed to the crime and often also pleaded guilty. Cases involving confessions of the person inculpated by postconviction DNA testing are those of Rolando Cruz, Alejandro Hernandez, Christopher Ochoa, Antron McCray, Kevin Richardson, Yusef Salaam, Raymond Santana, and Korey Wise.

37. In addition, five of those twelve rape cases were in the Central Park Jogger case, which was investigated as a murder, where the victim was in critical condition and in a coma.

38. Anne Coughlin has written an important article examining the victim-blaming narratives endorsed by leading training manuals and employed to "minimize" the acts of a suspect during interrogations. See Anne M. Coughlin, "Interrogation Stories," 95 *Va. L. Rev.* 1599 (2009). Coughlin argues that "[v]ictim-blaming is incompatible with the contemporary goals of rape law, and the police should stop feeding those stock stories to accused rapists." Ibid., 1660.

39. Frazier v. Cupp, 394 U.S. 731, 739 (1969); Laurie Magid, "Deceptive Police Interrogation Practices: How Far Is Too Far?" 99 *Mich. L. Rev.* 1168, 1169 (2001); Inbau et al., *Criminal Interrogation and Confessions,* 486–487.

40. Memorandum in Opposition to Defendant's Motion to Suppress Statements, 3, Commonwealth v. Vasquez, C-22,213 to -22,216, C-22,763 (Va. Cir. Ct. Oct. 1984).

41. The exonerees were James Dean, Jeffrey Deskovic, Byron Halsey, Travis Hayes, Ronald Jones, John Kogut, Eddie Lowery, and Debra Shelden.

42. See generally, Saul M. Kassin et al., "Police-Induced Confessions: Risk Factors and Recommendations," 34 *Law & Hum. Behav.* 27–32 (2010); Louis C. Senese, *Anatomy of Interrogation Themes: The Reid Technique of Interviewing and Interrogation* (Chicago: John E. Reid and Associates, 2005).

43. Inbau et al., *Criminal Interrogation and Confessions*, 367.

44. Richard Ofshe and Richard Leo, "The Decision to Confess Falsely: Rational Choice and Irrational Action," 74 *Denv. U. L. Rev.* 979, 993 (1997).

45. Trial Transcript, 78–79, State of Louisiana v. Dennis P. Brown, No. 128, 634 (La. Dist. Ct. April 3, 1985).

46. Trial Transcript, State of New York v. Douglas Warney, Ind. No. 96-0088 (N.Y. Sup. Ct. Feb. 11, 1997).

47. Ibid., 570–571.

48. Jim Dwyer, "Inmate to Be Freed as DNA Tests Upend Murder Confession," *New York Times,* May 16, 2006.

49. Those exonerees are Paula Gray (who inculpated Kenneth Adams, Verneal Jimerson, Willie Rainge, and Dennis Williams), Antron McCray, Kevin Richardson, Raymond Santana, Yusef Salaam, and Korey Wise (who each implicated others in the Central Park case), James Dean, Ada JoAnn Taylor, Debra Shelden, and Thomas Winslow (who variously implicated each other and Kathy Gonzalez and Joseph White in the Beatrice Six case), Alejandro Hernandez and Rolando Cruz (who implicated each other), Marcellius Bradford and Calvin Ollins (who confessed and implicated Larry Ollins and Omar Saunders), Travis Hayes (who implicated Ryan Mathews), John Kogut (who implicated John Restivo and Dennis Halstead), and Chris Ochoa (who implicated Richard Danziger).

50. Trial Transcript, 942, State v. White, No. 9316 (Neb. Dist. Ct. Nov. 7, 1989).

51. Ibid., 953.

52. Ibid., 924, 931, 939.

53. Ibid., 959.

54. Patrick McCreless, "Justice . . . Finally," *Cullman Times* (Culman, AL), October 22, 2008.

55. Trial Transcript, 862, State of Illinois v. Ronald Jones, No. 85-12043 (Cir. Ct. Cook County July 12, 1989).

56. Trial Transcript, 450, State of Oklahoma v. Ronald Keith Williamson, CRF 87-90 (Okla. Dist. Ct. April 21–28, 1988).

57. Ibid., 541–542. However, in a possible inconsistency if Williamson's statement was interpreted to mean stabbing using a knife, Dr. Jordan also stated that he did not believe the puncture wounds on her body were caused by a knife. Ibid., 551–552.

58. Jim Trainum, "Editorial, Get It on Tape: A False Confession to Murder Convinced a Cop That a Visual Record Can Help Ensure an Innocent Person Isn't Convicted," *Los Angeles Times,* October 24, 2008, 6.

59. Motion to Suppress Hearing Transcript, 40, People v. Hatchett (Mich. Cir. Ct. Sept. 22, 1997).

60. Washington v. Murray, 4 F.3d 1285, 1292 (4th Cir. 1993).

61. Statement of Earl Junior Washington, June 4, 1982 at 6.

62. Trial Transcript, 527–537, 540, 566, Commonwealth of Virginia v. Earl Junior Washington (Va. Cir. Ct. Jan. 19, 1984).

63. Margaret Edds, *An Expendable Man: The Near-Execution of Earl Washington, Jr.* (New York: New York University Press, 2003), 248.

64. Jerry Markon, "Wrongfully Jailed Man Wins Suit," *Washington Post,* May 6, 2006, B01 (describing that jury awarded $2.25 million finding that "Wilmore deliberately falsified evidence, which resulted in Washington's conviction and death sentence").

65. Trial Transcript, 5291–5292, People v. McCray et al., No. 4762/89 (N.Y. Sup. Ct. Aug. 8, 1990).

66. Trial Transcript, 22, Commonwealth of Pennsylvania v. Bruce Donald Godschalk, No. 00934-87 (Pa. Ct. Com. Pl. May 27, 1987).

67. Trial Transcript, 1292, State of Oklahoma v. Robert Lee Miller, Jr., CRF-87-963 (Okla. Dist. Ct. May 15–17, 1988).

68. Trial Transcript, 146, State of Illinois v. Alejandro Hernandez et al., No. 84-CF-361-01-12 (Ill. Cir. Ct. Feb. 20, 1985).

69. Transcript of Taped Interview of David Jones, 33, People v. Jones, No. BAO71698 (Cal. Super. Ct. July 15, 1993).

70. Maura Dolan and Evelyn Larrubia, "Telling Police What They Want to Hear, Even if It's False," *Los Angeles Times,* October 30, 2004.

71. Trial Transcript, 2-133 to 2-135, Commonwealth v. Yarris, No. 690-82 (Pa. Ct. Com. Pl. June 29, 1982).

72. Leo, *Police Interrogation,* 261.

73. Trial Transcript, 96, State of Louisiana v. Dennis Brown, No. 128,634 (La. Dist. Ct. April 12, 1985).

74. Trial Transcript, 77, 122, State of Illinois v. Ronald Jones, No. 85-12043 (Ill. Cir. Ct. Feb. 24, 1986).

75. Washington Trial Transcript, 622–623.

76. See Leo and Ofshe, "The Decision to Confess Falsely," 1119 ("the reliability of a confession statement can usually be objectively determined by evaluating the fit between a post-admission narrative and the crime facts.").

77. In other cases, the law enforcement account of the interrogation does not describe any statements made inconsistent with the crime, but absent a complete recording of the interrogation, one cannot be confident what transpired.

78. Washington Trial Transcript, 596.

79. Ibid., 618.

80. See, e.g., Eric M. Freedman, "Earl Washington's Ordeal," 29 *Hofstra L. Rev.* 1091 (2001).

81. Trial Transcript, 714–715, State v. Halsey, Nos. 63-01-86, 210-02-87 (N.J. Super. Ct. Mar. 7, 1988).

82. See Godschalk Trial Transcript, 72.

83. Brooke Masters, "Missteps on the Road to Justice," *Washington Post,* December 1, 2000, A1.

84. Maurice Possley, "Lab Didn't Bother with DNA," *Chicago Tribune,* August 25, 2006.

85. The eight are: Jeffrey Deskovic, Travis Hayes, Ryan Matthews, Antron McCray, Kevin Richardson, Raymond Santana, Yusef Salaam, and Korey Wise. See Brandon L. Garrett, "Claiming Innocence," 92 *Minn. L. Rev.* 1629, 1660–1661 (2008). A total of sixteen exonerees were convicted despite DNA tests excluding them at the time they were convicted (the other eight had not falsely confessed.) Those cases are discussed in Chapter 4.

86. See Deskovic Report.

87. Trial Transcript, 280, People v. Hatchett, 97-1497-FC (Mich. Cir. Ct. Mar. 6, 1998).

88. According to Steven Drizin, there were no motions to suppress Cruz's confession because the defense theory was that the noncustodial confession never happened, but rather that it was a dream statement made up by the police.

89. Colorado v. Connoley, 479 U.S. 157, 161 (1986); ibid., 175 (Brennan, J., dissenting).

90. 384 U.S. 436 (1966).

91. Richard A. Leo, "Inside the Interrogation Room," 276; see also Steven D. Clymer, "Are Police Free to Disregard Miranda?" 112 *Yale L.J.* 447, 502–512 (2002); Richard A. Leo, "Questioning the Relevance of Miranda in the Twenty-First Century," 99 *Mich. L. Rev.* 1000, 1010 (2001); Louis Michael Seidman, "Brown and Miranda," 80 *Cal. L. Rev.* 673, 745 (1992).

92. Trial Transcript, 20, People v. Lloyd, No. 85-00376 (Mich. Rec. Ct. May 2, 1985).

93. Arizona v. Fulminante, 499 U.S. 279 (1991); Schneckloth v. Bustamonte, 412 U.S. 218, 226 (1973). The voluntariness standard regulates only confessions made in custody. Oregon v. Elstad, 470 U.S. 298, 311–314 (1985). Nine additional exonerees did not confess, but they did talk to police and reportedly volunteered information before any custodial interrogation began. Many of these statements were quite damaging at trial, precisely for the same reason that the false confessions were; they were reported to include nonpublic details about the crime. I describe those cases in Garrett, "Substance of False Confessions," 1106–1107.

94. Brown v. Illinois, 422 U.S. 590, 604 (1975) ("[T]he burden of showing admissibility rests, of course, on the prosecution.")

95. See Steven A. Drizin and Richard A. Leo, "The Problem of False Confessions in the Post-DNA World," 82 *N.C. L. Rev.* 891, 919–920 (2004).

96. Trial Transcript, 4:26–4:27, State of New York v. John Kogut, Ind. 61029 (N.Y. Sup. Ct. May 1986).

97. Trial Transcript, 2160, State of Florida v. Jerry Frank Townsend, No. 79-7217 (Fla. Cir. Ct. July 16, 1980).

98. Miller Trial Transcript, 1039.

99. Brown Trial Transcript, 165.

100. Trial Transcript, 125–126, State of Ilinois v. Ronald Jones, No. 85-12043 (Ill. Cir. Ct. July 13, 1989).

101. Trial Transcript, 3572–3574, State of Illinois v. Paula Gray, No. 78 C4865 (Ill. Cir. Ct. Oct. 16, 1978).

102. Vasquez Memorandum in Opposition, 3.

103. Tina Kelley, "New Jersey Drops Charges for Man Imprisoned 19 Years," *New York Times,* July 10, 2007, B3.

104. Trial Transcript, 692, 695, State of New Jersey v. Byron Halsey, No. 0063-01-86 (N.J. Sup. Ct. App. Div. March 11–18, 1988).

105. Trial Transcript, D-182, State of Illinois v. Lafonso Rollins, No. 93 CR 6342, (Ill. Cir. Ct. March 2, 1994).

106. Godschalk Trial Transcript, 126–127 (May 26, 1987).

107. Warney Trial Transcript, 6.

108. Godschalk Trial Transcript, 154.

109. Gray Trial Transcript, 1313.

110. Memorandum, Commonwealth of Virginia v. David Vasquez, C-22213–22216, C22763 (Va. Cir. Ct. Jan. 25, 1985).

111. Return to People's Petition for Writ of Habeas Corpus at 25, In re David Allen Jones, No. BA071698 (Cal. Super. Ct. June 17, 2004).

112. Ardy Friedberg and Jason Smith, "Townsend Released; Judge Cites 'An Enormous Tragedy'; Attorneys Say Suspect Was Easily Led to Confess," *Sun-Sentinel,* June 16, 2001, p. 1A.

113. Townsend Trial Transcript, 43, 50.

114. The State apparently also introduced into the record "transcriptions" of expert evaluations they had conducted. Ibid., 100.

115. Ibid., 397–400.

116. Townsend Trial Transcript, 516–517.

117. Frank Lee Smith's case is discussed in detail in Chapter 8.

118. Deskovic Report, 7.

119. See, e.g., Richard A. Leo et al., "Bringing Reliability Back In: False Confessions and Legal Safeguards in the Twenty-First Century," 2006 *Wis. L. Rev.* 479, 486 (2006).

120. Vasquez Memorandum in Opposition, 1–2.

121. Dana Priest, "At Each Step, Justice Faltered for VA Man," *Washington Post,* July 16, 1989, A1.

3. EYEWITNESS MISIDENTIFICATIONS

1. Trial Transcript, 29–33, State of New York v. Vincent H. Jenkins, No. 82-1320-001 (N.Y. Sup. Ct. May 31, 1983). Vincent Jenkins changed his name after his conviction to Habib Abdal.

2. Ibid., 52–59.

3. See Gary L. Wells and Deah S. Quinlivan, "Suggestive Eyewitness Identification Procedures and the Supreme Court's Reliability Test in Light of Eyewitness Science: 30 Years Later," 33 *Law & Hum. Behav.* 14 (2009).

4. Jenkins Trial Transcript, 62 (June 1, 1983).

5. Ibid., 86.

6. Ibid., 36, 49–52.

7. Ibid., 52.

8. Watkins v. Sowders, 449 U.S. 341, 352 (1981) (Brennan, J., dissenting).

9. Trial Transcript, 196, State of Illinois v. Jerry Miller, No. 81-C-7310 (Ill. Cir. Ct. Sept. 29, 1982).

10. Gerry Smith, "Rape Conviction Gone, Stigma Isn't," *Chicago Tribune,* October 22, 2007, 1.

11. In two of those cases, those of William Gregory and Mark Webb, while the complete trial transcript could not be located, portions were obtained because the eyewitness identification was described in police reports or portions of the trial were quoted in judicial decisions that were obtained.

12. The online appendix details the coding criteria; the features of each of the cases; the types of suggestive procedures used, if any; the types of unreliability identified, if any; and provides quotations from the relevant trial testimony to describe what the trial records show. See http://www.law.virginia.edu/innocence. In a handful of cases, the complete trial transcripts were not obtained, but portions relevant to the eyewitness identifications were obtained. Any additional information from postconviction decisions or news reports is also noted.

13. Gary L. Wells et al., "Eyewitness Identification Procedures: Recommendations for Lineups and Photospreads," 22 *Law & Hum. Behav.* 605 (1998).

14. See Wells and Quinlivan, "Suggestive Eyewitness Identification Procedures," 6 (discussing data from archival studies, showing that eyewitnesses in real cases make misidentifications, but emphasizing that filler identifications cannot tell one at what rate innocent people are misidentified).

15. Alvin G. Goldstein, June E. Chance, and Gregory R. Schneller, "Frequency of Eyewitness Identification in Criminal Cases: A Survey of Prosecutors," 27 *Bull. Psychonomic Soc'y* 73 (1989).

16. Thirty-seven were identified by 2 eyewitnesses, nineteen were identified by 3 eyewitnesses, eight were identified by 4 eyewitnesses, three were identified by 5 eyewitnesses, and one was identified by 10 eyewitnesses.

17. Trial Transcript, 343, State of Florida v. Cody Edward Davis, Case No. 06-004031CF A02 (Fla. Cir. Ct. Aug. 16, 2006).

18. Samuel R. Gross, "Loss of Innocence: Eyewitness Identification and Proof of Guilt," 16 *J. Legal Stud.* 400, 416 (1987) (describing misidentifications in which the suspect was initially located based on appearance).

19. Amy Bradford Douglass, Caroline Smith, and Rebecca Fraser-Thill, "A Problem with Double-Blind Photospread Procedures: Photospread Administrators Use One Eyewitness's Confidence to Influence the ID of Another Witness," 29 *Law & Hum. Behav.* 543–562 (2005); see Wells et al., "Eyewitness Identification Procedures," 625–626.

20. Of the 190 exonerees who had eyewitness evidence in their cases, 159 involved a rape conviction, 9 involved a murder, 17 involved a rape and a murder, and 5 involved other crimes (a robbery, three carjackings, and an attempted murder).

21. Thirty-one of the exonerees *not* convicted of rape had eyewitnesses identify them. Of the exonerees convicted of murder, 41% (nine of twenty-two) had eyewitnesses.

Of those convicted of rape and murder, 33% (seventeen of fifty-two) had eyewitnesses. All five of the exonerees convicted of other crimes (not rape or murder) had eyewitnesses testify. Only one exoneree convicted of a murder, Kevin Lee Green, had a victim eyewitness identify him at trial. His pregnant wife had been gravely assaulted, the murder victim was his unborn child, and perhaps in part due to substantial memory loss and brain damage, his wife identified him at trial. See "Falsely Accused," 16 *Forensic Examiner* 82 (September 22, 2007). The other exonerees convicted of murder who had eyewitness testimony all had testimony by nonvictim eyewitnesses. Of the exonerees convicted of murder and rape, three had victim eyewitnesses, all where there was a victim of a rape apart from the victim of the murder, and fourteen others had a nonvictim eyewitness testify.

22. Only 23 of the entire group of 190 cases had identifications by acquaintances. See Lawrence A. Greenfeld, U.S. Department of Justice, Bureau of Justice Statistics, *Sex Offenses and Offenders* (1997), 4 (three out of four reported rapes involve offenders with whom the victim had a prior relationship).

23. Elizabeth Hampson, Sari M. van Anders, and Lucy I. Mullin, "A Female Advantage in the Recognition of Emotional Facial Expressions: Test of an Evolutionary Hypothesis," 27 *Evolution & Hum. Behav.* 27 (2006).

24. Manson v. Brathwaite, 432 U.S. 98, 119 (1977).

25. Gary Wells and Elizabeth Loftus, *Eyewitness Testimony* (Cambridge: Cambridge University Press, 1984), 12, 28–29; Gary L. Wells and Lisa E. Hasel, "Facial Composite Production by Eyewitnesses," 16 *Current Directions Psychol. Sci.* 6 (2007); N. A. Brace et al., "Identifying Composites of Famous Faces: Investigating Memory, Language and System Issues," 12 *Psychol. Crime & L.* 351 (2006).

26. Trial Transcript, 34, State of Louisiana v. Allen H. Coco, No. 14891-95 (La. Dist. Ct. Nov. 6, 1997).

27. For example, of the fifty-three showups, twenty-nine occurred in cases in which there was also a photo array. Of the cases with lineups, forty-seven occurred in cases in which there was also a photo array. It is a promising area for future research to explore the reinforcing effect of conducting multiple identification procedures and of different types with an eyewitness. Studies have found that repeat viewings, or "laps," increase choosing rates and error rates, with particularly high error rates among witnesses who choose to view a second time. See, e.g. Nancy K. Steblay et al., "Sequential Lineup Laps and Eyewitness Accuracy," *Law & Hum. Behav.* (forthcoming 2011).

28. Hearing Transcript, 163, State of California v. James Ochoa, No. 05NF2056 (Cal. Sup. Ct. June 8, 2005); see also Steve McGonigle and Jennifer Emily, "A Blind Faith in Eyewitnesses, 18 of 19 Local Cases Overturned by DNA Relied Heavily on Unreliable Testimony," *Dallas Morning News,* October 12, 2008, 1A ("Most police agencies don't have written policies on identification techniques, and police officers receive little formal training.").

29. 432 U.S. 98 (1977).

30. United States v. Wade, 388 U.S. 218, 228 (1967).

31. See Brian L. Cutler, Steven D. Penrod, and Hedy Red Dexter, "Juror Sensitivity to Eyewitness Identification Evidence," 14 *Law & Hum. Behav.* 190 (1990); Wells et al., "Eyewitness Identification Procedures," 619–620.

32. See Wells et al., "Eyewitness Identification Procedures," 635–636.

33. Stovall v. Denno, 388 U.S. 293, 302 (1967).

34. Throughout this chapter, statistics are provided based on percentages of the 161 trials obtained with eyewitness identifications. As noted, many trials had more than one eyewitness testifying, and for those, any one eyewitness is counted. For example, if there was a showup for any one of the eyewitnesses, or for multiple eyewitnesses, this is counted as one case involving a showup.

35. One study suggests that proper showups conducted on the scene may create different risks of error than a poorly handled lineup. Richard Gonzalez, Phoebe C. Ellsworth, and Maceo Pembroke, "Response Biases in Lineups and Showups," 64 *J. Personality and Soc. Psychol.* 525 (1993). In a poorly handled lineup, a witness may comparison shop for the person who looks most like the attacker. In a showup it is clear that the choice is yes or no, was this the attacker or not, and the greater risk may be that a guilty suspect might not be identified. Regardless, "there is clear evidence that showups are more likely to yield false identifications than are properly constructed lineups." See Wells et al., "Eyewitness Identification Procedures," 630–631.

36. Bibbins v. City of Baton Rouge, NO. CIV.A.04-122-JJB, 489 F.Supp. 2d 562, 570 (M.D. La. May 11, 2007).

37. Trial Transcript, 12, 147–149, Commonwealth of Virginia v. Willie Davidson (Va. Cir. Ct. May 27, 1981).

38. Trial Transcript, 17, 21, 23, State of Florida v. Alan J. Crotzger, Case No. 81-6604 (Fla. Cir. Ct. April 19, 1982).

39. Trial Transcript, 445, Commonwealth v. Neil Miller, No. 085602-04 (Mass. Sup. Ct. Dec. 14, 1990).

40. These cases were not coded as showups, since the police did not arrange for the eyewitnesses to see those images. Nor were a few cases in which the victim saw someone in the neighborhood and identified the person as the attacker—unless the police followed that identification up with a showup.

41. Wells et al., "Eyewitness Identification Procedures," 630–635; Elizabeth F. Loftus, James M. Doyle, and Jennifer E. Dysart, *Eyewitness Testimony: Civil and Criminal* (LexisNexis 4th ed. 2007) § 4-9. Similarly, in a few cases the witness was shown only three photos, a lineup with so few choices that it was coded as inherently suggestive. Wells et al. describe how to best structure lineups or photospreads, a subject that can raise some more complex issues depending on the relationship between what the witness described and what the suspect looks like. For the most part, the preferred method is to pick fillers who fit the witnesses' description of the perpetrator. Wells et al., "Eyewitness Identification Procedures," 632.

42. Trial Transcript, 52, 99, Commonwealth of Virginia v. Marvin Lamont Anderson (Va. Cir. Ct. Dec. 14, 1982).

43. Ibid., 22, 27–28, 62, 198.

44. Ibid., 66.

45. Ibid., 201–204.

46. Frank Green, "Va. Court Rejected First Appeal," *Richmond Times-Dispatch*, July 16, 2007, A7; see also http://www.innocenceproject.org/Content/49.php.

47. Trial Transcript, 72–73, State of Illinois v. Ronnie Bullock, No. 83 C 5501 (Ill. Cir. Ct. April 30, 1984).

48. Trial Transcript, 37, State of Missouri v. Lonnie Erby, No. 851-2663 (Mo. Cir. Ct. June 9, 1986).

49. Trial Transcript, 101, Commonwealth v. Thomas Doswell, No. CC 8603467 (Pa. Ct. of Common Pleas Nov. 19, 1986).

50. Many more cases likely involved such repetition of just the exoneree in multiple procedures, but it was often not clear from the testimony whether any of the fillers were repeated along with the exoneree. See Wells et al., "Eyewitness Identification Procedures," 603; Ryann M. Haw, Jason J. Dickonson, and Christian A. Meissner, "The Phenomenology of Carryover Effects Between Show-up and Line-up Identification," 15 *Memory* 117 (2007).

51. Trial Transcript, 26, 31–33, State of Texas v. Larry Fuller, No. F81-8431-P (Tex. Dist. Ct. May 13, 1981).

52. Deah S. Quinlivan et al., "Do Prophylactics Prevent Inflation? Post-Identification Feedback and the Effectiveness of Procedures to Protect against Confidence-Inflation in Earwitnesses," 33 *Law & Hum. Behav.* 111 (2009). Because there is less research on voice identifications, and because they raise issues separate from eyewitness identifications, I conservatively did not count as suggestive any of the cases that involved single-voice identifications or other suggestive voice identification procedures.

53. Ibid.; Wells et al., "Eyewitness Identification Procedures," 615, 629–630.

54. In all other cases, the eyewitness or the police described telling the eyewitness to simply look at the photos or lineup, they could not recall any specific instructions, or worse, the police told the eyewitness that a suspect had been located.

55. See Loftus, Doyle, and Dysart, *Eyewitness Testimony,* § 4-8(b) (describing study by Roy Malpas and Patricia Devine, and noting eighteen other studies demonstrating higher false identification when such biased instructions were provided).

56. Trial Transcript, 60–61, State of Illinois v. Richard Johnson, No. 91 CR 20794 (Ill. Cir. Ct. Oct. 6, 1992).

57. Trial Transcript, 70–71, State of Ohio v. Robert L. McClendon, No. 90CR-05-2586 (Ohio Ct. of Common Pleas Aug. 26, 1991).

58. Trial Transcript, 34, State of Illinois v. Alejandro Dominguez, 89 CP 1995 (Ill. Cir. Ct. 1995).

59. Johnson Trial Transcript, 39.

60. Trial Transcript, 54, State of Texas v. Gilbert Alejandro, No. 90-09-8445-CR (Tex. Dist. Ct. December 11, 1990).

61. Trial Transcript, 305, State of Indiana v. Larry Mayes, No. 1CR-6-181-17 (Ind. Sup. Ct. July 6, 1982).

62. Those exonerees were Edward Honaker, Lesly Jean, Larry Mayes, Leo Waters, and Glen Woodall.

63. Jean v. Rice, 945 F.2d 82, 87 (4th Cir. 1991).

64. Due to evidence that hypnosis can create false or inaccurate memories, some courts bar all testimony by hypnotized witnesses at trial. Other courts admit the evidence, but only if experts also testify as to the dangers of such techniques. Council on Scientific Affairs, "Scientific Status of Refreshing Recollection by the Use of Hypnosis," 253 *J. Am. Med. Ass'n* 1918, 1919 (1985); Lisa K. Rozzano, "The Use of Hypnosis in Criminal Trials: The Black Letter of the Black Art," 21 *Loy. L.A. L. Rev.* 635, 645 (1987).

65. Trial Transcript, 37–38, State of Texas v. Larry Fuller, No. F81-8431-P (Tex. Dist. Ct. Aug. 24, 1981).

66. Trial Transcript, 63, State of Ohio v. Anthony Green, No. CR 228250 (Ohio Ct. of Common Pleas Oct. 13, 1988).

67. Jennifer Thompson-Cannino and Ronald Cotton, *Picking Cotton: Our Memoir of Justice and Redemption* (New York: St. Martin's Press, 2009), 134.

68. Trial Transcript, 230–232, State of Texas v. Thomas Clifford McGowan, Jr., 85-81070-MU (Tex. Dist. Ct. March 5, 1986). In addition, the photo array was itself flawed; most of the photos were hard-to-make-out, black-and-white photos or photos with captions indicating they were from a different police department.

69. Trial Transcript, 148, State of Missouri v. Larry Johnson, No. 341-00274 (Mo. Cir. Ct. August 20, 1984).

70. I was very conservative in my criteria for counting a case as involving an "unreliable" identification. I only included, as the online Appendix details, cases in which (1) the eyewitness identified another person, or (2) the eyewitness admitted earlier uncertainty, or initially failed to identify the exoneree, or (3) an eyewitness admittedly could not see the attacker's face. I separately note, but did not code as unreliable, cases involving gross discrepancies between the eyewitness' initial description of the person who attacked them and the defendant's appearance; cases involving a lengthy duration from incident to first identification; cases involving very poor lighting conditions; and cases with a limited opportunity to view the defendant. Such cases were extremely common in the data set but were not deemed "unreliable" on that basis, because although they occurred frequently, discrepancies in descriptions are not predictive of accuracy, and because almost all cases involved very limited opportunity to view under poor conditions.

71. Trial Transcript, 304, State of Wisconsin v. Steven A. Avery, No. 85 FE 118 (Wis. Cir. Ct., Dec. 10, 1985).

72. Doswell Trial Transcript, 691, 742.

73. Trial Transcript, J-128, People v. Dean Cage, 94 29467 (Ill. Cir. Ct. January 9, 1995).

74. Bill Rankin, "Exonerations Urge Changes for Eyewitnesses," *Atlanta Journal-Constitution*, December 25, 2008, C1.

75. Trial Transcript, 298–300, State of Texas v. Donald Wayne Good, F33-31435 (Tex. D. Ct. Sept. 15, 1987).

76. See Wells et al., "Eyewitness Identification Procedures," 622–623, 635.

77. See Wells et al., "Eyewitness Identification Procedures," 619, 635–636; Loftus, Doyle, and Dysart, *Eyewitness Testimony*, § 6-2.

78. Trial Transcript, 172–173, State of Georgia v. Calvin Crawford Johnson, No. 12-22011-3 (Ga. Sup. Ct. Nov. 3, 1983).

79. Calvin C. Johnson Jr., *Exit to Freedom* (Athens: University of Georgia Press, 2003), 99–100.

80. Calvin Johnson Trial Transcript, 174, 183–185.

81. Trial Transcript, 206, State of Georgia v. John Jerome White, No. 314 (Ga. Sup. Ct. May 29, 1980).

82. See Rankin, "Exonerations Urge Changes," C1.

83. See Thompson-Cannino and Cotton, *Picking Cotton,* 134; Jennifer Thompson, Editorial, "I Was Certain, but I Was Wrong," *New York Times,* June 18, 2000, 15.

84. See Gary L. Wells, "Eyewitness Identification: Systemic Reforms," 2006 *Wis. L. Rev.* 615, 627 (2006).

85. Trial Transcript, 295, People v. Anthony Capozzi, #85-1379-001 (N.Y. Sup. Ct. Jan. 27, 1987).

86. Trial Transcript, 3–114, State of Maryland v. Kirk N. Bloodsworth, No. 84-CR-3138 (Md. Cir. Ct. Mar. 1, 1985).

87. Terry Chalmers, City of Mount Vernon Police Department Reports, August–October, 1986 (on file with author).

88. While other exonerees had witnesses who simply could not identify anyone, aside from these four cases, the other cases all included eyewitness who testified if asked that they were certain about their identifications. The four cases are those of Kirk Bloodsworth, Jimmy Ray Bromgard, William Dillon, and Jerry Miller.

89. Jerry Miller Trial Transcript, 226.

90. Trial Transcript, 43, 71, State of Montana v. Jimmy Ray Bromgard, No. DC 87-148 (Mont. Cir. Ct. Nov. 17, 1987).

91. Ibid., 351–352.

92. There is no evidence that congruence of description with the defendant predicts the accuracy of an eyewitness identification. See Gary L. Wells, "Verbal Descriptions of Faces from Memory: Are They Diagnostic of Identification Accuracy," 70 *J. Applied Psychol.* 619 (1985) (finding that congruence and accuracy of eyewitness reports were not highly related); Melissa Pigott and John Brigham, "Relationship Between Accuracy of Prior Description and Facial Recognition," 70 *J. Applied Psychol.* 547–548 (1985) (finding no such relationship and citing additional studies).

93. These data are limited to major differences in physical descriptions. They do not include cases where witnesses described clothing defendants claimed never to have worn or owned, or where witnesses could not describe the attacker much at all. For example, a difference that could have been accounted for by the passage of time from incident to arrest, such as a week's growth of hair, were discounted. Nor were minor descriptive differences, such as between hazel and green eyes, or light and light-brown hair, counted. As described in the Appendix, approximately half of the data was blind coded. I thank Jessica Kostelnik for her help calculating an interrater reliability score. An interrater reliability analysis using the Kappa statistic was performed to determine consistency among raters in coding the two central questions concerning whether eyewitness identifications in a case involved any of the enumer-

ated indicia of police suggestion or unreliability. Kappa values from 0.40 to 0.59 are considered moderate, 0.60 to 0.79 substantial, and 0.80 outstanding. Analyses revealed outstanding interrater reliability for suggestion (Kappa 0.89, p 0.001, 95% CI 0.77 - 1.01) and substantial interrater reliability for reliability (Kappa 0.78, p 0.001, 95% CI 0.60 - .96).

94. Trial Transcript, 326, State of Texas v. James Curtis Giles, Nos. F-83-87258-UKJ, F-77-8236-KJ (Tex. Dist. Ct. June 6, 1983).

95. Avery Trial Transcript, 315–316.

96. Because eyewitness uncertainty is such a clear indication of unreliability, I focus in this chapter on cases where eyewitnesses were uncertain at the time of the identification. As noted, although many of these cases involved such limited opportunity to view the culprit, the only cases that I labeled as "unreliable" were the fifteen most extreme cases, in which the witnesses reported they could not see the culprit's face at all.

97. Greenfeld, *Sex Offenses*, 3, 11.

98. Dennis Brown Trial Transcript, 103.

99. Trial Transcript, 78–79, State of Wisconsin v. Fredric Karl Saecker, No. 89-CF-33 & 36 (Wis. Cir. Ct. Jan. 3. 1990).

100. See Sandra Guerra Thompson, "Judicial Blindness to Eyewitness Misidentification," 93 *Marq. L. Rev.* 7, 20–21 (2009) (citing Gary L. Wells and Eric P. Seelau, "Eyewitness Identification: Psychological Research and Legal Policy on Lineups," 1 *Psychol. Pub. Pol'y & L.* 765, 766 (1995)).

101. See Wells and Quinlivan, "Suggestive Eyewitness Identification Procedures," 5. On disagreement concerning effects of certain estimatory variables in some types of cases, see Steven E. Clark and Ryan D. Godfrey, "Eyewitness Identification Evidence and Innocence Risk," 16 *Psychonomic Bull. & Rev.* 23 (2009).

102. Of the cases in which the eyewitnesses stated for how long they looked at the attacker, 58 (of 161 cases) said that they saw the attacker for less than a minute, most often just for seconds. Another 56 cases involved durations of less than twenty minutes. Another 38 cases involved durations of more than twenty minutes, 10 of which involved durations of more than an hour. (In 9 cases, no information was available where the eyewitness did not discuss duration at trial). While the relationships between the various factors involved are complex, and these exonerations involve different types of identifications under very different circumstances, I note one possible hypothesis: that suggestion played a greater role in cases involving identifications under conditions that would otherwise tend to be more accurate. Of those 36 cases with long durations, 6 did not involve suggestion, 3 of which raise different issues because they were acquaintance cases. Again, however, many of those cases implicated still different factors affecting reliability, for example, where they were also cross-racial identifications or involved identification procedures first conducted long after the crime.

103. Gary L. Wells and D. M. Murray, "What Can Psychology Say about the Neil vs. Biggers Criteria for Judging Eyewitness Identification Accuracy?" *J. Applied Psychol.* 68 (1983).

104. Trial Transcript, 129, State of Louisiana v. Willie Jackson, No. 87-0205 (La. Dist. Ct. Aug. 24, 1989).
105. Gary L. Wells and A. L. Bradfield, "'Good, You Identified the Suspect': Feedback to Eyewitnesses Distorts Their Reports of the Witnessing Experience," 83 *J. Applied Psychol.* 360 (1998).
106. Trial Transcript, 118, State of Texas v. Andrew William Gossett, No. F99-22771-W (Tex. Dist. Ct. Feb. 8, 2000); Brian L. Cutler, *Eyewitness Testimony: Challenging Your Opponent's Witness* (National Institute for Trial Advocacy, 2002), 19.
107. See Roger B. Handberg, "Expert Testimony on Eyewitness Identification: A New Pair of Glasses for the Jury," 32 *Am. Crim. L. Rev.* 1013, 1023 (1995); Charles A. Morgan III et al., "Acccuracy of Eyewitness Memory for Persons Encountered During Exposure to Highly Intense Stress," 27 *Int'l J. L. & Psychol.* 265 (2004).
108. See Wells and Quinlivan, "Suggestive Eyewitness Identification Procedures."
109. While in 66 cases the first identification occurred less than a week after the crime, in 53 cases it was more than a week, in 15 cases it was more than three months, in 8 cases more than six months, and in 5 cases more than a year.
110. See, e.g., Gary L. Wells and Elizabeth Olson, "The Other-Race Effect in Eyewitness Identification: What Do We Do About It?" 7 *Psychol. Pub. Pol'y & L.* 230 (2001); Gary L. Wells and Elizabeth F. Loftus, eds., *Eyewitness Testimony: Psychological Perspectives* (Cambridge: Cambridge University Press, 1984), 1; Elizabeth F. Loftus, *Eyewitness Testimony* (Cambridge, MA: Harvard University Press, 1979).
111. Of the 93 cross-racial identification cases, 74 cases involved a black defendant and a white eyewitness. Three of those cases involved male eyewitnesses; thus 71 involved a male black defendant and a female eyewitness. Seven cases involved a Hispanic defendant and a white eyewitness. Six involved a black defendant and a Hispanic witness. Three involved a white defendant and a black witness. Two involved a white defendant and a Hispanic witness. One last case, that of Michael Blair, involved a defendant who was part Asian and who self-identified as white, but whom white eyewitnesses regarded as a minority (they thought he was Hispanic). Of the 93 cross-racial identification cases, 86 involved victim identifications and 9 involved non-victim eyewitnesses (two involved both types). It was not possible to obtain data on the race of the victims for some of these cases. However, the denominator used here is the full set of 190 cases with eyewitness identifications, because information about victim race could also be obtained for many cases in which no trial transcript was obtained.
112. Of the 171 exonerees convicted of rape, 42 were white and 129 were minorities. See Sean Rosenmerkel, Matthew Durose, and Donald Farole Jr., U.S. Department of Justice, Bureau of Justice Statistics, *Felony Sentences in State Courts, 2006* (2009), table 3.2 (finding that 30% of rape convicts were minorities); Matthew R. Durose and Patrick A. Langan, U.S. Department of Justice, Bureau of Justice Statistics, *Felony Sentences in State Courts, 2002,* (2004), 6, table 5 (finding in survey of 300 counties that 37% of rape convicts were minorities). There may not have been any greater racial disparity in data from closer to the 1980s, when these exonerees were chiefly convicted, although data from that period were not consistently compiled. Green-

feld, *Sex Offenses,* 10 (finding 44% of rape arrestees and 47.8% of imprisoned rape convicts were minorities); Brian A. Reaves and Pheny Z. Smith, U.S. Department of Justice, Bureau of Justice Statistics, *Felony Defendants in Large Urban Counties, 1992* (1995), 4 ("Whites (48%) and blacks (49%) comprised roughly equal percentages of rape defendants"); but see Patrick A. Langan and Helen A. Graziadei, U.S. Department of Justice, Bureau of Justice Statistics, *Felony Sentences in State Courts, 1992* (1995), 5 (finding that 30% of rape convicts were black and 4% were "other").

113. Greenfeld, *Sex Offenses,* 11. Seventy-seven exonerees were black and convicted of raping a white victim, and 7 were Latino and convicted of raping a white victim. In addition, 4 black exonerees were convicted of raping Latino victims, while 5 white exonerees were convicted of raping black or Latino victims.

114. Rosenmerkel et al., *Felony Sentences in State Courts, 2006,* table 3.2 (finding that minorities account for 40% of felony sentences in state courts); Heather C. West and William J. Sabol, U.S. Department of Justice, *Prison and Jail Inmates at Midyear 2008,* (2008), 17, table 16 (finding that minorities account for almost 60% of prison inmates and black men are 6.6% more likely to be incarcerated than white men).

115. There are several possible explanations for the racial disparity among exonerees. These 250 exonerees include far more minorities than even already disproportionately minority rape and murder convicts. The other-race effect may cause eyewitness misidentifications disproportionately involving black defendants and white victims. Another hypothesis is that black defendants may be overrepresented in the kinds of serious rape and murder prosecutions common in this set of DNA exonerations. One explanation could be victim related, that is, that cases involving black defendants and white victims disproportionately receive lengthy sentences of the sort that makes DNA testing feasible years later. The most comprehensive data on race-of-victim effects is in the death penalty context. U.S. General Accounting Office, *Death Penalty Sentencing: Research Indicates Pattern of Racial Disparities* (1990), GAO/GGD-90-57, 6 (reviewing twenty-three studies of the death penalty after 1973, and concluding that "[i]n 82% of the studies, race-of-victim was found to influence the likelihood of being charged with capital murder or receiving a death sentence, i.e., those who murdered whites were found to be more likely to be sentenced to death than those who murdered blacks. This finding was remarkably consistent across data sets, states, data collection methods, and analytic techniques.") There is not much data available concerning rape prosecutions. Ethnographic studies of prosecutorial charging have observed race-of-victim effects. Lisa Frohmann, "Convictability and Discordant Locales: Reproducing Race, Class, and Gender Ideologies in Prosecutorial Decisionmaking," 31 *Law & Soc'y Rev.* 531, 535 (1997); Cassia Spohn and David Holleran, "Prosecuting Sexual Assault: A Comparison of Charging Decisions in Sexual Assault Cases Involving Strangers, Acquaintances, and Intimate Partners," 18 *Just. Q.* 651, 652 (2001). Additional data, some empirical, and chiefly from mock jury studies, suggests that jurors may discriminate against black defendants and also tend to convict in cases involving white victims. See Samuel R. Sommers and Phoebe C. Ellsworth, "How Much Do We Really Know about Race and Juries? A Review of Social Science Theory and Research," 78 *Chi.-Kent*

L. Rev. 997 (2003); Sheri Lynn Johnson, "Black Innocence and the White Jury," 83 *Mich. L. Rev.* 1611 (1985). Finally, black defendants may be disadvantaged in other ways, for example by being disproportionately targeted by police, or disproportionately needing indigent representation, and would thus be overrepresented among wrongful convictions. See also Andrew E. Taslitz, "Wrongly Accused: Is Race a Factor in Convicting the Innocent?" 4 *Ohio St. J. Crim. L.* 121 (2006).

116. Trial Transcript, 224, State of Texas v. Thomas Clifford McGowan, No. F85-81070-MU (Tex. Dist. Ct. March 5, 1986).

117. Trial Transcript, 190, State of Texas v. Patrick Leondos Waller, No. F92-40874 (Tex. Dist. Ct. Dec. 7, 1992).

118. Trial Transcript, 215, State of Missouri v. Larry Johnson, No. 341-00274 (Mo. Cir. Ct. Aug. 20, 1984).

119. Trial Transcript, 240, State of South Carolina v. Perry Renard Mitchell, No. 83-GS-32-479 (S.C. Cir. Ct. Jan. 19, 1984).

120. Trial Transcript, 40–41, State of Wisconsin v. Anthony T. Hicks, No. 90CF1412 (Wis. Cir. Ct. Dec. 18, 1991).

121. State v. Cromedy, 158 N.J. 112 (1999).

122. See Michael Kennan, "Child Witnesses: Implications of Contemporary Suggestibility Research in a Changing Legal Landscape," 26 *Dev. Mental Health L.* 100 (2007); Richard Friedman, "The Suggestibility of Children; Scientific Research and Legal Implications," 86 *Cornell L. Rev.* 33 (2000); Maggie Bruck, Stephen J. Ceci and Helene Hembrooke, "Reliability and Credibility of Young Children's Reports," 52 *Amer. Psych.* 136, 140 (1998); see, e.g., State v. Michaels, 642 A.2d 1372 (1994).

123. Trial Transcript, 237–239, People of the State of California v. Leonard McSherry, No. A040264 (Cal. Sup. Ct. October 12, 1988).

124. Ibid., 107, 121.

125. Ibid., vol. 3, p. 184.

126. Ibid., 90.

127. Ibid., 124.

128. Leonard McSherry v. City of Long Beach, 423 F.3d 1015 (9th Cir. 2005).

129. Trial Transcript, 4–110, 4–58, 5–105, Commonwealth v. Rodriguez U. Charles, Criminal Action Nos. 035942-45; 036191-84 (Mass. Sup. Ct. Feb. 1, 1984).

130. Pretrial Hearing Transcript, 354–355, State of West Virginia v. Larry David Holdren, No. CR-83-F-181 (W. Va. Cir. Ct. Dec. 12, 1983).

131. Bloodsworth v. State, 512 A.2d 1056 (Md. 1986).

132. The three were Steven Avery, Chester Bauer, and Darryl Hunt. Courts have increasingly admitted expert testimony concerning eyewitness memory and the possibility of a mistaken eyewitness identification. See Brian L. Cutler and Margaret Bull Kovera, *Evaluating Eyewitness Identifications* (New York: Oxford University Press, 2010), 10–14; see, e.g., Utah v. Clopton, 223 P.3d 1103, 1107–1118 (2009); Sturgeon v. Quarterman, 615 F.Supp. 2d 546, 572–573 (S.D. Tex. 2009); United States v. Smithers, 212 F.3d 306, 311–312 (6th Cir. 2000). Other courts have similarly denied defendant's access to experts on eyewitness memory or found it error to permit such an expert to testify. See, e.g., State v. Young, 2010 WL 1286933 (La. 2010).

133. Loftus, Doyle, and Dysart, *Eyewitness Testimony,* § 8-18.
134. Trial Transcript, 87, State of Texas v. Carlos Lavernia, No. 76,122 (Tex. Dist. Ct. Jan. 21, 1985).
135. Trial Transcript, 781, State of West Virginia v. William O'Dell Harris, No. 86-F-442 (W. Va. Cir. Ct. July 14, 1987).
136. Lavernia Trial Transcript, 156.
137. Hicks Trial Transcript, 586–587.
138. Mitchell Trial Transcript, 318.
139. Trial Transcript, 896, People of the State of New York v. Alan Newton, Ind. No. 2054/84 (N.Y. Sup. Ct. May 1, 1985).
140. Commonwealth v. Yarris, 519 Pa. 571, 601–602 (Pa. 1988).
141. Throughout I refer to misidentifications and not to mistaken identifications. That term was chosen because these identifications of the innocent were often not the product of accidents or mistakes, but rather the use of suggestive police procedures that could predictably result in unreliable and erroneous identifications.
142. According to the Bureau of Justice Statistics, only 0.8% of felony defendants are convicted of rape and only 0.7% of felony defendants are convicted of murder. Thomas H. Cohen and Brian A. Reaves, U.S. Department of Justice, Bureau of Justice Statistics, *Felony Defendants in Large Urban Counties, 2002* (2006), 27, table 28.
143. Bruce W. Behrman and Sherrie L. Davey, "Eyewitness Identification in Actual Criminal Cases: An Archival Analysis," 25 *Law & Hum. Behav.* 475 (2001); Gonzalez et al., "Response Biases in Lineups and Showups," 535–536.
144. Wells, "Systemic Reforms," 632–635.
145. Wells and Quinlivan, "Suggestive Eyewitness Identification Procedures." On the challenges of conducting field experiments, see Nancy K. Steblay, "Commentary on 'Studying Eyewitness Investigations in the Field': A Look Forward," 32 *Law & Hum. Behav.* 11 (2008). On the methodological flaws of a field study conducted in Chicago, see D. L. Schacter et. al., "Policy Forum: Studying Eyewitness Investigations in the Field," 32 *Law & Hum. Behav.* 3–5 (2008).
146. Trial Transcript, 43–48, 65, 107–108, State of Louisiana v. Dennis P. Brown, No. 128,634 (La. Dist. Ct. Sept. 11–12, 1985); see also Center on Wrongful Convictions of Youth, *Dennis Brown,* at www.cwcy.org/exonereesViewDetail.aspx?id15. The officer administering the lineup, however, did not warn the victim that the attacker might not be present in the lineup. Brown also later falsely confessed to having committed the crime.
147. Ibid., 627–629; see also Loftus et. al., *Eyewitness Testimony: Civil and Criminal* § 4-10 (LexisNexis 4th ed. 2007).
148. See Ohio Rev. Code Ann. § 2933.83(A)(6) (2010); N.C. Gen. Stat. § 15A-284.52(b)(14) (2007); Amy Klobuchar, Nancy K. Mehrkens Steblay, and Hilary Lindell Caliguri, "Improving Eyewitness Identifications: Hennepin County's Blind Sequential Lineup Pilot Project," 4 *Cardozo Pub. L. Pol'y. & Ethics J.* 381, 405–410 (2006); Otto H. MacLin, Laura A. Zimmerman, and Roy S. Malpass, "PC_Eyewitness and Sequential Superiority Effect: Computer-Based Lineup Administration," 3 *Law & Hum. Behav.* 303, 304–305 (2005).

149. Researchers have also long recommended use of a sequential presentation, when also double-blind, although some recent research suggests that under some conditions sequential procedure performs less well, in part because it is a "more conservative" procedure. See Wells, "Systemic Reforms," at 627–628; Wells et al., "Eyewitness Identification Procedures," 616–617, 639–640 (citing "rather impressive" research in support of the sequential procedure). But see Paul Giannelli and Myrna Raeder, ABA Criminal Justice Section, "Achieving Justice: Freeing the Innocent, Convicting the Guilty," 25 (2006).

150. See Wells et al., "Eyewitness Identification Procedures," 635–636, 640–641; see also Amy Douglass and Nancy Steblay, "Memory Distortion in Eyewitnesses: A Meta-Analysis of the Post-Identification Feedback Effect," 20 *Applied Cognitive Psychol.* 859 (2006).

151. Abdal Trial Transcript, 209–210.

152. However, juror understanding of factors affecting eyewitness accuracy may be improving over time, due to media accounts of errors. See Sarah L. Desmarais and J. Don Read, "After 30 Years, What Do We Know about What Jurors Know? A Meta-Analytic Review of Lay Knowledge Regarding Eyewitness Factors," *Law & Hum. Behav.* (2010).

4. FLAWED FORENSICS

1. The victim later wrote a confessional book explaining her false testimony titled *Forgive Me.* Cathleen C. Webb and Marie Chapian, *Forgive Me* (Old Tappan, NJ: F.H. Revell Co., 1985).

2. Rob Warden, "The Rape that Wasn't, the First DNA Exoneration in Illinois," http://www.law.northwestern.edu/wrongfulconvictions/exonerations/ilDotson Summary.html.

3. Ibid.

4. Clive A. Stafford Smith and Patrick D. Goodman, "Forensic Hair Comparison Analysis: Nineteenth Century Science or Twentieth Century Snake Oil?" 27 *Colum. Hum. Rts. L. Rev.* 227, 242–245 (1996).

5. Trial Transcript, 359, State of Illinois v. Gary E. Dotson, No. P.C. 4333 (Ill. Cir. Ct. July 25, 1985).

6. Affidavit of Edward T. Blake, D. Crim., State of Illinois v. Gary E. Dotson, No. P.C. 4333 23 (Ill. Cir. Ct. July 29, 1985).

7. Ibid.; see also Michael Serrill and Laura Lopez, "Law: Cathy and Gary in Medialand," *Time,* May 27, 1985.

8. Larry Green, "12-Year Legal Nightmare at End," *Los Angeles Times,* August 15, 1989, 5.

9. See National Academy of Sciences Urges Reform, http://www.innocenceproject .org/Content/1866.php.

10. There were at least 185 exonerees who had forensic evidence in their cases. Of those, 153 trials were located and analyzed in this chapter. To break it down step by step: 4

exonerees of the 185 who had forensic evidence in their cases pleaded guilty, and thus had no trial. In 2 more cases, those of Dana Holland and Earl Washington Jr., forensic analysis was conducted before trial, but there was no trial testimony regarding that analysis. That leaves 179 exonerees who had forensics introduced at a trial. However, in 4 of these cases, the forensic evidence was introduced at trial by stipulation, so there was no testimony by a forensic analyst for either side. Six additional exonerees had analysts testify only for the defense at their trial. Thus, in 169 cases, analysts testified for the prosecution. Finally, in 16 exonerees' cases, although news reports indicate there was forensic analysis at trial, the transcripts could not be located. That left 153 cases in which prosecution analysts testified and transcripts were located.

11. Of the 185 exonerees' cases involving forensic analysis, 125 were rape cases, 41 were rape and murder cases, 16 were murder cases, and 3 were "other" crimes. Thus, 73% (125 of 171) rape cases had forensics, 79% (41 of 52) rape-murder cases had forensics, and 73% (16 of 22) murder cases had forensics. The proportion of cases involving forensic evidence was fairly evenly distributed across crimes.

12. The National Academies, Committee on Identifying the Needs of the Forensic Sciences Community, *Strengthening Forensic Science in the United States: A Path Forward* (2009), 22 (hereafter cited as NAS Report).

13. See Joseph L. Peterson and Penelope N. Markham, "Crime Laboratory Proficiency Testing Results, 1978–1991, II: Resolving Questions of Common Origin," 40 *J. Forensic Sci.* 1009, 1010 (1995).

14. See Michael J. Saks and Jonathan J. Koehler, "The Individualization Fallacy in Forensic Science," 61 *Vand. L. Rev.* 199 (2008); NAS Report, 7–8, 21–22.

15. Daubert v. Merrell Dow Pharmaceuticals, Inc., 509 U.S. 579, 595 (1993); United States v. Frazier, 387 F.3d 1244, 1263 (11th Cir. 2004).

16. 509 U.S. 579 (1993).

17. Samuel R. Gross and Jennifer L. Mnookin, "Expert Information and Expert Evidence: A Preliminary Taxonomy," 34 *Seton Hall L. Rev.* 141, 169 (2003).

18. NAS Report, 9–13, 53, 106–109; see also Peter J. Neufeld, "The (Near) Irrelevance of *Daubert* to Criminal Justice: and Some Suggestions for Reform," 95 *Am. J. Pub. Health* S107 (2005).

19. After the NAS contacted me and requested data on the role that forensic science played in wrongful convictions, I began a study of the forensic science testimony in exonerees' trials, which was published in the *Virginia Law Review* and coauthored with Peter Neufeld. We found that invalid forensic science testimony was not just common but prevalent at these exonerees' trials. Invalid testimony was identified for 60% of the exonerees whose trial transcripts were obtained and had prosecution forensic testimony. See Brandon L. Garrett and Peter J. Neufeld, "Invalid Forensic Science Testimony and Wrongful Convictions," 95 *Va. L. Rev.* 1 (2009). This chapter updates those findings with new transcripts subsequently obtained. This chapter also has a broader focus and examines not just validity of testimony at trials but also vague testimony and reliability of underlying forensic techniques.

20. Michael J. Saks, "Judging Admissibility," 35 *J. Corp. L.* 135, 145 (2009).

21. See Paul C. Giannelli, "Regulating Crime Laboratories: The Impact of DNA Evidence," 15 *J. L. & Pol'y* 59, 61–67, 72 (2007).

22. The phenomenon of cognitive bias, including that of forensic scientists, is discussed in Chapter 9.

23. Melendez-Diaz v. Massachusetts, 129 S.Ct. 2527, 2536 (2009).

24. Robert Bazell, "DNA Acquittals Shaking Up Forensic Science," *NBC News,* February 12, 2008; Jane Campbell Moriarty, "'Misconvictions,' Science, and the Ministers of Justice," 86 *Neb. L. Rev.* 1 (2007).

25. "DNA Crime Labs: The Paul Coverdell National Forensic Sciences Improvement Act: Hearing Before the Comm. on the Judiciary," 107th Cong. 2–3 (2001) (statement of Sen. Orrin G. Hatch, Chairman, S. Comm. on the Judiciary).

26. See William C. Thompson, "Beyond Bad Apples: Analyzing the Role of Forensic Science in Wrongful Convictions," 37 *Southwestern U. L. Rev.* 101, 112–119 (2009).

27. The states are: Arizona, California, Connecticut, Florida, Georgia, Idaho, Illinois, Indiana, Kansas, Kentucky, Louisiana, Maryland, Massachusetts, Mississippi, Missouri, Montana, Nebraska, Nevada, New Jersey, New York, Ohio, Oklahoma, Pennsylvania, South Carolina, Texas, Virginia, Wisconsin, and West Virginia.

28. Gilchrist v. Citty, 173 Fed.Appx. 675, 677 (10th Cir. 2006).

29. Quantification techniques later permitted additional conclusions regarding mixed stains, but these exonerees' trials predated such techniques.

30. NAS Report, 160.

31. See Barry Scheck, Peter Neufeld, and Jim Dwyer, *Actual Innocence* (New York: Signet 2001), 209–210.

32. NAS Report, 160–161.

33. Williamson v. Reynolds, 904 F. Supp. 1529, 1552–1553 (E.D. Okla. 1995).

34. A report later issued by several of the most distinguished forensic analysts in the nation concluded that while an experienced analyst might make an error when comparing a single hair, "it is highly unlikely that a competent hair examiner would incorrectly associate" so many different hairs. Richard E. Bisbing et al., "Peer Review Report: Montana v. Jimmy Ray Bromgard," 2.

35. Trial Transcript, 250, State v. Chester Bauer, No. 83-CR-27 (Mont. Dist. Ct. July 16, 1983).

36. Trial Transcript, 385, State v. Timothy Edward Durham, No. CF-91-4922 (Okla. Dist. Ct. Mar. 9, 1993).

37. Trial Transcript, 246, Commonwealth of Kentucky v. William Gregory (Ky. D.Ct. 1993).

38. Trial Transcript, 177, State v. Curtis Edward McCarty, No. CRF-85-02637 (Okla. Dist. Ct. Mar. 24, 1986).

39. Trial Transcript, 152, State v. Larry L. Peterson, A-3034-89T4 (N.J. Super. Ct. Mar. 6, 1989).

40. Max M. Houck et al., "The Science of Forensic Hair Comparisons and the Admissibility of Hair Comparison Evidence: Frye and Daubert Considered," *Mod. Microscopy J.* 5 (Mar. 2, 2004).

41. Trial Transcript, 2837, People v. Kharey Wise, No. 4762/89 (N.Y. Sup. Ct. Nov. 13, 1990).
42. NAS Report, 161.
43. The sixteen exonerees are: J. Abbitt, R. Alexander, J. Deskovic, C. Elkins, N. Hatchett, T. Hayes, E. Karage, R. Krone, R. Matthews, A. McCray, J. Ochoa, K. Richardson, M. Roman, R. Santana, Y. Salaam, and K. Wise. The four cases where the DNA tests appeared to show guilt were three that involved invalid testimony, the cases of G. Alejandro, C. Heins, and J. Sutton, while the last case, that of T. Durham, involved a lab error. James Ochoa had no trial and pleaded guilty despite a DNA exclusion. Krone had exculpatory DNA results presented at a second trial, of which I was not able to obtain a transcript. For those two cases, Ochoa and Krone, trial transcripts were not obtained. Thus a total of eighteen cases with DNA testimony at trial were obtained. I also note that Richard Alexander was excluded at trial by DNA in an additional rape that he was not charged with, but which prosecutors said was part of a series of attacks by the same perpetrator.
44. Trial Testimony, 149, State v. Gilbert Alejandro, No. 90-09-8445-CR (Tex. Dist. Ct. Dec. 11, 1990).
45. Trial Testimony, 168–230, State v. Josiah Sutton, No. 800450 (Tex. Dist. Ct. 1999).
46. William Thompson, Review of DNA Evidence in *State of Texas v. Josiah Sutton* (2003), http://www.scientific.org/archive/Thompson%20Report.PDF.
47. See William C. Thompson et al., "How the Probability of a False Positive Affects the Value of DNA Evidence," 48 *J. Forensic Sci.* 47, 48 (2003).
48. Erin Murphy, "The Art in the Science of DNA: A Layperson's Guide to the Subjectivity Inherent in Forensic DNA Typing," 58 *Emory L.J.* 489 (2008).
49. Adam Liptak, "The Nation: You Think DNA Evidence Is Foolproof? Try Again," *New York Times,* March 16, 2003.
50. C. Michael Bowers, "Scientific Issues," in Faigman et al., *Modern Scientific Evidence: The Law and Science of Expert Testimony* (St. Paul, MN: West Group, 2009–2010), § 37:12–37:13, 37:23, 37:34–37:36.
51. See Flynn McRoberts and Steve Mills, "From the Start, a Faulty Science," *Chicago Tribune,* October 19, 2004.
52. NAS Report, 176.
53. Paul C. Giannelli, "Bite Mark Evidence," *GP Solo* (Sept. 2007); Faigman et al., *Modern Scientific Evidence,* § 37:4–37.6.
54. The fifth exoneree with invalid bite mark testimony was Roy Brown, whose case is discussed below; the odontologist found inconsistencies and yet called them "explainable." The two exonerees with vague testimony concerning bite mark comparisons were James O'Donnell and Calvin Washington. In O'Donnell's case the marks were said to be "consistent" with his teeth. In Washington's case, while Washington was himself excluded (he was missing most of his teeth), his codefendant was said to have teeth that were "consistent with" the bite marks.
55. Trial Transcript, 15, State of Arizona v. Ray Milton Krone, No. CR 92-00212 (on file with authors).

56. Robert Nelson, "About Face," *Phoenix New Times,* April 21, 2005.

57. Maurice Possley and Steve Mills, "Guilty, Said Bite Expert. Bogus, Says DNA," *Chicago Tribune,* July 10, 2008.

58. Iain A. Pretty, "Reliability of Bitemark Evidence," in *Bitemark Evidence,* ed. Robert B. J. Dorion (New York: Marcel Dekker, 2005), 531, 543.

59. See Garrett and Neufeld, "Invalid Forensic Science Testimony," 68.

60. ABFO Bitemark Methodology Guidelines at www.abfo.org/pdfs/ABFO%20Manual %20-%20Revised%2010-5-2009.pdf.

61. Trial Transcript, 294, *State of Idaho v. Charles I. Fain* (Idaho D. Ct. Oct. 14, 1983).

62. See NAS Report, 148–149.

63. Faigman et al., *Modern Scientific Evidence,* § 38.1.-38.2.

64. Trial Transcript, 290, State of Texas v. David Shawn Pope, No. F85-98755-NQ (Tex. Dist. Ct. Feb. 4, 1986).

65. Trial Transcript, 3-207, 3-214–3-225, Commonwealth of Massachusetts v. Stephan Cowans, No. 97-11231 (Mass. Sup. Ct. June 24, 1998); Ron Smith & Associates, Inc., *Reference: Request for Latent Print Consultation Services* (Mar. 8, 2004), 6.

66. The cases are those of: Gilbert Alejandro, Gene Bibbins, Roy Brown, David Bryson, Ulysses Charles, Stephan Cowans, Rolando Cruz, William Gregory, Alejandro Hernandez, Dana Holland, Ray Krone, Curtis McCarty, Neil Miller, Marlon Pendleton, Larry Peterson, George Rodriguez, Lafonso Rollins, Josiah Sutton, Ronald Taylor, Earl Washington, Kenneth Waters, and Ronald Williamson. In five cases, such as the Peterson case discussed next, we do not know if the analyst intentionally or negligently concealed the presence of abundant spermatozoa that could have been tested; in such cases, later analysis reported, though, that they were readily detected and should easily have been tested.

67. See Garrett and Neufeld, "Invalid Forensic Science Testimony," 76–77.

68. Margaret Edds, *An Expendable Man: The Near-Execution of Earl Washington, Jr.* (New York: New York University Press, 2003), 246.

69. Trial Transcript, 740, 774, People v. Roy Brown, 91-2099 (N.Y. Sup. Ct. Jan. 13–23, 1992).

70. Trial Transcript, 83, State of Louisiana v. Gene Bibbins, No. 2-87-979 (La. Dist. Ct. Mar. 25, 1987).

71. See Gregory v. City of Louisville, 444 F.3d 725, 732 (6th Cir. 2006).

72. Maurice Possley et al., "Scandal Touches Even Elite Labs: Flawed Work, Resistance to Scrutiny Seen Across U.S.," *Chicago Tribune,* October 21, 2004, § 1, 1.

73. The Innocence Project, Larry Peterson, at www.innocenceproject.org/Content/148 .php.

74. Center for Wrongful Convictions, Dennis Williams, www.law.northwestern.edu/ wrongfulconvictions/exonerations/ilWilliamsChart.pdf.

75. Trial Testimony, 636–637, State of Oklahoma v. Ronald Keith Williamson, CRF 87-90 (Okla. Dist. Ct. April 21–28, 1988).

76. Williamson v. Ward, 110 F.3d 1508, 1522 (10th Cir. 1997).

77. Barry Scheck et al., *Actual Innocence,* 165.

78. The Innocence Project, Robert Miller, www.innocenceproject.org/Content/219 .php.
79. Jason Volentine, "Stolen Lives: The Story of the Beatrice Six (Part Three)," *KOLN/ KGIN,* March 17, 2009; Lynn Safranek, "Old-style Testing of Blood and Fluids Proves to Be No Match for Modern DNA Testing," *Omaha World-Herald,* January 26, 2009.
80. Maurice Possley, "'Always Knew I Was Innocent,' Imprisoned in a 1992 Sexual Assault, Marlon Pendleton Is Told by His Lawyer That New DNA Tests Show That He Was Not the Assailant," *Chicago Times-Tribune,* November 24, 2006.
81. Trial Testimony, 1–169, Commonwealth v. Neil Miller, No. 085602–085604 (Mass. Sup. Ct. Dec. 14, 1990).
82. Frontline, *Burden of Innocence,* http://www.pbs.org/wgbh/pages/frontline/shows/ burden/profiles/miller.html.
83. Fred C. Zacharias, "Structuring the Ethics of Prosecutorial Trial Practice: Can Prosecutors Do Justice?" 44 *Vand. L. Rev.* 45, 91 (1991); see also Model Rules of Prof'l Conduct R. 3.4(e).
84. Darden v. Wainwright, 477 U.S. 168, 181 (1986).
85. People v. Linscott, 142 Ill.2d 22, 38 (Ill. 1991).
86. Trial Transcript, 899, Commonwealth of Pennsylvania v. Drew Whitley, CC 89-2462 (Pa. Ct. of Common Pleas July 21, 1989).
87. Ibid., 50–57 (July 24, 1989).
88. Paul C. Giannelli and Edward L. Imwinkelried, *Scientific Evidence,* (4th ed. 2007), § 4.01–.05, 13.07.
89. Paul C. Giannelli, "Microscopic Hair Comparison: A Cautionary Tale," 46 No. 3 *Criminal Law Bulletin* Art. 7 (2010).
90. Only 3% of law enforcement requests to crime labs involve requests for DNA analysis. See Matthew R. Durose, Bureau of Justice Statistics, Census of Publicly Funded Forensic Crime Laboratories 10 (2005), http://bjs.ojp.usdoj.gov/content/pub/pdf/ cpffcl05.pdf.
91. Ninety-three exonerees had invalid forensic science testimony at their trials. Nineteen more had vague and potentially misleading testimony, using terms like "associated with," "similar," or "consistent." Fourteen more had exculpatory forensic evidence that was not disclosed and/or erroneous analysis such as laboratory errors in their cases. Finally, at least one transcript that could not be located, that of Harold Buntin, according to available reports had invalid testimony at his trial; another had vague testimony; and one more, that of Thomas Webb, involved vague testimony that evidence was "consistent."
92. In a preliminary effort, I obtained a small random set of transcripts from similar rape and murder trials. Each of those defendants was found guilty and, as far as we know, they really were. I found that just in these exonerees' cases, almost two-thirds of those trials had invalid forensic science testimony. The trials included the same types of errors and they even involved some of the same analysts who testified in the exonerees' trials. Thirty trial transcripts in such "matched" cases were collected from Missouri (10 transcripts), Texas (11), and Virginia (9). See Garrett and Neufeld, "Invalid Forensic Science Testimony," 28–29.

93. See, e.g., Lopez v. State, 643 S.W.2d 431, 433 (Tex. App. 1982); State v. Bridges, 421 S.E.2d 806, 808 (N.C. Ct. App. 1992).
94. See Rob Warden and Locke Bowman, "Independent Crime Labs Could Stop Forensic Fraud," *Chicago Sun-Times,* November 7, 2004.
95. See Michael R. Bromwich, Executive Summary, in *Fifth Report of the Independent Investigator for the Houston Police Department Crime Laboratory and Property Room* 1–2 (May 11, 2006), at http://www.hpdlabinvestigation.org.
96. Comm. on Scientific Assessment of Bullet Lead Elemental Composition Comparison, Nat'l Research Council, *Forensic Analysis: Weighing Bullet Lead Evidence* (2004), 90–94.
97. Andrew E. Taslitz, "Convicting the Guilty, Acquitting the Innocent: The ABA Takes a Stand," 19 *Crim. Just.* 18–19 (2005).
98. See, e.g., United States v. Bentham, 414 F. Supp. 2d 472, 473 (S.D.N.Y. 2006) ("False positives—that is, inaccurate incriminating test results—are endemic to much of what passes for 'forensic science.'").
99. Identifying the Needs of the Forensic Sciences Community, www8.nationalacademies.org/cp/projectview.aspx?key48741.
100. See NAS Report, 7.
101. Ibid., 37, 53.
102. 129 S.Ct. 2527, 2537 (2009).
103. The Court merely defended confrontation as not "useless" and "one means" to ensure accuracy where forensic error or incompetence "may be" uncovered through cross-examination. Ibid., 2536–2537.
104. See NAS Report, 21–22.

5. TRIAL BY LIAR

1. Trial Transcript, 88–89, 104–105, State of Illinois v. David A. Gray, Case No. 78-CF-124 (Ill. Cir. Ct. Sept. 29, 1978).
2. Ibid., 152, 241.
3. Ibid., 252.
4. Ibid., 74.
5. Ibid., 160–212.
6. Ibid., 173.
7. Patrick E. Gauen, "Evidence in Alton Rape Case Is Vanishing," *St. Louis Post-Dispatch,* July 3, 1998, A1; Gray Trial Transcript, 13, (Sept. 29, 1978).
8. Gray Trial Transcript, 8.
9. Ibid., 36.
10. Gauen, "Evidence in Alton Rape Case."
11. Gray Trial Transcript, 111.
12. Ibid., 95.
13. Ibid., 112.
14. Ibid., 110.

15. Ibid., 297.

16. Ibid., 132, 144.

17. Ted Rohrlich and Robert W. Stewart, "Jailhouse Snitches: Trading Lies for Freedom," *Los Angeles Times,* April 16, 1989, 1.

18. Gray Trial Transcript, 131.

19. Ibid., 303.

20. Ibid., 308–310.

21. For that reason, the Illinois Appellate Court dismissed David Gray's *Massiah* claim brought on appeal. See People v. Gray, 299 N.E.2d 206, 210 (Ill. App. 5 Dist. 1979).

22. Gray Trial Transcript, 12.

23. Ibid., 31.

24. Ibid., 25–26.

25. Ibid., 37.

26. Ibid., 44.

27. Ibid., 294–295.

28. Ibid., 19.

29. See Gauen, "Evidence in Alton Rape Case."

30. Hoffa v. United States, 385 U.S. 293, 311 (1966) (citation omitted).

31. Steve Mills and Ken Armstrong, "Another Death Row Inmate Cleared," *Chicago Tribune,* January 19, 2000, N1 ("Jailhouse informants are considered among the least reliable witnesses in the criminal justice system."); see also James S. Liebman, "The Overproduction of Death," 100 *Colum. L. Rev.* 2030, 2088–2089 n.149 (2000); Alexandra Natapoff, *Snitching: Criminal Informants and the Erosion of American Justice* (New York: New York University Press, 2009), 70–72.

32. United States v. Bernal-Obeso, 989 F.2d 311, 335 (9th Cir. 1993).

33. Samuel Gross, "Lost Lives: Miscarriages of Justice in Capital Cases," 61 *Law & Contemp. Probs.* 125, 138 (1998).

34. See Peter Neufeld, Letter to Hon. Governor Phil Bredesen, January 25, 2004 (on file with author).

35. 360 U.S. 264 (1959).

36. 377 U.S. 201, 203–206 (1964).

37. Kansas v. Ventris, 129 S. Ct. 1841, 1844 (2009).

38. Daniel Richman, "Cooperating Defendants: The Costs and Benefits of Purchasing Information from Scoundrels," 8 *Fed. Sent. Rep.* 292, 294 (1996).

39. *Hoffa,* 385 U.S. at 311.

40. Trial Transcript, 222, State of New York v. John Kogut, Ind. #61029 (Nassau County Ct. May 13, 1986).

41. Trial Transcript, 46–47, State of Michigan v. Kenneth Wyniemko, No. CR-94-1595 (Mich. D. Ct. Aug. 11, 1994); ibid., 64–65 (Nov. 3, 1994).

42. Trial Transcript, 2126, State of Illinois v. Willie L. Rainge, Kenneth E. Adams, and Dennis Williams, Information No. 78-I6-5186 (Ill. Cir. Ct. Sept. 27, 1978).

43. Trial Transcript, 881, Commonwealth of Pennsylvania v. Drew Whitley, No. CC 8902462, 8902609 (Pa. Ct. of Common Pleas July 18, 1989).

44. Trial Transcript, 1229, State of Florida v. Wilton Allen Dedge, Case No. 82-135-CF-A (Fla. Cir. Ct. Aug. 22, 1984).

45. Trial Transcript, 1696, State of Texas v. Calvin Edward Washington, No. 87-08-C (Tex. D. Ct. Nov. 30, 1987).

46. Ibid., 1338.

47. Ibid., 1339.

48. Trial Transcript, 791, State of New York v. Steven P. Barnes, Ind. 89-96 (N.Y. Sup. Ct. May 15, 1989).

49. See Natapoff, *Snitching*, 94; R. Michael Cassidy, "'Soft Words of Hope': Giglio, Accomplice Witnesses, and the Problem of Implied Inducements," 98 *Northwestern U. L. Rev.* 1129 (2004).

50. People v. Cruz, 643 N.E.2d 636, 643–644 (Ill. 1994).

51. Williamson v. Ward, 110 F.3d 1508, 1512 (10th Cir. 1997).

52. Waymong Dotson Statement, August 4, 1987, 7 (on file with author).

53. Ibid., 8.

54. Trial Transcript, 726, 778, State of Idaho v. Charles I. Fain, Criminal Case No. C-5448 (Idaho D. Ct. Oct. 26, 1983).

55. Ibid., 764.

56. Ibid., 771.

57. Ibid., 772.

58. Barnes Trial Transcript, 538.

59. Trial Transcript, 165–166, Commonwealth of Pennsylvania v. Bruce Donald Godschalk, No. 00934-87, (Pa. Ct. of Common Pleas May 27, 1987).

60. Trial Transcript, 575–576, State of Oklahoma v. Ronald Keith Williamson, CRF 87-90 (Okla. D. Ct. April 22, 1988).

61. Trial Transcript, 727, State of New York v. John Restivo and Dennis Halstead, Ind. #61322 (Nassau County Ct. October 20, 1986).

62. Ibid., 760–761.

63. Ibid., 730.

64. Whitley Trial Transcript, 879.

65. Fain Trial Transcript, 740.

66. Ibid., 737, 782–783.

67. Ibid., 850.

68. Ibid., 1322–1323.

69. Trial Transcript, 2488, State of Florida v. Chad Richard Heins, Case No. 94-3965-CF (Fla. D. Ct. Dec. 10, 1996).

70. Washington v. State, 822 S.W.2d 110, 121 (Tex. App. Waco 1991).

71. Godschalk Trial Transcript, 70 (May 27, 1987).

72. Ibid., 165.

73. Dedge v. State, 442 So. 2d 429, 430 (Fla. App. 5 Dist. 1983).

74. Staff, "Cases Involving Preston," *Florida Today* (Melbourne, FL), August 30, 2009, A12; John A. Torres and Jeff Schweers, "Dog Handler Led to Bad Evidence," *Florida Today* (Melbourne, FL), June 21, 2009.

75. Dedge Trial Transcript, 1214–1215.

76. Ibid., 418
77. Ibid., 1213.
78. Ibid., 1215.
79. Ibid., 1216.
80. Ibid., 417–418.
81. John A. Torres, "After 22 Years Dedge Again Tastes Freedom," *Florida Today* (Melbourne, FL), August 13, 2004, 1; Dedge Trial Transcript, 1205, 1225.
82. Staff, "Prior Zacke Knowledge May Have Been Hidden," *Florida Today* (Melbourne, FL), January 23, 2006, A1.
83. Trial Transcript, 2–11, Commonwealth of Pennsylvania v. Nicholas Yarris, No. 690-82 (Pa. Ct. of Common Pleas June 29, 1982). He also said Yarris had claimed to have told police about the murder "and he was trying to put it on someone else in order to help him out with his first case," ibid., 2–15.
84. Ibid., 1–84, 1–88, 1–121, (June 28, 1982).
85. Ibid., 2–9.
86. Ibid., 9 (July 1, 1982).
87. Ibid., 2–12.
88. Ibid., 2–11.
89. Fain Trial Transcript, 847, 1323.
90. People v. Halstead, 580 N.Y.S.2d 413 (2d Dep't 1992).
91. Yarris Trial Transcript, 2-39-40.
92. Fain Trial Transcript, 743.
93. Calvin Washington Trial Transcript, 1363–1364.
94. Ibid., 1382.
95. Restivo Trial Transcript, 750.
96. Rainge, Adams, and Williams Trial Transcript, 2125–2135.
97. Trial Transcript at 646, 665–666, State of Oklahoma v. Dennis Fritz, CRF 87-90 (Okla. Dist. Ct. April 7, 1988).
98. Jim Cuddy Jr., "DNA Test Fails to Link Wilkinsburg Man to /81 Murder," *Pittsburgh Post-Gazette,* May 23, 1991 D12.
99. John Biemer, "Exonerated Earlier of Rape, Man Also Wins Related Case," *Chicago Tribune,* June 6, 2003, 6.
100. Ren E. Lee, "Rape Case Closed, But 'Justice Was Not Served,'" *Houston Chronicle,* February 21, 2007 A1.
101. The only codefendants who were not exonerated were those who testified against Chaunte Ott. The codefendants were also excluded by the postconviction DNA testing; however, one was himself murdered years before, and the other had received a plea deal and had served his five years. See Meg Jones, "Man Released from Prison on New DNA Evidence in Murder," *Journal Sentinel,* January 8, 2009.
102. People v. Jimerson, 652 N.E.2d 278, 282–286 (Ill. 1995).
103. David Protess and Rob Warden, *A Promise of Justice,* (New York: Hyperion Books, 1998), chap. 12, 16.
104. Trial Transcript, 35–36, 43, State of Oklahoma v. Ronald K. Williamson and Dennis L. Fritz, CRF 87-90 (Okla. Dist. Ct. July 20, 1987).

105. Trial Transcript, 63–64, Commonwealth of Massachussetts v. Kenneth Waters, No. 82-4115-4116 (Mass. Sup. Ct. May 4, 1983); http://www.innocenceproject.org/Content/285.php.

106. See Staff, "Wrongfully Convicted? DNA Testing May Set Convicted Murderer William Dillon Free After 26 Years," *Florida Today,* October 10, 2007, A1.

107. Bob Burtman, "Hard Time," *Houston News,* September 10, 1998; Jeffrey Rice, "Hard Time," *Houston Chronicle,* November 26, 2000, 6.

108. Jeffrey S. Neuschatz et al., "The Effects of Accomplice Witnesses and Jailhouse Informants on Jury Decision Making," 32 *Law & Hum. Behav.* 137 (2008) (finding that "conviction rates were unaffected by the explicit provision of information indicating that the witness received an incentive to testify" and "the presence of a confession, albeit a secondary confession, had a significant influence on mock juror conviction rates.")

109. Hoffa v. United States, 385 U.S. 293, 311 (1966).

110. Whitley Trial Transcript, 886–888.

111. Ibid., 883–884, 889–890.

112. Dodd v. State, 993 P.2d 778, 784 (Okla. Crim. App. 2000) (adopting procedure for jailhouse informant testimony that ensures "complete disclosure"); see also Cal. Penal Code § 1127a(b) (West 2004) (requiring courts to instruct jury on in-custody informant testimony); United States v. Villafranca, 260 F.3d 374, 381 (5th Cir. 2001) ("The testimony of a plea-bargaining defendant is admissible if the jury is properly instructed."); State v. Bledsoe, 39 P.3d 38, 44 (Kan. 2002) (noting that trial court "gave a cautionary jury instruction regarding the testimony of an informant"); Alexandra Natapoff, "Beyond Unreliable: How Snitches Contribute to Wrongful Convictions," 37 *Golden Gate U. L. Rev.* 107, 112–115 (2006) (proposing model statute requiring pretrial evaluations of informant testimony).

113. 725 Ill. Comp. Stat. Ann. 5/115-21(d) (West Supp. 2007).

114. Staff, "Dillon Forgives Accuser at Hearing," *Florida Today,* November 2, 2009.

6. INNOCENCE ON TRIAL

1. "Autopsy Reports Coming In," *Culpeper Star-Exponent,* July 7, 1982; "Police Believe Williams' Killer Knew Victim," *Culpeper Star-Exponent,* September 9, 1982.

2. Trial Transcript, 47, Commonwealth of Virginia v. Earl Junior Washington (Va. Cir. Ct. Jan. 19, 1984).

3. Va. Code Ann. § 19.2-163.

4. Washington Trial Transcript, 644–647.

5. Ibid., 629–630, 718–720.

6. Ibid., 805–811.

7. Ibid., 132, 151, 13. The court had only asked that the expert evaluate Washington's "present status" and capacity to stand trial. The psychologist did not examine his mental capacity at the time of the murder or interrogation, nor whether mental retardation could have affected the voluntariness of his confession. Washington's attor-

ney later stated that he believed that the court would have denied any request for funding for an expert. Brooke Masters, "Missteps on the Road to Injustice," *Washington Post*, November 30, 2000.

8. Affidavit of John W. Scott, November 3, 1989 (on file with author); Brandon L. Garrett and Peter J. Neufeld, "Invalid Forensic Science Testimony and Wrongful Convictions," 95 *Va. L. Rev.* 1, 76–77 (2009).

9. See, e.g., Nancy M. Steblay et al., "The Effects of Pre-trial Publicity on Juror Verdicts: A Meta-Analytic Review," 23 *Law & Hum. Behav.* 219 (1999).

10. The sixteen exonerees who pleaded guilty are: Larry Bostic, Marcellius Bradford, Keith Brown, James Dean, John Dixon, Kathy Gonzalez, Anthony Gray, Eugene Henton, William Kelly, Michael Marshall, Christopher Ochoa, James Ochoa, Debra Shelden, Ada JoAnne Taylor, David Vasquez and Thomas Winslow. Three exonerees, Steven Phillips, Jerry Townsend, and Arthur Whitley, were convicted at a trial, but pleaded guilty to an additional charge or charges. Thus, a total of nineteen exonerees pleaded guilty to a crime of which they were later exonerated.

11. Diane Jennings, "Two Men's DNA Exonerations in '88 Austin Murder Reveal Triumph, Tragedy," *Dallas News*, February 24, 2008.

12. Hearing Transcript, 5, State of New Jersey v. John Dixon, Ind. No. 2683-5-91 (N.J. Sup. Ct. Nov. 12, 1991).

13. See American Bar Association Standing Committee on Legal Aid and Indigent Defendants, *Gideon's Broken Promise: America's Continuing Quest for Equal Justice* (2004), 17.

14. Memorandum of Law, State of Maryland v. Anthony Gray, Case No. C-91-409 (Feb. 20, 1992).

15. Matthew Durose and Patrick A. Langan, U.S. Department of Justice, Bureau of Justice Statistics, *Felony Sentences in State Courts, 2004* (2007), 1, table 4.1; see also Brandon L. Garrett, "Judging Innocence," 108 *Colum. L. Rev.* 55, 74 n.73 (2008).

16. *60 Minutes*, "DNA Helps Free Inmate after 27 Years," May 4, 2008, at www.cbsnews.com/stories/2008/05/02/60minutes/main4065454.shtml.

17. Brandon L. Garrett, "Claiming Innocence," 92 *Minn. L. Rev.* 1629, 1680–1681 (2008).

18. Stephen P. Garvey et al., "Juror First Votes in Criminal Trials," 1 *J. Empir. Leg. Stud.* 396 (2004); Saul Kassin and Lawrence Wrightsman, *The Psychology of Evidence and Trial Procedure* (New York: Hemisphere Publishing, 1985), 8.

19. Paula Hannaford-Agor et al., *Are Hung Juries a Problem?* National Center for State Courts (2002), 49.

20. See Dan Simon, "A Third View of the Black Box: Cognitive Coherence in Legal Decision Making," 71 *U. Chi. L. Rev.* 511–586 (2004) (providing a review of the literature); Saul M. Kassin and Lawrence Wrightsman, *The American Jury on Trial: Psychological Perspectives*, (New York: Hemisphere Publishing, 1988), 153–156.

21. Trial Transcript, 1739, State of Connecticut v. Miguel Roman, No. 54423 (Ct. Sup. Ct. April 30, 1990).

22. Hannaford-Agor et al., *Are Hung Juries a Problem?* 35 (finding 92% of defendants in sample were tried alone).

23. See Dale A. Sipes et al., *On Trial: The Length of Civil and Criminal Trials,* National Center for State Courts (1988).

24. See Trial Transcript, 204, State of Texas v. Carlos Lavernia, No. 76,122 (Tex. Dist. Ct. Jan. 21, 1985); and Trial Transcript, 352–353, State of Texas v. Thomas Clifford McGowan, No. F85-81070-MU (Tex. Dist. Ct. March 5, 1986).

25. Kim North Shine, "Convicted Rapist Turns to DNA Tests," *Macomb Free Press,* November 27, 2002.

26. Additional exonerees, 8%, argued that no crime had occurred at all (17 of 207 trials). Unsurprisingly, such arguments failed. After all, DNA testing ultimately excluded these people, and therefore, almost all of the exonerees' cases were ones in which a crime did in fact occur, but the wrong man was convicted.

27. Trial Transcript, 549, State of Texas v. Brandon Moon, No. 50,015 (Tex. D. Ct. January 14, 1987).

28. Tara M. Burke and John W. Turtle, "Alibi Evidence in Criminal Investigations and Trials: Psychological and Legal Factors," 1 *Canadian J. Police & Security Services* 286 (2004); R. C. L. Lindsay et al., "Mock-Juror Evaluations of Eyewitness Testimony: A Test of Metamemory Hypotheses," 15 *J. App. Soc. Psychol.* 447 (1986).

29. Trial Transcript, 614–615, State of Oklahoma v. Timothy Edward Durham, No. CF-91-4922 (Okla. Dist. Ct. March 9, 1993).

30. Ibid., 580.

31. Trial Transcript, 375, State of Ohio v. Anthony Green, No. CR 228250 (Ohio Ct. of Common Pleas, Oct. 13, 1988).

32. Trial Transcript, 503, 506, State of Louisiana v. Rickey Johnson, No. 30,770 (La. Dist Ct. Jan. 5, 1983).

33. Trial Transcript, 1044–1045, 1070, State of West Virginia v. James Edmund Richardson, Jr., Criminal No. 89-F-5 (W. Va. Cir. Ct. July 27, 1989).

34. Trial Transcript, V3-26-27, State of Missouri v. Antonio Beaver, No.961-2972 (Apr. 24, 1997).

35. Trial Transcript, 23, State of Oklahoma v. Arvin Carsell McGee, No. CF-88-886, CF-89-1344 (Okla D. Ct. Sept. 14, 1988).

36. See 547 U.S. 319 (2006); Keith A. Findley and Michael S. Scott, "The Multiple Dimensions of Tunnel Vision in Criminal Cases," 2006 *Wis. L. Rev.* 291, 343–346.

37. For two of the few articles discussing standards for admission of third-party guilt evidence prior to *Holmes,* see Brett C. Powell, "Perry Mason Meets the 'Legitimate Tendency' Standard of Admissibility (And Doesn't Like What He Sees)," 55 *U. Miami L. Rev.* 1023 (2001); Stephen Michael Everhart, "Putting a Burden of Production on the Defendant Before Admitting Evidence That Someone Else Committed the Crime Charged: Is It Constitutional?" 76 *Neb. L. Rev.* 272 (1997).

38. Trial Transcript, 477–478, State of California v. Frederick Rene Daye, CR-67014/DA-A75647 (Cal. Sup. Ct. May 21, 1984).

39. Ibid., 557–558.

40. See Tony Perry, "DNA Test Frees Inmate after 10 Years," *Los Angeles Times,* September 29, 1994, 3; Carl Rothman, "Suspect in 1985 Rape and Murder of 2 Kids Is Dead," *Newark Star-Ledger,* November 24, 2009.

41. S. A. Reid, "DNA That Freed One Links Another to Cobb Rape," *Atlanta Journal-Constitution*, February 16, 2007, D4; Christopher J. McFadden, "The Exoneration of Robert Clark," *Fulton County Daily Report*, June 16, 2006, 4; Trial Transcript, 145–147, State of Georgia v. Robert Clark, Jr., Ind. No. 82-0481 (Ga. Sup. Ct. May 24, 1982).

42. Trial Transcript, 867–868, State of Oklahoma v. Ronald Keith Williamson, CRF 87-90 (Okla. Dist. Ct. March 22, 1988).

43. Trial Transcript, 164, State of Louisiana v. Dennis P. Brown, No. 128,634 (La. Dist. Ct. Sept. 11, 1985).

44. Trial Transcript, 80, State of Texas v. Charles Chatman, No. F81-2101 QK (Tex. Dist. Ct. 1981).

45. Trial Transcript, 391, Commonwealth of Pennyslvania v. Thomas Doswell, No. CC 8603467 (Pa. Ct. of Common Pleas November 19, 1986).

46. Trial Transcript, 1398, State of Ohio v. Clarence A. Elkins, No. 98-06-1415 (Ohio Ct. of Common Pleas May 20, 1999).

47. Trial Transcript, 878, State of Oklahoma v. Dennis Leon Fritz, No. CRF-87-90 (Okla. Dist. Ct. April 6, 1988).

48. Trial Transcript, 180–181, Commonwealth of Pennsylvania v. Bruce Donald Godschalk, No. 00934-87, (Pa. Ct. of Common Pleas May 27, 1987).

49. Ronald Jones Transcript, 84 (July 13, 1999); ibid., 183 (Aug. 19, 1989).

50. Trial Transcript, 94, State of New York v. Anthony Capozzi, #85-1379-001 (N.Y. Sup. Ct. Jan. 27, 1987).

51. Trial Transcript, 197, State of Texas v. Larry Fuller, No. F81-8431-P (Tex. Dist. Ct. Aug. 24, 1981).

52. Trial Transcript, 28–29, State of Maryland v. Kirk N. Bloodsworth, No. 84-CR-3138 (Md. Cir. Ct. Mar. 1, 1985).

53. Trial Transcript, 513, State of Georgia v. Douglas Eugene Echols, No.086-0565 (Ga. Sup. Ct. March 23, 1987).

54. Sharon Cohen, "Jailed at 14, Youth Refused to Surrender Hope," *Los Angeles Times*, June 9, 2002.

55. Trial Transcript, 870–872, State of New York v. James O'Donnell, No. 289-97 (N.Y. Sup. Ct. April 28, 1998).

56. Trial Transcript, 69, State of New York v. Kevin Richardson and Kharey Wise, No. 4762/89 (N.Y. Sup. Ct. Oct. 22, 1990).

57. Trial Transcript, 10, Commonwealth of Massachusetts v. Stephan Cowans, No.97-11231 (Mass. Sup. Ct. July 7, 1998).

58. Trial Transcript, 1211, 1214, State of Illinois v. Michael Evans and Paul Terry No. 76-1105, 76-6504 (Ill. Cir. Ct. April 25, 1977).

59. John H. Blume, "The Dilemma of the Criminal Defendant with a Prior Record—Lessons from the Wrongfully Convicted," 5 *J. Empirical Legal Stud.* 492 (2009) (reviewing case summaries of 119 exonerees and finding that of those who testified, 43% had criminal records, while of those who did not, 93% had criminal records).

60. Sixteen exonerees were excluded by DNA testing at the time of their convictions: Joseph Abbitt, Richard Alexander, Jeffrey Deskovic, Clarence Elkins, Nathaniel

Hatchett, Travis Hayes, Entre Nax Karage, Ray Krone, Ryan Matthews, Antron McCray, James Ochoa, Kevin Richardson, Miguel Roman, Raymond Santana, Yusef Salaam, and Korey Wise. However, one of the sixteen, James Ochoa, did not have a trial but pleaded guilty despite DNA testing that excluded him. In addition to the fifteen exonerees who were excluded by all of the non-DNA forensics in their case, twenty-three more exonerees were excluded by some but not all of the forensics in their case.

61. In forty-one trials the State had two experts, in thirty-two trials the State had three experts, in sixteen trials the State had four experts, in five trials the State had five experts, in five trials the State had six, and in five trials the State had seven.

62. See, e.g., Hannaford-Agor et al., *Are Hung Juries a Problem?* 47; Darryl Brown, "The Decline of Defense Counsel and the Rise of Accuracy in Criminal Adjudication," 93 *Cal. L. Rev.* 1585, 1603 & n.62–63 (2005). Chapter 4 discusses difficulties exonerees had in obtaining forensic experts and why under existing doctrine courts often deny such experts. See also Paul C. Gianelli, "Ake v. Oklahoma: The Right to Expert Assistance in a Post-Daubert World," 89 *Cornell L. Rev.* 1305 (2004).

63. Brief of Appellants, Jimmy Ray Bromgard, On Appeal from the United States District Court for the District of Montana, Billings Division, Cause No. CV-05-32-BLG-RFC 4 (2009).

64. Adam Liptak, "DNA Will Let a Montana Man Put Prison Behind Him, But Questions Still Linger," *New York Times,* Oct. 1, 2002.

65. Trial Transcript, 3, State v. Jimmy Ray Bromgard, No. 88108 (Mont. Dist. Ct. Nov. 16, 1987).

66. State v. Bromgard, 285 Mont. 170 (1997).

67. See, e.g., The Spangenberg Group, *State and County Expenditures for Indigent Defense Services in Fiscal Year 2002* (2003), 34–37.

68. Clair Johnson, "Yellowstone County Wins Bromgard Case," *Billings Gazette,* November 19, 2009; see also Office of the State Public Defender, at http://publicde fender.mt.gov/ ("On July 1, 2006 the Office of the State Public Defender assumed responsibility for statewide Public Defender Services, previously provided by cities and counties").

69. State v. Stinson, 134 Wis. 2d 224 (Wis. App. 1986).

70. Thus more exonerees had public defenders and retained counsel than the average criminal defendant in the United States, perhaps due to the disproportionate numbers in large jurisdictions and in serious felony cases, as well as the desire of these innocent individuals to vigorously defend themselves at a trial. See Steven K. Smith and Carol J. DeFrances, U.S. Department of Justice, *Indigent Defense* (1996), 1 ("nearly 80% of local jail inmates indicated that they were assigned an attorney"). Studies suggest that retaining private counsel or counsel from a public defender's office, as opposed to a court-appointed lawyer, is associated with better outcomes at trial and also on appeal. See, e.g., David T. Wasserman, *A Sword for the Convicted: Representing Indigent Defendants on Appeal* (New York: Greenwood Press, 1990), 99, 152.

71. Trial Transcript, 332–334, State of Texas v. Donald Wayne Good, F33-31435 (Tex. Dist. Ct. Sept. 15, 1987).

72. Berger v. United States, 295 U.S. 78, 88 (1935).

73. As I discuss in Chapter 7, seventy-seven exonerees brought claims relating to prosecutorial misconduct during their appeals or postconviction.

74. Kathleen A. Ridolfi and Maurice Possley, "Preventable Error: A Report on Prosecutorial Misconduct in California, 1997–2008" (2010); James S. Liebman, Jeffrey Fagan, and Valerie West, *A Broken System: Error Rates in Capital Cases, 1973–1995* (2000), 4–5; Marshall J. Hartman and Stephen L. Richards, "The Illinois Death Penalty: What Went Wrong?" 34 *J. Marshall L. Rev.* 409, 422–430 (2001); Ken Armstrong and Maurice Possley, "Trial & Error; How Prosecutors Sacrifice Justice to Win; The Verdict: Dishonor," *Chicago Tribune,* January 10, 1999, 1.

75. In their appeals or postconviction, nineteen exonerees made Fourth Amendment claims regarding police search or seizure of evidence or lack of probable cause to arrest, all without any success. Similarly, eight exonerees alleged that law enforcement destroyed evidence that could have helped their case, without success.

76. Steve McGonigle and Robert Tharp, "DA Joins Fight to Clear Man," *Dallas News,* February 23, 2007.

77. Elkins v. Summit County, Ohio, No. 5:06-CV-3004, 2009 WL 1150114 (N.D. Ohio April 28, 2009).

78. Doswell v. City of Pittsburgh, Civil Action No. 07-0761, 2009 WL 1734199, at *5 (W.D. Pa. June 16, 2009).

79. McGowan Trial Transcript, 396.

80. Trial Transcript, 455–456, State of Ohio v. Anthony Green, No. CR 228250 (Ohio Ct. of Common Pleas Oct. 13, 1988).

81. Trial Transcript, 2461–2462, State of Florida v. Chad Richard Heins, Case No. 94-3965-CF (Fla. D. C. Dec. 10, 1996).

82. Trial Transcript, 349, Commonwealth of Virginia v. Arthur Lee Whitfield, F 841-82 (Va. Cir. Ct. Jan. 14, 1982).

83. McCarty v. State, 765 P.2d 1215, 1220 (Okla. Ct. of Crim. App. 1988).

84. Taylor v. State, 1997 WL 167849, at *3 (Tex. App.-Hous. 1 Dist. April 10, 1997).

85. Few criminal trials result in hung juries. One study of felony trials in four counties found that about 6% of trials resulted in a hung jury and 4% more resulted in a mistrial. Of those, less than a third result in a second jury trial; most are dismissed or result in guilty pleas. Hannaford-Agor et al., *Are Hung Juries a Problem?* 25, 31.

86. The nine exonerees who had hung juries are: Richard Alexander, Scott Fappiano, Donald Wayne Good, David Gray, Eddie Lowery, Arvin McGee, Willie Nesmith, Thomas McGowan, and Julius Ruffin. McGee had a hung jury and then a mistrial (he was tried three times). Julius Ruffin had two hung juries and was convicted in his third trial. The fifteen exonerees who had multiple trials because their convictions were vacated on appeal or postconviction are: Kirk Bloodsworth, Ronald Cotton, McKinley Cromedy, Rolando Cruz, Wilton Dedge, Michael Evans, Donald Wayne Good (he had both two hung juries and one new trial granted due to a vacatur), Alejandro Hernandez, Darryl Hunt, Ray Krone, Johnnie Lindsey, Curtis

McCarty, Willie Rainge, Mark Webb, and Dennis Williams. All of those had two trials, except Cruz and Hernandez, who had three trials. In addition to those twenty-three exonerees who had multiple trials, Dana Holland, Steven Phillips, and LaFonso Rollins had multiple trials for a different reason, not due to hung juries or new trials granted, but rather because they had separate trials for separate crimes that they were charged with.

87. Trial Transcript, 1078–1085, 774, People v. Roy Brown, 91-2099 (N.Y. Sup. Ct. Jan. 13–23, 1992).

88. Trial Transcript, 917–918, People v. Anthony Capozzi, 4-89-657 (N.Y. Sup. Ct. Feb. 5, 1987).

89. Trial Transcript, 2525, State v. Chad Richard Heins, No. 94-3965-CF (Fla. Cir. Ct. Dec. 13, 1994); see also Brandon L. Garrett and Peter J. Neufeld, "Invalid Forensic Science Testimony and Wrongful Convictions," 95 *Va. L. Rev.* 1, 66 (2009).

90. Trial Transcript, 46, Jerry E. Watkins v. State of Indiana, 3CSCC-87C8-CB-764 (Ind. Sup. Ct. Aug. 1987).

91. Alan Berlow, "The Wrong Man," *Atlantic,* November 1999.

92. David Harper, "McGee Case: City to Pay: Lawsuit Is Settled for $12.25 million," *Tulsa World* (Okla.), June 3, 2006.

93. Trial Transcript, 293, State of Oklahoma v. Arvin Carsell McGee, No. CF-88-886, CF-89-1344 (Okla Dist. Ct. Sept. 14, 1988); ibid., 11–16 (Sept. 28, 1988 Hearing).

94. Trial Transcript, 619, Commonwealth v. Eric Sarsfield, No. 87-66 (Mass. Sup. Ct. July 6, 1987).

95. Ken Armstrong and Maurice Possley, "Reversal of Fortune," *Chicago Tribune,* January 13, 1989.

96. Trial Transcript, Commonwealth of Virginia v. Willie Davidson, No. 919-81 (Va. Cir. Ct., May 27, 1981) (page numbers illegible).

97. Trial Transcript, E-33, State of Illinois v. Richard Johnson, No. 91-CR-20794 (Ill. Cir. Ct. Oct. 6, 1992).

98. Trial Transcript, 390–391, State of Utah v. Bruce Dallas Goodman, No. 605 (Utah Dist. Ct. Jan. 30, 1986).

99. Trial Transcript, 36, State of South Carolina v. Perry Renard Mitchell, No. 83-GS-32-479 (Ct. of Gen. Sess. January 23, 1984). The jury took only one hour to convict. Ibid., 37.

100. For a discussion of related issues, including some advantages that defendants have over prosecutions, but concluding that the playing field in criminal cases is decisively tilted, see Richard A. Uviller, *A Tilted Playing Field: Is Criminal Justice Unfair?* (New Haven, CT: Yale University Press, 1997).

101. Dennis Fritz, *Journey Toward Justice* (Santa Ana, CA: Seven Locks Press, 2006), 318.

102. Fritz Trial Transcript, 1071–1072.

103. Fritz, *Journey Toward Justice,* 318.

7. JUDGING INNOCENCE

1. See Shaila Dewan, "Despite DNA Test, Prosecutor Retries a '92 Murder Case," *New York Times,* September 6, 2007.
2. See Flynn McRoberts and Steve Mills, "From the Start, a Faulty Science," *Chicago Tribune,* October 19, 2004.
3. Brewer v. State, 725 So. 2d 106 (Miss. 1998).
4. Ibid., 133.
5. Brewer v. Mississippi, 526 U.S. 1027 (Mem) (1999).
6. Brewer v. State, 819 So. 2d 1165, 1168 (Miss. 2000).
7. Brewer v. State, 819 So. 2d 1169 (Miss. 2002).
8. McCarty v. State, 765 P.2d 1215, 1218 (Okla. Cr. 1988).
9. McCarty v. State, 904 P.2d 110 (Okla. Crim. App. 1995) (denying relief on claims regarding hair comparison and serology testimony at the second trial, but remanding for new capital sentencing hearing).
10. McCarty v. State, 114 P.3d 1089 (Okla. Crim. App. 2005).
11. See Cheryl Camp, "Convicted Murderer Is Freed in Wake of Tainted Evidence," *New York Times,* May 22, 2007, A16.
12. Roger J. Traynor, *The Riddle of Harmless Error* (Columbus: Ohio State University Press, 1969).
13. Judge Jerome Frank and Barbara Frank, *Not Guilty* (Garden City, NY: Doubleday, 1957).
14. See Victor E. Flango, National Center for State Courts, *Habeas Corpus in State and Federal Courts* (1994), 62–63; Nancy King, Fred L. Cheesman II, and Brian J. Ostrom, National Center for State Courts, *Final Technical Report: Habeas Litigation in U.S. District Courts* (2007), 58.
15. Later in the chapter I describe in greater detail the "matched comparison group" that I constructed to compare the exonerees' reversal rate to that of a similarly situated group of cases. In that matched group, there was no significant difference in the reversal rate (and just a single additional reversal).
16. These results update a study that I previously published, titled "Judging Innocence," which examined written decisions during the appeals and postconviction litigation of the first 200 exonerees. See Brandon L. Garrett, "Judging Innocence," 108 *Colum. L. Rev.* 55 (2008). As I explained in that study, by written decisions I refer to decisions that were available on Westlaw or Lexis-Nexis or state court databases and that provided a reason for the decision, regardless whether they were characterized by the judge as "reported" or "unreported." Ibid., 68 & n.46. Most postconviction rulings are summary or not published, and judges often rule on selected claims, without saying what other claims were raised in a petition. Failure to issue a written decision, however, may not be random. For example, judges may tend to write decisions just discussing the claims they perceive to have the most merit. For all of those reasons, which create challenges for any effort to study criminal appeals and postconviction review, the data reported here is from a selected sample and necessarily incomplete.

17. See Brandon L. Garrett, "The Substance of False Confessions," 62 *Stan. L. Rev.* 1051, 1107–1109 (2010).

18. Trial Transcript, 2, 43, State of Oklahoma v. Ronald K. Williamson and Dennis L. Fritz, CRF 87-90 (Okla. Dist. Ct. July 20, 1987).

19. The exonerees are: James Dean, Jeffrey Deskovic, Bruce Godschalk, Byron Halsey, Alejandro Hernandez, Nathaniel Hatchett, Stephen Linscott, Freddie Peacock, Yusef Salaam, Jerry Townsend, Douglas Warney, Earl Washington Jr., and Ronald Williamson. See Washington v. Murray, 4 F.3d 1285, 1292 (4th Cir. 1993) (stating that Washington "had confessed to the crime not in a general manner, but as one who was familiar with the minutiae of its execution"); Godschalk v. Montgomery County Dist. Attorney's Office, 177 F. Supp. 2d 366, 367 (E.D. Pa. 2001) (quoting unpublished state court decision finding "plaintiff's conviction 'rests largely on his own confession which contains details of the rapes which were not available to the public'" (citation omitted)); Townsend v. State, 420 So. 2d 615, 617 (Fla. Dist. Ct. App. 1982) ("Townsend confessed to all of the collateral crimes as well as those for which he was charged, and he took the police to the scene and corroborated facts known to the police which only the killer would know."); People v. Hatchett, No. 211131, 2000 WL 33419396, at *1 (Mich. Ct. App. May 19, 2000) (stating that "the prosecution presented overwhelming evidence" and that police "testified that defendant's statement included information that only the perpetrator of the crimes would know," facts "fully corroborative" of the victim's account); State v. Dean, 464 N.W.2d 782, 789 (Neb. 1991) ("[T]he presentence investigation contained numerous statements made by the defendant to law enforcement officers. Those statements were corroborated not only by the physical evidence found at the crime scene and the scientific examination of that evidence, but also by interviews with other people involved or intimately familiar with some details of the crimes against the deceased as heretofore related."); State v. Halsey, 748 A.2d 634, 636–638 (N.J. Super. Ct. App. Div. 2000) (citing "overwhelming" evidence of his guilt and describing each of the facts he supposedly volunteered in his confession); People v. Peacock, 417 N.Y.S.2d 339 (N.Y. App. Div. 1979) (denying relief citing "strong evidence of guilt, including defendant's confession"); People v. Warney, 750 N.Y.S.2d 731, 732–733 (N.Y. App. Div. 2002) ("Defendant confessed to the crime and gave accurate descriptions of many details of the crime scene."); People v. Salaam, 590 N.Y.S.2d 195, 196 (N.Y. App. Div. 1992) ("Details of this statement were corroborated overwhelmingly by substantial physical evidence."); Williamson v. State, 812 P.2d 384, 396 (Okla. Crim. App. 1991) ("[T]he Appellant made certain admissions, in addition to a confession, which were corroborated by the extrinsic evidence.").

20. People v. Cruz, 121 Ill.2d 321, 336 (Ill. 1988).

21. Those exonerees are Curtis McCarty, Marvin Mitchell, Bruce Nelson, and Walter Snyder.

22. 388 U.S. 218 (1967).

23. State v. Cromedy, 727 A.2d 457 (N.J. 1999) (reversing conviction for failure to instruct jury concerning error and cross-racial identifications); Jean v. Rice, 945 F.2d 82, 87 (4th Cir. 1991) (finding violation of *Brady* where use of hypnosis was not dis-

closed to the defense and where there was "little" evidence to corroborate the witness identifications); State v. Cotton, 351 S.E.2d 277, 280 (N.C. 1987) (granting new trial where evidence of eyewitnesses' identification of another person supported third-party guilt theory); Webb v. State, 684 S.W.2d 800, 801 (Tex. App. 1985) (reversing conviction where victim violated rule against discussion with other witnesses); People v. Evans, 399 N.E.2d 1333, 1337 (Ill. App. 1979) (noting that new trial had previously been granted to Evans).

24. 432 U.S. 98 (1977).

25. People v. Barnes, 558 N.Y.S.2d 339 (4 Dept. 1990).

26. Bryson v. State, 711 P.2d 932 (Okla. Cir. 1985).

27. State v. Green, 585 N.E.2d 990 (Ohio App. 8 Dist. 1990).

28. McCarty v. State, 765 P.2d 1215, 1218 (Okla. Cr. 1988).

29. State v. Krone, 897 P.2d 621, 624–625 (1995).

30. People v. Linscott, 159 Ill. App. 3d 71, 80–81 (Ill. App. Ct. 1987).

31. Williamson v. Ward, 110 F.3d 1508, 1520 (10th Cir. 1997) (noting that in reversing the conviction the district court also emphasized failure to adequately challenge the forensic evidence, and not reviewing the merits of that decision); People v. Williams, 444 N.E.2d 136, 138, 143 (Ill. 1982) (reversing after trial attorney was disbarred, citing counsel's joint representation of three capital defendants before two juries and also citing failures to move to suppress central evidence, including hair evidence); People v. Rainge, 445 N.E.2d 535, 547 (Ill. App. Ct. 1983) (reversing on similar grounds).

32. People v. Rainge, 445 N.E.2d 535, 551 (Ill. App. Ct. 1983).

33. State v. Bauer, 210 Mont. 298 (1984).

34. See Massiah v. United States, 377 U.S. 201, 203–206 (1964).

35. State v. Hunt, 378 S.E.2d 754, 757–759 (N.C. 1989) (describing improper introduction of unsworn statements).

36. People v. Cruz, 643 N.E.2d 636, 644 (Ill. 1993).

37. The Tenth Circuit later affirmed the grant of habeas, but on other grounds, and without reviewing rulings relating to the informant testimony. Williamson v. Ward, 110 F.3d 1508, 1512 (10th Cir. 1997); Williamson v. Reynolds, 904 F. Supp. 1529, 1550–1551 (E.D. Okla. 1995).

38. Trial Transcript, 1737, Jerry E. Watkins v. State of Indiana, 3CSCC-87C8-CB-764 (Ind. Sup. Ct. Aug. 1987).

39. Watkins v. Miller, 92 F. Supp. 2d 824, 834 (S.D. Ind. 2000).

40. Watkins Trial Transcript, 2172.

41. Anthony G. Amsterdam, "Verbatim: Lady Justice's Blindfold Has Been Shredded," *Champion,* May 2007, 51.

42. In a groundbreaking article, law professor William Stuntz developed these arguments about the perverse incentives that the structure of criminal procedure rules create. See William J. Stuntz, "The Uneasy Relationship between Criminal Procedure and Criminal Justice," 107 *Yale L.J.* 1, 37–45 (1997).

43. John Scalia, U.S. Department of Justice, Bureau of Justice Statistics, *Prisoner Petitions Filed in U.S. District Courts, 2000, with Trends, 1980–2000,* 1–2.

44. Arizona v. Youngblood, 488 U.S. 51 (1988).
45. James Liebman, Jeffrey Fagan, and Valerie West, *A Broken System: Error Rates in Capital Cases, 1973–1995* (2000), 5.
46. See Flango, *Habeas Corpus*, 62–63; King et al., *Habeas Litigation*, 58.
47. For a more detailed discussion of this matched comparison group, see Garrett, "Judging Innocence," 154–157. The claims that received reversals in the matched comparison group mirrored the claims on which exonerees received relief: five state law evidentiary claims, four ineffective assistance of counsel claims (one accompanied by a prosecutorial misconduct claim), a *Jackson* claim, a right to counsel claim, and a suggestive eyewitness identification claim.
48. The winning claims, namely those for which a new trial was granted and that ruling was upheld on appeal, were as follows: state evidentiary claims (6); *Brady* claims (5); ineffective assistance of counsel claims (4); claims concerning jury instructions (2); *Bruton* unconstitutional joinder claims (2); prosecutorial misconduct claims (2); due process and right to counsel claims (1); ex post facto challenge to a state statute (1); and fabrication of evidence (1).
49. The fourteen cases include the five reversals relating to eyewitness identifications: a state law claim regarding failure to provide a jury instruction explaining the dangers of cross-racial misidentification (M. Cromedy); a state evidentiary violation relating to an eyewitness identification (M. Webb); a *Brady* claim related to payment of a reward to an eyewitness (M. Evans); the trial court's decision to bar evidence that another victim of similar attacks identified another person (R. Cotton); and a *Brady* claim regarding hypnotism of the victim in order to elicit an identification (L. Jean). The eight additional reversals related to trial evidence: another related to expert evidence on a bite mark central to the case (R. Krone); prosecutorial misconduct for misrepresenting hair and blood evidence (S. Linscott); a *Brady* violation related to hair analysts (C. McCarty); ineffective assistance of counsel relating to expert issues regarding competence, a confession, and forensic testimony (R. Williamson); improper admission of an unsworn statement by a cooperating witness (D. Hunt); a fabrication claim regarding testimony of a cooperating codefendant (V. Jimerson); and two appeals involving ineffectiveness of counsel including failure to move to suppress central physical evidence such as hair evidence (W. Rainge and D. Williams). The last case, not discussed earlier in this chapter, involved a state law evidence claim related to a dog scent identification in the case of Wilton Dedge. See Dedge v. State, 442 So. 2d 429 (Fla. App. 1983). For just the noncapital cases, that figure is seven of eleven reversals.
50. Two reversals were granted for *Brady* claims that alleged the state concealed police reports relating to third-party guilt, in the cases of Kirk Bloodsworth and Jerry Watkins. See Bloodsworth v. State, 512 A.2d 1056 (Md. 1986); Watkins v. Miller, 92 F. Supp. 2d 824, 834 (S.D. Ind. 2000). The third such reversal occurred after the trial court in Rolando Cruz's case barred evidence of a third party's pattern of similar crimes and confessions, although the reversal was also on the basis that prosecutors improperly impeached a witness. See People v. Cruz, 643 N.E.2d 636, 653–661 (Ill. 1994).

51. Johnny Lindsey won a reversal due to a conviction on an amended criminal statute that was not yet in effect at the time of his conviction, Lindsey v. State, 672 S.W.2d 892 (Tex. App. 1984). Donald Wayne Good's conviction was reversed because the prosecutor improperly referred to his demeanor when he testified. Good v. State, 723 S.W.2d 734 (Tex. Ct. App. 1986). Paula Gray's conviction was reversed due to her defense lawyer's conflicts in jointly representing codefendants. Gray v. Director, Dept. of Corrections, State of Illinois, 721 F.2d 586, 598 (7th Cir. 1983). In addition to the reversal of his second conviction for failure to allow him to present evidence of third-party guilt and improper prosecutorial questioning, Rolando Cruz's first trial was reversed for prejudicial joinder of his case with codefendants. People v. Cruz, 521 N.E.2d 18, 25 (Ill. 1988). His codefendant, exoneree Alejandro Hernandez, had a reversal for the same reason. People v. Hernandez, 521 N.E.2d 25, 37–38 (Ill. 1988).

52. See Williamson v. Ward, 110 F.3d 1508, 1520 (10th Cir. 1997).

53. State v. Cotton, 351 S.E.2d 277, 280 (N.C. 1987).

54. See Brandon L. Garrett and J. J. Prescott, "Determinants of Success in Post-conviction Litigation by the Innocent," (2011) (draft on file with author).

55. See, e.g., King et al., "Final Technical Report," 89 (concluding that "it appeared that the presence of an innocence claim operated somehow to make a grant of relief on a *different* claim more likely"); see also Thomas Y. Davies, "Affirmed: A Study of Criminal Appeals and Decision-Making Norms in a California Court of Appeal," 1982 *Am. B. Found. Res. J.* 543, 625–628; David T. Wasserman, *A Sword for the Convicted: Representing Indigent Defendants on Appeal* (Westport, CT: Greenwood Press, 1990), 138–148.

56. See Chapman v. California, 386 U.S. 18, 24, 26 (1966). The *Brecht v. Abramson* test, see 507 U.S. 619, 639 (1993), which requires that the State show that error did not substantially influence the jury, applies during federal habeas corpus review; but with fewer exonerees pursuing habeas petitions and only a handful pursuing them after 1993 when *Brecht* was decided, that more stringent test was never cited in these cases.

57. Properly applied, harmless error analysis should ask only whether the State can demonstrate that error did not sufficiently affect the outcome at trial and not, conversely, whether evidence of guilt outweighed the impact of any error. See Sullivan v. Louisiana, 508 U.S. 275, 279 (1993) ("The inquiry . . . is . . . whether the guilty verdict actually rendered in this trial was surely unattributable to the error. That must be so, because to hypothesize a guilty verdict that was never in fact rendered—no matter how inescapable the findings to support that verdict might be—would violate the jury-trial guarantee.").

58. Those cases are: Dennis Brown, State v. Brown, No. L-82-297, 1983 WL 6945, at *14 (Ohio Ct. App. Sept. 16, 1983); Ronnie Bullock, People v. Bullock, 507 N.E.2d 44, 49 (Ill. App. Ct. 1987); Frederick Daye, People v. Daye, 223 Cal. Rptr. 569, 580 (Cal. Ct. App. 1986); Jeffrey Deskovic, People v. Deskovic, 607 N.Y.S.2d 957, 958 (N.Y. App. Div. 1994) ("There was overwhelming evidence of the defendant's guilt in the form of the defendant's own multiple inculpatory statements, as corroborated by such physical evidence as the victim's autopsy findings"); Bruce Godschalk,

Godschalk v. Montgomery County Dist. Attorney's Office, 177 F. Supp. 2d 366, 367, 369 (E.D. Pa. 2001) (quoting criminal trial court); Hector Gonzalez, State v. Gonzalez, 696 N.Y.S.2d 696, 697 (N.Y. App. Div. 1999); Larry Holdren, Holdren v. Legursky, 16 F.3d 57, 63 (4th Cir. 1994); D. Hunt, State v. Hunt, 457 S.E.2d 276, 293 (N.C. Ct. App. 1994); Leonard McSherry, People v. McSherry, 14 Cal. Rptr. 2d 630, 636 (Cal. Ct. App. 1992) (referring to "the unusual circumstances in this case, overwhelmingly identifying appellant as the perpetrator") (depublished); Alan Newton, Newton v. Coombe, No. 95-9437, 2001 WL 799846, at *6 (S.D.N.Y. July 13, 2001) (noting evidence of guilt "extremely strong"); David Shawn Pope, Pope v. State, 756 S.W.2d 401, 403 (Tex. App. 1988); Anthony Robinson, Robinson v. State, No. C14-87-00345-CR, 1989 WL 102335, at *7, *10 (Tex. App. Sept. 7, 1989); Yusef Salaam, People v. Salaam, 590 N.Y.S.2d 195, 196 (N.Y. App. Div. 1992).

59. People v. Deskovic, 607 N.Y.S.2d 696, 697 (N.Y. App. Div. 1994).

60. No written decision mentioned that an exoneree raised *Schlup,* the "innocence gateway" that excuses procedural defaults of constitutional claims on the basis of newly discovered evidence. Schlup v. Delo, 513 U.S. 298, 326–327 (1995).

61. See Nicholas Berg, "Turning a Blind Eye to Innocence: The Legacy of Herrera v. Collins," 42 *Am. Crim. L. Rev.* 121, 135–137 (2005) (surveying more than 170 cases in which actual innocence claims were asserted and concluding that no court has granted relief solely on basis of such claims).

62. See Herrera v. Collins, 506 U.S. 390, 417 (1993) (assuming arguendo that persuasive demonstration of actual innocence would render an execution unconstitutional, but stating that if such a claim existed, the threshold would be "extraordinarily high").

63. See, e.g., Kyles v. Whitley, 514 U.S. 419, 435 (1995); see also Scott E. Sundby, "Fallen Superheroes and Constitutional Mirages: The Tale of *Brady v. Maryland,*" 33 *McGeorge L. Rev.* 643, 659 (2002) (describing *Brady* as a postconviction "due process safety check").

64. See Hunt v. McDade, 205 F.3d 1333 (4th Cir. 2000).

65. Editorial, "Badly Botched Case Wrongful Convictions Undermine Faith in Justice System," *Charlotte Observer* (N.C.), December 29, 2003, 12A; Associated Press, "DNA Tests Exonerated Man Who Spent 18 Years in Prison for Murder of a Woman in 1984," *St. Louis Post-Dispatch,* February 7, 2004, 21.

66. Seven exonerees proffered third-party guilt evidence, seven presented police reports suppressed at the time of trial, four presented recantations of key witnesses, two presented new alibi evidence, two presented new evidence undercutting informant testimony, one presented evidence of police hypnosis of the victim, and one presented new forensic expert evidence (some presented more than one type).

67. See Jackson v. Day, No. CIV.A.95-1224, 1996 WL 225021 *1 (E.D.La May 2, 1996).

68. See Answer in Opposition to Respondent's Motion to Dismiss, Eddie Joe Lloyd v. Grayson, No. 88CV-73351-DT (E.D. Mich) (on file with author).

69. See 443 U.S. 307, 324 (1979) (holding that habeas relief is available if petitioner shows that no rational trier of fact "could have found proof of guilt beyond a reasonable doubt" based on evidence presented at trial).

70. See, e.g., 28 U.S.C. § 2244(d) and § 2254(d)–(e).

71. See Flango, *Habeas Corpus,* 46–47.

72. Strickland v. Washington, 466 U.S. 668, 689–690, 693–694 (1988).

73. Randall Coyne, *Capital Punishment and the Judicial Process* (Durham, NC: Carolina Academic Press, 1994), 148; see also Stephen B. Bright, "Counsel for the Poor: The Death Sentence Not for the Worst Crime but for the Worst Lawyer," 103 *Yale L.J.* 1835, 1844 (1994); Robert R. Rigg, "The Constitution, Compensation, and Competence: A Case Study," 27 *Am. J. Crim. Law* 1, 7–9 (1999).

74. See also Bright, "Counsel for the Poor"; Rigg, "The Constitution." John Jeffries and Bill Stuntz have proposed that *Strickland* claims could be a vehicle for judges to more broadly grant relief on innocence-related grounds. See John C. Jeffries Jr. and William J. Stuntz, "Ineffective Assistance and Procedural Default in Federal Habeas Corpus," 57 *U. Chi. L. Rev.* 679, 691 (1990).

75. Williamson v. Ward, 110 F.3d 1508, 1522 (10th Cir. 1997).

76. People v. Williams, 444 N.E.2d 136, 138, 143 (Ill. 1982), U.S. ex. rel. Gray v. Dir., Dept of Corr., 721 F.2d 586, 597 (7th Cir. 1983).

77. See, e.g., Washington v. Murray, 4 F.3d 1285, 1288–1292 (4th Cir. 1993).

78. Brandon L. Garrett, "Judging Innocence," 108 *Colum. L. Rev.* 55, 115 (2008).

79. Berger v. United States, 295 U.S. 78, 88 (1935).

80. Mooney v. Holohan, 294 U.S. 103, 112 (1935).

81. Batson v. Kentucky, 476 U.S. 79 (1986).

82. Brewer v. State, 725 So.2d 106, 123–124 (Miss. 1998).

83. State v. Krone, 897 P.2d 621, 624–625 (Ariz. 1995); People v. Cruz, 643 N.E.2d 636, 653–661 (Ill. 1994). As described, seventy-seven exonerees brought claims related to prosecutorial misconduct of one kind or another. Forty-two exonerees brought claims related to prosecution arguments, twenty-nine brought *Brady* claims, four brought fabrication claims, and twenty-one brought claims related to jury instructions. Four exonerees brought claims that made generalized claims of prosecutorial misconduct that the court did not specify. Three more cases involved claims of improper questioning of witnesses, one case involved a discovery violation, and a final case involved a prosecution motion. Some cases involved more than one type.

84. See, e.g., Arizona v. Youngblood, 488 U.S. 51, 72 (1988) (Blackmun, J., dissenting).

85. State v. Jean, 311 S.E.2d 266, 274 (N.C. 1984) (Exum, J., dissenting).

86. State v. Goodman, 763 P.2d 786, 789–790 (Utah 1988) (Stewart, J., dissenting).

87. See, e.g., People v. Cruz, 643 N.E.2d 636, 688 (Ill. 1994) (Heiple, J., dissenting).

88. Herrera, 506 U.S. 390, 403–404 (1993).

8. EXONERATION

1. See *Frontline,* "Requiem for Frank Lee Smith," at www.pbs.org/wgbh/pages/frontline/shows/smith/eight/.

2. Smith v. Dugger, 565 So. 2d 1293, 1296 (Fla. 1990); Sydney Freedberg, "DNA Clears Inmate Too Late," *St. Petersburg Times,* December 15, 2000, 1A.

3. Freedberg, "DNA Clears Inmate."

4. Ibid.

5. Barry Scheck, "Did Frank Lee Smith Die in Vain?" www.pbs.org/wgbh/pages/frontline/shows/smith/ofra/scheck.html.

6. See Fla. Stat. Ann. § 925.11(f)(3) (West 2010).

7. Bain v. State, 9 So. 3d 723 (Fla. Dist. Ct. App. 2009); Mitch Stacy, "Fla. Man Exonerated After 35 Years Behind Bars," *Associated Press*, December 18, 2009.

8. They spent a total of more than 3,250 years behind bars. See Innocence Project, "250 Exonerated: Too Many Wrongly Convicted," 2–3, at www.innocenceproject.org/news/250.php.

9. See Cathy Maston and Patsy Klaus, U.S. Department of Justice, *Criminal Victimization in the United States, 2005,* (2006), Statistical Tables, table 34(b) (finding that 31.4% of rape and sexual assault cases involved stranger-perpetrators).

10. See, e.g., Ron C. Michaelis et al., *A Litigators Guide to DNA* (Boston: Academic Press/Elsevier, 2008), 45.

11. Gov. Wilder's Executive Clemency Offer, Jan. 14, 1994, at www.pbs.org/wgbh/pages/frontline/shows/case/cases/washingtonclem.html.

12. See John M. Butler, *Forensic DNA Typing: Biology & Technology Behind STR Markers,* 2d ed. (Boston: Academic Press/Elsevier, 2005), 146.

13. Ibid., 33–35.

14. Ibid., 201–298.

15. Dinitia Smith and Nicholas Wade, "DNA Test Finds Evidence of Jefferson's Child by Slave," *New York Times,* November 1, 1998.

16. See Federal Bureau of Investigation, Department of Justice, *CODIS: Combined DNA Index System* 2 (2007), at www.fbi.gov/hq/lab/pdf/codisbrochure2.pdf.

17. See DNA Fingerprint Act of 2005, 42 U.S.C. § 14132(a)(1) (2005) (permitting arrestee profiles to be entered); Michelle Hibbert, "DNA Databanks: Law Enforcement's Greatest Surveillance Tool?" 34 *Wake Forest L. Rev.* 767 (1999).

18. The three states are Louisiana, Texas, and Virginia, See La. Rev. Stat. Ann. § 15.609; Tex. Gov't Code Ann. § 411.1471; Va. Code Ann. § 19.2-310.2:1. See also Julia Preston, "U.S. Set to Begin a Vast Expansion of DNA Sampling," *New York Times,* February 5, 2007 ("Federal Bureau of Investigation officials said they anticipated an increase ranging from 250,000 to as many as 1 million samples a year. The laboratory currently receives about 96,000 samples a year.").

19. Jeffrey Rosen, "Genetic Surveillance for All," *Slate,* March 17, 2009.

20. Sixty-five of the cases involved "cold hits" in a DNA database, while forty-seven involved nondatabase DNA testing that confirmed another's guilt.

21. James Dao, "Lab's Errors Force Review of 150 DNA Cases," *New York Times,* May 7, 2005, A1.

22. Margaret Edds, *An Expendable Man: The Near-Execution of Earl Washington, Jr.,* (New York: New York University Press, 2003), 244–250.

23. Brandon L. Garrett, "Claiming Innocence," 92 *Minn. L. Rev.* 1629, 1655–1670 (2008).

24. Henry J. Friendly, "Is Innocence Irrelevant? Collateral Attack on Criminal Judgments," 38 *U. Chi. L. Rev.* 142, 159–160 (1970).

25. 506 U.S. 390, 417 (1993).

26. House v. Bell, 547 U.S. 518, 540–548 (2006).

27. Ibid., 571 (Robert, C.J., dissenting).

28. David G. Savage, "Murder Charges Dropped Because of DNA Evidence," *Los Angeles Times,* May 13, 2009.

29. The Court has ruled in other cases in which the convict later proved innocence and was exonerated through postconviction DNA testing. All were summary denials of cert. except one—the case of Arizona v. Youngblood, discussed in the next section.

30. 129 S. Ct. 2308, 2316 (2009).

31. Osborne v. District Attorney's Office, Reply to Brief in Opposition 8.

32. 129 S.Ct. 2308, 2319.

33. Ibid.

34. In re Davis, 130 S. Ct. 1 (2009).

35. Skinner v. Switzer, No. 09-9000, 2010 WL 545500 (May 24, 2010).

36. Tim Arango, "Death Row Foes See Newsroom Cuts as a Blow," *New York Times,* May 20, 2009.

37. See Alaska Stat. § 12.73.010–12.73.090 (2010).

38. Gerry Smith, "Rape Conviction Gone, Stigma Isn't," *Chicago Tribune,* October 22, 2007.

39. Jim Dwyer, "New York Fails at Finding Evidence to Help the Wrongly Convicted," *New York Times,* July 6, 2006.

40. Arizona v. Youngblood, 488 U.S. 51, 57–59 (1988); see also Brandon L. Garrett, "Judging Innocence," 108 *Colum. L. Rev.* 55, 95, 117 (2008).

41. See The Innocence Project, *Preservation of Evidence Fact Sheet* (2009), at http://www.innocenceproject.org/Content/253.php.

42. Commonwealth v. Godschalk, 679 A.2d 1295 (Pa. Super. 1996).

43. State v. Halsey, 748 A.2d 634, 636 (N.J. Super. Ct. 2000).

44. Waller v. State, Nos. 05-02-00117-CR, 05-02-00118-CR, 05-02-00119-CR, 05-02-00120-CR, 2003 WL 22456324, at *2 (Tex. Crim. App. October 30, 2003); Jennifer Emily, "Exonerated by DNA, Patrick Waller Is Released from Prison," *Dallas News,* July 3, 2008.

45. Dedge v. State, 732 So.2d 322, 323 (Fla. App. 5 Dist. 1998) (W. Sharp., J. dissenting); Laurin Sellers, "DNA Testing Frees Man Accused in 1981 Rape," *Orlando Sentinel,* August 12, 2004.

46. See N.Y. Crim. Proc. Law § 440.30(1-a) (McKinney Supp. 1999); 725 Ill. Comp. Stat. 5/116-3(a) (West Supp. 1998).

47. For a detailed analysis of these statutes, see Garrett, "Claiming Innocence," 1673–1682.

48. See, e.g., People v. McSherry, 14 Cal. Rptr. 2d 630 (Cal. Ct. App. 1992) (failing to vacate conviction despite DNA exclusion, citing to serology results and the victim's identification); Watkins v. State, No. 30A04-9504-PC-118, 1996 WL 42093 (Ind. Ct. App. Jan. 29, 1996) (stating that DNA results exonerating Jerry Watkins only "suggest the possibility" of another perpetrator and that the DNA evidence was merely "cumulative" of inconclusive serology evidence at trial).

49. See *Frontline,* "The Case for Innocence," http://www.pbs.org/wgbh/pages/front line/shows/case/interviews/keller.html.

50. Ibid. at http://www.pbs.org/wgbh/pages/frontline/shows/case/etc/update.html.

51. Ralph Blumenthal, "12th Dallas Convict is Exonerated by DNA," *New York Times,* January 18, 2007.

52. Hearing Transcript, 3–4, State of West Virginia v. Glen Dale Woodall, No. 87-F-46 (W. Va. Cir. Ct. May 4, 1992).

53. Lola Vollen and Dave Eggers, eds., *Surviving Justice: America's Wrongfully Convicted and Exonerated* (San Francisco: McSweeney's, 2005), 32.

54. Fernanda Santos, "With DNA from Exhumed Body, Man Finally Wins Freedom," *New York Times,* January 24, 2007.

55. Email, Elizabeth Webster, Communications Director, The Innocence Project, 11/9/2009 (on file with author); *Strengthening Forensic Science in the United States: Hearing Before the S. Comm. on the Judiciary,* 111th Cong. (2009) (statement of Peter Neufeld, Co-Director, The Innocence Project).

56. See Barry C. Scheck, "Barry Scheck Lectures on Wrongful Convictions," 54 *Drake L. Rev.* 597, 601 (2006).

57. Fifteen of thirty-six with written decisions were capital cases. These death row inmates, though actually guilty, had a strong incentive to pursue every avenue for review, regardless of whether their claims had merit. I discuss these "guilt confirmation" cases in more detail in an article. Garrett, "Judging Innocence," 141.

58. For example, an opponent to the Virginia DNA statute cited "a strong possibility of abuse." Craig Timberg, "DNA Spurs Crime Panel to Debate Changes in Va.," *Washington Post,* December 2, 2000, B1.

59. U.S. Department of Justice, *Cost Study of DNA Testing and Analysis Report, North Carolina Office of State Budget and Management* (2006), 7–8, at http://www.osbm .state.nc.us/files/pdf_files/3-1-2006FinalDNAReport.pdf.

60. Gabrielle Fimbres, "Lab Work a Lot Cheaper Than Lockup," *Tucson Citizen* (Ariz.), August 23, 2000, 1A; see also Holly Shaffter, "Postconviction DNA Evidence: A 500 Pound Gorilla in State Courts," 50 *Drake L. Rev.* 695, 735 (2002).

61. See Kaine's Full Statement in Norfolk Four Case, at http://voices.washingtonpost .com/virginiapolitics/2009/08/kaines_full_statement_on_norfo.html ?sidST2009080602217. For an in-depth account and analysis of those confession statements, see Tom Wells and Richard A. Leo, *The Wrong Guys: Murder, False Confessions, and the Norfolk Four* (New York: W. W. Norton, 2008).

62. Edwin M. Borchard, *Convicting the Innocent: Errors of Criminal Justice* (New Haven, CT: Yale University Press, 1932), 275.

63. Janet Roberts and Elizabeth Stanton, "A Long Road Back after Exonerations, and Justice Is Slow to Make Amends," *New York Times,* November 25, 2007.

64. Chris William Sanchirico, "Character Evidence and the Object of Trial," 101 *Colum. L. Rev.* 1227, 1271–1272 (2001).

65. See Innocence Project, *Making Up for Lost Time: What the Wrongfully Convicted Endure and How to Provide Fair Compensation* (2009).

66. Fran Spielman, "Former Death Row Inmate to Get $2.2 Million," *Chicago Sun-Times,* December 16, 2003, 22.

67. The case then settled for slightly less than that, avoiding an appeal. David Harper, "McGee Case: City to Pay: Lawsuit Is Settled for $12.25 million," *Tulsa World* (Okla.), June 3, 2006.

68. Ibid.

69. For a review of these statutes, see *Final Report of the New York State Bar Association's Task Force on Wrongful Convictions* (2009), 138–140; Adele Bernhard, "Justice Still Fails: A Review of Recent Efforts to Compensate Individuals Who Have Been Unjustly Convicted and Later Exonerated," 52 *Drake L. Rev.* 703 (2004).

70. Jeff Carlton, "Texas DNA Exonerees Find Prosperity after Prison," *Associated Press,* September 4, 2009.

71. Hugo Kugiya, "Free of Death Row; Hard Road for 13 Former Inmates," *Newsday* (NY), May 19, 2002, A5.

72. Meg Laughlin and Daniel de Vise, "Former Convict Is Overwhelmed by His Freedom," *Miami Herald,* July 7, 2001, 11A.

73. Adam Liptak, "DNA Will Let a Montana Man Put Prison Behind Him, but Questions Still Linger," *New York Times,* October 1, 2002.

74. Mike Wagner and Geoff Dutton, "Columbus Man Finally Freed from Prison," *Columbus Dispatch,* March 10, 2009.

75. Ibid.

76. *Frontline,* "The Burden of Innocence," at www.pbs.org/wgbh/pages/frontline/shows/burden/etc/script.html.

77. Michael Hall, "The Exonerated," *Texas Monthly,* November 2008, 162.

78. Sharon Waxman, "For the Wrongly Convicted, New Trials Once the Cell Opens," *New York Times,* January 25, 2005.

79. Barbara Novovitch, "Free after 17 Years for a Rape That He Did Not Commit," *New York Times,* December 22, 2004, A22.

80. Todd Richmond, "Avery, County Settle for $400,000," *St. Paul Pioneer Press,* February 15, 2006.

81. That story is now the subject of a movie. See John Larrabee and Russ Olivo, "Reluctant Hero," *Rhode Island Monthly,* February 2010.

82. Mike Mather, "30-Year-Old DNA Clears Richmond Man of Rape," at www.wtkr.com/news/wtkr-mather-dna-story-mar05,0,7898871.story.

83. James F. McCarty, "Wrongly Convicted, Now Free DNA Testing Clears Man Jailed for 4 Years in Rape Case," *Cleveland Plain Dealer,* October 7, 1994, 1B.

84. Jennifer Thompson-Cannino and Ronald Cotton, *Picking Cotton: Our Memoir of Justice and Redemption* (New York: St. Martin's Press, 2009).

85. Steve McGonigle, "Rape Victim Is for Exoneration," *Dallas Morning News,* April 6, 2007.

86. *Dateline NBC,* "Profile: Suspicion," June 4, 2008.

87. Jenkins v. Scully, No. 91-CV-298E, 1992 WL 205685, at *2 (W.D.N.Y. July 16, 1992); Jenkins v. Scully, No. 91-CV-298E(M), 1992 WL 205685, at *1 (W.D.N.Y. April 15, 1993).

88. Gene Warner, "What Price to Pay for Wrongful Convictions," *Buffalo News,* April 12, 2008, A1.

9. REFORMING THE CRIMINAL JUSTICE SYSTEM

1. See North Carolina Actual Innocence Commission, Mission Statement, Objectives, and Procedures, at www.innocenceproject.org/docs/NC_Innocence_Commission_Mission.html; Jack Betts, jackbetts.blogspot.com/2010/02/lake-innocence-process-most-important.html.
2. Christine C. Mumma, "The North Carolina Actual Innocence Commission: Unknown Perspectives Joined by a Common Cause," 52 *Drake L. Rev.* 647 (2004). In 2007, the commission was renamed the North Carolina Criminal Justice Study Commission.
3. N.C. Gen. Stat. § 15A-284.50–53 (2002).
4. Ibid. at 52(b).
5. Ibid.
6. N.C. Gen. Stat. § 15A-211 (2009); see also H.B. 33, 2009 Gen. Assem., 2009–2010 Sess. (N.C. 2009).
7. See Criminal Cases Review Commission, at www.ccrc.gov.uk/about.htm/; see also Jerome M. Maiatico, "All Eyes on Us: A Comparative Critique of the North Carolina Innocence Inquiry Commission," 56 *Duke L.J.* 1345 (2007) (comparing North Carolina and U.K. commissions).
8. Canada Criminal Code, R.S.C., ch. C-46, § 696.1–696.6 (1985).
9. "Gov. Easley Signs Innocence Inquiry Commission Bill," *U.S. State News,* August 3, 2006.
10. www.innocencecommission-nc.gov/inthenews.htm ("Since 2007, the Commission has received over 300 applications and has accepted five of those cases for investigation.").
11. Robbie Brown, "Judges Free Inmate on Recommendation of Special Panel," *New York Times,* February 17, 2010.
12. Radley Balko, "Schwarzenegger Vetoes Justice," *FOXNews.com,* November 5, 2007.
13. See Innocence Commissions in the U.S., at www.innocenceproject.org/Content/415.php; see also Cal. Comm'n on the Fair Admin. of Justice, *Final Report* (2008), at www.ccfaj.org/documents/CCFAJFinalReport.pdf; Innocence Comm'n for Va., *A Vision for Justice: Report and Recommendations Regarding Wrongful Convictions in the Commonwealth of Virginia* (2005), at www.exonerate.org/ICVA/full_r.pdf; Commission on Capital Punishment, State of Illinois, *Report of the Governor's Commission on Capital Punishment* (2002), at www.idoc.state.il.us/ccp/ccp/reports/commission_report/index.htm; Stanley Z. Fisher, "Convictions of Innocent Persons in Massachusetts: An Overview," 12 *B.U. Pub. Int. L.J.* 1 (2002); John T. Rago, "A Fine Line between Chaos & Creation: Lessons on Innocence Reform from the Pennsylvania Eight," 12 *Widener L. Rev.* 359 (2006); North Carolina Innocence Inquiry Commission, www.innocencecommission-nc.gov.

14. See Samuel R. Gross et al., "Exonerations in the United States 1989 Through 2003," 95 *J. Crim. L. & Criminology* 523 (2005).

15. James S. Liebman, "The New Death Penalty Debate: What's DNA Got to Do With It?" 33 *Colum. Hum. Rts. L. Rev.* 527 (2002).

16. Adam Liptak, "U.S. Prison Population Dwarfs that of Other Nations," *New York Times,* April 23, 2008.

17. Barry C. Scheck and Peter J. Neufeld, "Toward the Formation of Innocence Commissions," 86 *Judicature* 98, 98 (2002).

18. See Brian A. Reeves, Bureau of Justice Statistics, *Census of State and Local Law Enforcement Agencies, 2004* (2007), 1.

19. Jeremy W. Peters, "Wrongful Conviction Prompts Detroit Police to Videotape Certain Interrogations," *New York Times,* April 11, 2006.

20. See Jodi Wilgoren, "Confession Had His Signature; DNA Did Not," *New York Times,* August 26, 2003.

21. Trial Transcript, 40–41, Michigan v. Eddie Joe Lloyd, 85-00376 (Mich. Rec. Ct. May 2, 1985).

22. See Peters, "Wrongful Conviction."

23. See D.C. Code Ann. § 5-116.01 (2007) (requiring police to record all custodial investigations); 725 Ill. Comp. Stat. Ann. 5/103-2.1 (2006) (requiring police to record interrogations in all homicide cases); Md. Ann. Code, Crim. Proc. § 2-401 (2008) (requiring that law enforcement make "reasonable efforts" to record interrogations); Me. Rev. Stat. Ann. tit. 25, § 2803-B (2007) (mandating recording "interviews of suspects in serious crimes"); Mont. Code Ann. § 46-4-406–46-4-411 (2010) (requiring recording of interrogations in all felony cases); N.C. Gen. Stat. § 15A-211 (2010) (requiring complete electronic recording of custodial interrogations in homicide cases); Neb. Rev. Stat. § 29-4501-4508 (2009), effective July 18, 2008 (requiring electronic recording of interrogations in several types of felony cases); N.M. Stat. § 29-1-16 (Supp. 2006) (requiring police to record all custodial investigations); Ohio Rev. Code Ann. § 2933.81 (2010); Tex. Code Crim. Proc. Ann. art. 38.22, § 3 (Vernon Supp. 2007) (rendering unrecorded oral statements inadmissible); Wis. Stat. Ann. §§ 968.073, 972.115 (requiring recording of felony interrogations and permitting jury instruction if interrogation not recorded); Ind. R. Evid. 617 (requiring that in order to be admissible, entire interrogations in felony criminal prosecutions must be recorded); Stephan v. State, 711 P.2d 1156, 1158 (Alaska 1985) ("[A]n unexcused failure to electronically record a custodial interrogation conducted in a place of detention violates a suspect's right to due process . . ."); Commonwealth v. DiGiambattista, 813 N.E.2d 516, 535 (Mass. 2004) (allowing defense to point out failure to record interrogation and calling unrecorded admissions "less reliable"); State v. Scales, 518 N.W.2d 587, 592 (Minn. 1994) ("[A]ll questioning shall be electronically recorded where feasible and must be recorded when questioning occurs at a place of detention."); State v. Barnett, 147 N.H. 334 (2001); State v. Cook, 847 A.2d 530, 547 (N.J. 2004) ("[W]e will establish a committee to study and make recommendations on the use of electronic recordation of custodial interrogations."); In re Jerrell C.J., 699 N.W.2d 110, 123 (Wis. 2005)

("[W]e exercise our supervisory power to require that all custodial interrogation of juveniles in future cases be electronically recorded where feasible, and without exception when questioning occurs at a place of detention."); State v. Hajtic, 724 N.W.2d 449, 456 (Iowa 2006) ("electronic recording, particularly videotaping, of custodial interrogations should be encouraged, and we take this opportunity to do so.").

24. A recent survey of 631 police investigators found that 81% believed that interrogations should be recorded. See Saul Kassin et al., "Police Interviewing and Interrogation: A Self-Report Survey of Police Practices and Beliefs," 31 *Law & Hum. Behav.* 381 (2007).

25. Transcript of Motion to Suppress Hearing, 72–73, United States v. Bland, No. 1:02-CR-93 (N.D. Ind. Dec. 12, 2002).

26. Stoker v. State, 692 N.E.2d 1386, 1390 (Ind. Ct. App. 1998).

27. See Peters, "Wrongful Conviction."

28. See Brandon L. Garrett, "The Substance of False Confessions," 62 *Stan. L. Rev.* 1051, 1109–1118 (2010).

29. Darryl Fears, "Exonerations Have Changed Justice System," *Washington Post,* May 3, 2007.

30. Trial Transcript, 182, State of New Jersey v. McKinley Cromedy, Ind. No. 1243-07-93 (N.J. Super. Ct. July 27, 1994).

31. Ibid., 104.

32. Ibid., 142.

33. Ibid., 164, 168.

34. State v. Cromedy, 727 A.2d 457 (N.J. 1999).

35. Ibid.

36. Tom Avril, "Eyewitness' Blind Spot," *Philadelphia Inquirer,* May 22, 2006.

37. Office of the Attorney General, N.J. Department of Law and Public Safety, *Attorney General Guidelines for Preparing and Conducting Photo and Live Lineup Identification Procedures* (Apr. 18, 2001). The attorney general referred to "recent cases, in which DNA evidence has been utilized to exonerate individuals convicted almost exclusively on the basis of eyewitness identifications." Letter from New Jersey Attorney General John J. Farmer, Jr., to All County Prosecutors et al. (Apr. 18, 2001), 1.

38. State v. Delgado, 188 N.J. 48, 62–63 (N.J. 2006) (citing Court Rule 3:17).

39. State v. Romero, 191 N.J. 59, 76 (2007).

40. State v. Henderson, 2009 WL 510409 (N.J. Feb. 26, 2009).

41. *Report of the Special Master,* State of New Jersey v. Karry R. Henderson, No. A-8 (2010).

42. Bloodsworth v. State, 512 A.2d 1056, 1062 (Md. 1986).

43. John Monahan and Laurens Walker, *Social Science in Law,* 6th ed. (New York: Foundation Press, 2006), 567–605; see, e.g., Utah v. Dean Lomax Clopton, 2009 UT 84 ("Over the last two decades, numerous other state courts have either reversed decisions to exclude or encouraged the inclusion of eyewitness expert testimony").

44. See 725 Ill. Comp. Stat. 5/107A-5 (2003); Md. Code Ann., Pub. Safety § 3-506 (2007); N.C. Gen. Stat. § 15A-284.52 (2007); Ohio Rev. Code Ann. § 2933.83 (2010); W. Va. Code Ann. § 62-1E-1 (2010); Wis. Stat. § 175.50 (2005).

45. See, e.g. Va. Code Ann. § 19.2-390.00-02 (2005).

46. Jennifer Emily, "New Dallas Policy Regulates, Limits Showups," *Dallas Morning News,* December 10, 2008; Jennifer Emily, "Dallas Police Drop Study, Plan Photo-Lineup Changes," *Dallas Morning News,* January 16, 2009; The Justice Project, *Eyewitness Identification: A Policy Review* (2006), http://www.thejusticeproject. org/wp-content/uploads/polpack_eyewitnessid-fin21.pdf.

47. Trial Transcript, 508, 524–529, State of West Virginia v. Glen Dale Woodall, Ind. No. 87-P-46 (W. Va. Cir. Ct. July 2, 1987).

48. In re an Investigation of The W. Va. State Police Crime Lab., Serology Div., 438 S.E.2d 501, 502–503 (W. Va. 1993).

49. See ASCLD/LAB, *West Virginia State Police Crime Laboratory, Serology Division, South Charleston, West Virginia, ASCLD/LAB Investigation Report* (July 23, 1993) at http://www.law.virginia.edu/pdf/faculty/garrett/innocence/wva_cvrime_ lab.pdf.

50. In re an Investigation of The W. Va. State Police Crime Lab., Serology Div., 438 S.E.2d at 506; see Kit R. Roane and Dan Morrison, "The CSI Effect," *U.S. News & World Report,* April 25, 2005, 48.

51. In re Renewed Investigation of State Police Crime Laboratory, Serology Div., 633 S.E.2d 762, 766 (W. Va. Jun. 16, 2006).

52. See Michael R. Bromwich, *Fifth Report of the Independent Investigator for the Houston Police Department Crime Laboratory and Property Room, Executive Summary* (2006), 2; Roma Khanna and Steve McVicker, "Police Lab Tailored Tests to Theories, Report Says," *Houston Chronicle,* May 12, 2006.

53. Editorial, "Crime Lab Legacy," *Houston Chronicle,* August 12, 2009.

54. See, e.g., Minn. Stat. §299C.156 (2007) (establishing Forensic Laboratory Advisory Board); N.Y. Exec. Law §§995-a to -b (McKinney 2003) (establishing forensic science commission and requiring accreditation); Okla. Stat. Ann. tit. 74, §150.37 (2007) (requiring accreditation); Tex. Code Crim. Proc. Ann. art. 38.35(d) (Vernon 2005) (requiring accreditation by the Texas Department of Public Safety); Va. Code Ann. §9.1-1101 (2006) (creating Department of Forensic Science and oversight committee).

55. See ASCLD/LAB Home Page, www.ascld-lab.org/.

56. Mandy Locke and Joseph Neff, "Inspectors Missed All SBI Faults," *News Observer* (Charlotte), August 26, 2010.

57. For example, in one positive step, the International Association for Identification (IAI) adopted new guidelines concerning fingerprint testimony, to more clearly acknowledge the limitations of the method. See IAI Resolution 2010-18.

58. See Dodd v. State, 993 P.2d 778, 784 (Okla. Crim. App. 2000) (adopting procedure for jailhouse informant testimony that ensures "complete disclosure"); Cal. Penal Code § 1127a(b) (West 2004) (requiring courts to instruct jury on in-custody informant testimony); United States v. Villafranca, 260 F.3d 374, 381 (5th Cir. 2001)

("The testimony of a plea-bargaining defendant is admissible if the jury is properly instructed."); State v. Bledsoe, 39 P.3d 38, 44 (Kan. 2002) (noting that trial court "gave a cautionary jury instruction regarding the testimony of an informant"); Alexandra Natapoff, "Beyond Unreliable: How Snitches Contribute to Wrongful Convictions," 37 *Golden Gate U. L. Rev.* 107, 112–115 (2006) (proposing model statute requiring pretrial evaluations of informant testimony).

59. See 725 Ill. Comp. Stat. Ann. 5/115-21(d) (West Supp. 2007); Dodd v. State, 993 P.2d at 785 (suggesting in concurring opinion that reliability hearings be conducted); Myers v. State, 133 P.3d 312, 321 (Okla. Crim. App. 2006) (describing post-*Dodd* case in which reliability hearing was conducted, though not required by *Dodd*); D'Agostino v. State, 823 P.2d 283 (Nev. 1992) (holding that before admitting testimony of a jailhouse informant in a capital sentencing-phase hearing, the judge should first review its reliability).

60. See Province of Ontario, Ministry of Attorney General, *In-Custody Informers, Crown Policy Manual* (March 21, 2005), R. v. Brooks, [2000] 1 S.C.R. 237 Can.; Kent Roach, "Unreliable Evidence and Wrongful Convictions: The Case for Excluding Tainted Identification Evidence and Jailhouse and Coerced Confessions," 52 *Crim. L. Q.* 210 (2007); Hon. Fred Kaufman, *Report of the Kaufman Commission on Proceedings Involving Guy Paul Morin* (1998).

61. *Report of the 1989–1990 Los Angeles County Grand Jury, Investigation of the Involvement of Jailhouse Informants in the Criminal Justice System in Los Angeles County* (1989–1990), 149; Henry Weinstein, "Use of Jailhouse Informants Is Uneven in State," *Los Angeles Times,* September 21, 2006, 3; Staff, "Man Who Showed How to Fake Confessions Is Indicted for Perjury," *Los Angeles Times,* March 4, 1992, 1.

62. The eleven cases in which the DNA testing confirmed the guilt of another are those of Kirk Bloodsworth, Kennedy Brewer, Rolando Cruz, Alejandro Hernandez, Verneal Jimerson, Ray Krone, Robert Miller, Frank Lee Smith, Earl Washington, Dennis Williams, and Ron Williamson.

63. 553 U.S. 35, 85–86 (2008) (Stevens, J., concurring).

64. United States v. Quinones, 196 F. Supp. 2d. 416, 420 (S.D.N.Y. 2002).

65. United States v. Quinones, 313 F.3d 49 (2d Cir. 2002).

66. See Death Penalty Information Center, *Innocence and the Death Penalty,* at www .deathpenaltyinfo.org/innocence-and-death-penalty (listing 138 death row exonerees since 1973). For excellent discussions of the role that these DNA exonerations have played in altering the death penalty debate, see Liebman, "The New Death Penalty Debate," and Colin Starger, "Death and Harmless Error: A Rhetorical Response to Judging Innocence," *Colum. L. Rev. Sidebar* 1, February 23, 2008.

67. See Bureau of Justice Statistics, U.S. Department of Justice, *Sourcebook of Criminal Justice Statistics 2003,* 147, table 2.56; see also Frank R. Baumgartner, Suzanna L. De Boef, and Amber E. Boydstun, *The Decline of the Death Penalty and the Discovery of Innocence* (New York: Cambridge University Press, 2008).

68. Kansas v. March, 548 U.S. 163, 189 (2006) (Scalia, J. concurring).

69. Md. Code Ann., Crim. Law § 2-202 (2010).

70. Massachusetts Governor's Council on Capital Punishment, *Final Report* (2004), at http://www.lawlib.state.ma.us/docs/5-3-04Governorsreportcapitalpunishment. pdf.

71. Robert H. Jackson, "The Federal Prosecutor," 24 *J. Am. Judicature Soc'y* 18, 18 (1940).

72. Josh Bowers, "Punishing the Innocent," 156 *U. Penn. L. Rev.* 1117 (2008).

73. Editorial, "Craig Watkins Is the 2008 Texan of the Year," *Dallas News*, December 28, 2008.

74. Alex Holmquist, "Ramsey County: Better ID Methods Sought for Witnesses New Techniques to Be Focus of St. Paul Conference," *St. Paul Pioneer Press (MN)*, October 23, 2009, B1.

75. Peg Lautenschlager, Wisconsin Attorney General, "Eyewitness Identification Best Practices" (June 15, 2005); John J. Farmer, Jr., Attorney General of the State of New Jersey, "Letter to All County Prosecutors: Attorney General Guidelines for Preparing and Conducting Photo and Live Lineup Identification Procedures" (April 18, 2001); Office of the Utah Attorney General, *Best Practices Statement for Law Enforcement: Recommendations for Recording of Custodial Interviews* (October 2008).

76. Jonathan Saltzman, "Homicide Conviction Rate in '09 Up Sharply," *Boston Globe*, December 28, 2009.

77. See, e.g., Report of the Task Force on Eyewitness Evidence, Suffolk County District Attorney's Office (July 2004), at www.innocenceproject.org/docs/Suffolk_eyewit ness.pdf.

78. See, e.g., American Bar Association Standing Committee on Legal Aid and Indigent Defendants, *Gideon's Broken Promise: America's Continuing Quest for Equal Justice* (2004); The Spangenberg Group, *State and County Expenditures for Indigent Defense Services in Fiscal Year 2002* (2003), 34–37; Note, "Gideon's Promise Unfulfilled: The Need for Litigated Reform of Indigent Defense," 113 *Harv. L. Rev.* 2062, 2065 (2000); Darryl K. Brown, "Rationing Criminal Defense Entitlements: An Argument from Institutional Design," 104 *Colum. L. Rev.* 801, 807–808 and n.28, 815 (2004).

79. See *Oversight of the Department of Justice's Forensic Grant Programs: Hearing Before the S. Comm. on the Judiciary, 110th Cong.* (2008) (statement of Glenn A. Fine, Inspector General, U.S. Department of Justice); *Oversight of the Justice For All Act: Hearing Before the S. Comm. on the Judiciary, 110th Cong.* (2008) (statement of Peter Neufeld on Behalf of the Innocence Project).

80. *Letter from Assistant Attorney General William Moschella to U.S. Senator Orrin Hatch,* April 28, 2004, H.R. Rep. No. 108-711 at 133–156 (2004).

81. See Department of Justice, Technical Working Group for Eyewitness Evidence, *Eyewitness Identifications: A Guide for Law Enforcement* (1999), at www.ncjrs.gov/ pdffiles1/nij/178240.pdf; National Institute of Justice, U.S. Department of Justice, *National Commission on the Future of DNA Evidence*, www.ojp.usdoj.gov/nij/top ics/forensics/evidence/dna/commission/welcome.html.

82. Kansas v. Marsh, 548 U.S. 163, 194–195 (2006) (Scalia, J., concurring). Much of the thrust of his opinion, however, concerns a separate topic, the degree of error in our

system of capital punishment, which he argued has been "reduced to an insignificant minimum," or at least that the public is comfortable with the risks of error that exist. Ibid., 199. Justice Scalia was responding to a dissent by Justice Souter. Souter discussed several studies of false capital convictions, stating that "Today, a new body of fact must be accounted for in deciding what, in practical terms, the Eighth Amendment guarantees should tolerate, for the period starting in 1989 has seen repeated exonerations of convicts under death sentences, in numbers never imagined before the development of DNA tests." Ibid., 207–208 (Souter, J. dissenting). This book does not squarely address such debates, as I do not examine any set of capital convictions. However, as discussed earlier in this chapter, seventeen DNA exonerees had been sentenced to death, some multiple times, before their exoneration. For a discussion of the debate between Souter and Scalia, see Samuel R. Gross, "Souter Passant, Scalia Rampant: Combat in the Marsh," 105 *Michigan Law Review First Impressions* 67 (2006).

83. While scholars have estimated troubling error rates based on exonerations in death penalty cases, the cases that Justice Scalia was preoccupied with, such efforts are possible because we know how many people have been sentenced to death. See D. Michael Risinger, "Innocents Convicted: An Empirically Justified Wrongful Conviction Rate," 97 *J. Crim. L. & Criminology* 761 (2007) (estimating a 3.3% to 5% wrongful conviction rate for capital rape-murder exonerations involving convictions in the 1980s); Samuel R. Gross and Barbara O'Brien (draft on file with author).

84. See Sean Rosenmerkel, Matthew Durose, and Donald Farole Jr., U.S. Department of Justice, Bureau of Justice Statistics, *Felony Sentences in State Courts, 2006* (2009), table 1.2.1 (finding that of 1,132,290 felony convictions in state courts, only 10,540 involved rape convictions resulting in a prison sentence). A study from the early 1990s reported slightly higher figures. See Patrick A. Langan and Jodi M. Brown, U.S. Department of Justice, Bureau of Justice Statistics, *Felony Sentences in State Courts, 1994* (1992), 2 (finding that of 872,217 felony convictions, about 20,000 felons were convicted of rape, 71% of whom received a prison sentence).

85. The most complete effort to examine rape convictions, for example, used limited data and included no data on how many convicts were both convicted at a trial and received prison sentences of a given length, much less how many of those involved stranger-perpetrators. See Lawrence A. Greenfield, U.S. Department of Justice, Bureau of Justice Statistics, *Sex Offenses and Sex Offenders (1997)*, v, 13–14. The aggregate data presented in that study suggest that exonerees' convictions are atypical of the vast majority of rape convictions. Approximately 75% of rape convictions involve nonstranger acquaintance crimes, and of the approximately 21,000 rape convictions annually in the 1980s, 80% involved a plea bargain. In the 1980s, approximately two-thirds of rape convicts received a prison sentence, and among those, the average jail term was eight months, a fraction of the average of thirteen years that these innocent convicts served before being exonerated. Ibid. Another study suggests just a few thousand rape convictions involved a trial. See also Patrick A. Langan and Helen A. Graziadei, U.S. Department of Justice, Bureau of Justice Statis-

tics, *Felony Sentences in State Courts, 1992* (1995), 9 (finding that 3,952 rape convicts were convicted at a trial). Only 16% of rape convicts in another 1992 study received a maximum sentence of more than ten years, and many of those may not have served that long. Brian A. Reaves and Pheny Z. Smith, U.S. Department of Justice, Bureau of Justice Statistics, *Felony Defendants in Large Urban Counties, 1992* (1995), 33. Thus, the number of comparable cases during the relevant time period may not be great, and factoring the degree to which some innocent individuals never seek DNA testing, or where DNA tests cannot be conducted because the evidence was not preserved, the error rate is still higher.

86. Instead, a few jurisdictions have conducted partial or flawed retesting efforts. For example, an effort in Virginia has tested only selected cases and used outdated testing technology. See, e.g., Frank Green, "DNA Retests Needed in up to 400 Cases in Virginia," *Richmond Times-Dispatch,* May 14, 2009. Other efforts have similarly involved small numbers of cases handpicked by law enforcement or crime laboratories. See Jodi Wilgoren, "Prosecutors Use DNA Test to Clear Man in '80s Rape, *New York Times,* November 14, 2002.

87. District Attorney's Office for Third Judicial Dist. v. Osborne, 129 S. Ct. 2308, 2323 (2009).

88. D. Michael Risinger et al., "The Daubert/Kumho Implications of Observer Effects in Forensic Science: Hidden Problems of Expectation and Suggestion," 90 *Cal. L. Rev.* 1 (2002).

89. Richard A. Posner, "An Economic Approach to the Law of Evidence," 51 *Stan. L. Rev.* 1477, 1495 (1999); Dan Simon, "The Limited Diagnosticity of Criminal Trials," 63 *Vand. L. Rev.* (forthcoming 2011); Dan Simon, "A Third View of the Black Box: Cognitive Coherence in Legal Decision Making," 71 *U. Chi. L. Rev.* 511 (2004); Keith A. Findley and Michael S. Scott, "The Multiple Dimensions of Tunnel Vision in Criminal Cases," 2006 *Wis. L. Rev.* 291.

90. Itiel E. Dror, David Charlton, and Ailsa E. Peron, "Contextual Information Renders Experts Vulnerable to Making Erroneous Identifications," 156 *Forensic Sci. Int'l* 74–78 (2006).

91. Trial Transcript, 189–190, State of California v. Frederick Rene Daye, D 002073 (Cal. Ct. App. May 24, 1984).

92. Maurice Possley, "Exonerated by DNA, Guilty in Official's Eyes," *Chicago Tribune,* May 28, 2007.

93. Judith Graham, "Crime Labs Contaminate Justice," *Chicago Tribune,* June 21, 2001.

94. Linda T. Kohn, Janet M. Corrigan, and Molla S. Donaldson, *To Err Is Human: Building a Safer Health System* (Washington, D.C.: National Academy Press, 2000), 3–7.

95. See Peter Pronovost et al., "An Intervention to Decrease Catheter-Related Bloodstream Infections in the ICU," 355 *New Engl. J. Med.* 2725–2732 (2006).

96. See Keith Findley, "Proceedings of the Conference on New Perspectives on Brady and Other Disclosure Obligations: What Really Works: Report of the Working Groups on Best Practices," 31 *Cardozo L. Rev.* 1961, 1974–1975 (2010).

97. Gary L. Wells and Deah S. Quinlivan, "Suggestive Eyewitness Identification Procedures and the Supreme Court's Reliability Test in Light of Eyewitness Science: 30 Years Later," 33 *Law & Hum. Behav.* 1, 1 (2009) ("DNA exoneration cases can only represent a fraction, probably a very small fraction, of the people who have been convicted based on mistaken eyewitness identification.").

98. Trial Transcript, 76, State of Illinois v. Ronald Jones, No. 85-12043 (Ill. Cir. Ct. July 17, 1989).

99. William Shakespeare, *Macbeth,* act. 3, sc. 2, 8–12, act. 5, sc. 5, 69.

100. Letter from Kirk Bloodsworth to Congress (May 24, 2004), at www.thejusticepro ject.org/testimony/kirk-bloodsworth-letter-to-congress/.

101. Ben Protess, "The DNA Debacle," *ProPublica,* May 5, 2009 (describing half-billion dollars in grant for DNA backlog elimination allocated under the 2004 Justice For All Act).

102. Trial Transcript, 321, State of Texas v. Ronald Gene Taylor (Tex. Dist. Ct. April 28, 1995).

103. See 145 Cong. Rec. S14533-02.

APPENDIX

1. The Innocence Project Home Page, at www.innocenceproject.org (providing count of postconviction DNA exonerations; the number as of July 2010 is 255).

2. These documents are available online at a set of University of Virginia School of Law Library research collection webpages. See Brandon L. Garrett, "Convicting the Innocent," at http://www.law.virginia.edu/innocence. Links are available at that webpage to appendixes and resources related to each book chapter. For example, for records relating to exoneree false confessions, see www.law.virginia.edu/html/ librarysite/garrett_falseconfess.htm. For records relating to forensic analysis, see Brandon L. Garrett, "Exoneree Trials: Testimony by Forensic Analysts," at www .law.virginia.edu/html/librarysite/garrett_exoneree.htm.

3. Brandon L. Garrett, *Judging Innocence: An Update* (2009), at www.law.virginia .edu/html/librarysite/garrett_exonereedata.htm.

4. An interrater reliability analysis using the Kappa statistic was performed to determine consistency among raters in coding the two central questions concerning whether eyewitness identifications in a case involved indicia of police suggestion or unreliability. Kappa values from 0.40 to 0.59 are considered moderate, 0.60 to 0.79 substantial, and 0.80 outstanding (Landis and Koch, 1977). Analyses revealed outstanding interrater reliability for suggestion (Kappa 0.89, p .0.001, 95% CI 0.77 - 1.01) and substantial interrater reliability for reliability (Kappa 0.78, p .0.001, 95% CI 0.60 - .96). See J. R. Landis and G. G. Koch, "The Measurement of Observer Agreement for Categorical Data," 33 *Biometrics* 59–174 (1977).

5. For example, trial records obtained often do not provide basic data, such as the race of the defendant and the race of the victim, data that is readily available in exonerees'

comparatively well-publicized cases. Indeed, trial records are sealed in sexual assault cases in several key jurisdictions. For cases in which the only records are written judicial decisions, data is even more scant. Even data as basic as the year of conviction, or types of evidence presented at trial, was not typically reported in "matched" cases identified through judicial decisions.

Acknowledgments

This book benefited from invaluable comments on the manuscript by Kerry Abrams, Samuel Gross, Richard Lempert, Greg Mitchell, John Monahan, Maurice Possley, George Rutherglen, Colin Starger, Zahr Stauffer, Steven Sun, and Larry Walker. Several of the chapters began as law review articles studying aspects of DNA exonerations: "Judging Innocence," 108 *Columbia Law Review* 55 (2008); "Claiming Innocence," 92 *Minnesota Law Review* 1629 (2008); "Invalid Forensic Science Testimony and Wrongful Convictions," 95 *Virginia Law Review* 1 (2009) (with Peter Neufeld); "The Substance of False Confessions," 62 *Stanford Law Review* 1051 (2010); and "DNA and Due Process," 78 *Fordham Law Review* (2010). I benefited greatly from collaborating with Peter Neufeld on the study of the forensic testimony in exonerees' trials, and with J. J. Prescott on a project in progress analyzing the litigation of exonerees using a series of regressions.

I thank for their comments on book chapters or previous law review articles that led to this book: Anthony Amsterdam, Rachel Barkow, Tony Barkow, Josh Beaton, Adele Bernhard, Edward Blake, Richard Bonnie, Darryl Brown, Rebecca Brown, Albert Choi, Anne Coughlin, Steven Drizin, Jeff Fagan, Jonathan Haidt, Bernard Harcourt, Toby Heytens, Roger Hood, Richard Hynes, Jim Jacobs, Saul Kassin, Jody Kraus,

Eric Lander, Richard Leo, Richard Lewontin, James Liebman, Paul Mahoney, Nina Morrison, Erin Murphy, Caleb Nelson, Peter Neufeld, Sinead O'Doherty, Richard Ofshe, Carolyn Ramsey, D. Michael Risinger, Austin Sarat, Barry Scheck, Richard Schragger, Stephen Schulhofer, Elizabeth Scott, Dan Simon, Nancy Steblay, Susan Sturm, William Thompson, Gary Wells, and Rob Warden. The book benefited from presentations at Chicago, Georgia, Harvard, New York University, University of Virginia, Toronto, and Tulsa law schools, and conferences including the Annual Conference of the American Society of Criminology, the Annual Conference of the Law and Society Association, the Innocence Network Conference, the Conference on Empirical Legal Studies, and the Fourth Meeting of the National Academy of Sciences, Committee on Identifying the Needs of the Forensic Sciences Community. I thank students in my Wrongful Convictions seminars and my Habeas Corpus course for their comments over the years.

Assembling this body of records from the cases of the first 250 DNA exonerees was possible only with the help of many others. I am very grateful to the law firm Winston & Strawn, which had scanned much of the Innocence Project's files and provided access to those documents. I give special thanks to Maddy DeLone, Huy Dao, Emily West, and others at the Innocence Project for all of their help in both locating materials and exchanging data, as well as Christine Mumma of the North Carolina Center on Actual Innocence and the staff of the Center on Wrongful Convictions for their help locating materials in several cases. I obtained still more trial records with the assistance of the superlative staff of the UVA Law Library, and in particular Michelle Morris, Ben Doherty, and Kent Olson. Perhaps the largest group of records was obtained with the help of countless court clerks, court librarians, court reporters, prosecutors, defense lawyers, postconviction lawyers, and innocence projects, who graciously searched through archives and files. The Dallas District Attorney's Office was particularly helpful, and provided trial transcripts for a number of cases that otherwise would not have been located. I give special thanks to Dianne Johnson and Betty Snow of UVA Law School for all of their assistance scanning these files.

Once these materials were collected and scanned, a team of superlative research assistants helped to review and code all of the documents over

several years: Jeffrey Bender, Catherine Byrd, James Cass, Christine Chang, Veronica Dragalin, Rebecca Ivey, Tifani Jones, Bradley Justus, Jessica King, David Koenig, Shannon Lang, Josephine Liu, Rebecca Martin, Erin Montgomery, Sinead O'Doherty, Nilakshi Pardigamage, T. J. Parnham, Rebecca Reeb, Richard Rothblatt, Kerry Shapleigh, Natalie Shonka, Jason Shyung, Elizabeth Studdard, Steven Sun, Elizabeth Tedford, and Justin Torres. I thank Jessica Kostelnik for her help calculating an interrater reliability score concerning eyewitness coding and Edward Kennedy for his help analyzing data and preparing charts displaying several of the results. I thank Mary Wood for assistance creating the law library research resource websites that have made some of the materials from these exonerees' cases available online to the public.

This book is a testament to the persistence and courage of these innocent people, who typically struggled for many years to prove their innocence. I also thank the exonerees to whom I reached out when researching this book, who were kind enough to answer questions about their cases and to provide trial materials or other records.

I had the privilege to work for Peter Neufeld and Barry Scheck at the law firm then called Cochran, Neufeld & Scheck, LLP, from 2002 to 2004. While there, I had the opportunity to represent several DNA exonerees with respect to civil wrongful conviction actions filed following their exoneration.

I thank Elizabeth Knoll for her editorial suggestions and guidance, as well as all of those at Harvard University Press whose work improved the manuscript.

This book would not have been possible without the intellectual contributions of my colleagues at the University of Virginia School of Law. This research was also financially supported by generous grants from the Olin Program at UVA Law, summer research grants from UVA Law, and a very generous grant over several years from the Open Society Institute, Criminal Justice Fund.

My most heartfelt appreciation is reserved for my family, who supported this work over many years. My amazing children were both born as I worked on this book, and they have brought joy to my every day. My parents, Theodore and Bonnie Garrett, my sister, Natalie Garrett, and my in-laws, Richard and Janice Abrams, have all encouraged and helped

me in countless ways. My greatest thanks are to my wife, Kerry Abrams, who not only is a lovely and brilliant partner in all things, but also made the most invaluable, insightful, and thought-provoking contributions to this book in all of its stages, as an unparalleled reader, editor, and sounding board.

Index